A THEORY OF ART

SUNY Series in Systematic Philosophy
Robert C. Neville, Editor

Whether systematic philosophies are intended as true pictures of the world, as hypotheses, as the dialectic of history, or as heuristic devices for relating rationally to a multitude of things, they each constitute articulated ways by which experience can be ordered, and as such they are contributions to culture. One does not have to choose between Plato and Aristotle to appreciate that Western civilization is enriched by the Platonic as well as Aristotelian ways of seeing things.

The term "systematic philosophy" can be applied to any philosophical enterprise that functions with a perspective from which everything can be addressed. Sometimes this takes the form of an attempt to spell out the basic features of things in a system. Other times it means the examination of a limited subject from the many angles of a context formed by a systematic perspective. In either case systematic philosophy takes explicit or implicit responsibility for the assessment of its unifying perspective and for what is seen from it. The styles of philosophy according to which systematic philosophy can be practiced are as diverse as the achievements of the great philosophers in history, and doubtless new styles are needed for our time.

Yet systematic philosophy has not been a popular approach during this century of philosophical professionalism. It is the purpose of this series to stimulate and publish new systematic works employing the techniques and advances in philosophical reflection made during this century. The series is committed to no philosophical school or doctrine, nor to any limited style of systematic thinking. Whether the systematic achievements of the previous centuries can be equalled in the 20th depends on the emergence of forms of systematic philosophy appropriate to our times. The current resurgence of interest in the project deserves the cultivation it may receive from the SUNY Series in Systematic Philosophy.

A THEORY OF ART

Inexhaustibility by Contrast

STEPHEN DAVID ROSS

State University of New York Press

ALBANY

Published by
State University of New York

© 1982 State University of New York, Albany

For information, address State University of New York
Press, State University Plaza, Albany, N.Y., 12246

Library of Congress Cataloging in Publication Data

Ross, Stephen David.
 A theory of art.

 Includes index.
 1. Art—Philosophy. I. Title.
 N70.R67 701 81-9027
 ISBN 0-87395-554-4 AACR2
 ISBN 0-87395-555-2 (pbk.)

10 9 8 7 6 5 4 3 2

Contents

v

Preface

Art is among the most typical, pervasive, and fundamental of human activities, taking a remarkable variety of forms and imbued with an apparently unquenchable drive toward novelty and variation. Given its pervasiveness throughout human life, we may wonder why we have so little understanding of the nature of art. We lack even a rudimentary understanding of art in general—though we possess remarkable insights into individual works and periods. Yet given the variety of works, styles, and arts, it is not surprising that we have no adequate general theory of art, for every such theory is dissipated into new forms and developments in artistic production. It is worth noting in addition that however profound and incisive our understanding of masterpieces of art, they transcend every particular knowing, every particular experience. There is a fecundity—an inexhaustibility—to our experience of art, a crystallization of the inexhaustibility of our lives and surroundings, that surpasses any particular insights we may attain.

The immense variability of works and styles of art threatens every theory of art with inadequacy. Yet there are other inadequacies in traditional and common views of art which are far more indicative of our limited grasp than the limitations of generalization. It is my intention in this book to provide a general understanding of the richness and power of works•of art, in their myriad forms, including masterpieces but also lesser achievements, including acknowledged failures. I have been particularly struck by the remarkable implausibility of well-known views of art, implausible not only in scope and application to all times and works of art, but implausible in their scale of values. Many candidates for aesthetic value seem to me largely worthless, as if art had no legitimacy and supremacy. I begin with the assumption that art would not be so widespread and revered if it did not offer us an irreplaceable value.

Yet many well-known theories offer us trivial values. If art is mimetic, especially of ordinary objects and persons, why is imitation important? Much twentieth-century art is not obviously mimetic; but where it is, of what value is reproduction? Alternatively, art has been held to be emotionally expressive. Again, some works of art are not emotional and are far from obviously expressive. But even worse, what value has expression? Are everyday emotions worth repeating? And if the emotions are not common, are they supreme?

There have been theories which assign to art a major value, but these have often been of limited scope, based on implausible assumptions. That art might mirror the divine order of the universe would be a supreme value—if there were such an order—but not one obviously different from the values of science. That art might bring us into relation with timeless forms would be a supreme value—but tarnished by the obvious sensuousness of artistic means and in competition with other forms of understanding. Kant's view that beauty is delight in the free play of the cognitive faculties is a notable exception, since artistic value here is both unique and supreme. But it suffers from the narrowness of Kant's view of the faculties and a rejection of both content and cognition as distinctively aesthetic.

The twentieth century has posed a challenge to everyone concerned with art: artists and critics as well as philosophers. The rate of variation, the diversity of new forms, the departures from rules, have not only called established styles, conventions, and traditions into question, but even the nature of art and the canons of criticism. Masterpieces have been called into question by trends toward simplification; artists have been called into question by ready-mades; criticism has called itself into question through a succession of new techniques and methods that virtually matches art itself for instability; fine art has been called into question by the power and influence of popular arts.

The natural consequence has been confusion, sometimes despair. Yet there have been positive as well as negative elements in the apparent chaos. Important aspects of art and criticism have been emphasized that were not adequately recognized before: the relevance of social and institutional milieux to art—the "Artworld," the cultural "superstructure"; the relationship of works of art to other works, of artists to their predecessors—"intertextuality"; the capacity of major works of art to disclose obscured but fundamental relationships in human life that we might otherwise fail to recognize overtly—"hermeneutics"; the continual movement from work to work, text to text, apparently unceasingly and without independent criteria—"deconstruction." All of

these are partial expressions of the scope and power of art, but are inadequate foundations for a general understanding of the nature of art. Nevertheless, they include two of the fundamental elements necessary to such an understanding: (1) the wealth of features relevant to works of art; (2) the extraordinary precision of detail that is prominent in the greatest works and relevant in all works. These traits are stumbling blocks for most theories of artistic revelation: whatever is revealed by a work of art is but a part of its richness and importance.

Taken all together, what these developments in art and theory indicate is that both similarities and differences are important in art, and in remarkably diverse ways. Here developments in structuralism and semiotics have made important contributions, though under severe constraints, emphasizing unrecognized similarities on the one hand and the element of difference derived from Saussure's view of language on the other. The synthetic interplay of similarity and difference is what I call "contrast"; its central feature is its capacity to rise to higher and higher levels of contrast, so that, for example, stylistic developments at one phase of art—contrasts themselves—are contrasted with later developments in even more complex ways. Such contrasts are the elements of aesthetic value. They display both similarities and differences, in synthesis and conjunction, but in inexhaustible variety. The emphasis on difference, at a variety of levels, is the manifestation of inexhaustibility. My view is that art, with its interpretation and criticism, manifests inexhaustibility in the sense that there is unlimited potential for new oppositions and variations, promoting new differences and similarities, relevant to works of art. New methods of criticism—psychoanalytic, social, structuralist, semiotic, deconstructive, etc.—simultaneously reveal new contrasts in works of art and create new norms of opposition and synthesis.

The view that art manifests inexhaustibility provides an explanation of its variety. The principle that inexhaustibility is manifested through contrast explains the importance of both conventions in art and departures from them. This principle also provides a basis for understanding the uniqueness of art as well as its moral, philosophical, and factual character. These function in works of art as contrasts. Emphasis on contrast as such in art is its distinguishing feature, compared with philosophy and science, for example, in which contrasts are necessary and prominent, but not emphasized. The social milieux, the traditions and styles, the recurrent uniformities in art are neither necessary nor sufficient determinants of the nature of art or its values, but are prominent components of major contrasts.

Art is the manifestation of inexhaustibility through contrast. The major categories in terms of which we understand individual works are all contrasts, and of an indefinite number of types. I discuss some of these in detail below in Chapters 4 and 5. The dimensions of aesthetic value, present wherever such value is relevant, are perfection, invention, and celebration. All are forms of contrast—with mediocrity, repetition, and triteness respectively—but all express incomparability as well, the uniqueness and sovereignty of individual works of art. There are five general types of contrast that express the conditions of artistic production. These are traditionary, intramedial, intermedial, intermodal, and intersubjective contrasts: expressing the historical location of artistic production, the composition of the work, the plurality of modes of judgment (art in relation to science and ethics), and the diverse persons to whom the work is relevant. Other important contrasts involve space and time, surface and depth, beauty and ugliness; and there are many more. All are contrasts in that they involve not simply *what* is contrasted but *how*, in an indefinite or inexhaustible variety of ways.

The notions of contrast and inexhaustibility in relation to art can be developed in some detail independent of a systematic theory of inexhaustibility. But I believe a thorough treatment of inexhaustibility and contrast, as well as of the uniqueness of art and its relations with other domains of judgment—especially science and philosophy—requires a systematic and general theory. So that the discussion of art may be as rigorous and precise as possible, I develop the systematic basis of the theory in Chapter 3, after a discussion of some of the major traditional views of art. The discussion of the major types of contrast in art, in Chapters 4 and 5, is built upon the general theory, but is written to be as intelligible as possible independent of the more technical discussion. The final chapter, on the theory of interpretation and criticism, rests on principles developed in earlier discussions, but is also written to be as independent as possible. It is in this final chapter that I come to terms with recent developments in literary theory but in a far more general and, I hope, adequate way. I argue that there are different modes of judgment with different modes of validation, and that they produce different ways to respond effectively to art: by description, criticism, interpretation, and philosophy, as well as by a synthesis of them all, which I call "illustrement." Such a synthesis of irreducible modalities can have no specific and permanent nature: it is an inexhaustible interplay of determinateness and indeterminateness, like all other rational activities, in which novelty and understanding are thoroughly intertwined.

Acknowledgments

In most cases, my debts are acknowledged in the text or accompanying footnotes. In two instances, however, the debt is too great to acknowledge in passing. I have been profoundly influenced by Justus Buchler's work, especially *Metaphysics of Natural Complexes*, but also *Toward a General Theory of Human Judgment, Nature and Judgment*, and *The Concept of Method.*[1] The systematic theory at the foundation of my analysis of art is based on *Metaphysics of Natural Complexes*, though I take full responsibility for its presentation here and for my differences with Buchler. A more detailed analysis can be found in my *Transition to an Ordinal Metaphysics* which may be read as an introduction to an ordinal theory.[2] The general theory of judgment from which I depart is to be found in *Toward a General Theory of Human Judgment*, though I have made significant revisions in Buchler's analysis. I have developed the categories of the theory of judgment in my *Philosophical Mysteries* and my criticisms of Buchler's version in "Complexities of Judgment."[3] Finally, I acknowledge my respect for Buchler's theory of poetry in *The Main of Light*, but find it necessary to take a very different approach to art.[4] Our views are similar in some fundamental respects, but they appear to follow from very different conceptions of artistic value. I believe that my theory of art and aesthetic value expresses far more

1. Justus Buchler: *Toward a General Theory of Human Judgment*, New York, Columbia University Press, 1951; *Nature and Judgment*, New York, Columbia University Press, 1955; *The Concept of Method*, New York, Columbia University Press, 1961; *Metaphysics of Natural Complexes*, New York, Columbia University Press, 1966.

2. Stephen David Ross: *Transition to an Ordinal Metaphysics*, Albany, State University of New York Press, 1980.

3. Stephen David Ross: "Complexities of Judgment," *Southern Journal of Philosophy*, XIV/1, Spring 1976; *Philosophical Mysteries*, Albany, State University of New York Press, 1981.

4. Justus Buchler: *The Main of Light: On the Concept of Poetry*, New York, Oxford University Press, 1974.

thoroughly than does Buchler's the nature of art and the relevant implications of the fundamental premises which we share.

The theory of art and aesthetic value developed here is inspired by Whitehead's theory of intensified contrast without his cosmological concerns and expanded in its scope, implications, and details.[5] Since I do not accept Whitehead's generalized theory of experience, I do not interpret intensity of contrast in terms of feeling, but in terms of the characteristics of both works of art and natural objects in the context of typical and historical human experience. Nevertheless, Whitehead's theory of intensity of contrast seems to me the most plausible theoretical expression of the impressive tradition in which aesthetic value is interpreted as multiplicity in unity. Here Kant, Schelling, Hegel, Coleridge, and Empson may be mentioned as forebears, though none offers a theory of adequate generality. Only a theory of contrast, expanded in terms of the contexts and functions of works of art, producing levels upon levels of complex contrasts, can help us to understand the range of developments in both contemporary and traditional forms of art as well as the inexhaustible promise we find in the greatest works of art.

5. Alfred North Whitehead: *Process and Reality; Adventures of Ideas*, Chapters 17, 18.

CHAPTER 1

Introduction

The history of theories of art displays a great variety of approaches which differ not only in their philosophical and theoretical assumptions, but in their view of what is important and valuable in art. Two major but opposing conceptions of what is artistically valuable may be characterized as *Rightness* and *Richness*. Works of art and natural phenomena are valued when they are complete, whole, harmonious, fulfilling in some profound and essentially complete way; they are also valued because of their wealth of considerations, prodigality of imagination, range, and scope. The opposition as described is very crude, and a natural conclusion is that neither rightness nor richness alone is a supreme artistic value, but that a greater value lies in their combination.

Yet the difficulties posed for each alternative by twentieth–century art are not resolved in their conjunction. Many important works are skewed, distorted, unbalanced, and unharmonious, especially works of literature: Kafka's *Metamorphosis*, Joyce's *Finnegans Wake*. Other works are greatly oversimplified, minimalistic, impoverished in their range of considerations, especially in the visual arts: works by Rothko and Brancusi. Like other theories of art, those founded on rightness and richness, separately or together, are insufficiently general, failing to include many obviously important works. Such theories can be generalized to include a wider range of works by blunting the focus of the values from which they sprang. At the extreme, rightness and richness can be made to include each other, the harmony of a wealth of elements, the wealth of a plurality including fulfilling and complete forms. A remarkable effort at synthesis can be found in Kant's Third *Critique* where beauty is the object of a universal satisfaction (rightness) founded on a free imagination (richness). The synthesis requires a reconciliation of taste and genius, as if each alone would be unable to produce masterpieces of art.[1]

1. See Hans-Georg Gadamer: *Truth and Method*, New York, Seabury, 1975, for a striking criticism of Kant's reconciliation of taste and genius.

It seems to me that despite such efforts toward reconciliation, there is a fundamental divergence, a temperamental opposition, in the polarity of rightness and richness. I would include under rightness, truth and being, aptness and utility, pleasure and harmony. Beauty in works of art has been and may be regarded as an achievement of what is right and true, pleasurable and fulfilling. Alternatively, beauty may be found in wealth of imagination, richness of development, range of attention. Aquinas's definition of beauty as "that whose very apprehension pleases" is of a rightness in apprehension.[2] Coleridge's definition of beauty as "that in which the many, still seen as many, become one" is of a plurality reconciled but not obliterated, a richness maintained through synthesis.[3] Rightness has sometimes been thought an object of cognition, sometimes an object of feeling. For this reason, the theoretical opposition of knowledge and feeling does not parallel that between rightness and richness. Similarly, richness can be apprehended by the understanding or by the emotions.

Does the value of works of art lie closer to fulfillment or closer to fecundity? Artists testify to either value, as do critics; neither are satisfactory authorities. We can include rightness as an important component of the rich tapestry of works of art. We can include plurality and diversity as important components of the harmony achieved by a work in its fulfillment. Both efforts at reconciliation stumble over the many works which are incomplete and distorted, but which transform human thought and feeling by their presence. Part of the difficulty is that we lack a general theoretical understanding of what rightness means, what totality is to be completed in art; we also lack a theoretical understanding of which of the manifold and diverse traits of a work of art are relevant to it and contribute to its richness. One of the major achievements of the ordinal theory I will develop in Chapter 3 is to provide a framework in which highly idiosyncratic works may be understood in their rightness, and purified, minimalist works may be understood to be indefinitely rich. The fundamental premise of an ordinal theory, that anything whatsoever, any order, is inexhaustible in its relations and functions applies directly to works of art, including the most rarified and minimalist works, which are also inexhaustible in their range of relevance and in what they are, due to the inexhaustible perspectives in which they are located. What is relevant to a work of art, however purified, is inexhaustible because of the presence of other works, artistic traditions, social expectations, and changing conditions of experience. The theory of intensity of contrast provides an explanation

2. Thomas Aquinas: *Summa Theologica*, Ia; IIae, 27, ad 3.
3. Samuel Taylor Coleridge: *Biographia Literaria*, II, 232.

of how a minimalistic work can be all the richer due to its purification.

Nevertheless, rightness and richness are both remarkably plausible artistic values, and either a novel, synthetic approach to artistic value must be taken within which both are major values, or one of the two must be made the basis for the other. I frankly cannot see why harmony and fulfillment must include richness, while the remarkable quality of art is that it adds to the rich complexity of things, enhances experience. This is another way of stating the supreme value of art which I will develop: art enhances and enriches more than it completes or fulfills. Rightness here becomes one of the major dimensions of enhancement, that which I call perfection. Perfection always involves rich and intense contrasts with imperfection, incompleteness, and mediocrity. Only an ordinal theory can make this principle entirely clear.

An ordinal theory rejects unconditional absolutes and pervasive hierarchies. As a consequence, metaphysics cannot rule supreme over other branches of science and philosophy. There can be no direct connection between a metaphysical theory and applications in other fields—science and art—in the sense that they are deducible from it, entailed by it, grounded in it. Only in a very loose sense does a metaphysical theory explain science and art at all, though it certainly must contribute to our understanding of them. Analogously, a general theory of art cannot be expected to explain what is valuable in individual works, but only to contribute to our understanding of such works by defining their most general and pervasive traits. This is a modest role for a general theory to play, and I will explain its character further.[4] One of the strengths of an ordinal theory is to delineate the kinds of connections that make philosophy relevant to other branches of knowledge and imagination without presuming to make them subservient to philosophy.

The ordinal theory of intensity of contrast is developed in detail in Chapter 3. What is required in advance is a presentation of the theory of intensity of contrast independent of its ordinal formulations. I will undertake such a presentation with the understanding that the ordinal theory is required for accuracy and completeness.

The notion of intensity of contrast is discussed explicitly in Whitehead's *Process and Reality*.[5] It is a central feature of his cosmology. Contrast is one of the eight categories of existence: "Modes of Synthesis of Entities in One Prehension." (PR 22) The unification of many into

4. See my *Transition to an Ordinal Metaphysics*, Chapter VII.

5. See especially Part II, Chapters II and IV; Part III, Chapter V. Page references are to the Corrected Edition, D. R. Griffin and D. W. Sherburne eds., New York, Free Press, 1978.

one experience is the central movement in Whitehead's theory, and it inevitably engenders contrasts: the synthesis or unification of a multiplicity in one prehension or feeling. This notion of prehension is very general in Whitehead's theory: for the moment we may neglect it and consider his position, with some simplification, to be that the conjunction of diverse components is a contrast, that a contrast is comprised of a synthesis of one and many in which multiplicity is preserved, in which synthesis does not supersede differences. Contrasts are then pervasive throughout nature and experience. The crucial property they possess that makes them central to art is that they accommodate more and more complex levels of contrast, higher and higher syntheses. In Whitehead's words, "the eighth category includes an indefinite progression of categories, as we proceed from 'contrasts' to 'contrasts of contrasts,' and on indefinitely to higher grades of contrasts." (PR 22) This property, I will argue, is essential if we are to understand the richness and power of some of the minimalist works of twentieth-century art. It is the property that enables art, through intensity of contrast, to manifest inexhaustibility.

This notion of higher levels and complexities of contrast marks one of Whitehead's advances over Coleridge's definition: "beauty is where the many, still seen as many, become one." This is surely a major contrast, but it is mute on higher levels and complexities of contrast (though the infinite and inexhaustible character of the opposition peculiar to art is clear in Schelling while the notion of level upon levels of contrast is mirrored in Schlegel's theory of romantic irony). Coleridge's definition does, however, emphasize in plain language that the many are not superseded and synthesized, overcome in unification, but maintain their plurality and diversity.

If contrast is unity amidst plurality, then intensity of contrast must be the heightened opposition of synthesis and plurality, realized either in the strength of the unification or the opposing polarities of the diversity. Whitehead discusses both of these. In his view, the first form of intensity is common in nature: mountains and the sea, the order of planets, the beauty of natural order. The second is more often found in organic systems, rapid transformations and adaptations, the beauty of variation and invention. Intensity in both cases emphasizes sovereignty of character amidst diversity and variability. Inexhaustibility is a joint function of plurality and identity, each a function of the other, manifested in intensity of contrast.

The presence of aesthetic value as a potential in every being cannot easily be explained by most theories of aesthetic value except by appeal

to subjectivity and an "aesthetic attitude." Here cosmologies and theologies, with their emphasis on God's supreme purpose analogized in every created thing, have the better of it. How is it that a close attention paid to almost anything rewards our aesthetic sensibilities and can be incorporated into works of art? The answer I will give, departing from Whitehead's, is not that each such thing attains intensity in its own experience, but that everything inhabits a wealth of contrasts, that every being is inexhaustible, and that any such being can be brought within a synthesis that manifests its inexhaustibility through the production of intense contrasts. Analogously, I depart also from Whitehead's emphasis on intensity of feeling in experience, for it seems to me that intensity belongs to contrasts in opposition, not to our feelings of them. We often miss the greatest contrasts until after the fact, when they are pointed out to us. These contrasts and their intensity therefore belong to the objects, to the works of art, not to the experiencing subject, and bring appropriate pleasures and satisfactions only when they have been recognized and admired. If aesthetic value is intensity of contrast, it belongs to the synthesis in which intensity is engendered, not to our sensibilities. Neither Whitehead's theory of experience nor his cosmology seems to me necessary to the theory of contrast, and I will develop an alternative theory in which the metaphysical issues can be addressed without Whitehead's less plausible assumptions.

The theory to be developed here, then, is that aesthetic and artistic values—they are of the same species—are intense contrasts. Contrasts are conjunctions, unifications, syntheses, of dissimilar, opposing constituents. Intensity is attained where the opposition is strong or where the unification is exceptional. The most important feature of contrast is its capacity to produce level upon level of complex contrast upon contrast. In this respect it is very like romantic irony, which admits of irony upon irony, and the theory of romantic irony is an incomplete theory of contrast founded upon the central contrast of artist and audience.

The notion of intensity of contrast may appear to be a matter of degree: greater unification of disparate elements, a greater range of variation within a common synthesis. In this sense, artistic value would also be a matter of degree, and the greater the intensity of contrast, the greater the value. Now I can understand the notion of greater and lesser *intensity of feeling*, though I think it would be very difficult to explain. But many intensely felt works of art are sentimental and trite, many great works are cold and restricted in the feelings they engender. I do not share the common view that works of art arouse in us im-

5

mediately the question of how good they are, how much better and worse than others. I do not believe that evaluation, estimation, and appraisal are defining elements of aesthetic judgment. The fundamental question of artistic value, I believe, is not *how much value a work has*, but *what* its characteristics are, not *how much* intensity of contrast there is, but *how* a work achieves its intensity of contrast.

Fundamentally, artistic value is grounded in *incomparability*. Yet while works of art are incomparable in many respects, especially those respects which define their value, they are indefinitely comparable in other respects. The theory of contrast makes both of these features clear. Contrasts are dependent on similarities and differences, on relations as well as sovereignty. Works of art and natural objects are comparable *because* they are contrasting, as are any and all of their constituents. Nevertheless, the complexity of contrasts also engenders uniqueness and singularity, since there are contrasts in every work that can be shared with no other works or objects. The terms of contrasts are relational and common; the contrasts achieved are frequently incomparable and unique, are always singular in some important respects.

In addition, intensity is not a matter of degree. Particular contrasts are not more intense than others, for there could be no scale of measurement. They are rather intense in the ways they are: conjunctions mated with departures, similarities with dissimilarities, unification with plurality. How then are works of art judged better than others? Most of the time, I suggest, they are not so comparable except in a particular respect. Some paintings are more balanced, more serene, more harmonious, than others, better perhaps in that respect—but not overall, in all respects. I think it is a fundamental error pervasive throughout the history of art to suppose that artistic value forces a scale of measurement upon us. Works of art are comparable as are all things, but artistic values are not. Intensity of contrast is not a matter of degree but of kind.

The central difficulty has been mentioned for a theory in which artistic value is founded on richness and complexity, ascending to higher and higher levels upon levels of opposition and relation: how it is able to deal with important works of sublime simplicity, how it is able to explain movements toward purification as in minimalist painting. Two answers will be given: First, mentioned above, perfection is a primary mode of contrast, one of its three fundamental dimensions. This means that every fine work of art and natural beauty is appreciated for its perfection in some respects in contrast with works and objects that lack such perfections. This is obviously insufficient to do

6

full justice to minimalism, however, for salient perfection is frequently a minor quality of minimalist works. The second answer is given by the capacity of contrasts to engender complexity by aggregation through time. Purity and simplicity can only be in certain respects, frequently heightening the rich intensity of contrasts in other respects, at other levels. Here the capacity of contrasts to enter rich and complex aggregates is essential again. Here also, history and tradition are essential components of complex contrasts, providing a background against which minimalist works inhabit more complex contrasts in proportion to their purity and simplicity. This solution has the further advantage of acknowledging that the history and traditions of art are primary features of intense and compelling contrasts, part of the essential values of art, rather than accidental features of time and development as in theories which emphasize purely sensuous pleasures. The capacity of works of art to absorb traditions and subsequent events into themselves requires an ordinal theory for explanation, since in such a theory the identity (or integrity) of an order is a function of some of its constituents and is variable with the location of the order in question.

There are many theories of art: significant form, expression, objectified pleasure, and so forth. Most of them can be classified as theories of rightness or richness or as a synthesis of the two, usually from one side or the other. All, I will argue, are incomplete theories of contrast, even where no contrasts are explicitly indicated. The reason for this is that what they propose is not aesthetically valuable unless it involves intensity of contrast, however covertly assumed. Far more important, all such theories are insufficiently general, and in two senses. There are arts and works of art which are neglected in the theory proposed. There are also important features of relevant works which are not included within the theory proposed—for example, the contrast of colors in a theory of forms, random and aleatory elements in a theory of expression, terrible and fearsome elements in theories of harmonious beauty and pleasure, and so forth. In fact, I will argue, no single relationship can define artistic value, only a relationship built upon level upon level of complex oppositions, similarities and differences. Complexity is the foundation of the ordinal theory, which is why that theory can provide an adequate basis for a theory of art. Art is built upon complexity and inexhaustibility even in its simplest and purest works. Only the theory of contrast as delineated here can explain this feature of art: that the simplest works are sometimes pregnant with the most sublime, profound, and complex qualities.

The theory of contrast is closely related to Kant's theory of purposiveness and finality given by the free play of the cognitive faculties

7

without the reference to the subject that his analytic of aesthetic judgment requires. The four moments of the beautiful are all rejected, in most cases for fundamental reasons. Contrasts and their intensity refer to the aesthetic object, to the work of art, not to a delight in immediate apprehension. Universality is not a necessary condition of aesthetic judgment, for the standards of intense contrasts are context-sensitive and responsive to changing conditions. Since pleasure is not a necessary condition of the beautiful, it is not necessary to distinguish artistic pleasure from agreeableness nor aesthetic judgment from interest. The legitimacy of aesthetic value lies in the singular properties of intense contrasts, referred to the aesthetic object, apprehended by the mind in all the ways it is capable of apprehension and understanding. No transcendental deduction is appropriate or necessary, for aesthetic judgment is neither universal nor grounded within itself, but is a response to complex features of orders and their inexhaustibility.

Nevertheless, Kant's explanation of beauty, that it reflects the finality, purposiveness, and order inherent in objects, is fulfilled and enriched by the theory of contrast. Contrasts and their intensity are the particular forms of order to which aesthetic judgment refers. The theory of contrast offers a more substantive foundation for the forms of order to which the imagination refers in its freedom of development. It also develops, as Kant's theory cannot, the inexhaustibility and complexity of levels upon levels of contrast inherent in finality and purposiveness. As Kant suggests, but does not develop, aesthetic response is not to a specific type of order, which would become rule-governed, but to *any* order, to a wealth of relevant structures and exemplifications. In this sense, the theory of contrast emphasizes the fecundity, inexhaustibility, and novelty of contrasts in a historical and lived context as Kant's theory of the pure aesthetic judgment cannot. Human history pertains to aesthetic value and to art intrinsically—though this is only one of the fundamental modes of contrast—not merely in empirical admixture. The theory of contrast also provides a natural theory of criticism and interpretation embedded in the ordinal theory of different modes of judgment, one not at all suggested by the Kantian system, which is far too restrictive in its range of possibilities.

A further comparison may be made with Goodman's approach in *Languages of Art,* where he rejects pleasure and emotion as primary features of artistic value, and delineates a symbolic theory in which works of art and their components not only *denote,* but *exemplify and express.* Emotion and feeling are not aesthetic values in themselves, but

only insofar as they function symbolically, cognitively.[6] The richness of Goodman's theory is given by the capacity of aesthetic components to refer in a great variety of ways at any time, symbolizing many different kinds of things or properties, and varying in their meaning under different circumstances. Yet Goodman never explains *how* the symbolic meaning of a work of art is engendered. The theory of intensity of contrast also emphasizes the varieties of meaning and relevance in works of art, but assigns this to their identity rather than to their significance alone: being rather than meaning. Here the ordinal theory is essential, since it treats being as ordinal, a function of relational conditions.

Goodman has no adequate solution to the question of when symbolism becomes aesthetically valuable. Why should complex qualities be more important than simpler ones? He rejects feeling and emotion, and concludes that "Symbolization, then, is to be judged fundamentally by how well it serves the cognitive purpose: by the delicacy of its discriminations and the aptness of its allusions The general excellence just sketched becomes aesthetic when exhibited by aesthetic objects."[7] Richness and complexity are not values in themselves, but only as they serve cognitive purposes. Goodman blunts the force of his major insight: that artistic means lead inevitably to complexity, manifesting richness and (effectively) inexhaustibility. If art gives us knowledge, it is a knowledge of ordinal complexity and inexhaustibility. But it is more accurate to say that art *manifests* inexhaustibility than that it tells us of it.

The difficulty for cognitivist theories of art is the central role of invention and novelty in works of art. The importance of invention and creation suggests that being predominates over meaning in art: being as the construction of something new *so that* it may be known. Macleish's famous line that "a poem should not mean but be" is closer to the truth, and closer to the spirit of the theory of intensity of contrast, provided we abandon the opposition he suggests between meaning and being, knowledge and being. Macleish seems to claim that a poem should not be interpreted as meaning something, but be taken as it is: pure aestheticism. Goodman is surely right that being is meaningful in art. The difference is that a poem is made, fashioned and created, and *thereby* means more than any interpretation can provide. Being is in this sense wider than meaning. This principle is included in

6. Nelson Goodman: *Languages of Art*, Indianapolis, Hackett, 1976, p. 248.
7. Ibid., pp. 258-59.

Goodman's view that what works of art mean is variable with conditions. It is also manifested in the principle that reference admits of increasing levels of complexity, symbolization upon symbolization. Yet even this richness is not sufficient: we need an inexhaustible richness of the *being* of works of art manifested in the changing relations of these works to human experience and the surrounding world. The ordinal theory provides a metaphysical theory in which works of art (certain kinds of orders) function differently and possess different properties in different contexts and locations. Meaning here is but one component of complex intense contrasts. Put another way, we value works of art as excellent in virtue of what they are; but what they are, as well as what they mean, is always inexhaustible, variable with location and conditions.

An emphasis on symbolization and meaning leads us to the conditions that enable symbols to function rather than to the works or natural objects which offer us a source from which meaning may be derived. Perhaps the simplest way to make this point is to note that for works and their components to function as symbols, we must determine what they symbolize. Yet many works of art function by negating symbols and displaying ambiguity and complexity. We may, of course, say that they manifest or symbolize indeterminateness; yet the fact is that they *are* indeterminate in what they symbolize and how they function, and that is part of their fascination. They are indeterminate in many ways as well as determinate in many ways, for that is what all orders are. Symbolic theories take us away from the work of art to what it means. An ordinal theory can maintain the complexity and significance of works of art as orders along with the inexhaustibility of all orders, manifested in art through intensity of contrast. Symbolic theories take us from the work and its constituents to what they symbolize or express, though the uniqueness and novelty of the work are paramount. In other words, symbolic theories can explain what is common among works, but not what is unique. They sacrifice the sovereignty of the work of art to its richness. An ordinal theory can emphasize the sovereignty of the work of art yet can also accommodate an inexhaustible richness surpassing even that to be found in Goodman's theory. This is the support an ordinal theory gives to an adequate theory of art.

The fundamental principle of an ordinal theory is that whatever is is an order of constituents, whatever is relevant to it in a particular location, and every order functions as a constituent in other orders. The theory is functional in that *what* an order is, the constituents it has, are a function of its location in another order, a sphere of relevance.

Thus every work of art is an order with constituents relevant to it, every component of a work is an order inhabiting many spheres of relation with its particular constituents, and an immense variety of human orders provide relevant locations for works of art. This is a source of the immense variability of interpretations of works of art. They are interpreted differently, they *are* different, in different locations, because they function differently there, and there is no other sense of being than this functional, relational one.

All the fundamental categories of an ordinal theory define ways in which orders function as constituents in different ordinal locations. Of particular interest is the complementary pair of prevalence and deviance, loosely characterizable as typicality and atypicality. An order is prevalent when it is typical, maintaining a functional identity throughout a range of locations. It is deviant when atypical, variable over a range of locations. Buchler defines poetry as conveying a sense of prevalence, a sense of what something is over a range of functions and conditions.[8] The relevant point is that every order is prevalent somewhere; anything whatsoever may be regarded poetically, as prevalent, typical. Though I reject Buchler's definition of poetry, I do not reject the premise his theory rests on, which is that as prevalent, every order simply is an order, prevalent. No order is more prevalent than another, nor more real, more metaphysically fundamental, more an order than another. This is a doctrine of *ontological parity*. Poetry, according to Buchler, treats orders from the standpoint of their prevalence, simply as prevalent orders. In this sense, it maintains a sense of ontological parity. That every order is sovereign, in some sphere, and that art can maintain this sovereignty, is a fundamental tenet of an ordinal theory of art. An ordinal theory can wed richness with sovereignty as no other metaphysical theory can.

If artistic value is intensity of contrast, what is important is how the contrasts function and gain intensity. The capacity of contrasts to promote higher levels and richer complexities is the primary feature of our understanding of art, and a major contribution to the artistic importance of traditions and history. I will develop the theory of intensity of contrast in the following sequence. First, I will show how most of the major theories of art can be regarded as incomplete theories of contrast, to demonstrate that the theory I am defending can absorb the major insights of other theories without doing them violence. I will in the same stage of discussion indicate limitations in traditional theories of art that require an ordinal theory. Second, I will

8. Buchler, *The Main of Light*, p. 131.

develop the theory of intensity of contrast in detail, founded on the theory of orders. Third, I will distinguish and analyze a variety of major contrasts in application to art and natural beauty, to set forth the most important kinds of contrast employed in the analysis, appreciation, and criticism of works of art. I will also discuss in some detail the functions and kinds of contrast to be found in other domains of experience—science and philosophy. Finally, I will apply the theory to interpretation and criticism, delimiting a theory of illustrement in which our rational response to works of art is most completely fulfilled.

Theories of Art
As Theories of Contrast

Theories of art tend to follow two streams—that of the arts, articulating a particular genre or style, and that of philosophy, under epistemological and metaphysical constraints. Art entails novelty, invention, creation; yet few metaphysical theories permit genuine, if conditioned, creation. An adequate theory of invention is essential to the theory of art. Yet it must be based on the conditions of art, not considerations relevant primarily to other domains of experience. The ordinal theory is essential to a theory that emphasizes the diverse and inexhaustible relations of works of art yet maintains their sovereign integrity as well. The theory of intensity of contrast maintains a vital and intrinsic role for invention and creation: the production of intense contrasts in the context of established conditions. The work and its constituents are neither entirely subordinated to what they stand for, as in representational theories, nor entirely unique in themselves, but a synthesis of opposing forces.

The purposes of this chapter are diverse, and can be fulfilled only modestly. Nevertheless, it is essential to locate the theory of contrast historically and to apply the theory of contrast to other views of art. I will, then, in this chapter: place the theory of art in a historical perspective; define the scope of a number of theories of art—their inadequacies and their achievements; sketch some of the features of the theory of contrast in relation to other theories of art and show that such theories can be viewed as particular applications of a more general theory of contrast; and finally, develop some of the important features of the theory of orders in relation to other theories of art.

IMITATION

The oldest, apparently irrepressible theory of art is that of *mimesis*. Perhaps no one has held that *all* art is imitation or that art is *only*

13

imitation. Nevertheless, there are passages in Plato's dialogues which suggest that the mimetic function alone is relevant to artistic value. Still, the shortcomings of mimesis as a general theory of art are obvious, particularly with respect to music and architecture. Susanne Langer calls the mimetic theory "naive"—as if to suggest that early philosophers were ignorant enough to think, in spite of the evidence, that art might be wholly imitative.[1] The irony of such severity is that her own views of art are a species of mimesis: not representation, but symbolic form or virtual expression. I will classify both symbolism and expressionism as mimetic theories, for both require that works of art be subordinated to something other than themselves. Langer's early views are especially persistent in establishing something other than the work for which it is a symbol or appearance: a "symbol of feeling." The most desperate forms of mimesis are those, like Langer's later theory, which repudiate all objects and look to "pure appearances" as the basis of the arts.

The obvious and crucial question for mimetic theories is "imitation of what?" A wealth of answers has been proposed. The persuasiveness of such theories is strong enough to suggest that if only the imitated object could be properly circumscribed, art would be placed on a firm foundation—whether physical objects, feelings, ideals, or cosmic truths. Nevertheless, the inexhaustible fund of candidates suggests that the theory is limited and its truth partial. Many works are not obviously mimetic; more important, the faithfulness of representational works is seldom of primary artistic value. A great portrait by Hals or Rembrandt conveys a striking sense of character. Yet it may not be the character of the model. Is a portrait the less for misrepresenting its subject? Perhaps for a time; certainly not for posterity. Even if it is the feelings of the artist which are to be represented or expressed, it is not the *accuracy* of representation which is of importance, but the strength of conviction, the firmness of impulse.

The truth inherent in mimetic theory is a subtle and complex one. Langer pursues it in a theory where the work is symbolic of feeling yet also a mere image having no model. Such a view expresses a partial truth, but in confusing terms. Images without objects, appearances without a reality, are remarkably obscure. Langer exhibits the difficulty in traditional mimetic theory that the work is made an emissary for its object rather than a fully established being. The sovereignty of the work becomes unintelligible. A major strength of the theory of contrast is to maintain the duality of the essential relation at the fore-

1. Susanne Langer: *Feeling and Form*, New York, Scribners, 1953, p. 46.

front of the theory: the sovereignty of the work in contrast with its significations and ramifications.

A work of art is a novel being, not simply an appearance of another reality. Derivative though it may be in some respects, a work is unique in other respects. It is not necessary, as Northrop Frye seems to suggest, that literature be an *autonomous* reality in order to deny its wholly derivative character. "The anagogic view of criticism thus leads to the conception of literature as existing in its own universe, no longer a commentary on life or reality, but containing life and reality in a system of verbal relationships."[2] Starting from a mimetic theory, Frye can break away only by bifurcation. "Nature becomes, not the container but the thing contained, and the archetypal universal symbols, the country, the garden, the guest, the marriage, are no longer the desirable forms that man constructs inside nature, but are themselves the forms of nature." Nevertheless, "this is not reality, but it is the conceivable or imaginative limit of desire."[3]

Mimetic theories are important in opposing the doctrine of "the work of art itself." Objects imitated or symbolized, feelings expressed, if they are essential to the nature and value of a work of art, make it little in itself. The metaphysical truth, however, is that nothing is "in itself"—neither atoms, persons, nor works of art. This is a central principle of an ordinal theory: every order is at least doubly relational, in being comprised of constituents relevant to it and in being located as a constituent in other orders to which it is relevant. Moreover, these diverse relations are functional and inexhaustible. Complexity is the foundation of ordinality.

Mimetic theories emphasize the relations of a work of art but oversimplify them. The doctrine of the work itself emphasizes the uniqueness of the work though every being is uniquely what it is. What is needed is an understanding of how works of art can be both sovereign and relational, and especially, how the sovereignty is a function of constituents and relations. Both the ordinal theory and the theory of intensity of contrast address this issue directly, in two different ways, one metaphysically, providing a foundation for art in the integrity and constituents of every order, the other through the polarity of the elements of intense contrast.

Mimetic theories place a burden on a work of art to attain a value entirely extrinsic to it, and this is misconceived. But it is a welcome

2. Northrop Frye: *The Anatomy of Criticism*, Princeton, Princeton University Press, 1957, p. 122.

3. Ibid., p. 119.

propaedeutic to the conception of a work wholly intrinsic to itself, as if it had no relations. The difficulty is that works of art have too many and too obtrusive relations. We are therefore told to cultivate an "aesthetic attitude," setting aside what is irrelevant to the work. Yet as Langer points out, to artists and audiences experienced in art, nothing is more obvious than the value of a work.[4] Mimetic theories incorrectly focus on the relation of faithfulness; but the focus on relations is necessary though it must be reinterpreted.

It is worth considering in greater detail what mimesis suggests is the nature of artistic value. Several types of imitation may be considered.

Representation

The simplest form of mimesis is the representation of a physical object in painting and sculpture or of sound and movement in music and dance. The limitations of representation theory are clear for purer forms of music, non-representational painting, architecture, and modern dance. The deeper issue is to understand the value assigned to representation. Why might faithfulness be an artistic value? Why is it aesthetically valuable to bring an object before us again, either tangibly or in the imagination? It is this question which leads Plato to condemn imitation, for if verisimilitude were the primary value, whirling a mirror in the air would imitate all things truly. The notion of duplication seems offensive to artistic value, especially in painting, but even in musical performances. Two nearly-identical paintings are mere copies of each other and of little value. The value inherent in a series of similar studies on a single theme by the same artist resides in their differences as much as their kinship, in their subtle experiments and variety. An interpretation of a symphony identical with a prior performance is unoriginal. Once the question of verisimilitude and repetition is raised, it appears obvious that artistic value is a function of *both* similarities and differences, and that not imitation but contrast is the essential value.

The most profound difficulty of representational theories is the implicit principle that a work aims to represent its object *faithfully*. Langer rightly transcends this view by arguing that art often attains its end in the *appearance* of verisimilitude rather than in close approximation. Photographic realism is seldom a significant value in painting— though on occasion it may provide a basis for a genre of painting. Verisimilitude which fools the eye is fascinating upon initial encounter, but is a trick and appreciated only as such. Trickery is an artistic

4. Langer, *Feeling and Form*, p. 45.

value—if usually a minor one—but it accords little with representation. Moreover, it cannot be valued unless it is known to be a trick, so that verisimilitude must be conjoined with disparity of means in order to be artistically valuable. In many cases of representation—still lifes, for example—it is doubtful whether verisimilitude has any value whatsoever. Close scrutiny of Cezanne's treatment of space, lines, and perspective indicates how seldom he seeks to represent an appearance similar to that available to the eye.[5] Moreover, his apples and pears are not appetizing. El Greco too is famous for his elongated and distorted representations. Faithfulness is of little value here.

Ernst Gombrich makes the simple but vital point that literal faithfulness in painting is impossible. The artist does not *copy*, but *seeks a way to attain the appearance of verisimilitude*. "No artist can copy what he sees."[6] This is one of the reasons why experimentation is a vital element in art. "Only experimentation can show the artist a way out of the prison of style toward a greater truth. Only through trying out new effects never seen before in paint could he learn about nature. Making comes before matching." "All artistic discoveries are discoveries not of likenesses but of equivalences which enable us to see reality in terms of an image and an image in terms of reality."[7] A scene to be rendered faithfully will always have much more in it than is reproducible in any medium. The problem is one of representation in a particular respect rather than in another. "Why should not the painter be able to imitate the colors of any object if the maker of wax images manages this trick so well? He certainly can, if he is willing to sacrifice that aspect of the visible world that is likely to interest him most, the aspect of light."[8]

Similarly, Henri Pirenne argues that successful illusion in painting depends on peripheral awareness of the plane surface.

> Only when the perspectivic illusion of the painting is so perfect that it makes the painting appear three-dimensional, does skew viewing produce a distortion of appearance. Other paintings are deemed insensitive to the angle of viewing, mainly because their perspective design is not fully convincing, owing to the fact that the viewer remains unaware of facing a flat canvas. This awareness reduces the illusionary powers of viewing, the particular appearance we see from the correct centre of projection. Our

5. See Erle Loran: *Cezanne's Composition*, Berkeley, University of California Press, 1970; discussed below, pp. 167-68.

6. Ernst H. Gombrich: *Art and Illusion*, New York, Phaedon, 1960, p. xiii.

7. Ibid., pp. 320, 345.

8. Ibid., pp. 37-38.

eyes seem to select this appearance for all positions of viewing, because it resembles the way the painted object is seen in nature.[9]

Verisimilar achievements in linear perspective are attained at the expense of severe distortions from other points of view. Verisimilitude, therefore, is difficult to achieve and is to be appreciated only in the context of, relative to, therefore in contrast with, all other relevant artistic conditions.

Nelson Goodman takes a more extreme position and argues that verisimilitude is no part of representation, that art represents through symbols which may involve no resemblance whatsoever. Taking a step toward a fundamental principle of the ordinal theory, that orders are indefinitely complex and inexhaustible, Goodman denies that any object is so univocally conceivable that it may simply be copied.

> I have argued that the world is as many ways as it can be truly described, seen, pictured, etc., and that there is no such thing as *the* way the world is.

> The copy theory of representation, then, is stopped at the start by inability to specify what is to be copied. Not an object the way it is, nor all the ways it is, nor the way it looks to the mindless eye. Moreover, something is wrong with the very notion of copying any of the ways an object is, any aspect of it. For an aspect is not just the object-from-a-given-distance-and-angle-in-a-given-light; it is the object as we look upon and conceive it, a version or construal of the object. In representing an object, we do not copy such a construal or interpretation—we *achieve* it.[10]

Goodman goes on to define a representational theory in which imitation plays no intrinsic role. Unfortunately, he does not consider how verisimilitude can be of artistic value where it is not essential to representation. He cannot explain why representational art is nearly always different from its object—and why it should be, as Van Gogh tells us:

> Tell Serret that *I should be desperate if my figures were correct,* tell him that I do not want them to be correct, tell him that I mean: If one photographs a digger, *he certainly would not be digging then.* . . . Tell him that, for me, Millet and Lhermitte are the real artists for the very reason that they do not paint things as they are, traced in a dry analytical way, but as *they*—Millet, Lhermitte, Michelangelo—feel them. Tell him that my great longing is to learn to make these very incorrectnesses, those deviations, remodellings,

9. M. H. Pirenne: *Optics, Painting and Photography,* London, Cambridge University Press, 1970, pp. xv-xvi.

10. Goodman, *Languages of Art,* pp. 6n, 9.

changes in reality, so that they may become, yes, lies if you like—but truer than the literal truth.[11]

In other words, if representation does not require verisimilitude, why is the latter a value when it is, and how can it be? Moreover, why is there an equal impulse toward dissimilitude in art? The questions indicate that neither similarity nor dissimilarity is a value, but the two together in contrast.

The value of representational art, I suggest, is that the object and the work *are not the same;* but they are either similar in some respects or are intimately related. The bottles and pears of a still life are recognizable as bottles and pears, however unlikely we are to think them real. The work of art is in contrast with the object taken as model. A work standing for or imitating an object is in contrast with the original. The contrast here is to be understood precisely as difference coupled with similarity. The similarities add intensity and complexity to mere differences. Near-identity of structure and appearance, attained in a radically different medium, can be a vital contrast. Marble is not flesh or cloth, and where it takes on the form of a person draped with clothing, can be apprehended as a rich and poignant contrast. Vital contrasts— though very different ones—may be realized both through sculpture which "unfolds" from the stone, highly compatible with our expectations of the medium, as in many of Michelangelo's incomplete works, and through works which violate the expected qualities of stone, as in Bernini's *Apollo and Daphne.* Insofar as noteworthy verisimilitude is attained out of alien materials, representation can be a triumph over and through its medium. *Similarity coupled with difference* is the artistic value, and the basis is the intensity of contrasting qualities.

The Embodiment of Ideals

The question of why representation should be undertaken at all is a persistent one. Why is it valuable to represent the Duke of Marlborough or a pear in a bowl? Words and delegates represent, but only in virtue of their functions. Paintings on a museum wall do not function in the relevant ways. Truth and accuracy in a painting are both irrelevant and unmeasurable. The power and vitality of a painting are not so much a function of the objects it represents—pears and water—but of the *way*

11. Vincent Van Gogh: *Complete Letters*, Greenwich, New York Graphic Society, 1958, II, p. 401.

it represents, the properties of its medium and surface. Furthermore, the verisimilitude which is important in works of art—which contributes to intensity of contrast—may be neither representational nor mimetic. The value of a work does not depend on faithfulness to its object, but on heightened possibilities. Many near-imitations of a model can all be valuable insofar as they illuminate each other in contrast. The illumination is provided by differences as well as by likenesses.

Mimetic theory defines a work of art as an imitation. Why, then, imitate? Presumably to encompass or to possess, not the work, but the original. However, as Plato argues in the *Republic*, many of the originals given to us through art are false and damaging. Plato is consistent: a theory of imitation entails the importance of the original. The value of the work of art is given by what it imitates. It follows that the original of a sublime work of art must be an ultimate value. Ideals are prime candidates for such ultimate value; ordinary objects do not provide plausible values in their mere representation. Whether we agree with Plato that art is then a derivative imitation of an imitation, or with Schopenhauer that art is the most direct means for representing ideals —in both cases the work has value only through the ideals it brings before us.

Making or creating in mimetic theories is essentially derivative. The form, as transmitted through the work, gives it its truth, value, and being. The position is metaphysically inadequate: the work is a unique being, distinct from its ideal. The ideal-mimetic theory would make a work of art more valuable as it came closer to its model. Yet even where we have no standard against which to compare a work, it can be responded to favorably. Even more important, a great work presents to us an ideal realized for the first time in itself.

Such a view sounds like a version of the doctrine of the work of art itself: "do not judge a work by any standard other than itself." That is not my claim. Rather, I am denying that the appropriate ideals of balance, harmony, construction, or vitality by which to evaluate a novel work of art—or a great and enduring work for a new generation—are entirely antecedent to and independent of the work. Rather, it contributes to our standards of judgment, and these change in response to it. The standards relevant to artistic value emerge from concrete works and are transformed by novel inventions. A great work is a standard for later artists to aspire to. This is what Kant means by claiming both that "genius is a *talent* for producing that for which no definite rule can be given" and that "its products must be models, i.e. *exemplary*, and they

consequently ought not to spring from imitation, but must serve as a standard or rule of judgment for others."[12]

The conclusion is that ideals for art are not—as many philosophers would have it—antecedent to nor apart from individual works, to be expressed or imitated by them, but are intrinsic to them and defined by them. The artist both invents and realizes possibilities within his medium, even possibilities for new mediums, and attains ideals in his accomplishments. The ideals in art are created by artists in their individual works. The consequences for imitation theories are disastrous: art is not imitation but creation; not faithfulness but accomplishment.

The ideal-mimetic theory suffers from two major flaws: It resolves the issue for mimetic theories of the profound value of works of art by making them surrogates for transcendent ideals, but it thereby diminishes the sovereignty and intrinsic value of the work of art. As a consequence, such theories tend to be metaphysically as well as aesthetically inadequate, diminishing sovereignty and subordinating works of art to antecedent transcendent ideals. The theory of intensity of contrast preserves the sovereignty of the individual work in the contrast between the ideal and its realization, both poles essential to intensity of contrast. The ordinal theory emphasizes the conditions and relations of every work, emphasizing novelty but also relevance. As a consequence, it can maintain a primary emphasis on the novel constructed work as well as the emergence of novel ideals realized in such works, while the contrasts or syntheses among the diverse relevant constituents of the work—the ideal expressed in a particular medium —are the basis of its artistic value.

Wherever craft is a primary element in art, the individual work and pervasive ideals stand in tension. A novel work may attain an ideal of form or lighting set by its predecessors but realized to greater perfection in itself. Or it may strike out toward alternative ideals, realizing them well or only partially, setting a task for subsequent artists, founding a new school of art. Established ideals and a particular work stand in intense contrast when important differences and similarities are juxtaposed. The individual manifestation and the ideal are effective only together, each a component of an intense contrast. The work is valuable not as it imitates the ideal, but as it joins the ideal in a collaborative relationship, comprising an intense contrast.

12. Immanuel Kant: *Critique of Judgment,* Part I, par. 46.

21

Imitation of Feeling

If neither physical objects nor ideals can provide adequate mimetic models for all works of art, especially non-representational works, then an alternative is found in human feelings. The plausibility of such an approach is based on the deeply emotional character of artistic inspiration. In addition, most people are deeply moved by some works of art. Whether or not it is ordinary emotions which are mimicked, or whether there are unique "aesthetic emotions" as T. S. Eliot claims, nevertheless the basis and value of art are often held to be emotional.

Sometimes the feelings in a painting are obvious—as in a Pietà, there is suffering on the face of Christ. Nevertheless, this suffering may neither be expressed nor imitated, for an observer may be transported with joy and illumination rather than rendered sad. The suffering portrayed may be the cause of joy in a believer, a contrasting element in the rich powers of the work. The relevant contrast here is between the emotions of the audience and the emotions of the persons portrayed. Works of art do not imitate by inciting appropriate emotions in an audience—except, on occasion, in the theater. Nor are there always appropriate feelings to be symbolized in architecture, music, or non-representational painting—though we may fancy ourselves capable of inventing feelings appropriate to any work of art.

The question is whether we may expect all works of art to convey feelings, whether by imitation, expression, or symbols. As mentioned, artistic inventiveness is often emotionally inspired, and a sympathetic audience is often moved by a work of art. Equally certainly, there are observers capable of profound satisfaction with a work of art who are not particularly moved by it.

The fundamental question for mimetic theories is: *why imitate?* Why are the artist's emotions worth grasping, worth knowing or having? Why should we desire expressions of feeling in art? Would it not be better for there to be expressions of feeling among members of a community?[13] And how can we make sense of placing imitations of feeling—even symbols of feeling—in a museum?

One answer is that the feelings are special, worth attention. Are we then so sure that the feelings of artists are remarkable? No, it is the work of art which is remarkable, and it may be so in virtue of *creating* feelings, not merely imitating them. An alternative is that the emotions are universal, while expression is their exemplification. The plurality of works and forms of art then becomes an enigma, since a supreme

13. Tolstoi's theory, in *What is Art?*, is based on such an understanding.

expression of an archetype would appear to suffice for all time. More likely, it is the interaction of a common archetype with its plurality of expressions that is the source of artistic value—a central and important mode of contrast.

The mistake again consists in looking to something other than the work for which it is a surrogate. The truth is that works of art are in relation and, like all other beings, have a character determined by what they are related to. This is a basic principle of an ordinal theory. The context and surroundings of a work are in this sense "part" of it. In addition, feelings are both inspirational for and responsive to works of art. Nevertheless, a work is not always expressive of its artist's feelings, nor do we respond to all works as if they are. Many works incite strong feelings in an audience—and some people expect all works to do so. Yet this is not expression or imitation, but rather the subordination of making to doing. Art here has no life of its own, but—like digging and slapping—is to be judged as something done, in terms of consequences and principles of conduct. We have again sacrificed the sovereignty of works of art to an external value. We need a theory that can preserve the sovereignty of great works of art without sacrificing their relevance to experience and other works of art. The ordinal theory and the theory of intensity of contrast both have this complementary relationship at their foundation.

Expression theories can be classified as mimetic: feelings are represented or symbolized through the work of art. Such a classification ignores the distinction between expressing and imitating feeling, and quite complex theories of expression have been devised to make the distinction clear. Such theories fail for the simple reason that the feelings proposed—whether expressed, represented, evoked, symbolized, or imitated—are either ordinary feelings available elsewhere and without particular value, or are to be apprehended only through the particular works of art which express them. Where the object has neither independent existence nor access, there can be no meaningful symbolic relation. Where the feeling is common, frequently experienced, its contribution to the sublime values of a work of art is implausible. Entire theories of art stem from the emotional character of many works, overlooking the fact that ordinary emotions are largely trite while recondite emotions are largely inaccessible. The only acceptable conclusion is that it is not the feelings which matter but how they function in relation to the work of art. This is the conclusion of the theory of contrast. What is aesthetically relevant is what comprises an intense contrast—whatever it may be and however it does so. Feeling is one of the major modes of apprehension of intensity of contrast.

Emotion and feeling, then, are properties of our responses to intense contrasts, but the latter are the basis of aesthetic value. This is why we sometimes respond to great works unemotionally and coldly, aware of their power but still unmoved. In those cases where we ascribe emotional values to the works, it is not the feeling attached to them but the contrasting relations they enter that comprise artistic value.

A work of art is a creation, often the result of strong inspirational feelings, and often capable of arousing strong emotions: but it is the work which is remarkable. It would appear that novel feelings are only sometimes, if rarely, achievable; but novel works are common. Why are poets forever in search of new ways to capture approximately the same feelings? Because it is the making which is important, not the motivating feeling. Where there is an essential feeling in a work of art, Keats' melancholy, for example, it is the contrast between the common emotion and its particular manifestation that is of artistic value. This contrast is essential to the notion of aesthetic distance and to the advice given by Thomas Mann that the writer must control his emotions, not let them control him.[14] This is because the feeling is not art until it has been transmuted into intense contrast.

Certain aspects of art are nearly inexplicable in terms of mimetic or expressive theories, though they can be given an awkward analysis in terms of symbols. If the goal of art is to express a feeling, of what significance is *style*—understood here as the common qualities belonging to a variety of works of different artists, as we speak of the "classical style"? On the basis of expression theories, it is not the style, not the common elements of form which are important, but the feeling which is to be rendered. Symbolic theories suggest that a style is the common language in which feeling is to be expressed—though each artist finds his particular mode of expression within the common language (or modes of departure from the common style). The explanation is, unfortunately, too strong: it suggests that community of style is either a limitation which the artist is unable to transcend, or that it is required by the exigencies of communication. In neither case is a common style a value. But of course it is, though mimetic and expressive theories cannot explain why. Style in its ambiguous manifestations is one of the most salient and important modes of contrast: the individual work in contrast with the artist's other works, the individual artist's quirks and achievements in contrast with the common properties of the school to which he belongs. A common style is essential to certain typical and

14. See Edward Bullough: *Aesthetics,* London, Bowes and Bowes, 1957, pp. 93-117. See also below, pp. 47-48, 184-86.

important contrasts. That is why we are so concerned with style in our understanding of art.

The most famous example of a theory of imitated feelings is Aristotle's: the pity and fear imitated in tragedy provide a release of corresponding emotions in the audience, a *catharsis*. The basic elements here are the imitation of pity and fear—certainly not an identity, since the fear we feel for the characters and events is not the fear we are to release in catharsis. Though emotions are imitated, there is nevertheless not an identity to be attained. Catharsis is a contrast between the emotions portrayed in the work and the emotions felt by members of the audience. The diminution of either pole weakens the catharsis. Aristotle's theory of mimesis moves from faithful representation to the creation of a pseudo-reality: "the poet's function is to describe, not the thing that has happened, but a kind of thing that might happen, *i.e.*, what is possible as being probable or necessary."[15] Value here lies not in verisimilitude, but in the emotions which the work presents and which it evokes together in contrast.

The emotions within a stage work are always different from the audience's emotions. The regret and terror Oedipus feels for having married his mother cannot be shared by an observer, who has his own feelings to cope with in response. In addition, the emotions during a drama are different from feelings afterward—the latter including a sense of completeness and release from the terror of the events. The differences here are vital, for they generate the contrasts which art requires. When we identify too deeply with dramatic characters, and experience the emotions which they are represented to have, we fail to perceive the difference between the tragic onlooker and the participant. We have lost sight of the created aspect of the tragedy. Catharsis depends on differences in feeling, on contrasting tensions amidst differences and similarities. No mimetic theory alone can explain the artistic value of catharsis.

Imitation of a Model

An important conception of imitation is inherent in Aristotle's theory of art as *techne:* not the imitation of ideals nor the representation of physical objects, but the realization of a plan, conformation to a model. Aristotle assigns to art a creative capacity equivalent to that of nature. Yet he also understands both nature and art in terms of final causes. The result is that artistic novelty is compromised both by the restrictive-

15. Aristotle: *Poetics*, 1451.

ness of prior conditions and by subordination to timeless ends. The capacity of conditions to open up novel possibilities is limited by Aristotle's emphasis on formal purpose and natural order.

The basic issues here are cosmological and will be discussed below. The notions of balance, proportion, and harmony which Aristotle inherits from Plato are a function of Plato's cosmological assumptions: the world is ultimately one and its higher values are unified. A consequence for art is that new forms are disparaged. Given timeless paradigms, it follows that experimentation in drama, deviation from traditional forms of tragedy and comedy, and novelty in types of representation are all devoid of intrinsic value. Where art is compelled to pursue models outside itself, its creativity is compromised. Aristotle emphasizes creativity and novelty in both nature and art, yet just as nature is subordinated to final causes, art is subordinated to antecedent ends. The importance of invention as a primary value in art, and the contributions of art to the transformation of nature, are both unintelligible.

It is common to emphasize the creative aspect of Aristotle's theory: the function of art to describe "what is possible as being probable or necessary." I have noted how such a conception has led to the autonomous reality of Frye's theory of poetry. I will forego consideration of why such theories should be considered *mimetic* though imitative of no particular reality but of reality in general, another reality, another world. Mimesis and creation appear to be divergent tendencies: the first leading to similarity and resemblance, the second to departure and invention. Yet if art is the creation of another reality, its artistic values are its contrasts with our lived experience, similarities and differences. If art is imitation, its values must lie in the contrasts between the plan to which the work conforms and its singular manifestation in the work.

A more adequate view is that the arts are purposive and construct works according to plan, but plans neither distinguishable from their works nor antecedent to their arising. What this means in part is that a work of art redefines the standards according to which other works are to be judged. Even the modest imitation involved in following a plan compromises the capacities of the arts to transcend prior expectations. A failed expectation may be a greater artistic achievement than a realized one, in generating more intense and abiding contrasts in the novelties brought to pass.

Truth

The tension between art and truth (or art and reality) may be permanent. Some works of literature are deeply philosophical, purveyors of a

moral and cosmological tradition. Other works are, by comparison, a play with and upon words, full of characters and scenes, but pregnant with no obvious truths. The tension between art and truth is often the tension of flirtation: art may indulge itself with wise thoughts and seek to captivate us by them. But the truth that belongs to claims made and justified is distinguishable from objects created: claiming is not making, though one makes claims. The flirtation between art and science— though usually one-sided—is pregnant with novel possibilities brought to light by the inventiveness of the artist.

A true statement in a work of literature—though its truth may be artistically important—is artistic only insofar as something is made of it. Art creates from any materials. Something may be made of the claims asserted within a poem or drama. Or, the reverse, a work of literature may be constructed so that a claim is justified in terms of the materials employed. As I have argued elsewhere, a work of literature may provide a persuasive though implicit argument for suitable claims.[16] Its structure may provide an order in which premises and conclusions may be discerned.

Nevertheless, a work of art is not as such *for* the making of claims— for it would then be science or philosophy. Likewise, Spinoza's *Ethics*, though elegant in its structure and mode of presentation, is not essentially a making but asserting—or, if it leads the reader to wisdom, a doing as well. Plato is correct here, that claims belong to philosophy and science, and do not as claims belong to art. Art constructs novel beings, and what it constructs may be known. But it is not as such, in all its achievements, either descriptive knowledge or propositional truth. The legitimacy and autonomy of art are essential here. So is the priority of being over meaning.

The fundamental premise—which can be explained here but not conclusively established, since it must assume what would be proved— is that there are diverse modes of judgment, diverse cognitive functions, diverse spheres of validation in human experience. Claiming, making, and doing are distinct judgmental functions. The ordinal theory is expressed in a theory of plural but irreducible modes of judgment. There are at least three such modes—assertive, active, and constructive. There are also novel modes of judgment engendered by interrelationships among the established modes of judgment, new forms of knowledge, new ways of understanding.[17] The diversity and

16. Stephen David Ross: *Literature and Philosophy: An Essay in the Philosophical Novel*, New York, Appleton-Century-Crofts, 1969.

17. See Buchler, *Toward a General Theory of Human Judgment* and *Nature and Judgment*. See also my *Philosophical Mysteries*, Chapters III-V.

plurality are based on the pervasiveness of each mode throughout judgment and experience and the uniqueness and sovereignty of a mode of validation peculiar to each mode of judgment.

There are at least three distinct modes of judgment, corresponding to the functions of saying, doing, and making. The complexity, however, is that no human work possesses but one of these functions. A work is made, but to make it requires action, and the act or work may be regarded as a comment upon conditions and circumstances. The art for art's sake view is partly correct—that art, as making, is not to any other purpose. It is not intrinsically doing or claiming. But every work of art has consequences and can be evaluated in moral terms. Its greatest import may reside in being a commentary on a time or world view. We may develop methods for treating a work as making alone, but it cannot be only a making. Art is grounded on a unique and distinctive mode of judgment, but no individual work can be constructive judgment alone.

In what does the value of a work of art consist: making alone, or in assertive and moral qualities also? My conclusion, explained in detail below, is that no unqualified answer can be given to this question: the nature of art forbids it. The complexity of functions inherent in human works is a source of essential and profound contrasts for art. Where art is expected to be didactic, the artist may deny, repudiate, or simply avoid claims to truth, enriching the contrasts on which his work is based. Where art is created to be merely formal, truth is brought into complex relations in significant forms. How are we *supposed* to view a work of art? As it would provide intensity of contrast—that is, as an original creation, therefore, according to no fixed rules. Truth and verisimilitude can contribute to remarkably intense contrasts. But they are not necessary to contrasts in art. Truth can contribute to aesthetic value, but it is not necessary to aesthetic value. Moreover, even when it is relevant, its role is complex and diverse, since it functions at many levels of contrast and in inexhaustibly diverse ways.

There are at least three modes of judgment—assertion, action, and construction—with corresponding contrasts at different levels. The modes of judgment constantly interact and generate contrasts in experience. Nevertheless, in science, constructions have relatively well-defined rules in the service of justification. In morality, construction provides a basis for action where principles are insufficient. Making in both cases is in the service of another mode. Analogously, in art, claims and actions are in the service of intensity of contrast. An artist may construct his work so that it requires true claims, leads to true claims, or generates an impulse to moral action (revolutionary poetry, for example). A work of philosophical literature—*The Brothers Karamazov*—is

the stronger to the extent that it achieves some of its complex claim-making ends most successfully. Analogously, a work of literary philosophy—Kierkegaard's *Fear and Trembling*—depends on its artistic qualities as part of its philosophical character. Irony frequently mediates between literature and philosophy. The reason why no univocal analysis can be given of the interconnection of truth and art is that art resists formula, moving constantly to richer levels of contrast. Truth in art is important and recurrent, but its role there is inexhaustibly diverse and complex, constantly changing its forms and functions.

APPEARANCE AND REALITY

Mimetic theories undermine the ontological status of art by treating it as an appearance of a greater reality. The coordination of appearance and reality with mimesis affords two alternatives: to emphasize the reality of which art is an imitation or the work of the imagination in developing appearances. Mimetic theories usually support a greater reality in whose service art is placed, and are in effect depreciative of artistic creation and the sovereignty of the work of art.

Like the mimetic theory of which it is a species, the theory that art is an appearance of another reality captures an essential if partial truth—that a work of art, even where it has a model, nevertheless is not the model and does not seek to become it. A painting cannot be a room. A flute is not a bird. We might then say, with Schopenhauer and Langer, that art seeks to capture or imitate the *appearances* of things, not their reality. Properly understood, art cannot deceive, for it never pretends to reality: it would present to us appearances only.

A work of art, at its most realistic and imitative, nevertheless is not, cannot be, and should not be taken to be the reality of which it may be an appearance. As Schopenhauer emphasizes, the nature of the artistic medium is all-important. Canvas and paint are not the leaves and bark of the tree they represent. Close up, an impressionistic scene by Seurat bears no resemblance whatsoever to the original. Realism in art is only a near-identity: the medium and the qualities of the work are very different from the original. Where the verisimilitude of a painting of a tree is so great that we are astounded by the resemblance, our astonishment is that paint can be so much like bark and leaves—at the contrast between the achievement and the materials employed. A flute passage is not a bird call, however much it resembles one. The piano accompaniment of Schubert's *Gretchen am Spinnräde* is "like" the spinning wheel and the moving treadle—but singularly unlike as well.

The appearance-reality distinction in its epistemological function defines perceptions and thoughts to be appearances where they have

erroneously been taken as the reality. A speck in the sky "appears" to be a bird, though it is a balloon. We seek to move from the appearance to the reality. Because of this, Plato has no patience with art, seeking the reality for which it stands. Yet the striking quality of art is that *as* an appearance, it is not its reality and does not pass for it. We attend a hall to hear a concert, not to be deceived by the sounds but to know throughout that it is music, not something else. Events on a stage are not to be thought real. Though a playwright like Pirandello may toy with our conventional sensibilities, his characters never stop playing their parts.

To say here that art is appearance is to suggest the opposite of Plato's position—not that art is imitative of reality, but that we may address appearances "in themselves." I have noted Aristotle's position that art imitates by creating *probable* events, pretending to be nothing but itself. Langer's theory is the final extreme of this position, pure semblance with no reality. We have moved far from the original distinction. The notion of "mere appearance," lacking the polar reality, makes appearances one kind of reality, and the distinction between appearance and reality collapses. The medieval conception of art as symbolic illustriousness parallels the symbolism assigned to all reality—a mirroring of the divine. There is the reality of the temporal world including art and the reality of the eternal. The critical distinction here is not between appearance and reality, but between the temporal and the eternal. Without such ontological foundations, appearance and reality are inadequate categories for the analysis of art.

We have recurrently been led to consider the possibility of preserving art as appearance by repudiating the reality for which it is emissary. Langer pursues such a course, if somewhat inconsistently. At times, she holds a theory of expression, close to the view that art symbolizes deeper feelings. A work has the import of what it expresses. In this respect, her theory is simply a sophisticated theory of imitation, with all of the attendant problems. However, the more interesting theory in *Feeling and Form* is of a semblance uncoordinated with any reality.

> How can a work of art that does not represent anything—a building, a pot, a patterned textile—be called an image? It becomes an image when it presents itself purely to our vision, i.e., as a sheer visual form instead of a locally and practically related object. If we receive it as a completely visual thing, we abstract its appearance from its material existence. What we see in this way becomes simply a thing of vision—a form, an image. It detaches itself from its actual setting and acquires a different context.
>
> An image is, indeed, a purely virtual "object." Its importance lies in the fact that we do not use it to guide us to something tangible and practical,

but treat it as a complete entity with only visual attributes and relations. It has no others; its visible character is its entire being.[18]

The concept of pure semblance is a difficult one. Langer conceives of painting in terms of its "virtual space"—the semblance of a space which belongs to the painting alone. The reality she accepts is severely circumscribed—the physical world and human feelings. Like Whitehead, whom she admires, as well as Kant and Cassirer, she has only one world in which to place the space and time of art. Thus, a painting *seems* to define a space but cannot really do so. The time of music is not true or real time, but a virtual time symbolic of the movement of feelings. The time of a novel is not historical time, but only a semblance of time.

If the reality of which an appearance is a surrogate is undermined, so is the appearance. One of the greatest vices of post-Kantian thought is to have relinquished things-in-themselves for a world of pure appearances. If all is appearance, there is no reality. The alternative is that everything is reality, including appearances. A real being may, however, be an appearance in some of its relations—for example, in passing for something else. Langer's insight may be expressed quite differently: a work of art is a reality which is similar to other realities, but significantly different also, and which displays itself to be both alike and different. It is an intense contrast. It is real, but is an appearance relative to other realities which it represents, symbolizes, or resembles. Yet however similar it may be to other realities, it is unlike them and "just what it is in itself." The latter characteristic, its sovereignty, is prominent in a great work of art because of the intense contrasts which are unique to it and which are its reason for being.

The ordinal theory rejects the ontological basis of the distinction between appearance and reality. Only the reality of a work can justify its sovereignty. More to the point, every order is an order; none can be more so than another. Ordinality is founded on the principle of ontological parity, and this principle is the basis for the imaginative fecundity and power of great works of art. They compel us to enter new worlds and to contemplate novel possibilities. The power of what art brings before us testifies to its reality as an order. We can respond to, examine, and understand its properties. Works of art and their constituents are orders; fictions and imaginary realizations are orders. They have properties and constituents; they inhabit relational spheres and comprise relational spheres. Orders are not more or less real than others. And if they are appearances, they are not then unreal, but real

18. Langer, *Feeling and Form*, pp. 47, 48.

orders passing for, functionally equivalent to, other orders in certain respects.

Appearance theories define an important mode of contrast: the work is a reality within its medium but may also be an appearance, symbol, image, or imitation. The contrast is between the work in its medium—*merely* paint on canvas—and the other reality whose appearance it is. Were we to come upon a stage rehearsal without foreknowledge, taking it for reality, not only would we be mistaken about its nature; it would be a different event. Were we to think Shakespeare's characters real, they would sound peculiar to us. Poetry is never the way human beings really speak. Nevertheless, the metaphysics here is dangerous, for poetry is a genuine form of language, the Shakespearian tragedies are real works of art. These orders are all real, but of very different kinds.

The ontological parity of different orders requires a theory of how they are variable with ordinal location, so that the reality of Shakespeare's language or fictional worlds does not entail a uniform, unqualified nature to any of his works. An ordinal theory provides a basis for regarding works of art and their constituents as real, but without the conclusion that they thereby conflict with representational or fictional characters. The question is always *how* an order is real, meaning what particular integrity (or identity) does it have in a particular location. The function of orders in many different locations is the foundation of both the appearance-reality distinction for every order and the inexhaustible richness of complex works of art.

If we are struck by the ways in which art revels in appearances and not realities, it is because duplicate realities as such produce no contrasts for our assimilation. They are simply what they are relative to our perceptions of them. But a portrait which is very much like its subject, but subtly unlike her, is a revelation of character through distortions which contrast with more mundane perceptions. Were it a pure semblance, it would be a reality with no obligations beyond itself. The more accurate formulation is that it is a creation for which certain contrasting relations are of major importance.

ARTIFICE AND NATURE

Art as appearance in contrast with reality engenders a tension between art and nature. Nevertheless, the two contrasts may be interpreted quite differently. I have interpreted the appearance-reality distinction in terms of mimesis, leading through the rejection of reality

as a model to appearance as a function of art emphasizing the relational character of the work. However, relations are conditions of all beings. The special characteristic of art is the contrast generated *among* its relations, a contrast enjoyed by all complex beings but made intense in art.

What is lacking in such an account is a notion of artifice. Yet emphasis on the artificiality of art can easily lead to its depreciation relative to what is thought natural. The fact that art involves making can be perceived as an inalienable flaw: art is merely an imitation of the real, not nature herself. Conversely, the fact that art is a human construction provides no obvious explanation of the aesthetic values we assign to nature. One alternative is to emphasize qualities belonging to both nature and art: harmony, proportion, balance, and symmetry.

Such a view is plausible in terms of many works of the Western tradition through the nineteenth century. Throughout there are glimmerings of the weakness of the criteria—as in Shakespeare or Bruegel, where balance and harmony seem inadequate as the basis of value, or where art reaches a sublimity that nature cannot rival. With the advent of romanticism, however, the artist was made the focus of attention, and artifice became the predominant value. Nature lacks aesthetic qualities since her works are not the result of imagination, inspiration, or genius. Shaftesbury's straightforward conception of beauty in nature as well as art gave way to an emphasis on contrivance and artifactuality.

If nature and art are based on distinct principles, they lack common values. The problem is that even though art may not provide an understanding of nature, nature often provides objects for artistic judgment. Moreover, art makes important contributions to nature. The distinction between nature and art is too sharp. If art is real, then it is part of nature: a culmination of certain facets of nature as science is the controlled reflection of nature upon herself and morality involves the organization and control of antecedents and consequences. Art is part of nature, though its goal is not simply to attain values already "in" nature. Art is more original than that. Rather, it maximizes the attainment of intense contrasts, bringing the new and old together within natural processes.

Apart from mankind, nature lacks art—though she is filled with contrasts. However, they are neither assimilated nor intentionally created. More important, nature possesses her greatest aesthetic values in proportion to the effects of human life and art upon her. "The beauty of Nature is all the greater, the aesthetic delight or perception in the fact of Nature is all the purer and the deeper, as the impact of human life

33

upon Nature is more profound and extensive." "Man's art and vision too are one of the ways through which mankind invades Nature, so as to be reflected and meant by her."[19] To dance to the beginning of summer is to celebrate it, to make it noteworthy even where the dance is traditional. The contrast of summer in the cycle of the seasons is made intense by our celebration of it in art.

Art here is contrivance, but it is included within nature. Nature is transformed by art and given novel character. Natural possibilities are transformed by technology and taken into art. As Hegel suggests, nature is *for* art but imposes itself *upon* art. In its simplest form, the contrast between nature and art is felt in the constraints of materials. Complexly, nature is the result of historical developments while art is controlled adventure in novelty. Nature is always partly resistant to art, both through inertia and through its own novel creations. Nature and art are an intense and rich interplay of contrasts in their intimate relations and divergent impulses.

Much of nature is relatively free from human manipulation. Here nature and art may be sharply contrasted, and the values of each may be enhanced by the other. A splendid view may inspire a landscape; a novel painting may provide new ways of seeing the world, new appreciations of the fruits of chance and necessity. Often nature seems purposive, necessity in contrast with design. Often art seems unnatural and strange, gaining value by its unfamiliarity. The contrast between contrivance and its natural conditions is of fundamental value here. But it is not merely nature which serves to establish this contrast for art, but other art as well, prior works, traditions, and styles.

In an ordinal theory, there is no order of nature, for orders are inexhaustible and there is no order including all other orders. Nevertheless, there are orders irrelevant to human experience and orders which are typically human. This disparity, conjoined with the inexhaustible range of relevance of every order, engenders rich and complex contrasts: among orders made and orders found, among orders in judgment and the plenitude of our surroundings. Nature and art are to be thought opposed only as the foundations of complex contrasts involving discoveries and constructions, experience in a passive and in an active mode. Every construction adds to the plenitude of orders and the wealth of possible contrasts. This natural complexity is an important condition of the contrasts essential to artistic value.

19. Jacques Maritain: *Creative Intuition in Art and Poetry,* New York, Pantheon, 1953, pp. 6, 8.

BEAUTY

Two basic strains may be discerned in theories of beauty. First, historically the most important, beauty—the object and standard—is defined independent of art. Art here is instrumental, a means to an independent beauty. The natural teleology is toward the cosmological, the beautiful as a fundamental element of the world, to be realized through art but belonging elsewhere. A philosophy of beauty here is not intrinsically a philosophy of art, for beauty is at home outside art while art has no unique function relative to beauty. Such theories explain why both art and nature may have aesthetic value, but do so at the expense of the uniqueness of art.

The second strain within conceptions of beauty is given by the apothegm that "beauty is in the eye of the beholder." In Aquinas's formulation, "the beautiful is defined as that whose very apprehension pleases."[20] No doubt Aquinas means the pleasurable apprehension to be a criterion of a beauty in the object. But if we emphasize the apprehended pleasure, beauty and taste are conjoined in subjective experience, felt responses to works of art and nature. Yet the value of great works of art cannot be relegated to mere taste. The problem remains of explaining why beauty should please us or why what pleases us should be assigned a supreme value.

Beauty has persistently been problematic where regarded as the sole basis of artistic value. Setting aside a precise definition of beauty, we may note that many great works are not beautiful by any obvious standard: they may be violent or skewed and may overwhelm us with passions. Drama in particular is seldom beautiful. The tension between beauty and ugliness is recurrent. The worst problem is not that some ugly works are first-rate, that evil can be magnificent, but that once confronted, the tension seems to undergo a transformation. Ugliness becomes an element of the greatest works—as comic exchanges are elements of the finest tragedies. The temptation is to represent what is ridiculous, puny, comic, evil, beautiful, and ugly as elements of a work which coordinates them all in its singular unity. Unity becomes the dominant notion. Coleridge, indeed, defines beauty as unity in multiplicity. "The Beautiful, contemplated in its essentials, . . . is that in which the *many*, still seen as many, becomes one."[21]

20. Aquinas, *Summa Theologica*, Ia; IIae, 27, ad 3.
21. Coleridge, *Biographia Literaria*, II, 232.

The tension here is between beauty as an element within a work, a shape of line or relation of colors, and the completeness which a work must possess is we are to take it whole. Within a work there may be beautiful moments, shapes, or sounds, yet also sections which are emotionally empty, even monstrous. The whole work must "unify" all its elements, and do so well—let us even say "perfectly." Shall we then ask whether a beautiful whole may be comprised of ugly elements? That has been the traditional solution. Yet a work comprised of many beautiful moments may not be a successful union.

Beauty in the small and as the unity of a work stand in contrasting relations. Similarly, beauty has been contrasted with the sublime: harmonious grace contrasted with a spendor of diverse, fearful, even terrible events. The most transcendent works are often thought to be those—as in *Oedipus* and *Lear*—where the most pitiable and fearful elements are brought into dynamic completion. The point may then be made that few of the greatest works, even in painting and music, are "merely" beautiful. Artistic unity replaces the concept of beauty. We may note in addition that all beings are just what they are and thus unified—tables, theories, or galaxies.

There are two fundamental inadequacies of theories of beauty: First, it is extremely difficult to define a plausible conception of beauty adequate to the diversity of beautiful things; second, there are natural events and works of art which are not beautiful though of great aesthetic value. An aesthetics of beauty is not and cannot be a satisfactory theory of art, but is at best a formulation of a particular mode of value, either found within or demanded of works of art. Because beauty is found within nature, a cosmological theory is plausible. Here beauty in art and as a feature of the world may be conjoined. The tendency so to unify art and the world, artistic value and the core of the universe, is cosmological, and is a continual frustration of the achievements of individual artists. Beauty in the small, as an element of natural events and works of art, is an important but not pervasive character of aesthetic value, and cannot serve as the basis of a general theory of art. Beauty in the large, as a synthesis attained over the multiplicity of relevant components, is cosmological to the extent that unity and synthesis are made the primary notions. The movement is toward a greater unification and a more comprehensive synthesis, diminishing the power of individual works of art and making purification and simplification unintelligible.

One of the three fundamental dimensions of value in works of art is that of *perfection*—the highest standard of achievement. With respect to technique, it is that a given line could not be better drawn. With

respect to composition, it is that a painting is balanced and harmoni-ously interrelated. It must be understood that there is no *state* of perfection, that perfection is not a superlative. The value is one of completeness. It reflects the ways in which a work is sovereign, incom-parable. The quality may more persuasively be defined negatively: there are no *im*perfections in a fine work of art. Yet this is not quite correct, for there are flaws in both *Macbeth* and *Lear*. The imperfections must be minor while the perfections must sustain what we take to be of greatest importance. More important, perfection pertains more to a variety of relevant contrasts than to the work as a whole: all the ways in which a work attains perfection, completes its impulses, fulfills its conditions.

I will replace the concept of beauty with this sense of perfection in what is vital to the work of art. The point, however, is that neither beauty nor perfection is anything "in itself." Both are a variety of contrasts. A work is perfect relative to what is mediocre and inade-quate—for there is no sheer perfection. Perfection is a fundamental contrast in all art: the better with the worse, the perfect with the mediocre, the completed with the unfinished. It manifests the expand-ing levels of contrast essential to aesthetic value: many perfections within a work comprising a completed synthesis in the work as a whole, many perfections comprising a more comprehensive, complex perfec-tion. Yet there is no supreme, greatest perfection, for perfection is incomparable.

Perfection is a fundamental dimension of contrast and aesthetic value in that it manifests the constructed, created, finished character of a work of art or natural object. In this sense, perfection indicates its supreme value as beauty conceived as harmony or as the object of felt apprehension cannot. Perfection manifests the singularity and sover-eignty of the work of art: what it is, how it is sovereign and incompar-able. Yet the remarkable feature of the notion of perfection is that it is an incomparability comprised of common constituents. Works of art are comparable in their qualities, but sovereign and singular in their intense contrasts.

Perfection defines no uniform measure, but varies with works, styles, and traditions. There are works which are relatively unambitious, works of modest scale attaining measured and harmonious order. There are also works which take on the greater human experiences, filled with passion, pity, and fear. Such works are usually less pleasing and often lack the orderly fulfillment that modesty can provide. Yet they may achieve a remarkable intensity of contrast by means of their chosen themes, the dissonances inherent within them brought into

accommodation within the work. Harmony among similar shades of color is a modest achievement, but not so remarkable as a dynamic and pulsating order among dissonant and clashing hues. Beauty suggests order and harmony among compatible elements. Sublimity suggests the successful coordination of clashing movements. The opposition here engenders intense contrast: diverse elements conjoined. Such an achievement is the highest value in art.

A pernicious failing in theories of art is the supposition that standards of beauty exist independent of the works which achieve them. There is a beauty in nature—a rightness or perfection in what is there—but it is different from the perfection of a musical work. The artist does not *fulfill* or *meet* standards of perfection: he *invents* or *creates* them. It is the responsibility of the artist to invent or create novel ways in which separate and diverse elements of our experience may be brought together.

Virtually all traditional discussions of perfection treat it as excellence of a kind, antecedent to and imposed on works of art. It is consequently rejected by Kant as irrelevant to artistic value. Correctly conceived, perfection is always in a novel kind, singular and unique, incomparable. It is in this sense wedded to originality and invention, novelty and uniqueness.

UTILITY

Is a work of art useful? How could it help but be? Works of art are useful in many ways: for arousing loyalties, persuasion, the release of emotions, and so forth. More to the point, a work must have effects on its author and audiences. Of course, some works are not useful but destructive. Plato criticizes works of art which mislead and corrupt us. Nevertheless, to condemn art for corrupting us is to consider its effects important. Plato manifests his respect for the powers of art: a work has an influence, for better or worse. It may be destructive; it may be beneficial. It cannot be neither, indifferent to its consequences, for it would then have no value.

Why, then, has the problem of the utility of art remained unresolved? The issue is again of the sovereignty of the work of art, the legitimacy of artistic judgment. If art is but a means to certain human ends, to be judged by consequences and influences, it is a practical, not an aesthetic object. Its value lies in what it *does*, not in what it *is*. A created work will have effects, will produce influences; but its being is not reducible to its effects and uses.

The issues here are very complex. We are dissatisfied with Plato's censorship of the arts on moral grounds because the channeling of artistic invention is a diminution of possibilities. On the other hand, there is the suspicion that most people tolerate freedom in art because they do not believe it to be of any great consequence. Art for art's sake seems sterile and absurd, especially when we consider the greatest works of literature. On the other hand, to reject a poem written on a controversial question merely because we think the views are wrong seems equally misguided. Artists pass no examinations in humanity and moral vision; we should not expect wisdom from them. Yet we may be inspired to courage by a noble poem and vow great changes in response to a stirring drama. Still another prospect, unfortunately, is that our moral fervor will be sated in the theater, needing no further outlet in action. The conception of a completely disinterested response to a work of art seems to be derived more from painting and music than from literature, especially poetry and drama, where passions rage and moral concerns are paramount.

An even more important example is that of our aesthetic responses to works of art, the feelings engendered by a moving work, the knowledge and values imparted, the transformation of character. Can a work of art be separated from those effects which lie in human responses to it? If art exists to delight and reward us, it has specific consequences of a practical nature that are inherent in its aesthetic conditions. Here utility appears inseparable from art, though the utility of works of art is a peculiarly aesthetic one, inherent in a distinction between practical and aesthetic values.

The conclusion to which we may be led is that practical and aesthetic considerations stand in a permanent tension in art. In some works, the tension is muted although relevant; in other works it rises to prominence. There is a profound contrast inherent in the condition that works of art have effects and are inseparable from them, while the sovereignty and uniqueness of individual works impress us more as we come to know the works better. Many great works bear within themselves themes of inestimable human importance, and a sensitive audience may be stimulated by them to action; yet they are not to be confused with diatribes and manifestoes for social change.

A tension is generated within art as a consequence of the principle that a work is constructed while the artist *does* something in creating it. There can be no art that is making without doing—nor can there be a doing which is not also a making: of history or life if nothing else. The relevant principles are that there are many distinct modes of judgment,

39

but that every mode is pervasive throughout judgment. Claiming, making, and doing are different modes of judgment, but nothing produced by human beings can be relegated to one mode alone.

One way to resolve the tension between aesthetic value and utility is through the principle that although a work is both a making and a doing, it is appropriate in artistic response to consider only the making. This is the doctrine of the work of art itself, and is flawed by a variety of considerations. First, the work is something made—and, if a physical object, has causal consequences. To make an object is to cause its effects. It is not clear how a work is to be severed entirely from its effects and relations. If some effects are not essential to a work, others are of paramount importance. Irony would be unintelligible without norms of response and expectation. We cannot separate all the effects of a work from it, only some of them at best. Some works may be of little utilitarian importance, where practical and moral issues are not essential. But there are works whose moral implications are central and which cannot be ignored.

A second consideration may make this clearer. Although making and doing are distinguishable, they are never separable with regard to any work of art. There is a continuing contrast between the formal components of a work—its structure, elements, and materials—and the emotions and responses it engenders. We may err on both sides, overemphasizing the structure of the work, ignoring its effects, or overemphasizing its utility, treating art as doing. Plato has a tendency to regard art as doing, not making, for relative to a timeless form there can be no genuine creation. On the other hand, to suppose that a work can be created without creating also its many effects is to commit an analogous error.

The alternative conclusion, which I shall support, is that the tension between the components and the effects of a work of art is a fundamental means to intensity of contrast. The complexity of the contrast manifests the inexhaustibility of judgment and experience. A doctrinal drama emphasizes utility and forces us to consider both its effects and its claims. A particularly vicious work compels us to consider its moral effects. A drama lacking all moral and social significance is superficial and a waste of time. The next level of contrast is the presentation of didactic material in contexts which forbid our forecasting their effects. Sometimes too great a moral ambiguity may be a weakness. In some cases it may produce a remarkable intensity in the work. Irony is often essential to transform practical and moral considerations into art at a sufficiently complex level of contrast.

40

Art is always a mixture of making and doing. In general, artists are expected to emphasize creation and to subordinate moral considerations to their art. But it is often the greatest works which resist such expectations and bring moral questions before us. In an artistic tradition concerned with moral and political issues, some works achieve a particular poignancy by formal elegance. Where art is preeminently formal in character, moral issues add particular savor and contribute to intense contrast. Utility is a powerful means in art to intensity of contrast. As a consequence, the highest moral ideals of humanity are relevant to art.

<div align="center">STYLE</div>

That artists frequently work within a limited range of forms and materials, a common style, and that this style is an important feature of artistic value, is inexplicable in terms of most major theories of art. Many theories place the object of artistic achievement outside the work, in a model or ideal; others emphasize the individual expression of the artist. Where a single ideal defines artistic value, the great variety of styles is unintelligible. One of the many approaches should be paradigmatic. These theories cannot explain why artists employ a multiplicity of styles and why we value this multiplicity. In theories which emphasize the individual personality of the artist, the common elements of style within his school are at best a limitation and cannot be defended as values within his art.

The work "style" is ambiguous, containing within it a profound contrast. The same word designates both the individual and idiosyncratic qualities within an artist's work, the devices which distinguish it from the work of others, and also the common characteristics of a group of artists, usually of the same period, as we speak of the "classical" or "baroque" style. The latter sense of the word is particularly problematic for most theories of art, whether they look outside the work for its basis or within it to its idiosyncratic qualities. The question is not why there are styles, for that may be explained by reference to historical and cultural conditions. The question is whether style is relevant to artistic value—and if so, how we are to understand it. To take but one example: the impressionists *all together* manifest a community and yet a diversity of approaches to light and vision. Renoir alone, for example, not only could not define impressionism as a style (though Manet might), but gains in our appreciation if we understand

41

his better work relative to the work of the other impressionists. A work within a style given force by a number of important artists is a greater value than an idiosyncratic work which has few elements in common with other works.

The problem of style is related to the fact that a diversity of styles is often perceived to be an important value, yet there have been periods in which artists worked in common, and their similarities are also perceived to be important values. If a common style has merit for many artists, we must explain why it has no merit for others. If a multiplicity of styles has artistic value, and we value the inventiveness of artists, we must explain how a common style is not a weakness, a limitation of vision.

The primary contrast inherent in the concept of style is represented by the two central meanings of the word: the style of a group, period, or school and the idiosyncratic style of the individual artist. A similar contrast should also be mentioned: between an artist's characteristic style and an example of his work—whether it be viewed as a culmination of the style or as a development within it. The concept of style, I am suggesting, reflects a variety of contrasts which enrich works of art—indeed, virtually all artistic values can be interpreted in terms of the concept of style. At the least, the notion of style reflects the inadequacy of restricting attention to the individual work, since it is not simply "in itself," but belongs to a school and has a style in common with other works.

> A style is both more and less than the individual works of that style; more, because no one work exhausts it, and less, because it is manifest only in individual works. When we recognize a style we recognize it in works which strike us as variations of something which we know only in its modifications. . . . We may prefer on occasion to listen to the entirely unique voice in which an individual work addresses us, but we acknowledge its uniqueness only because we understand the common language spoken.[22]

If we set aside the basic contrast for a moment, we may discern a variety of other contrasts falling under the concept of style.

Content

One version of the relation between form and content is relevant here—a relation usually interpreted to require the coordination of

22. Eva Shaper: "The Concept of Style: The Sociologist's Key to Art," *British Journal of Aesthetics*, July 1969, p. 246.

content with appropriate forms. Often, however, we find dichotomies between content and form—comic exchanges in Shakespeare's tragedies, paintings by Bosch and Soutine, the tone of Kafka's short stories —which often achieve a striking intensity by their discordances. The contrast between form and content is one of the pervasive tensions in art.

Style—individual or common—is what transforms ordinary materials into art. A subject matter must be transformed by an artist's particular style to become the content of a work of art. The relevant contrasts here are diverse, for so is the concept of style. Variant settings of the same play or libretto, in styles of different periods, augment each other by way of contrast. In the hands of a lesser artist, conventions of style may be fetters inhibiting artistic achievement. In great works, stylistic conventions sometimes stand in marked contrast with the result, thereby attaining great artistic values.

The elements of style common to a period or school are relatively restricted—or there would be no style. On the other hand, with but few exceptions—atrocities, sexuality, sacrilege—the entire range of human experience is available within every art and style, especially where language is employed. Often, even great artists may find their stylistic means somewhat incompatible with certain intellectual or emotional themes. An artist who breaks partly out of the conventions of his period, yet remains faithful to the style, may transcend his limitations by an intensity of achievement. The interplay of restrictions of style with the openness of human experience is what often gives power to the greatest art.

Form

Classical opera may be represented as a contrast between style and content—the tragic emotions of the drama in contrast with the style of classical music. Nevertheless, opera represents a more obvious contrast: between form and style. Certain art forms, whether generic or particular, stand in concrete tension within a given style. The sonata *form*—as contrasted with the classical *style*—is certainly compatible with it, yet is not reducible to it since the form persevered into romanticism. Though Beethoven developed the major symphonic contrasts, the symphonies of Bruckner and Mahler represent the contrast between form and style most forcefully. Our conceptions of the symphonic form are in part fulfilled by, yet in sharp contrast with, classical style and its individual works. So also, the individual form given to a work within a style manifests the larger contrasts of the style—between what is common and what is individual. In one sense, impressionistic style is attained equally by Manet and Renoir; yet there is all the difference in

43

the world between the pointilistic play of light in *Chartres* and the caressed faces of Parisian ladies with their children. The content is relevant but so is the individual stamp given by each artist to a common style. The style represents the larger milieu within which, and in contrast with which, each individual expression of the style plays a role.

Genre

Another approach to the contrast of style is through the contrast between an individual work and its genre. Artists constantly test the limits of their genres, sometimes to define a new art form, sometimes to achieve a unique work which may have no successors. The theater is a traditional arena for experimentation upon the limitations of a given form. It is common for artists to describe their work as experimentation. Such a notion is applicable to all phases of art, especially for eliciting new possibilities from materials and new combinations and perceptions from vision. One mode of experimentation is transacted within a genre or style, ascertaining *its* possibilities. Every work of greatness defines both its form and its genre and represents a style. Yet it is also an individual, sovereign work and more than an application of rules. Whatever we take to be the sonata form, nearly no works—and certainly no composers—follow it faithfully.

We may return, then, to the primary contrast in style: the style is common in contrast with what is individual—whether it be the artist or his work. Style is a consequence of multiplicity in art, for wherever there is multiplicity there are similarities and differences, while individuality is also important. This central tension, represented by style, is a fundamental artistic value. It is an enrichment of a work that it belongs to a given style—an enrichment by contrast between the style of which it is an example and the unique ways in which it expresses the style or deviates from it.

The most obvious approach to style is historical, the fact that several artists worked in a common manner, that a given period had traits in common. It then seems a limitation upon an artist's inventiveness that he follows stylistic conventions developed by others. In theories such as Dewey's, art is a cultural expression, and style represents a culture's most obvious characteristics. Nevertheless, except from a historical point of view, there is no explanation of why and how a style generates artistic values, especially for later audiences.

Expressionism—cultural or individual—defines a theory of style which at least confronts the important question. A work of art as an

44

expression of a culture requires a common style insofar as the culture is common. The individual work represents the deviance of the individual within his social milieu or a departure from common human characteristics broader than social conditions. Not a bad metaphor here is of style as a language within which the artist seeks his individual mode of expression. Unfortunately, the historical approach still rules supreme, rendering the style an accident of circumstances, as the language a person utilizes is a historical condition, not one he may choose intentionally. Only a dialectical interpretation makes style here anything but chance.

An individual man, born into a given society and with a particular native language, nevertheless may choose to learn another tongue in which to express himself. Yet he may not become sufficiently fluent to write poetry effectively in the new language. Here, then, a historical circumstance of birth is important to an individual's artistic achievements. On the other hand, we may interpret the choice of language as motivated by artistic effectiveness. How are we to interpret a style so that it may be chosen purposefully? Only, it would appear, in that it is most familiar.

The theory of contrast provides an alternative answer. Style represents a milieu for the individual artist and his work, not just historical circumstance. An artist gains vitality and intensity in his work by contrasts within a common style. A common style here is not a constraint, a limitation of time and place. Rather, as with Shakespeare, the conventions and styles of the time may enable the artist to attain a greater art than he could achieve at any other time. Too great an emphasis on originality may inhibit the development of style and weaken individual works lacking common boundaries with other works. Twentieth-century art is weak—though energetic—in lacking enduring common styles. Each artist is limited to his own resources without the powers available from other artists working in a common style. Audiences resist so individualized and distinct works of art, seeking to type and categorize artists and their achievements, not only from a desire for familiarity, but also to attain more poignant contrasts. Style is a profound means to intensity of contrast, absorbing all other forms of contrast into itself, since it includes the fundamental contrast between the individual artist and his work and the common conditions of art and experience. This contrast of idiosyncracy and commonality in style is a supreme manifestation of inexhaustibility, the complementary and inseparable interplay of determinateness and indeterminateness in every order, every condition.

45

SUBJECTIVITY AND OBJECTIVITY

Subjectivity can be given a very broad purview, encompassing taste and pleasure, imagination, possibility, fiction, and the individual artist. Nevertheless, the concept has meaning only in contrast with objectivity, and it is the pair which has significance for art. For what is striking here is the way in which subjectivity passes into objectivity: taste is not personal but objectified; pleasure is insufficient to determine artistic greatness; art is sometimes cold and emotionless; finally, fiction in art is often a type of verisimilitude, and works may be condemned for being too fanciful, too implausible. Moreover, even the fairly general terms in which I have represented subjectivity fail to apply to many types of art—communal dancing, celebrations, social arts with a religious basis. There are important works in which individual contributions are minimized and emotional qualities are dimmed.

Central to the distinction between subjectivity and objectivity in art are the different standpoints of artist and audience. Emphasizing expression, we may emphasize also the subjective components of motivation and inspiration in the artist's experience. Here subjectivity is personal, and the work is the objective form given to subjective experience. From the standpoint of a member of the audience, the work is an object, yet it has value only within his subjective responses. We might therefore describe the situation as an objective communication between two different subjective experiences. A difficulty is that there are works not the outcome of any individual's inspiration and aesthetic responses which are not to art but to nature or thought.

A work of art is an object fashioned of physical materials, at least physically and perceptually available in performance. Nevertheless, artistic value depends on subjective conditions of creation and assimilation. Art involves both subjectivity and objectivity, and their contrasting interplay is the artistic condition. Yet the last thing we may wish to experience in a work of art are its author's feelings—which may be inspirational, but are not the work. We have no reason to suppose, for example, that Mozart was moved by any particular personal feelings in writing the *Symphony #40, Don Giovanni,* or the *Requiem.* Moreover, the subjective responses of an untutored audience may be irrelevant, mistaken. Finally, if a work of art is an object, it is one *for experience,* not an object like any other.

It is natural here to turn to Kant for whom the contrast between subjectivity and objectivity is of central importance. The fundamental tension is between subjectivity in personal experience and the requirement that it be for all humanity. This tension recurs in all creation,

where the artist is understood to create for himself and for all human beings simultaneously. A work is in constant tension between the artist's judgments and the judgments of others.

Aesthetic theory after Kant has largely turned on the tension between subjectivity and objectivity. In Schelling, the primary contrast is between nature as object and ego as subject, a fundamental and infinite opposition. "Every aesthetic production starts from the feeling of an infinite contradiction."[23] The work of art is the satisfaction of this contradiction. The nature of art here resides in contrast, represented by Schelling as the tension between subjectivity and objectivity. Hegel parts with Schelling on the reconciliation attainable in art, but accepts the opposition of subjectivity and objectivity as fundamental to experience and nature. To Hegel, however, art cannot overcome the tensions inherent within its sensuous elements, whereas philosophy can completely resolve them. But it is not necessary to rest the case in German idealism. In Roger Fry, the objective elements of the world stand in contrast with their imaginative counterparts in art.

The major difficulty with emphasizing subjectivity is that it focuses upon the artist and audience rather than the work. The sovereignty of the work is sacrificed to the human context. A work may be inspired by subjective feelings, or it may simply be well made, arousing significant feelings in an audience. But no specific feelings are necessary determinants of an important work of art. Rather, what is significant are the possibilities which are engendered and realized within the work and which are then available for personal response. The tension between subjectivity and objectivity is but one of the contrasts relevant to the character of works of art.

A closely related point of view—historically and theoretically—is the theory of romantic irony, that what is fundamental to a work of art is its double existence of creating a world and being a creation. The double character of such irony reflects the duality of subjectivity and objectivity, and can be taken to be the foundation of art.

> . . . Objectivity is irony and the spirit of epic art is the spirit of irony.
> Here you will be startled and will ask yourselves: how is that? Objectivity and irony—what have they to do with one another? Isn't irony the opposite of objectivity? . . . But I use the word here in a broader, larger sense, given it by romantic subjectivism. In its equanimity it is an almost monstrous sense: the sense of *art* itself, a universal affirmation, which, as such,

23. Friedrich W. J. von Schelling: *System of Transcendental Idealism*, in *Philosophies of Art and Beauty*, A. Hofstadter and R. Kuhns eds., New York, Modern Library, 1964, p. 35; selection translated by A. Hofstadter.

is also a universal negation; an all-embracing crystal clear and serene glance, which is the very glance of art itself, that is to say: a glance of the utmost freedom and calm and of an objectivity untroubled by any moralism.[24]

Mann's theory is Friedrich Schlegel's in a more palatable form.

In order to be able to write well on any subject one must no longer be completely absorbed in it. The thought that one would express with all deliberation must already be wholly in the past, and not really concern one at the time. As long as the artist is at the inventive and inspired stage he is, at least as far as communication is concerned, in a state neither of being free nor of allowing freedom.[25]

This general sense of irony is the basis of a thoroughgoing theory of contrast. It emphasizes the contrasts between appearance and reality and subjectivity and objectivity, and admits of levels upon levels of opposition and conjunction.

The irony of irony: generally speaking the most thorough irony of irony is the fact that one becomes weary of it if one is offered it everywhere and all the time; but what we would here chiefly have understood as irony of irony arises in more than one way: When a man talks of irony unironically, as I have just been doing; when he talks of irony ironically but without noticing that he is, at this very time, the victim of another, much more obvious irony; when he can no longer find a way out of irony as seems to be the case with this essay on unintelligibility; when the irony becomes mannered and so turns round, as it were, and ironizes the writer; when a man has promised irony for one table-book too many without first checking his stock and now must be ironical against his inclinations like an actor with the belly-ache; when a madness takes irony and it can no longer be governed.[26]

But the theory of general irony suffers from the same defects as that of subjectivity in tension with objectivity: it is a theory of contrast, but is not general enough, emphasizing certain contrasts exclusively, and overlooking others, especially those emphasized in earlier periods of art.

The dialectical form taken by the tension between subjectivity and objectivity in Hegel and Schelling expresses an important partial truth: a work of art, whatever other modes of contrast belong to it, is a created

24. Thomas Mann: "The Art of the Novel," *The Creative Vision*, Haskell M. Block and Herman Salinger eds., New York, Grove, 1960, pp. 88-89.

25. Friedrich Schlegel: *Lyceums-Fragment* 37; quoted in D. C. Muecke: *The Compass of Irony*, London, Methuen, 1969, p. 196.

26. Friedrich Schlegel: "Über die Unverständlichkeit," *Kritische Ausgabe*, II, pp. 318-19; quoted in Muecke, pp. 201-202.

object in a historical role. We find here one of the most important modes of contrast in art. The dialectic emphasizes that art is historically transcendent: in my terms, this is an expression of the fact that art is inventive creation. Ruling over all historical contrasts is the supreme and unavoidable contrast between the work as a historical object, located in space and time, part of a culture, and those modes of appreciation where it is regarded as timeless. This last mode of contrast cannot be explained by historicistic theories, though it is part of all critical response to art.[27]

The opposition of subjectivity and objectivity is an important source of contrast, but not all contrasts relevant to art, and certainly not all relevant to aesthetic value in nature. When we affirm the sovereignty of the work of art in the context of an emphasis on the interplay of subjectivity and objectivity, we are led to the central problems of idealism: that aesthetic value is defined by human subjectivity even though nature is recognized to possess aesthetic value. The ordinal theory resolves this difficulty by regarding art as the outcome of one of the major forms of judgment, but grounded in a more general metaphysical theory in which natural orders as well as works of art can possess intense contrasts and aesthetic value. Most theories of art are inadequate in some respects in relation to natural beauty; they are also metaphysically inadequate, based on far too narrow a perspective on experience and its surroundings.

PARADOX

What are we to make of the perennially paradoxical character assigned to art? The most straightforward approach is to regard logical paradoxes as mere conceptual difficulties. Thus Langer, fully aware of the strength of paradox in theories of art, comes down firmly onto the principle that "paradox is a symptom of misconception."[28] The concepts around which aesthetic theory is organized are inadequate to serve the complex purposes of art.

Most of the dominant ideas, even taken all alone, carry with them some danger of self-defeat. As soon as we develop them we find ourselves with dialectical concepts on our hands. We have Significant Form that must not,

27. See Gadamer, *Truth and Method*, for an excellent account of the timelessness of art generated within the historical location of artists and their works. Gadamer's theory is also a contrast theory—the fusion of horizons he speaks of produces inexhaustible contrasts—but far too restricted in its concern with time and historical distance.

28. Langer, *Feeling and Form*, p. 16.

at any price, be permitted to signify anything—illusion that is highest truth—disciplined spontaneity—concrete ideal structures—impersonal feeling, "pleasure objectified"—and public dreaming.

Nevertheless, we have something more here than inconsistency, for inconsistencies disappear once they have been recognized. The notion of "paradox" reflects the truth that the contradictory notions are both central to the understanding of art: taste and intense emotion; emotion and form; purposeless purposiveness; illusion and reality. Tensions are intrinsic to art. One solution is to look for a theory in whose terms the paradoxical elements are eliminated.

> Where both elements of an obvious antinomy maintain their semblance of truth, their pragmatic virtue, and both can claim to originate in certain accepted premises, the cause of their conflict probably lies in those very premises themselves. It is original sin. The premises, in their turn, are often tacit presuppositions, so that the real challenge to the philosopher is to expose and analyze and correct *them*. If he succeeds, a new scheme of the dominant ideas will be found implicit, without the paradoxical concepts of the old perspective.[29]

There is then the difficulty that it is no longer *art* which we are regarding as paradoxical, but our theories of art.

The question remains as to why paradox is so common in the arts—not only in theoretical formulations, but in the critical literature. It is common for critics to ascribe contradictory elements to a given painting: a Grünewald crucifixion is simultaneously agonized and triumphant. Themes of a contradictory nature constantly recur in the interpretation of literature. Dostoievski achieves some of his most intense effects by directly confronting the reader with paradox.

We may also note here William Empson's emphasis on "ambiguity" in poetry.[30] His position—which is both too sweeping to fit all poetry yet too narrow in its concern with language to fit the visual arts—emphasizes the multiple character of poetic language: that a great variety of heterogeneous emotions, references, and conceptions are simultaneously available in greater poetry. However, the term "ambiguity" is borrowed from assertive discourse, and functions weakly in the arts. Ambiguity is a failure in precision, yet poetic language is often extremely precise in its contrasting significations. Nevertheless, after noting the inadequacies of Empson's terminology and range of concern, we must admit that he has profoundly captured one of the most

29. Ibid., pp. 15, 16.
30. William Empson: *Seven Types of Ambiguity*, New York, New Directions, 1947.

important characteristics of great poetry: its richness and diversity where even incompatible notions are brought together in a poetic phrase or image.

I suggest that in addition to the shortcomings of theories of art which generate paradoxes, there is a feature of art itself that is closely related to paradox. I suggest in addition that the paradoxical character of art rests on an important metaphysical foundation given expression in the ordinal theory: that being is not wholly determinate, but involves an inexhaustible interplay of determinateness and indeterminateness, in complementary relationship. Langer mentions Nietzsche's attempt to mediate within the paradoxes of art by the polarity of order and inspiration.[31] She correctly notes that Apollo and Dionysus are not opposing extremes, for neither negates the other. Feeling and form are complementary. If so, then Nietzsche is not literally paradoxical in this aspect of his theory of art. Rather, feeling and form are contrasting tensions within art, and artistic value resides in their interplay.

We may generally understand the polarities within theories of art as expressions of tensions within works of art. A work is purposeless purposiveness in that it is both something made yet for a reason and to an end, an act as well as a construction. We may imagine that a more adequate theory of purpose would resolve the difficulty; an alternative is that *whatever* end may be postulated for works of art, an artist will invent a work rejecting the norm. In response to Schelling's conception of art as both in and out of time simultaneously, we may look to a more adequate theory of the respects in which art is timeless. Nevertheless, a work is both created at a time and place yet also possesses fundamental traits which are indifferent to its temporal location. All beings with physical embodiments are in time in some respects and out of time in others. Art, however, revels in its temporal tensions. Contrasting tensions are not merely inherent within works of art as they are in other beings, but inhabit their very hearts. Every relevant feature of a work of art is in contrast with other features, in and out of the work, and these contrasts are what the work emphasizes. In this sense art is quasi-paradoxical.

Art is not literally paradoxical any more than poetry is literally ambiguous. There are important and striking differences between the tensions in art and paradoxical assertions, between the richness of poetry and propositional equivocation. Paradox is typically a characteristic of assertions, not works, even works of literature—though because

31. Langer, *Feeling and Form*, p. 17.

it employs language, literature may develop paradoxical theories and express them. Art is the creation of intense contrasts. Both a theory of art and an analysis of a given work are claims about a subject matter, and may be paradoxical. The work is an intense contrast. Art as such is not claiming—though there may be claims within a work of art—nor is it doing; therefore, it is properly neither paradoxical nor ambivalent. Yet the complexity of art is its most important characteristic—a complexity of intense contrasts.

The reason why paradox haunts our theories of art is that art revels in contrast, heightening our awareness of the complementarity of determinateness and indeterminateness. Indeterminateness is a fundamental feature of all orders and all general categories relevant to orders. It is also relevant to all judgments, giving rise to what I have called the mysteries of philosophy and query.[32] Yet such indeterminateness is more a difficulty for science, more an omnipresent and unavoidable source of failure for action. Only in art (and philosophy, in its more systematic forms) is the relationship between determinateness and indeterminateness a primary feature of value.

In quite restricted forms, the theory of contrast has been anticipated by other writers. Arthur Koestler claims that a creative act is *bisociative:* "The bisociative act connects previously unconnected matrices of experience; it makes us 'understand what it is to be awake, to be living on several planes at once.'" In the interaction of two independent matrices or frames of reference, the result "is either a *collision* ending in laughter, or their *fusion* in a new intellectual synthesis, or their confrontation in an aesthetic experience."[33] Koestler's two-dimensional characterization of contrast is too restrictive. An analogous position is found in Max Ernst's description of collage:

> the exploitation of the chance meeting on a non-suitable plane of two mutually distant realities; the pairing of two realities which apparently cannot be paired on a plane apparently not suited to them. Speaking of the collage process in 1920 Breton wrote:
>
>> It is the marvellous capacity to grasp two mutually distant realities without going beyond the field of our experience to draw a spark from the juxtaposition; to bring within reach of our senses abstract forms capable of the same intensity and enhancement as any others;

32. Ross, *Philosophical Mysteries.*
33. Arthur Koestler: *The Act of Creation,* New York, Macmillan, 1964, p. 45.

and, depriving us of any system of reference, to set us at odds without our own memories.

(*Preface to Max Ernst exhibition,* May 1920)[34]

The question, however, is whether there are not *many* realities conjoined within a work of art, levels upon levels of contrasts and their intensities. Only a multidimensional theory of contrast can do justice to the richness of art and artistic inspiration. Such a rich notion of contrast requires the theory of orders, for only that theory offers an inexhaustible richness conjoined with definite limits and boundaries, determinateness conjoined with indeterminateness, as a basis for artistic value.

UNITY AND MULTIPLICITY

No notion is more pervasively recurrent in the literature of art than that of unity. Coleridge defines Beauty as the many become one and extends the notion as follows:

When the whole and the parts are seen at once, as mutually producing and explaining each other, as unity in multiety, there results shapeliness— *forma formosa.* Where the perfection of *form* is combined with pleasurableness in the sensations, excited by the matters or substance so formed, there results the beautiful.

Corollary—Hence colour is eminently subservient to beauty, because it is susceptible of forms, *i.e.* outline, and yet is a sensation. But a rich mass of scarlet clouds, seen without any attention to the *form* of the mass or of the parts, may be a *delightful* but not a beautiful object or colour.

When there is deficiency of unity in the line forming the whole (as angularity, for instance), and of number in the plurality or the parts, there arises the formal.

When the parts are numerous, and impressive, and predominate, so as to prevent or greatly lessen the attention to the whole, there results the grand.

Where the impression of the whole, *i.e.* the sense of unity predominates, so as to abstract the mind from the parts—the majestic.

Where the parts by their harmony produce an effect of a whole, but there is no seen form of a whole producing or explaining the parts, *i.e.* when the parts only are seen and distinguished, but the whole is felt—the picturesque.

34. Max Ernst: "Inspiration to Order," in Brewster Ghiselin: *The Creative Process,* Berkeley, University of California Press, 1952, pp. 66-67.

Where neither whole nor parts, but unity, as boundless or endless allness—the sublime.[35]

We come to an issue of fundamental importance for the theory of contrast as well as for any similar theory of richness in art, but also an unresolved issue of metaphysics: the nature of unity. In traditional philosophic terms, it is the problem of how many can be one, for anything whatsoever, insofar as it is *a* being, is one; yet it is comprised of many components and stands in many relations. Philosophers have dissipated enormous energies seeking simples which are indivisible, beings which are intrinsically unitary. Unfortunately, were we to take atoms as the building blocks of the world, indivisible unities with no parts, we would then find that they were divided in another sense: in being capable of an inexhaustible and indefinite variety of relations, since all complexes are comprised of them. In this functional sense— and there is no other sense of being in an ordinal theory—being is always qualified, and what is unitary or simple in one respect is plural and complex in other respects. Unity and multiplicity are not merely opposing concepts to be conjoined synthetically, but are complementary: every order is unitary in some respects and plural in other respects, and the two are closely interrelated. Every unity is plural in some respects; every plurality is unitary in some respects as *a* plurality. This complementarity is indicated by the relationship between integrity and scope: what an order is unitarily in a given location and its plural ramifications in that location.

To be anything at all is to be *something*, a thing, thus one; yet it is also to be many: to have many parts, to be a part of many things, to be in many relations. Everything is both one and many—in different respects —and there is no multiplicity which is not also unitary in being identifiable as such. A society is *that* society, unitary in that sense. A country is one in its geographical continuity. Most of the time, the precise oneness of a being escapes us, for it is complex and elusive. We confront the historical problem of identity. However, it is not "identity" which concerns us here, what makes an order "the same" in its various relations—though that is an important issue for poetry and music. Rather, we are concerned with the general character of being *an* order, unitary in its various components and relations. Every being is one in the same sense, though unity is considered especially relevant in art.

This issue is of such importance that the entire theory of intense contrast turns on how successfully unity can be defined amidst di-

35. Samuel Taylor Coleridge: *Letters, Conversations and Recollections*, London, Farrah, 1864, pp. 106-107.

versity. A contrast is comprised of diverse, opposing elements or char-acters of a work held closely together. The aesthetic issue is how we are to regard the specific unity of a contrast, given its multiplicity of components, how such a unification can be intense. But the more general issues of unity haunt us, since every being is comprised of dissimilar and contrasting constituents. In effect, every being is a contrast. A red ball is both red and round, and its shape and color are different characteristics. It is a contrast, though not a very intense one.

Everything is an order, what it is. In what sense, then, is *Guernica* more unified than a red ball? I doubt that it is. In what sense is *War and Peace* more of a unity than Spinoza's *Ethics?* I am certain that it is not. Coleridge defines beauty as the many *still seen as many* become one—not a greater unity, but a conformation of unity and multiplicity. Neither unity nor intensity admits of degrees. Nor does complexity in an ordinal theory. Every order is inexhaustible, complex in its relations and its integrities. No order is more of an order than another, nor is any more complex or simpler than another. The fundamental concept here is not unity or simplicity, but *integrity:* the function of an order in a particular location as one order, unitary. Every order has an integrity in being what it is, in being singular. Yet a being may have an integrity in some respects and be a multiplicity in others. Moreover, every order has many integrities, since it is located in many other orders.

A work of art has an integrity, but it is not superior in this respect to anything else, even those beings devoid of artistic value. Humdrum anaesthetic experience has integrity also. This is a truth fatal to Dewey's theory of art as an experience. What then is the force of the claim that a work has a special kind of unity? I suggest two preliminary answers: First, while a work of art is not more unified than other beings, its constituents may be more varied, more opposed, more atypical in human experience. This is partly what intensity of contrast means. The color and shape of a red ball are generally compatible in our experi-ence. A work of art, however, especially a complex and difficult work like *Lear,* is an extraordinary conjunction. A work may be praised for conjoining in one integrity a remarkable variety of elements that can be found in conjunction nowhere else. One dimension of intensity of contrast is being defined here, that attained by interrelating a great diversity of elements, attaining an extraordinary and remarkable con-junction. Part of the singularity of a work of art is being defined also, that pertaining to rarity and achievement. What is needed are theoreti-cal categories defining what is typical and atypical in experience as a basis for aesthetic value. These concepts in the ordinal theory are given by *prevalence* and *deviance*. Nevertheless, they are ordinal concepts,

55

relative to particular orders. A contrast can be intense only relative to certain typical features of an order, based on oppositions determined by that order. The basis for human art must surely be human experience, conceived here not as subjective or personal, but in terms of the two related orders of historical experience in the aggregate and the most typical features of lived experience.

Second, the constituents of a work may be interrelated solely as its constituents, or they may be interconnected in many ways within the work. It is only when diversity among constituents of a work is overcome by complexity of interconnection that it is truly successful. An image in the first canto of a long poem and an image in the next-to-last may have no other relationship than that of belonging to the same poem. But where images are interrelated among themselves and interconnected with other elements of the poem, artistic unity is paramount. There is resonant reenforcement of the integrity of the work by virtue of its diverse constituents. This is surely a large part of what Coleridge means by imagination where "the parts of the meaning—both as regards the ways in which they are apprehended and the modes of combination of their effects in the mind—mutually modify one another."[36] What is involved here is the scope of a gross integrity over many other integrities, the range of an intense contrast throughout the work of art. Again, the relationship between prevalence and deviance is essential.

Many recent theories of art are incomplete theories of contrast, though they conceive of the inexhaustible multiplicity of art in very different ways. Nelson Goodman defines art in terms of syntactic and semantic density, relative repleteness, and multiple and complex reference.[37] Each of these expresses a mode of plurality, even inexhaustibility: of character, referential field, range of relevant references, and ambiguity. However, Goodman does not develop an explanation of how art leads continuously to new and higher levels of multiplicity. He cannot, then, explain why richness and range are aesthetic values. Jacques Derrida expresses the inexhaustibility of text and interpretation in terms of the concepts of *trace* and *differance*,[38] dialectical concepts that contain opposition and reconciliation, but which lack the range and variety of the concept of contrast. He elaborates in great

36. See I. A. Richards: *Coleridge on Imagination*, Bloomington, Indiana University Press, 1969, p. 86.
37. Goodman, *Languages of Art;* see also his *Ways of Worldmaking*, Indianapolis, Hackett, 1978, esp. Chapter IV.
38. Jacques Derrida: *Of Grammatology*, tr. by G. C. Spivak, Baltimore, Johns Hopkins University Press, 1974.

detail the inexhaustible interplay of determinateness and indeterminateness given by language, but restricts his consideration to language alone, and repudiates a theory of the indeterminateness of being, of orders. Far more important, he dwells on indeterminateness, effectively obscuring its complementary relationship with determinateness. The sovereignty of the text vanishes into the morass of its interpretations. In *S/Z*, Roland Barthes develops a matrix mode of analysis in reading which he suggests is analogous to a musical score, with full interaction among the categories and registers.[39] Again, however, the categories are too limited to include the full range of the theory of contrast. Only this theory is able to accommodate the full scope of relevant features and significations of works of art without sacrificing the precision needed for an understanding of individual works. Only an ordinal theory can sustain the full theory of contrast in which being is always functional and complementary and inexhaustibility is an intrinsic characteristic of every work of art.

39. Roland Barthes: *S/Z*, New York, Hill & Wang, 1974.

The Theory of Contrast

Our theory of art must provide answers to two fundamental questions: (1) How is creation possible and how is it to be understood? (2) What is the nature of intensity of contrast? The two questions are closely related and demand a single theory that can provide answers to both of them. What is required is a theory of possibility in relation to actuality and a theory of variation in relation to conformation. In my view, an ordinal theory provides the most effective foundation for both possibility and variation, and I have indicated in earlier discussions how the most important traditional issues in the theory of art lead to both ordinality and intensity of contrast. Ultimately, the value of art is that it manifests inexhaustibility, by enhancement and revelation. Our appreciation of artistic value is a response to inexhaustibility, to a sovereignty achieved through the contrasting interplay of determinateness and indeterminateness. Inexhaustibility can be understood and expressed satisfactorily only by means of an ordinal theory: it leads directly to ordinality. Nevertheless, the theory of contrast can be treated to some extent independent of its metaphysical foundations. Intensity of contrast, I am arguing, is the basis for art and aesthetic value, however one conceives the precise nature of intense contrast. Nevertheless, the richness of contrasts and their reflexivity, the inexhaustibility of levels of contrast, the infinite and reflexive illusoriness of art, all demand a metaphysical foundation which I believe can be provided only by an ordinal theory. I will now sketch the general features of an ordinal theory, establishing the foundations of the theory of contrast. I will explain the precise characteristics and nature of intensity of contrast in the latter half of the chapter.

THE ORDINAL THEORY

Every work of art and every art, theory, mathematical system, and physical object—in short, every being whatsoever—is comprised of

constituents. They constitute it *an order*—*that* order of *those* constituents. To be is to be an order of constituents and to be a constituent of an order. To be, here, is to be *relevant,* for whatever is relevant to an order is one of its constituents. An order is a sphere of relevance. It follows that constituents and orders are not simply parts and wholes. Socrates defines justice as a part of virtue. In the ordinal theory, virtue is a constituent of justice in being the larger class of which justice is a manifestation, while justice is a constituent of virtue in being one of its fundamental forms. Justice and virtue are relevant to and constitutive of each other.

The richness and scope of works of art, the inexhaustibility of relevance in the greatest masterpieces, testifies to the inexhaustibility and complexity of orders, the relevance of constituents over an indefinite range of diversity and variation to any particular order. Not only the words, but the events and characters, their passions and thoughts, are relevant to *The Brothers Karamazov,* as are matters of feeling, justice, virtue, and love. Art strongly exhibits the inexhaustible range of relevance of orders as well as the indeterminateness inherent in all determinations. Nevertheless, it exhibits equally strongly the determinateness inherent in all indeterminateness, the complementarity of limitation and openness which is definitive of inexhaustibility.

To be is to be an order of constituents and thereby a constituent of other orders. Conversely, it is to be a constituent of an order and thereby to have constituents. Relevance here is functionally triadic: every order locates its constituents and is located as a constituent in other orders, and the ordinal locations involved are interrelated. The order-constituent relation is an ordinal articulation of the concept of being, as is every pair of ordinal categories. The being of a work of art, along with that of every order, is given by the ways in which its constituents function within it and in which it functions as a constituent in other orders. There is no other sense of being except this functional one, but there are many different ways in which an order functions in relation to other orders. Being here is elliptical for being-an-order, being-a-constituent, being-a-prevalence, being-a-deviance, etc. These are all fundamental senses of being, none more fundamental than the others. There is no general sense of Being different from the being of every order, but there are many equally general and fundamental senses of being, each different in certain ways from any of the others, though related to them. This is a primary source of inexhaustibility.

Whatever is discriminated is an order. The converse, however, is false: there are orders which may never be discriminated. The concept

59

of order is far wider than that of discrimination, experience, or perspective (an order in human experience). In this sense, the ordinal theory is ontological, a general theory of being (ordinality) inclusive of but not restricted to human understanding and experience. Whether there are orders which cannot be discriminated will not be considered here. The sense of impossibility involved is obscure. There are orders human beings cannot discriminate, for they are too remote from our time and place in things. No other relevant sense of possibility would seem to be intelligible. Nevertheless, there cannot be an order which does not "exist"—which is located in no order—since it would then be an order yet not an order. The relevant question is, what *kind* of order is it? What is it relevant to, and what is relevant to it? The answer is given by its constituents and by the orders of which it is a constituent. Every order is relational in possessing constituents and in being a constituent of other orders. Nothing is "in itself." Nothing is without qualification.

So general a theory of relationality is essential to an adequate theory of art. Great works of art inhabit remarkably far-reaching and changeable spheres of relevance. The monuments of literature—*The Divine Comedy, King Lear*—seem relevant to any time, any place, over an extraordinary range of events and passions, in an enormous variety of ways. Moreover, the kinds of relevance change with human experience, as we find in *Hamlet* traces of Freud, in the *Iliad* traces of bicamerality. Art cannot be understood without a rich and detailed theory of the inexhaustibility of our experience and our surroundings.

The theory of contrast is fundamentally a relational theory. It is essential to contrasts, however, that there is unitariness as well as plurality of relevance and that the two are complementarily related. Unitariness is a function of constituents; constituency is a function of the integrity of relevant orders. The ordinal theory is the only metaphysical theory known to us in which this close functional complementarity is thoroughly sustained. It is needed, therefore, to sustain the uniqueness and sovereignty of works of art in the context of their shared features and relational constituents.

Consider a song, a poem set to music. If the poem has a being "in itself," the song will violate it. If the song "fulfills" the poem, then the poem is incomplete without the music. Were a work of art to possess the self-sufficiency and self-absorption that are often ascribed to such works, it would be unavailable for assimilation, unsuitable employed as a constituent of another work, and unsusceptible to multiple interpretations. Any theory of the work itself forces upon us the conclusion that the better a poem in itself, the less suitable it is for a musical setting.

Likewise, either the music is a setting for the poem, or it is complete in itself. How then may a song be the basis of a string quartet? The notion of a self-sufficient work is anathema to all complex contrasts, to all novel interpretations of a work, and to all criticism. It is also metaphysically indefensible. The sovereignty of a work of art is essential to it, but only where it is a function of the relations and constituents of the work and where these are variable with location and context.

A painting may be regarded as an array of paints upon a canvas. It may also be a still life representing a bottle and two pears. The painting *is* comprised of canvas and paints. It *is* a painting of a bottle and pears. It *is* an example of the artist's early period. It *is* an influence upon later art. And so forth. In every case, the painting is located in an inclusive order and its constituents relevant *for* that order. I call the unitary and specific role an order plays in a particular location its *integrity* within that order. Every order has many integrities, for it is multiply located. Some of its constituents belong to and define such an integrity—belong to it, that is, insofar as it plays a particular role in a particular location. Every order also possesses a *scope* consisting of the other orders to which it is relevant in the order including them. In this sense, an order has an integrity comprised of some of its constituents within a super-altern order; it also has a scope comprised of those other constituents of the superaltern order of which it is a constituent. Integrity and scope together define an order as a sphere of relevance with subaltern constituents located in a superaltern order. If we, in an extreme of austerity, were to define a painting entirely in terms of paints arranged on canvas, its integrity would be given by its materials. The scope of the painting within human life would then include its influences, period, and representations, probably even its subject matter. On the other hand, to a sensitive observer a painting is more likely to possess an integrity comprising its content, forms, and ambiance, even its mood, while its scope for such an observer would include his specific responses varying with circumstances. Some integrities are functions of how a work is interpreted; others are functions of spheres of relevance not wedded so closely to specific interpretations—for example, a work in a historical context as contrasted with its integrity in a given exhibition.

Every order has many integrities insofar as it is located within many other orders. What is it "in itself"? Nothing in itself. What is it *altogether*? Nothing altogether. If it has an identity within and among its many integrities, we may speak of an order within and among them. We may do so, however, only within an order more comprehensive in relevant respects than those considered. A sum of integrities is an

61

integrity within a superaltern order. And there is never a total integrity for an order, fully circumscribing it and exhausting it, not even an open-ended and cumulative one. Orders are complex and inexhaustible. This is a central principle of an ordinal theory. No interpretation and critical analysis could tell us *all* that a great work means or might mean. It surpasses any telling, especially as the future brings new relations for it. And the new relations of great works—as well as new developments in the artistic future—change the characters of second-rate and minor works, whose integrities are also inexhaustible. A lost minor painting may be unearthed and discovered to be an incomplete precursor of an important later development. The expansion of artistic imagination, as well as the future of mankind, will create new arenas within which past works of art will play different roles.

Whatever is is an order; every order is an order. Does this mean that everything *is*? The ambiguity of this question haunts philosophy. Are there winged horses, Olympian gods? Indeed, they are figments of the imagination, mythical creatures. They can be analyzed and understood; they are efficacious and may be manipulated; they are relevant to other orders as those orders are relevant to them. Can anything then fail to be? There are no beings which are not orders, nor orders which are not beings. Nevertheless, not all orders are actualities: some are possibilities. Not all orders are important: some are trivial. An ordinal ontology does not commit us to a timeless realm of essences—for there are no timeless essences. There is nothing timeless in all respects. A consequence is that unrestricted application of the word "everything" is meaningless. There is only *everything within a specified order*.

The question is not of being but of *kind:* orders are often mistakenly conceived, either assigned the wrong constituents or placed incorrectly within orders. Once discriminated, an order prevails—though difficult questions may remain concerning its nature and location. We expand Plato's discovery that not to be is not nothingness but misplacement: not to be in one order is to be in another. And what is no order cannot be spoken of. Nevertheless, many orders are spoken of whose integrity is mainly that of words—even when their scope is of great forcefulness in human lives.

For the arts, whatever can be discriminated is an order: Hamlet, Elsinore, the constructed space of a painting, the relational orders of musical events in Beethoven's *Grosse Fugue*, tonality, even beauty and feeling. Whatever is relevant to a work of art is a constituent within it and an order itself of relevant constituents. But art includes as relevant an inexhaustible range of orders and constituents, drawn from everywhere in human experience, including orders yet to emerge. This

inexhaustibility of art is a manifestation of the inexhaustibility of every order, emphasized in art through intensity of contrast. Nevertheless, inexhaustibility is not unlimited indeterminateness. Every order has limits and boundaries, orders to which it is irrelevant.

The task remains, therefore, of elucidating the orders specifically relevant to art—and it is the province of criticism and analysis more than philosophy to provide this. Some traits are public, discriminable by all who look carefully into art. Others are private and idiosyncratic, apprehendable only by a few. A theory of interpretation is required which recognizes the insularity of many powerful responses to art. Some constituents of a work belong to it only relative to one person's experience. Nevertheless, one man's meat *is* all too often another's poison, and we may discriminate constituents of works of art not only as they function in one person's experience, but among the experiences of members of a society or enduring human experience. Important interpretive criticism does not so much define a work for all time as it illustrates the work for many human beings in its enduring traits. Nevertheless, all discrimination is the judgment of orders, giving their constituents and locating them in other orders.

In a sufficiently broad sense, nature includes art, and all novelty belongs to the creative processes of nature. Yet our experience fails to indicate that there is but one such process, all-encompassing, but rather, displays many processes, intersecting in complex ways, productive of novel orders in their concurrences. All creation belongs to nature—except that nature is no order, and no order encompasses all beings, especially all inventions. An all-encompassing order could have no location and could have no limits. It could not then be an order. Irrelevance is essential to the limits and determinateness of orders. There is always more in heaven and earth than we may know of in any philosophy. This is not a consequence of man's finitude, as if an infinite being could comprehend all things, but a denial that total comprehensiveness is intelligible. The powers of the artistic imagination, both its inventiveness and its inclusiveness, testify to the relativity but also the limitations of every order, so that new forms of inclusiveness are constantly being engendered, but no total inclusiveness is possible or intelligible.

An important claim about works of art is that they unify their composite elements. This unification is held to be an essential component of artistic sovereignty. I will return to the question of whether a work of art manifests a special and definite unity, and whether the sovereignty of works of art—essential to any adequate theory of art— depends on such a unification. From a theoretical perspective, how-

ever, every order is one in being *an* order, in possessing an integrity. But how in an ordinal theory may we say that *an* order belongs as a constituent to *many* other orders, since its integrity differs in every case? The answer is the fundamental reply to all forms of extreme relativism. There are connections and relations among orders. A statue has different appearances in an indefinite number of visual orders, depending on the angle from which it is viewed. Yet they are related perspectives, interconnected by the laws of optics. Were there no interrelations of visual perspectives relative to a given work, it would be difficult to regard it as individual or singular. So also, where a poem is used as the text for a song, the qualities of the song and of the poem read separately may be quite different, but if they are not interrelated in some important ways, the double function would be unintelligible. Where there is too great a disparity, we criticize the song for violating the poem. On the other hand, the difference between violating a poem and being in intense contrast with it is frequently difficult to delineate, and we may find ourselves confronting the subtle problem of the aesthetic unity of a rich and complex work.

However, ontological unity is more intelligible. We have an order with integrities in several superaltern orders. These orders are interconnected: sometimes they are mutually constitutive, sometimes they have common constituents. These interrelations are the foundation of ontological identity—one order with different integrities in different locations. Consider any example of transitive relations. A theme is part of a movement which is part of a symphony. The relation "part of" here makes the theme "the same" in both the movement and the symphony—though its qualities may differ somewhat in the movement heard alone. *Because* several orders are interconnected, a given constituent of one is a constituent within another. In a transitive relation of constituency—*A* constitutive of *B*, *B* constitutive of *C*, *A* constitutive of *C*—*A* belongs both to *B* and *C*. In some cases, depending on the particular relations involved, a given order (constituent) is the same in its role in different orders because of the specific relations among the orders involved.

This answer will not altogether suffice, for were an order always "the same" in all its relations, then orders would be comprehensively interconnected and exhaustible. The universe would comprise a total order and every being would have a determinate location. Like ordinality, identity is a qualified, functional notion. Often, the only way an order is the same in its many relations is where a functional identity is preserved: sometimes a common element of form, sometimes only continuity amidst diversity. The identity of an order—as distinct from

64

its many integrities—is often simply a functional interrelation among various integrities and orders located together in a more inclusive order such as human experience, a given science, a spatiotemporal region, or important proximate concerns. The identity is provided by the constraints of the superaltern order. There may be no common constituents belonging to all members of a family, simply a sufficient likeness or continuity of likenesses to satisfy the conditions imposed by the inclusive order. Where an order functions unitarily, over a range of subaltern locations, it "is" one. That is the only meaning of identity.

The integrity of an order is a triadic relation: constituents C_i belong to the integrity of order B in its role in a superaltern order A. Identity is a quadratic relation: constituents D_j belong to the integrities C_i of superaltern orders B_k. Where the many integrities C_i play a role together in a gross superaltern order A including the B_k's, we have a gross integrity C including the C_i's. The identity of an order is an integrity, but a gross integrity of many distinct integrities functioning as one within a superaltern order. In no other sense—and especially no unqualified sense—is an order identical throughout many roles and locations.

A work of sculpture manifests different appearances in its varied visual perspectives, and no common element of form may be preserved among all or even many of them. Yet there is a spatial and visual continuity which affords a principle of identity. It is because all the visual perspectives express a functional integrity of wide scope that identity in such cases is unproblematical. On the other hand, a particular perspective is sometimes claimed to be essential to a work of art—a particular seat in the hall, a particular point of illusion. A musical composition is never performed the same way twice, and there is no common element of form throughout all its performances. Nor, properly speaking, is there strict continuity, but rather, a close similarity of forms that accommodates the functional identification of an individual work. A truly bizarre performance might be considered aberrant— "another" work having little in common with the established work— even where all the notes were played correctly. A gross superaltern order—for example, music history as contrasted with distinct performances—must be the basis for a judgment of identity. No order is simply *the same*, without qualification, in all its locations and integrities.

These considerations are relevant to the complex and annoying problem of the identity of a work of art. Often normative criteria are employed in denying something to be a work of art: it is not good enough, not sufficiently creative, original, or expressive. Putting aside such considerations, and accepting the existence of mediocre and even

atrocious works of art, we note that poems are often translated into other languages with varying success. Do we then have the same or a different poem? What is the relationship between a drama and its text, or between two varied, even diversely edited performances? Are different interpretations different works? Does transposing a song to a different key change it into a different song? What of using modern instruments instead of ancient instruments to perform baroque music? What of using different music for a dance in different performances? There is no single criterion of identity applicable to all these different cases except the very general, functional, and ordinal criterion given above.[1]

The identity of works of art is particularly problematical. There are performing arts whose works are given different interpretations and plastic arts with singular works. Individual masterpieces are given diverse interpretations by different audiences and understood in many different ways by different cultures and generations. Works of art are used and abused in many ways, truncated and combined with other works in diverse and unexpected ways, all producing different integrities.

The identity of a work of art has no single criterion—and that is as it should be. Often we are concerned with a particular integrity of a work, not with its identity—for example, whether a musical transposition violates a work. In such a case, we are concerned with whether a change of key changes something else of vital importance within the work. In other cases, we may be concerned with the functional unitariness of a work from order to order: how a poem is affected by different translations; how different performances of a play are relevant to each other.

The identity of works of art is not more elusive than the integrities of many other orders—persons, nations, social theories, a mansion undergoing restoration. The difference is that works of art revel in their plurality, manifest their inexhaustibility. They confront us with variation and discontinuity among their different integrities, obscuring their identity. Our responses to them are equally diverse: they are conceived in different ways by different audiences and have different meanings in different cultures. Even more important, their richness and complexity make them relevant to a great variety of orders, many of which are otherwise typically unrelated. *Doctor Faustus,* for example,

1. Goodman's notational criteria for musical and dramatic works and literary texts, in *Languages of Art*, are far too limited to be applied to diverse translations, adaptations, and editions of such works. The reason for this is that Goodman's criteria are non-functional though the general theory in *Ways of Worldmaking* ought to lead to a functional theory of identity.

addresses history, music, science, and myth among its other concerns: its integrity relative to any of them is significantly different from its integrity relative to others. Nothing is in itself; no order simply is what it is. Neither is any work of art. It possesses that identity or integrity that enables it to function as a unitary constituent of a significantly comprehensive order within human experience.

The general theory of orders requires expression in specific categories and principles. I have briefly considered the categories of integrity and scope. I will now consider two additional pairs of categories which define ways in which constituents may belong to their orders. These are essential to an adequate theory of art and aesthetic value.

PREVALENCE AND DEVIANCE

Categories adequate to invention and creation are necessary for a theory of art. We must accommodate the becoming of orders novel in some respect and relative to given conditions. However, there are important deviations in art unrelated to time and becoming. Novelty is less germane than departure. The more general notion is therefore of a constituent *deviant within an order*. The negative integers begin with the number -1 which is deviant relative to the positive integers. The third chapter of a novel may begin a new development whether or not the novel is read in sequential order. The central notion is of a variation in integrity over a range of locations within an order, a deviance in the unitary function of a constituent of an order, its atypicality relative to some orders in contrast with its integrities in other orders.

Becoming is a limited category, emphasizing only temporal departures, while there are beginnings, changes, and deviations which are not historical or temporal. If there were a largest prime number, then at that point there would begin an infinite sequence of numbers none of which is prime. This is no temporal beginning, no becoming, but it is a novelty within the sequence of integers. It is a *deviance* within the order of integers relative to the order of primes. Constituents which are not deviant in this sense relative to certain constituents in an order are *prevalent*.[2] Prevalence reflects conformation, deviance variation. What prevails is typical over a range of constituents; what deviates is atypical. A constituent prevails where it possesses a gross integrity over a range of subaltern integrities and ordinal locations; a con-

2. See Buchler, *Metaphysics of Natural Complexes*, Chapter II, and my *Transition to an Ordinal Metaphysics*, Chapter V; see also the discussion in the Introduction above, pp. xi-xii.

stituent is deviant where its gross integrity is discontinuous with subaltern integrities over a particular range of ordinal locations. It follows that a constituent cannot be prevalent and deviant in the same respect, relative to the same constituents. However, a deviant constituent must be typical in some range, and is therefore prevalent somewhere. Conversely, since there is no gross integrity of an order which exhausts its diverse integrities, every order must be deviant somewhere. The incipient phases of a culture give way to its dominance over many years; the negative integers, beginning with the number -1, prevail within the number system. Conversely, there is modular arithmetic in which the integrities of ordinary numbers are transformed relative to the infinite sequence of integers. Deviance reflects disparity among an order and certain of its subaltern orders. Prevalence reflects dominance throughout an order and certain of its subaltern orders. Properly speaking, a constituent prevails or deviates within an order only relative to certain specified subaltern orders—different orders in each case.

It follows that there can be no constituent of an order deviant in all respects, including that of belonging to the order. A complete novelty would belong to no order and would therefore be deviant in none. Invention is always relative to some order—if only the artist's own experience. No invention can be totally new, deviant in all orders and respects. Inventions for contrast need not be new within all experience, but may be novelties within a given mode or style. What is new in actuality arises from possibilities. What is new as a possibility emerges from prior conditions and is partly continuous with them. Deviances are dependent on ordinal prevalences.

I have had occasion to note Buchler's conception of what is intrinsic to poetry:

> It is closely related to poetry's sense of ontological parity, but it should be formulated independently. We shall describe it as an emphasis upon the *prevalence* of what is, and consequently as communicating a *sense* of prevalence.[3]

Many questions can be raised concerning the "sense of prevalence": for example, how a *sense* of prevalence is distinguished from knowledge *about* it; in what way scientific knowledge of what prevails is different from a sense of what prevails. Action profoundly reflects a sense of what must be taken into account and responded to through manipulation and control. Philosophy conveys a remarkable sense of what gen-

3. Buchler, *The Main of Light*, pp. 129-30. See above, p. 11.

erally prevails. To convey a sense of prevalence does not seem to be a distinguishing characteristic of poetry.

There are related difficulties. Why is it unique to *poetry* to convey a sense of prevalence? Do not paintings convey a sense of visual prevalence? Cannot every art convey a sense of prevalence in its own way? In addition, what of deviance?[4] Consider Buchler's example:

> The poetic shaping of a complex discriminates the aspect of finality in that complex. It exhibits the complex as a finality. It conveys the sense of prevalence.

> Those ships which left
> Side by side
> The same harbor
> Towards an unknown destination
> Have rowed away from one another.[5]

The sense of this poem is at least as strongly that there is separation as that there is participation. Now all prevalences are deviances and all deviances are prevalences—relative to different locations.[6] If a poem conveys a sense of prevalence, it may also convey a sense of deviance. Art can engender contrasts which emphasize deviance as much as prevalence—and of necessity most promote *both* deviance and prevalence. According to the theory of contrast, prevalence and deviance are of aesthetic value only in conjunction, in intense contrast. Prevalence and deviance *together,* then, are the aesthetic value.

Of paramount importance for art are deviances which are not temporal, not becomings: the place on a canvas where a line begins or ends; the shape and boundary of a region; the beginning of a thematic development; the appearance of a character on stage; the first time a character in a novel uses a certain phrase or experiences deep sorrow; the initiation of a recurrent motif in visual, spatial, or literary terms; and so forth. While the term "invention" suggests temporal novelty, artistic contrasts depend greatly on nontemporal deviances. A musical invention is less a temporal change than a variation within the themes of a work. Transformations in musical development are structural deviances relative to the stated theme as well as temporal novelties relative to what came before.

4. Buchler's word is "alescence."

5. Buchler, *The Main of Light,* pp. 131-32. Poem by Saigyō Hōshi, translated by Arthur Waley, *Japanese Poetry: The Uta,* London, Lund Humphries, 1919.

6. Buchler holds only the latter principle and denies the former. See my discussion in *Transition to an Ordinal Metaphysics,* Chapter V.

We may emphasize also the endurance of greater works of art through many generations of audiences. Such a work takes on diverse emotional qualities, lends itself to variant interpretations, admits of differences in response, criticism, interpretation, and analysis. Such differences are not simply changes. Different interpretations and emotional responses can coexist as powers of the work, different from each other but prevailing collectively in the scope of the work. It is not becoming which is significant here, but the mutual prevalence of a wide range of deviant possibilities. A new interpretation arises temporally within history, but it is deviant for the work as a contrast to which time may be irrelevant.

The typical characteristics of an order prevail within that order, restrictive in their conformation. Even changes and beginnings are prevalences in appropriate orders: waves prevail in the ocean, though a single tidal wave is deviant relative to the others. Cycles may be prevalent; processes prevail. Within such complex developments, there are deviant initiations. Consider now a contrast as a union of differences. The constituents of the contrast must remain deviant with respect to each other though mutually prevalent in other respects. The interplay of prevalences within a work and deviances among its constituents is the foundation of intensity of contrast.

The artistic value of a work of art resides in what we take to be exceptional about it in contrast with everything else of relevance. The notion of salient significance, of extraordinariness and noteworthiness, involves both prevalence and deviance. The sovereignty and incomparability of a work of art are the result of a contrast of prevalences amidst deviances. Whatever is thought noteworthy in a work is regarded as deviant relative to other works and experiences, though noteworthy only in relation to certain important prevalences. The created work is a deviance relative to the order of typical human experience—thereafter, however, prevalent within experience and art. The freshness or spontaneity of a great work of art—if interpreted as belonging to the work rather than its creator—is an enduring quality of uniqueness and extraordinariness, a prevalence in intense contrast with typical and variable experience. Freshness and spontaneity—indeed, all artistic values—are prevailing deviances. Intensity of contrast is the interplay of typicality and atypicality, variation and conformation. The interplay of prevalence and deviance is the foundation of aesthetic value.

Every prevalence is deviant somewhere; every deviance prevails somewhere. In this general sense of prevalent deviance, everything may be taken to possess aesthetic value. This is the basis for the

possibility that anything may be found to have, or given, aesthetic value. Nevertheless, the disconnection of the orders in which a given natural object prevails and deviates may inhibit intensity of contrast. In a great work of art, the wealth, interplay, and intensity of prevailing deviances is the basis of its supreme value.

Even where a contrast is relatively simple in certain respects—two fields of color juxtaposed—each color is deviant relative to the other, sharply contrasting at their boundary, both colors prevalent within the painting. Where one musical theme is followed by another, the second is deviant relative to the first. A variation is deviant relative to the theme. A harmonic transposition is deviant relative to prior harmonies. All these deviances prevail within the work as well as within the sensibilities of human beings. Yet they are all deviant with respect to other constituents of the work. This is in part what contrast means. A character enters a novel and thereafter prevails. An intellectual theme is explored within concrete events and prevails in diverse forms within the work. A metaphor is the juxtaposition of different images, jointly prevalent within the poem, yet each deviant relative to the other as well as within common usage. Once a linguistic form prevails commonly, its artistic function becomes trite. Summarizing these different examples, we may say that the entire theory of contrast turns on the concept of prevalent deviance. A necessary condition of contrast is that its elements prevail within some orders together, while they are either deviant with respect to each other or jointly deviant within some orders of human experience. Prevalent deviance is not simply sameness conjoined with difference, but the inexhaustible interplay of typicality and atypicality in different but relevant respects relative to the sovereign integrity of a particular order.

POSSIBILITY AND ACTUALITY

Prevalence and deviance are the foundation of contrasts: possibility and actuality are fundamental to the inexhaustibility of art including the relations of a work of art to its interpretations. Everything that is actual within a work of art possesses a wealth of diverse possibilities—including those which depend on interpretation and response. Such possibilities depend on the functioning of a work among diverse orders and conditions. As conditions change, possibilities change also, and of possibilities which come to prevail, some may become actual, others may not. Any order possesses both actual and possible constituents—more accurately, some of the constituents of every order are actualities, others are possibilities within that order.

71

Since Hume, philosophers have found the concept of possibility elusive, the concept of logical possibility alone intelligible. Yet logical possibilities are virtually unrestricted in their relations except for their dependence on discourse. Logical possibilities and contradictions flow from discourse, not from ordinal conditions generally. Ordinal possibilities represent the conditions of orders at their boundaries, alternatives engendered by the concurrence of interconnected but distinct spheres of relevance. On a Humean view, it is a logical possibility that a bachelor might fly away, though not that he be married. Yet a physical object may not fly against the laws of nature (*its* nature). How logical possibilities may be related to possibilities of imagination or interpretation is a subject hopeless of illumination. Logical possibilities of themselves provide no aesthetic value; yet the discernment of possibilities within a medium or in perception is fundamental to artistic insight.

Three conditions are the basis for distinguishing possibilities from actualities. In any order, some of the constituents are what Aristotle calls "logical subjects": they are the actualities which possess possibilities in that order. Aristotle grants such actualities primary being. It is unnecessary to make such a concession. Nevertheless, actualities may be distinguished without ontological priority on the basis of Aristotle's approach. In this sense a possibility belongs to an actuality within an order. In the order of sensitive response to art, a painting may move us. In the order of physical particles, energy and forces, no possibility of such emotional impact resides. Within a given musical tradition, certain possibilities of harmonic development prevail—thereby defining an observer's expectations. The actualization of some of these fulfills our expectations; the actualization of others surprises us. In all cases, possibilities belong to actualities: harmonic resolutions belong to developments; the ending of a mystery novel belongs to the succession of literary events; the ways in which a stone may be shaped are a function of its materials as well as the instruments available. No ending can be determined in all its characteristics from prior events; no ending can be actual relative to a narrative sequence. The greater the necessity, the more compelling may be the narrative—or, alternatively, the more predictable may it be.

The three distinguishing characteristics of possibilities and actualities may be stated: (a) Within a given order, possibilities are *of* and *for* actualities. (b) Within a given order, possibilities are always multiple for any actuality. (c) Within a given order, actualities must be logically compatible, but contradictory possibilities may prevail together within the same order. Though not a distinguishing condition of actualities

and possibilities, an additional principle may be mentioned: (d) Possibilities prevail in every order. Condition (c) taken alone leads to logical possibilities: everything which is logically compatible with an actuality is a possibility for it. The remaining conditions define a more restrictive conception. In particular, condition (a) establishes a strong sense of possession: possibilities are specifically *of* certain actualities within a definite order. Technically, this means that the relevant actualities must belong to the integrities of their possibilities, but not conversely. It is no power of bread to fly, to change into a butterfly, even to be poisonous insofar as bread is a food. A work of art too, as well as its various constituents, has genuine and efficacious powers, possibilities of response and of combination. Without a theory of real— that is, efficacious—powers, the nature and limitations of artistic mediums cannot be accommodated. An artist does not sever himself from constraints to be inventive, but develops available possibilities while at the same time establishing new possibilities relevant within his conditions. The theory of logical possibility is too often countered by too strict a theory of causality, neither theory faithful to the arts.

Condition (a) entails that a work of art cannot be regarded "in itself" but always within some order. A work is no different in this respect from any other being. Nothing is in itself. There is an indefinite number of orders, and no all-encompassing order. Any work possesses multiple possibilities which differ from order to order—society to society, individual to individual—and which are dependent on the mode of judgment assigned to the work in interpretation: constructive, active, or assertive. Since there is an indefinite number of orders relative to any given being, an indefinite number of possibilities is relevant to any work of art. A work is an actuality, but all actualities have powers whose nature depends on the orders of which they are constituents. A work is nothing "in itself" relative to its multiplicity of powers, but is multiple with respect to its many possibilities. Nevertheless, its multiplicity of possibilities in no way undermines its integrity, for it can have its integrity only by virtue of *its* many possibilities. Moreover, though possibilities may vary with ordinal location, they may also remain constant throughout a range of different locations. It is again the specific interplay of prevalence and deviance, over a range of different ordinal locations, which is the basis of artistic value, manifesting inexhaustibility through the interplay of actualities and possibilities.

The asymmetry between actualities and possibilities is fundamental. Possibilities belong to actualities; actualities do not belong to possibilities in the same sense. In a given order, possibilities prevail as powers of

prevailing actualities. Where possibilities appear to have actual constituents, a subtle shift of order has been involved. Given certain weather conditions, rain is a distinct possibility. Rain is also actually wet. But possible rain is not actually wet. Wetness is an actual trait of actual rain. Wetness is as much a possibility relative to the conditions as is the rain—and the same for any actual traits of rain. In this sense, possibilities reside in actual constituents and not the reverse. Nevertheless, possibilities and actualities are only functionally distinct, depending on ordinal location.

Condition (b) is a consequence of the principle that there is no all-encompassing order, that orders are indefinitely complex. The principle of the inexhaustibility of orders is given direct expression by this criterion of possibility. Alternatives are generated by the interconnection of orders, none of which is self-contained. This is of utmost importance to art, for works of art generate contrasts from such possibilities. If only one possibility belonged to a given work in a given order, much of the haunting mystery and freshness of art would vanish. All contrasts would be trite once experienced fully. The sense we have that artists draw inspiration from a wide range of experiences, bringing them together within a novel work, reflects the condition that intersecting orders generate multiple possibilities. Art is here the supreme revelation of multiplicity within the orders of human experience.

Finally, (c) is the condition whereby a multiplicity of contrasting possibilities can be united in actuality—a unity essential to the concept of contrast. While possibilities may be multiple and logically incompatible, the actual work—or any part of it—must be consistent with itself. Every work possesses contrasting constituents—and these include its many possibilities. A work which is consistent in one order—an interpretation or performance—may be wildly inconsistent in another. This is why difficult works can be magnificent creations in one performance and altogether chaotic in another.

Actualities must be logically compatible in an order while possibilities are plural and incompatible. Yet whatever is possible in one location is actual in another (and conversely). It is possible that Hamlet will kill his uncle while praying, but he actually does not and the killing (and non-killing) are jointly relevant as actualities within interpretations of the play. This dual nature of actualities and possibilities in works of art is essential to many of their most important contrasts, since the plurality of possibilities contrasts sharply with the restrictiveness of relevant actualities. Interpretation of works of art depends on actualities in relation to possibilities, the latter providing a richness and diversity to interpretations that is incorporated within the integrity of enduring

74

works in their relevance to different audiences and in different periods of art.

The prevalence of both actualities and possibilities in a work of art permits us to say, somewhat incoherently, but expressive of a profound truth, that a rich work is a created *world*. Such a work is the creation of a new order—not novel in all its constituents, which would be impossible and absurd, but in many of its possibilities and actualities, relations and qualities. The integrity of this order, in its complexity and prevalence, is the basis of the sovereignty of the work of art. Its scope and possibilities manifest its inexhaustibility. The conjunction of breadth of possibility and coherence of actuality makes of such a work a comprehensive order rivalling any other within human experience. Even a representational painting of pears and bowl on a table can afford so wide a range of perceptual responses as possibilities for such objects as to transform all other ways of apprehending ordinary objects. The space of the painting reflects upon and transforms ordinary visual space. The various objects within the work stand in deviant possible and actual relations as contrasted with what is commonplace. The sense in which a fine work of art is the creation of a new world, however limited and modest, is that of actualities intersecting inexhaustibly with possibilities. An ordinal theory rejects the intelligibility of any world order, of any order inclusive of all other orders. There are, then, inexhaustibly many, inexhaustibly rich, comprehensive orders, interconnecting in complex and varied ways. Such comprehensive orders are the only worlds we will ever know.[7] In some arts—music, for example—new actualities are created, arrangements and sequences of sounds, rhythms, and tensions, as well as possibilities inherent in perceptual expectations as well as in response and interpretation. A rich order of possibilities and actualities is a "world" in this sense.

Nothing is simpler than to create a new order, for every order is new in some respect. Every creation is new in some respect. Anyone could invent a new word, a new number, if only by writing out a sufficient number of ciphers. Creative construction is the simplest act of which a person is capable, and sheer novelty has little value. Yet artistic originality is extremely difficult to attain, a rare achievement. A work of art is not

7. See Goodman, *Ways of Worldmaking*. Although Goodman speaks of many ways of making worlds, he rejects the metaphysical mode of discourse and denies that we can speak of worlds. We can speak only of world-versions. A major difficulty is that he offers no criteria for determining when a version is a *world*-version, since there are no criteria establishing a world as such. A major difference in our views is that Goodman treats the work of art as a symbol which may thereby be a world-version. I suggest that rich and complex works *are* effectively worlds themselves: comprehensive orders whose depths are worth plumbing as well as judgments inexhaustibly relevant to other orders.

simply a new order, but an order rich and intense in its contrasts, requiring novelty to attain them. Invention is a dimension of contrast, but not all originality contributes to the intensity of contrasts. Some new orders may be relatively devoid of interesting possibilities—a nonsense word of four hundred and eighty three letters, for example. Fine art is achieved when orders justify their creation by their celebrative qualities and their excellences—by their intensity of contrast, engendering a plurality of possibilities.

It behooves us, then, to carry the analysis of intensity of contrast two steps further: to reexamine the relation between constructive judgment and intensity of contrast, and to provide a more precise definition of contrast in terms of the ordinal categories, explaining how a contrast may be intense and how it manifests inexhaustibility. I will begin with the second of these concerns.

ORDINALITY AND INTENSITY OF CONTRAST

We return to the question of the unitariness of a work of art. A contrast is the unification within one order of constituents which are significantly different from each other. Yet it is not enough to have differences: all beings are different from each other in some respects. The problem is how incompatible beings can be conjoined to generate intense contrasts. If they can be so conjoined, they are compatible; if they are incompatible, they cannot be conjoined within a single order. The ordinal theory does not appear to resolve these difficulties on a fundamental level, since anything is an order, even a poor work of art, and possesses an integrity as such. An important consideration is that incompatibility as well as compatibility, difference as well as similarity, are ordinal concepts. All concepts are ordinal. Difference is always in certain respects and relative to certain conditions. Nevertheless, intense contrast is founded on the relationship of similarities and differences within a single order.

This issue is exacerbated for art both by the extreme complexity of many great works and by the unity assigned to them. The richness of possibilities within a great work of art seems to render hopeless any significant unity. The felt unity thought to belong to better works seems incompatible with complex richness. Coleridge's definition of Beauty—"in which the many, still seen as many, becomes one"— expresses the difficulty without affording us a glimpse of a systematic resolution.

We may approach the issue from the side of complexity. Yet sheer numerical multiplicity seems insufficient as the basis of contrast. Some

works of art have a wider range than others in certain respects, and include a greater number of certain kinds of elements. Yet the latter works may be as successful. There is a consummation of restraint that is of paramount aesthetic value. We may wish to say that a work of art attains a unity among diverse elements—but numerical diversity alone will not do, nor will emphasis on sheer difference. Indeed, to many critics, the logical incompatibility of different interpretations seems to tear the work of art apart, dissolving it into a plurality of apprehensions having nothing intrinsic in common. I have noted that any actuality within an order possesses many possibilities, and many of these will be logical contradictories. How could there be a greater difference than this? But from this point of view, every order seems to be as diverse as any other. Within every order, there are possibilities which are contradictories. There is no greater incompatibility possible. On the other hand, numerical diversity is equally irrelevant. The real number system gives us a nondenumerably infinite number of constituents with little aesthetic value.

It is tempting to count orders and to claim that an order is more diverse—thus a more intense contrast—than another if it possesses more constituents or if it is a constituent of a greater number of orders. The problem is that orders are not in general countable. Ordinality, inexhaustibility, complexity, and relevance do not admit of degrees. If we could count up all orders and their constituents, we would have achieved an all-encompassing order, and the world would be successfully unified, at least in this respect. But that is impossible, as every new work testifies. Every creation is a novel constituent of the scope of established orders—for example, of the measure provided by numbers. Inexhaustibility entails that no measure of numerical size can be provided for orders generally—though under sufficiently restricted conditions, a measure can be obtained of a particular integrity of some orders. A given integrity of an order may have a measure, but its scope, its ramifications, and its possibilities will be unmeasurable and indeterminate in certain respects.

From the side of unity we may make no further progress, for every order is one as an order. Yet it is many in its constituents and its relations. The notion of a greater or lesser unity is quite opaque, since each order has precisely that unitariness appropriate to it—its integrity within another order. Nevertheless, there are always many integrities, so that even an integrity is many in certain respects, though it reflects how an order is one as a constituent in other orders. We may have completed, unqualified unities and completely countable multiplicities only in a finished world—a universe incompatible with the arts, their inventions and creations.

Every integrity of an order is its role within some other order but no collection of integrities can exhaust an order. A rich work of art affords a variety of different interpretations, not all of which are compatible or unifiable. Every significant component inhabits many different spheres of relations with many different integrities, not all of which are compatible with each other. The integrities of such a work are many, and it may not be unifiable in all of its integrities. Moreover, such a gross integrity is of little artistic importance. What is required is a vital and important interconnection of integrities.

A clue to the solution to these difficulties—which are immense for any theory of art—may be found by turning from art to nature: to the aesthetic values found in uncontrived orders. Nature is an indefinite multiplicity, an inexhaustible complexity. No order itself, nature is indefinitely many orders and indefinitely complex and inexhaustible. Multiplicity is everywhere; unity is evanescent and elusive. What, then, is an intense contrast within nature? How does the diversity of natural orders attain a fusion that affords aesthetic value? What unitariness is relevant besides the many integrities of inexhaustibly diverse orders? Let us take a toad and compare it to a mountain: who would find the toad beautiful, even to possess aesthetic value? But mountains, in their grandeur, are nearly always objects of aesthetic value. So too, a great storm may be overwhelming, though neither beautiful nor beneficial.

On the other hand, toads are fascinating. It is a mainstay of many forms of contemporary art that anything at all—at least anything natural—may be a valuable object of aesthetic consideration. A sufficiently close attention paid to mountains, storms, even toads and algae, rewards us with the aesthetic values appropriate to them. We find profound values in nature's contrasting elements in terms of our personal or human experience. Differences and multiplicity belong to all things—to nature and also to human contrivance. Aesthetic values— intense contrasts—are created in and of this multiplicity, constructions of unique importance within and for human experience.

I can find no alternative to this conclusion. The contrasts which are the basis of aesthetic value are not just collections of diverse elements, assemblages of heterogeneous components, unities of differing constituents, but rest on what is important relative to typical human experience. Inexhaustibility is pervasive throughout orders; art manifests this inexhaustibility relative to and within typical and historical experience. The field of lived experience is the order relative to which artistic value is achieved, relative to which contrasts may be intense. It does not follow—though it is often assumed—that aesthetic value resides only where it is *felt* to belong, beauty in the eye of the beholder.

Intensity of contrast is relative to typical human experience, to orders in which we make judgments and use our minds; but it is not thereby rendered subjective. Intense contrasts are comprised of elements which are or become important in human experience, but importance is not subjective. It is a property of relations within typical human orders in which judgment is paramount. A man may not know of the death of his family in an accident, yet it is of greatest importance to him. The measure of importance here is influence on judgments, modifications of their integrity. Intensity of contrast, aesthetic value, is the modification of the integrities of human orders, of orders of judgment, through the construction of sovereign, distinctive works. Such modifications need be neither subjective nor emotional. A work of art may be transcendent in its comprehensive achievements whether or not understood by a person of limited sensibilities or responded to with feeling by a person of exquisite sensibilities. There are great and enduring works which may move us little or not at all, yet which upon reflection have all the properties of aesthetic value. Art is typically human in providing intense contrasts in relation to human life and judgment. This humanness, however, is not a limitation to personal subjectivity or social relevance to whatever extent we share with other human beings and creatures typical properties of life and natural orders. Many orders are shared; they are the basis of the community of the values of art.

The doctrine of the work of art itself emphasizes the sovereignty of the work by severing it from its relations. I have countered this disjointedness with a theory in which sovereignty is a function of relatedness. The doctrine of art for art's sake emphasizes the free and unrestricted play of imagination severed from the rest of experience. The reply is that art is a free play of imagination grounded in conditions and utilizing every means it can drawn from natural and experienced orders. Sovereignty and uniqueness are functions of connections and similarities. That is the basis of the theory of contrast. The conclusion is that artistic value expresses the free play of the imagination, of judgment in all its modes, emphasizing all the contrasts relevant to such judgment, subservient to no particular external modes of validation. The absence of a particular standard of validation to which contrasts are subordinated —truth or utility—entails that art manifests inexhaustibility of judgment. Inexhaustibility, however, is a joint function of determinateness and indeterminateness, of integrity and of scopic possibilities, of uniqueness and commonality. It is translated, then, into a sovereignty defined in relation to the common, idiosyncratic, and typical elements of human experience and judgment. Kant was correct in this respect: art is the free play of the cognitive faculties (judgment for its own sake),

79

freed from the validating conditions essential to the other forms of judgment. Art is the manifestation of inexhaustibility: a manifestation in judgment relative to typical human experience of the inexhaustible interplay of prevalence and deviance, actuality and possibility, determinateness and indeterminateness. By the free play of imagination and judgment we reveal to ourselves the limits of every judgmental determination, thereby manifesting through art the inexhaustibility of every order.

The relevant diversity among the constituents of a contrast is not mere difference, but incompatibility in some respect—though the constituents are obviously compatible in other respects within the contrast. Two contrasting constituents of an order are incompatible to the extent that each is deviant relative to the other within that order— deviant relative to the other's prevalence, deviant in relation to the other's integrity relative to typical human experience. Two adjacent colors contrast when each is deviant relative to the other's prevalence— the prevalence excluding it, the deviance thus a contrast with what is otherwise typical. Each contrasting color affects the other, gives it a unique function within the work, though the contrast is intense by virtue of the deviance of the contrasting hues. Harmonious colors are different but compatible, not excluded from each other's prevalence but encompassed by it. Still, two harmonizing colors *are* different, and there are relevant orders within which each is deviant relative to the other. A uniform field of pastel blue, though blending with a more intense shade of the same hue, will admit a single line of the latter with striking effect. Nevertheless, we may say that *generally speaking* the colors harmonize, each compatible with the other in typical experience. Aesthetic value rests on the capacity of orders to admit constituents within their prevalence, playing upon what is novel and unexpected relative to prevailing expectations within experience and judgment.

A contrast is where orders not mutually constitutive or relevant within important or typical experience, not mutually constitutive or relevant within established forms of judgment, are brought together in a new relation where each is deviant relative to the integrity of the other, yet where they prevail jointly within the work. Each is sovereign within the work in virtue of its prevalence there, but each is transformed by the other. Each is relevant to the other's integrity, but through deviance as well as prevalence. There is also a weaker relation where constituents which are not mutually constitutive, or which are relevant only to each other's scope, jointly prevail within a work. Such constituents do not modify each other's integrity within the work, and the intensity involved is not that attained where constituents are included in each other's integrity yet are mutually deviant as well.

80

In a representational painting, even remarkably contrasting colors may not be mutually deviant relative to each other's prevalence. The deviances may be asymmetric because of the representational emphasis. A blue sleeve against a drab brown background may function almost exclusively in its representational role—that is, the blue standing out against the background, the latter serving to highlight the blue. The brown is a deviant constituent of the integrity of the blue; the blue is only a constituent of the scope of the brown. The brown is typical; the blue is deviant. Often the background is simply that, setting forth the foreground hues—influencing them but not the reverse. Even more likely, the representational function will predominate, the blue belonging more to the sleeve and arm of the lady in the portrait than to the background. The central contrasts are the curve of the arm set off by the blue of the sleeve, the color of eyes and hair, and so forth. One of the interesting qualities of minimalist art is to set in relief certain contrasts that are often subordinate in other paintings. Two large uniform panels of different hues juxataposed are a sharp contrast along their borders. Each has become typical; therefore, the other is deviant relative to it. Each is uniform except for the contrast across the boundary; therefore, the integrity of each hue in the painting includes the other as a constituent. Such a contrast is sharply highlighted in minimalist painting, though it is present and important even in representational art.

> In the colour-form painting I have in mind, even primary hues, used pure, are compelled to reveal something of their constituent colours at the evocative call of other colours in a picture. It is possible, so to say, to force pure orange to reveal that it contains an element of leaf-green. . . . The collateral relationship can be exploited by the eye as I suggested in the case of oranges upon their trees in a southern landscape. Nor does this mean that the orange appears any the less orange. As usual, a source of affinity at one and the same time stresses the brilliance of difference. . . . Everyone perceives the closeness of orange to red, but used together these colours stress as well each other's difference.[8]

Where nature has aesthetic value—for example, in a mountain vista—we are struck both by the rarity of the scene but also by its singularity. There is novel conjunction relative to prevailing and ordinary experience. Aesthetic value resides in an order novel in its conjunctions but unified as a salient component of experience. The effort of climbing the mountain is fulfilled in the realized scene, fulfilled as few comparable efforts are, contrasting with the effort and with the general quality of toil in life.

8. Adrian Stokes: *Colour and Form*, reprinted in *The Image in Form*, R. Wollheim ed., New York, Harper & Row, 1972, p. 52.

Generally, experience lacks those fulfillments in which diverse orders significantly interpenetrate along a wealth of diverse constituents and their integrities. A fine work of art creates a novel order in which there is such interaction, diversity admitting interconnection and fusion throughout constituents at many levels and of many different kinds, an interplay of prevalence and deviance amidst a wealth of constituents and relations. Nevertheless, a great work may become familiar, its influence pervasive throughout the experiences of many people. Art transforms our experience, great art most of all, and what was once novel and intense in its contrasts may become familiar, even trite. The ways in which prevalences and deviances are related in the work are nullified by repetition, the deviances prevailing typically in ordinary experience. Here there is no longer tension and contrast, but prevailing conjunction. Such works may lose their savor and power to move us, prevailing without salient deviances. Nevertheless, an important work of art will become familiar only by lending its force to experience and defining common expectations in art and thought as well as action. Such prevalences establish a background from which other contrasts may emerge. Later works gain intensity from the prevailing background of artistic expectations defined by earlier masterpieces; reciprocally, however, they transform the integrities of the earlier works, engendering novel contrasts for them. Enduring greatness depends on a richness, intensity, and breadth of contrast which remains at variance with other experience, and which is a function of later developments in art as well as of other spheres of human judgment.

An important contrast is an order both recurrently prevalent and continuously deviant within typical and historical experience. Such a contrast is comprised of constituents which, though typically disparate, are brought into close relation within the created order. Thus, each is deviant relative to the other within the new order; yet each is at least a condition of the other's scope and, in intense contrasts, each a constituent of the other's integrity. This mutual deviance in integrity is the basis of most artistic values, a strong sense of interrelatedness conjoined with variation and deviance. Intensity of contrast is therefore dependent on two conditions: the joint prevalence within a work of constituents which are mutually deviant though constitutive of each other's integrities, contributing to their prevalence within the work; and the richness of deviances within the work relative to typical experience and judgment. Both are forms of prevalence in relation to deviance, engendering rich and inexhaustible possibilities for further orders and relations in human experience. The intensity with which prevalence is permeated by deviance is the manifestation of the inexhaustibility of orders.

A promontory rising from a desert plain prevails in the region but is deviant relative to the surrounding topography. The peak and the plain are deviant relative to each other in their topographical character, conjoined at their boundaries. Such a contrast is also deviant within typical experience, a rarity infrequently encountered or perceived. A work of art preserves its contrasting nature, avoids becoming trite, only insofar as it is both a prevalence of mutually deviant constituents and characteristically deviant within experience. The two orders of experience are different: the order in which the contrast remains deviant is experience as typified by characteristic traits; the order is which the work is prevalent is historical experience, an aggregate process. Thus, a fundamental contrast for art is that established by the dual status of an order deviant relative to the typical and characteristic traits of experience while prevalent within historical experience. A great work prevails as a historical creation become a monument, yet it contrasts as a deviance relative to typical experience in innumerable ways. When a work becomes typical in most important ways, it becomes trite and loses its contrasting nature.

Intensity in contrast is provided through the interplay of two factors: incompatibility of contrasted elements—defined as their characteristic disparity, their range of traits deviant in typical experience; and unity among the elements of the integrity of the work within collective and individual historical experience. Sometimes contrasting elements are merely coordinated, and that may be a fine achievement. Where a striking peak and a flat surrounding plain are together, apparently accidentally, there is nevertheless an intense contrast, a function of the rareness of the conjunction and the disparity of the constituents. In this case, each member is but a constituent of the other's scope. Nevertheless, the character of the plain is illuminated by the contrast, the unbroken flatness thoroughly pierced.

An exceptionally flat plain, broken by a remarkably pointed promontory, especially one with a remarkable shape, is a distinctive and intense contrast. The typical flatness is pierced by the promontory; its jutting forcefulness is sharply deviant relative to the plain. Such plains are not typically broken in our experience by so forceful an outbreak, especially one with so striking a shape and power. Far more important, the two may qualify each other in their proximity, the plain made flatter by the peak, the latter more pointed because of its surroundings. Here each is part of the other's integrity within their joint sphere of relevance. Here is immense vitality of contrast, a full aesthetic revelation.

It is imperative at this point to emphasize the ordinality of the theory, especially the ordinality of prevalence and deviance. I have defined a contrast as a prevalence of deviances—a double mode—where con-

stituents which jointly prevail within the work are mutually deviant in virtue of their other integrities; and where they are also jointly deviant relative to common experience. Two remarks are called for: First, because deviance is ordinal, aesthetic value—even the nature of a contrast—depends on the orders of experience or perspectives relative to which deviance is established. However, experiences vary in certain respects; there is no uniform fund of common experience relative to which a work of art possesses its values. It is valuable insofar as its novel prevalences are deviant relative to some perspectives—the audience's common human experiences, some particular sphere of experience, and so forth—but never all perspectives nor even all relevant perspectives. What I have called "typical" and "historical" experience are not two distinct orders but many, relative to different fields of individual and social experience.

Intensity is a function of spheres of experience, but experience, like every order, is inexhaustible. The intensity of contrast attainable by works relative to a wider sphere of experience is not greater than that attainable relative to a narrower personal or social sphere, for the intensities are not comparable, or are comparable only within still another order of experience, from some particular point of view. A work of profound significance within a particular culture, but of diminished stature for other cultures, is not of lesser artistic value than one significant across many cultures. Nevertheless, the common features of human experience do afford a community of intensity, so that works of great intensity for some human beings are often of great intensity for others, but most likely, not for all.

Far more important is the second emphasis on ordinality: aesthetic value—intensity of contrast—depends on a broad plurality of deviances, is a function of the inexhaustibility of orders of experience. There are two ways of emphasizing this point, both of great importance. First, we may emphasize the dependence of intensity of contrast on human responses and orders of experience. The prevailing contrasts within a work, the mutual deviances which jointly prevail there, are always relative to some order of experience—common, social, or individual.

The obvious question relative to intense contrasts, then, is: *what* is deviant in *whose* experience? Only an ordinal answer can be given. Experiences vary because individuals differ from each other and have different environments; because generations and societies have different characteristics; but also because "experience" is no name for a single domain of prevalence. Ordinality entails that there are many and somewhat diverse—if related—experiences. A great work of art is

an intense contrast relative to some or many domains of experience, but there are many and there is no order including them all, no all-encompassing order in which a work is *those* contrasts of *that* intensity, without qualification. The work cries out for diverse interpretations relative to diverse perspectives. It follows not only that different individuals will find different contrasts within a work relevant to their different perspectives; they will also identify diverse constituents of the work as relevant to these different constituents for different audiences and under different conditions, and there is no "description," no "interpretation," that can exhaust the relevant features of any work of art.

We have come to the second important emphasis on ordinality, given by the question of *what* is deviant in an intense contrast. The answer is ordinal. Like any order, a work of art has integrities in different ordinal locations. Its constituents vary from order to order, perspective to perspective, in certain respects. It follows that not only the words, the sequences of words, the syntax and grammar, the chapters, overall structure, and paragraphs of a novel are its constituents in terms of which deviances are engendered and apprehended, but the society described, the characters delimited, human history, the passing of time, memory, experience—in short, whatever within a work as interpretable from the standpoint of some perspective is a constituent of the work and of its contrasts *within that perspective*. I must emphasize again that constituents of an order are only in that sense "within" it: constituents are not parts. What belongs to a work as a constituent is a function of the order in which the work functions, and this may include mankind, morality, truth, love—in short, whatever is relevant to the work in terms of a rich and important interpretation within that perspective. I must also emphasize the importance of interpretation in works of art, since they are not simply what they are, but have aesthetic value only relative to a perspective which affords an interpretation. On the other hand, relative to any interpretation of a work of art, only some of its constituents belong to its integrity. The others belong to its scope. Relative to any interpretation, a work possesses an integrity— what it *is* or *means*—and a scope—what it *signifies* or *portends*. And relative to many such interpretations a work may possess an identity as well as a more comprehensive scope. In no sense does a work of art have a relevant identity independent of its ordinal locations in historical, individual, and social experience.

Contrast fundamentally involves ordinality. An intense contrast is the joint and deviant prevalence in the integrity of an order of constituents otherwise unrelated, thereby the continuing prevalence of a conjunction deviant relative to typical judgment and experience. The

joint prevalence of the constituents of the contrast requires in ideal cases that each be a constituent of the other's integrity. Yet a conjunction that prevailed permanently in experience, given ordinary responses and limitations, would not long remain contrasting and valuable. It would become typical, commonplace. And there is a tendency for works of art to do so. It is offset, however, by the ordinal condition of inexhaustibility—that what is deviant in typical experience may be richly diverse in its integrities relative to different perspectives. Interpretations vary from generation to generation and from individual to individual, not merely to express different reactions to a great work, but to express its richness and complexity, its inexhaustibility, manifested in its different integrities. These diverse intepretations give rise to what I call "intersubjective contrasts,"[9] based on the diversity of ordinal conditions among different spheres of experience which express an essential feature of intensity of contrast in art. In this respect, art not only manifests inexhaustibility but requires it, and the diversity of ordinal perspectives relative to different interpretive standpoints are not simply the milieux for art but one of its fundamental elements.

Intensity of contrast involves not only the joint prevalence of mutual deviances, but also the indefinitely rich interplay of diverse constituents of a work in their various prevalences and deviances. A particular musical progression may be common but utilized in a novel development, related to a text in a new way, thereby attaining a complex mixture of deviance and prevalence. A novel may delineate an immense range of human events, each of which may be familiar, but which in clarity of delineation and complexity of relations comprises an alternative world. Here the elementary constituents in one sense— words and events—may be typical and familiar, but the constituents comprised of them in the work may be original and deviant—if only in their range of control. Human experience is complex and diverse, with each individual and each generation comprising many—though interconnected—integrities. The responses to complex and important works of art are then also diverse and complex—though often interconnected —and a remarkable intensity of contrast can be achieved by the interplay of the diverse integrities of a work, with diverse constituents of varying scopes, in their mutual reenforcement and disparity.

Ordinality helps us resolve the issue of the plurality inherent in the notion of contrast: the work is exceptional and intense in attaining a vital unity relative to its plurality of constituents. Nevertheless, all orders are unified insofar as they possess an integrity—or are unified

9. See below. pp. 143-47.

in many ways insofar as they have many integrities. The unity relative to intense contrast is an emphasis on diverse prevalences of diversely deviant constituents. A great work of art is an order whose constituents are diverse—that is, mutually deviant relative to orders other than the work; whose constituents as jointly prevalent are extraordinary or deviant relative to typical experience; but whose constituents are also integrally interrelated within and for the work in a remarkable variety of ways. It is the wealth of interconnections among the integrities of the elements of the contrasts relative to the wealth of interpretations of the work that is the basis of intensity of contrast. This plurality and richness of integrities and relations is the revelation of inexhaustibility at the heart of ordinality. The implied ideal, that *every* meaning might fuse, that *every* constituent might be interconnected with every other in a work of art, is theoretically impossible of fulfillment, since total interrelationship would collapse into identity. It is impossible for two different orders to have exactly the same constituents.

Art is the purposive creation of intense contrasts, thereby the manifestation of inexhaustibility relative to judgment and experience. Art is inventive because an intense contrast is created, not merely an amplification of an established relation. Such amplification makes little sense where we are not speaking of an order of measurable quantity. Intensity of contrast is not an addition to a contrast of lesser intensity, but is the construction of a novel contrast intense in its conjunction of diverse elements.

It follows that we should not speak of increasing the intensity of a contrast, but rather of inventing contrasts of great intensity. New and important works of art are not "more intense" than their predecessors, but contrasts realized in extremes of intensity—though a part of their intensity is attained in contrast with their predecessors. The concept of contrast carries the weight of relationality. The concept of intensity emphasizes incomparability. Works of art, natural wonders, intense contrasts, are not as such ranked, higher and lower, but are sovereign, unique, and incomparable. Intensity of contrast mates incomparability with relationality, uniqueness with commonality, sovereignty with similarity, both poles of which are essential to aesthetic value and ordinality.

Art, then, is not *intensification* of contrast—as if mere amplification might do—but is the creation of works of sovereign intensity relative to the conjunctions and juxtapositions, the similarities and differences, to be found in the rest of experience. Such a formulation brings us back to the principle that art is construction, creation, making. And it faces us with the problem finally of the intrinsic connection between constructive judgment and intensity of contrast. For surely science, philosophy,

and politics must be inventive and creative, if not to the extent or in the ways that we expect from art. What, then, is the theoretical connection between works of art in their creative making and the aesthetic values which reside in intense contrasts? My final concern in this chapter is to trace the essential relationship between artistic construction and intensity of contrast and to explain why intensity of contrast is a supreme value.

I have noted the fundamental interpenetration of the modes of judgment, that all human products may be regarded as constructions —to assertive or practical ends; actions—to assertive or artistic ends; or assertions—of an active, synthetic, or artistic nature. Nevertheless, there are different modes of judgment with different methods and criteria of validation. We may think of assertion as judgment *about* a subject matter, faithful to it. We may amplify the concept of faithfulness in many ways: for example, assertions must conform to logical conditions and must be compatible with relevant evidence. Alternatively, we may develop the notion of assertion through appeal to pragmatic conditions—viewing assertions as answers to questions, solutions to problems. The principle that reason leads to univocal and precise answers is significant only within the mode of assertive judgment and properly belongs to science—where science is the general enterprise emphasizing this mode of judgment. More precisely, science is a mode of *query* in which assertive judgment is predominant. Science, ethics, philosophy, and art are all modes of query in which interrogation is ongoing and unending and in which there is a continual methodic concern for validation.

> Query is the genus of which inquiry is the species. . . . We shall think of query as a process expectative of or inclusive of invention. And we shall think of invention as the methodical process of actually producing in consummation of query.[10]

By way of contrast, action is not particularly stating or making claims—though the making of statements may in some cases be regarded as important actions, while assertions are of utmost importance to their evaluation. The goal of assertion is to make true claims—faithful in some sense to the facts, compatible with the evidence. The goal of action is to accomplish valid deeds—establishing control over experience. Justification in assertion looks to evidence and its formal conditions. Justification in action looks to conditions and results. Action looks to success and avoidance of failure, judged in terms of consequences.

10. Buchler, *Nature and Judgment*, pp. 7, 59.

Both assertion and action depend on validating conditions that lie outside themselves: on evidence or consequences. In this sense, both are to ulterior ends. The claim is frequently made, however, that art—constructive judgment—is for its own sake, to no ulterior end. Unfortunately, the two expressions—"for its own sake" and "to no ulterior end"—are misleading if not unintelligible. Art for art's sake is absurd, forcing upon art a purity that demeans it, depriving it of intermodal dimensions, leaving but a skeleton of artistic possibilities. "Art's sake" may include any subject matter or possibility, any topic or order, for any may contribute to profound and intense contrasts.

The notion of an "ulterior end" is more helpful but incomplete. Assertive validation is truth, a conformation among all relevant assertive conditions. Active validation is control, the minimization of prospects of failure in terms of conditions and consequences. Science and ethics look to external criteria of validation. Art looks to construction alone. The contrasts of which artistic value is comprised are assigned *to the work* not something else to which the work must conform or which it must attain. Validation in assertion and action may turn on the scope of the judgment—an unexpected outcome, for example. In art, validation turns on the constituents of the integrity of the work. It follows that a constructed work must include whatever may be relevant to its validation. Artistic value resides not in *restriction* to the work itself, but in the expansion of the work throughout its diverse relations. The work "itself" is the work inclusive of its many relations, its various integrities, its diverse possibilities, looking to no end outside itself. This discussion will be elaborated in the final chapter.

A work of art is the creation of a novel order whose value lies in no end other than its own integrities (inclusive of an inexhaustible wealth of possibilities). What could such value be? Not faithful creation—as mimetic theories hold—for that would determine validation in terms of correspondence, and be assertive. Not in terms of effects, for that would be active judgment. Both would undermine the sovereignty of the work of art, thereby neglecting its construction. Art is the construction of orders so that they will prevail within human life. There are only the diverse constituents of the work as they comprise its integrity. In constructive judgment, only the integrities of the work are relevant, along with what comprises them: the integrities and their constituents. However, these integrities are inexhaustible, comprising inexhaustible constituents and relations. The sole value that is possible is their mutual diversity and conjunction—that is, their intensity of contrast.

Intensity of contrast is the value inherent in constructive judgment to the extent that such judgment has only intrinsic standards, is to no

ulterior ends. Constructive judgment creates a work to *be*—and only thereby to *mean*, to signify—out of its many constituents. The only basis for such judgment must lie in the constituents of its integrity and their interrelations: contrasts and their intensity. The sovereignty of the work of art is an expression of its authority: that it is subordinate to no external end. Intensity of contrast is the only plausible value, an enrichment derived from nothing but the constituents of the work of art insofar as it is inexhaustible in its ordinality.

Why is such intensity of contrast a supreme value? A number of answers may be given, ranging from lived experience to ordinality itself. Intensity of contrast may be regarded as a product of a free act of mind lying in the act of creation itself, the production of a work to be in the fullest ordinal sense, filled with inexhaustible diversities and similarities. Of course, all the modes of judgment can be employed in intensity of contrast. Nevertheless, the free play of constructive judgment is the creation of works simply to be, dependent only on the contrast of what they are with what they are not and what they might be.

Being, in an ordinal theory, is functional and relational: what an order is is its function within and relevance to other orders. To be, then, is in contrast with all the locations and functions of an order. Alternatively, being is ordinality and inexhaustibility. Both assertion and action seek to simplify ordinality, to escape inexhaustibility, to establish conditions for truth and control. Only art dwells in the richness of ordinality and its inexhaustibility, seeking to enhance orders with novel possibilities, to engender new integrities, to create new intense contrasts. Science and politics certainly enrich experience and produce novel and intense contrasts. Art, however, revels in these contrasts, maximizes relevant possibilities, heightens variations and oppositions.

Science seeks an understanding grounded in actuality and integrity, though it can attain it only because of novel possibilities and the openness of its own scopic constituents. It emphasizes prevalence and actuality, while it indirectly exhibits deviance and possibility. Action seeks control over orders in experience through the transformation of possibilities into actualities, deviances into prevalences. It emphasizes the complementarity of the ordinal categories, but it exhibits as a specter the relevance of uncontrolled possibilities, deviances, and scopes. Only art revels in and manifests the inexhaustibility of orders, emphasizing the relevance of novel possibilities and deviances amidst the prevalence and actualities of orders in human experience.

Art is the manifestation of inexhaustibility, achieved through intensity of contrast. Reciprocally, it is the creation of intense contrasts, thereby manifesting inexhaustibility. In both cases, inexhaustibility

must be understood in the full sense of ordinality: the complementary relationship of determinateness and indeterminateness. Inexhaustibility is not pure indeterminateness, pure freedom, unrestrictedness. Nothing can be unconditioned. This principle is expressed by the complementarity of the ordinal categories: prevalence and deviance, integrity and scope, actuality and possibility. In each pair, one member may be regarded as expressive of determinateness, the other of indeterminateness—in a particular respect. In addition, each pair is dependent on ordinal location, and what is prevalent in one location is deviant in another and conversely; what is a constituent of the integrity of an order in one location is a constituent of its scope in another and conversely; what is a possibility in one location is an actuality in another and conversely. This functional complementarity is essential to the notion of ordinal inexhaustibility, and it is maintained throughout all the ordinal categories.

Every order is inexhaustible. The ordinal theory asserts this principle and thereby testifies to inexhaustibility. Science and morality confront inexhaustibility in every judgment: every theory is inexhaustible and is faced by inadequacies generated by the inexhaustibility of other orders. Action is faced with possibilities of failure at every turn. Both confront inexhaustibility; both can succeed in their judgmental terms only because of inexhaustibility—that which enables them to invent new judgments and to pursue new forms of query. But both are constrained by external validating conditions. Art, however, revels in inexhaustibility, creating new forms to enhance the openness of orders. Art is not unconditioned, for it could not then be anything at all. But it is an inexhaustible play of contrasts upon each other, an inexhaustible enhancement of orders in experience.

Inexhaustibility is expressed by all the ordinal categories. Art, then, is inexhaustible through the interplay of possibilities and actualities, integrities and scopes, as well as prevalences and deviances. I have emphasized the latter for a fundamental reason: that inexhaustibility is of *orders,* and requires an emphasis not only on integrities but on gross integrities over many different locations. This interplay of gross integrities over constituent integrities, seen as a form of contrast, is precisely prevalence amidst deviance. Nevertheless, the corresponding contrasts among integrities and scopes, possibilities and actualities, must be understood to be included in the contrast of prevalence and deviance. The sovereignty of a work of art, grounded in the first instance in its integrity and prevalence, has direct implications for its constituent actualities and possibilities, on the ways in which possibilities are constitutive of its prevalence. The interplay of possibilities and

actualities, which I have identified with the *worldiness* of art, is a direct expression of its inexhaustibility. Possibilities are such a direct expression of inexhaustibility. But they can be such only in a close and therefore contrasting relation to the integral prevalence of the work of art. Art manifests inexhaustibility through all the ordinal categories, an inexhaustibility inherent in the inexhaustibility of judgment and query, but which I am interpreting as an interplay of prevalence and deviance, related to the other categories through the nature of ordinality.

Intensity of contrast, then, has a metaphysical foundation in ordinality and inexhaustibility, but also manifests such inexhaustibility in the free play of judgment and query. This is a most supreme value. As a consequence, we appreciate the exhibition of pregnancy and promise, novelty and transformation, the excitement of intense contrast. These intense contrasts are savored because they are extraordinary and remarkable. It is not our appreciation that makes them extraordinary.

This leads me, in concluding this chapter, to a conception of art toward which I take a very qualified position—that works of art are expressive of emotion and produce particularly vital and intense emotional experiences. The theory of intensity of contrast entails that works of art need not be emotional to be effective and important. Rather, art is created for human response, but no particular mode of response alone is appropriate. This is a consequence of ordinal inexhaustibility. Intensity of contrast is defined relative to human perspectives, human orders. Yet such orders are inexhaustible individually in their constituents and integrities and inexhaustible as well collectively. There is no particular sphere of experience—emotional, intellectual, immediate, or otherwise—that can determine the value of art, for art both revels in and is the revelation of inexhaustibility through contrast. All the modes of judgment in response, all the forms of articulation and query, are the natural fulfillment of art and aesthetic value.

Aesthetic value is intensity of contrast, but relative to any kind, any sphere of experience: individual, social, or cultural, emotional or intellectual. Intensity is available for feeling, as is any constituent of experience, but is neither a form of feeling nor accessible only through certain kinds of feeling. The power of art is to enrich our surroundings, our lives, with novel forms and creations, enjoying inexhaustibility and enhancing it. We appreciate such achievements in all the ways we can, and in all the ways we can invent, therefore in no particular ways. This openness of art to novelty and inexhaustibility is what differentiates it from science and from practical affairs. Art is not in this way different from philosophy, which also manifests and revels in inexhaustibility. The difference here lies not in intensity of contrast or

ordinality, but in how they are manifested, a difference that is as likely to be diminished in certain works of art and philosophy as it is to be augmented.

Art is construction, and its value lies in the distinctiveness of its works. Such a distinctiveness is a contrast—a contrast among the constituents of the work and relative to the traits of experiences in which it is to be assimilated. The distinctive, remarkable character of a great work of art is a double contrast—relative to its constituents and relative to some spheres of human experience. Yet the distinctiveness of works of art is an achievement that manifests inexhaustibility: that is what intensity of contrast exhibits. The sovereignty of the work—its prevailing integrity—is manifested in inexhaustible ways and with inexhaustible contrasting relations. Such achievements arouse in us the most sublime of emotions, as we bask in their glory. But it is their glory and achievement which we admire, and we respond to them in all ways we can find by which we can express our admiration of them, ways which are themselves inexhaustible.

CHAPTER 4

Contrasts and Aesthetic Value: Dimensions and General Types

The theory of art and aesthetic value developed in this essay may be summarized in three brief principles: (1) *aesthetic value is intensity of contrast;* (2) *intensity of contrast manifests inexhaustibility;* (3) *art is the methodic construction of intense contrasts.* I have developed the theory of contrast in connection with an ordinal metaphysics and have argued that only an ordinal theory can provide a satisfactory basis for the theory of contrast and for methodic construction. I have also traced some of the elements of judgment and query in relation to ordinality, although a more complete analysis of art in relation to constructive judgment and query is required, and will be developed throughout the ensuing discussion, but primarily in connection with interpretation and criticism in Chapter 6. What is needed first is a detailed development of the notion of intensity of contrast in relation to art and works of art and to aesthetic value in nature. The purpose of this chapter and the next is to develop a rudimentary taxonomy of contrasts relevant to aesthetic value.

This will be accomplished by discriminating three dimensions of contrast—perfection, invention, and celebration—and five general types of contrast—traditionary, intramedial, intermedial, intermodal, and intersubjective—plus a type of contrast derived from fundamental ordinal considerations—integral and scopic contrasts. The three dimensions are inherent in all contrasts, in and out of art. They are dimensional in the two senses that they all apply to every intense contrast and that they must be understood together, in interaction, producing further contrasts among contrasts. In this sense, the three dimensions manifest the most general sense of what intense contrast is, and are to be understood in terms of the fundamental categories of the theory of orders.

94

The three dimensions of aesthetic value are perfection, invention, and celebration. They may be interpreted straightforwardly in terms of the ordinal categories: perfection as an emphasis on prevalence amidst deviance among relevant subaltern orders, invention as deviance among established prevalences, celebration as the sovereign interplay of all the categories in lived experience. Yet the principle that art manifests inexhaustibility, that aesthetic value is such a manifestation, suggests a very different triad of dimensions of aesthetic value, given directly by the pairs of ordinal categories: integrity with scope, prevalence with deviance, possibility with actuality. Integral-scopic contrasts are fundamental to art and aesthetic value. Indeed, I consider them so important, so essential to artistic inexhaustibility, that I place them in a class by themselves. The interplay of prevalence and deviance is the foundation of the notion of contrast, and cannot be regarded as simply one among other dimensions. Rather, all the dimensions of aesthetic value must be interpretable in terms of the interplay of prevalence and deviance. The contrast of possibilities and actualities is a more difficult matter. Rather than regarding this contrast as a dimension of aesthetic value, I view it as inherent in all contrasts: the interplay between the actual properties of works of art and their contrasts in relation to the possibilities engendered for them throughout different orders in human experience. Art revels in possibilities and in the related contrasts of prevalence and deviance, integrity and scope.

Another reason for emphasizing the dimensions of perfection, invention, and celebration is based on the established traditions of art. Perfection, invention, and celebration seem to me to express the powers assigned most commonly to works of art. Nevertheless, the apparent arbitrariness of this classification supports the general principle that the inexhaustibility of orders and of art entails that every classification of contrasts will be arbitrary in part, and that other classificatory systems would serve as well, to certain well-defined purposes, though any valid system, I claim, can be interpreted in terms of the ordinal categories.

The five major types of contrast are very general but are not dimensional: they are relevant to all intense contrasts, to all works of art and artistic value, but one or another may in a particular case be of quite minor importance. Nevertheless, they express certain fundamental features of works of art: that such works are constructed at a time and place, in the context of established traditions; that they are comprised of materials which have become typical over the history of art; that construction is only one of the modes of judgment, while every mode of

95

judgment is pervasive throughout judgment; finally, that every construction inhabits a public world containing diverse persons who interpret and judge works of art in different ways due to their different circumstances. The dimensions of aesthetic value pertain to intensity of contrast; the general types of contrast pertain to constructive judgment and by extension to aesthetic value in natural objects. Finally, integral and scopic contrasts manifest the ordinal inexhaustibility of works of art and intense contrasts which is a central feature of our experience of art. Nevertheless, the grounding of integral and scopic contrasts in the theory of orders suggests that they are not relevant to aesthetic value alone, but are inherent in ordinality generally.

All the major types of contrast interact at different levels. So do the specific types to be discussed in the next chapter. The taxonomy of contrasts is therefore rather loose, and for fundamental reasons. Ordinality and inexhaustibility, the richness of art, prohibit a rigid taxonomy of general types of contrast just as they prohibit a hierarchy of reality among orders. Indeed, one of the features of the richness of works of art consists in the complex and inexhaustible forms of contrast generated among established contrasts, which any rigorous taxonomy would overdetermine.

The discussion in this and the next chapter will range very widely, from the general dimensions of contrast in relation to the theory of orders to specific contrasts in relation to particular arts and works of art. These two chapters, therefore, are the bridging chapters between the general theory and the individual works to which it applies. Like the taxonomy, these applications and explanations are inevitably somewhat loose and varied, in part a consequence of the ordinal theory and its commitment to inexhaustibility, so that rigid hierarchies are always of limited generality, in part due to the inexhaustibility of art and works of art, prohibiting any theory which would confine invention and imaginative possibility.

THE DIMENSIONS OF ARTISTIC VALUE

The three dimensions of artistic value are perfection, invention, and celebration. Each comprises an inexhaustible family of contrasts; yet each may be viewed as a contrast in itself: perfection with mediocrity; invention with repetition; celebration with ordinariness. Each is a feature of the fundamental aesthetic contrast: what is noteworthy in contrast with what does not merit attention. Aesthetic value belongs to beings which are extraordinary in contrast with what is not—in terms not of a *reason, end,* or *result,* but of *how* and *in which respects* they are so.

A work of art is worthy of our attention, not in terms of its effects but in what it is. It is created to be given attention, and if successful, the attention is justified. The question a work of art poses for us is, "to what shall we attend, and in what manner?"

It follows that each of the three dimensions expresses not a measure or degree, but a type of incomparability. The sovereignty of the work of art is expressed through all the dimensions of value. A work is not more perfect, or perfect in more ways, than other works, not more inventive or more celebrative, but perfect in the ways it is perfect, original in just the respects it is original—including how perfect are its inventions and how original are its perfections—and finally, celebrative as it is celebrative. All these dimensions are comprised of contrasts, inexhaustibly and profoundly, so that relations are central to art as to all orders. However, the dimensions also express a work's sovereignty, how *it* is perfect, for example, while the relevant contrasts express its manifold relevance and significance. Put another way, perfection, invention, and celebration express sovereign traits of a work of art, its incomparability; but the constituents of sovereignty and incomparability are relational and manifold, ordinal and inexhaustible, not holistic, ineffable, and unanalyzable. The pervasiveness of relationality throughout contrasts entails, I will show, that sovereignty can be expressed by no particular forms of contrast, but lies in complex interactions among contrasts, especially in the contribution of all the major forms of contrast to integral and scopic contrasts which involve variations in the identity and prevalence of individual works and orders.

Perfection, invention, and celebration are "dimensions" and not "types." All are relevant to every work of art and to every candidate for artistic value, with different emphases. Each is comprised of contrasts; together, in higher levels of contrast, they define the forms of artistic value relevant to any individual work. Where one or another is largely absent, artistic value is greatly diminished. The first two dimensions closely interact, since a superior work is perfect in respects original to it, while its inventions are realized perfectly. Nevertheless, perfection and originality are not simply holistic qualities of a work of art, but include subtle properties of details and recessive features of works which may be largely repetitive on the whole. Invention is important even where works are largely repetitive—as in early Russian iconic art—but in the small rather than as gross properties of the work. Celebration is a function of both perfection and invention. It both is heightened by their presence and contributes to their intensity. Where important inventions and perfections are conjoined with great celebration, the work becomes celebrative of itself. We travel thousands of miles to visit

97

a museum or to witness a performance. When the celebrative dimension of art is diminished, works molder in libraries and museums. When their celebrative possibilities cease to be effective, works become mere artifacts, of historical importance only, lacking artistic vitality.[1] Artistic value is defined by the three dimensions together, in complex interaction, weakened where any of the three is diminished unless enhanced in compensating ways by the others at higher levels of contrast.

Artistic value is always complex, the fundamental dimensions closely interacting. A work that is rendered with great craft, but which is particularly trite, is not the better for its skill. Its perfection exposes its execrable taste. A purely formal conception of artistic value often makes such perversion unintelligible. We may imagine a sentimental subject given outstanding form, a perfectly structured novel about mediocre people.

A great achievement in one mode of contrast can highlight the lack of another. Perfection in line may render a triteness of color more noticeable. Perfection in technical skill may emphasize a lack of sensitivity in perception and feeling. Intensity of contrast is realized in the interplay of the many constituents of the work of art, in the various dimensions of value. A work must not only be inventive and original: it must be original in craft and excellence. The respects in which it is perfect must include its novelties and departures. Rich and complex contrasts require contributions from all the dimensions, in subtle and varied ways.

Where a work is craftsmanlike but excessively trite, or extremely original but without control or mastery, or even where it is both

1. This is surely what Dewey means in the opening paragraphs of *Art as Experience* (New York, Minton, Balch, 1934, p. 3) when he claims that

> When artistic objects are separated from both conditions of origin and operation in experience, a wall is built around them that renders almost opaque their general significance, with which esthetic theory deals. Art is remitted to a separate realm, where it is cut off from that association with the materials and aims of every other form of human effect, undergoing, and achievement.

> In common conception, the work of art is often identified with the building, book, painting, or status in its existence apart from human experience. Since the actual work of art is what the product does with and in experience, the result is not favorable to understanding.

Nevertheless, it is the work which is celebrative, not the activities of artist or audience. In addition, celebration is one of three dimensions of artistic value, and can neither be wholly absent from any work which was ever part of lived experience nor made the sole basis of artistic value. Celebration is a function of lived experience, but is not to be traced simply to the living of experience, as Dewey sometimes seems to suggest.

original and masterful but lacks a sense of noteworthiness, we have not merely mediocre art, but a work which deeply offends us. The pain is especially piercing where exceptional craft is mated with triviality. It is a perversion of talents, a pandering of gross sensibilities. An artist with great skills who does nothing original with them wastes himself, both morally and artistically. Were he to lack skill, we would not mind so much, for we can appreciate a person struggling to make his way. It is the sense of possible achievement that haunts us, artistic values turned awry. It is the promise of inexhaustibility arbitrarily denied that most deeply wounds our sensibilities, remarkable possibilities given unimaginative fulfillment.

Perfection

In the course of time, under different intellectual and rhetorical pressures, the work "perfection" has substantially changed its meaning. It has become not only a superlative, but the superlative of superlatives. As such a comparative, excellence in a kind, it has been rejected by many philosophers and artists as a standard for art. The basic meaning of perfection in art, however, is one of sovereignty and incomparability: completeness in realization. A perfectly sung note is not one which cannot be surpassed, theoretically or practically, but one finished in its relevant characteristics. A work is completed when there is nothing more to do that is relevant. This is the perfection appropriate to art.

Of course, something may always be done. A landscape may be altered, figures added or painted out. A shade of color may be tempered or rendered more pure. Another brushstroke may be added, another smoothed out. A landscape without figures may be changed into a more human work. However, in the latter case we have not rendered a work more perfect, but created a different work. It is sometimes said that a fine work of art is so complete that nothing could be added or subtracted without changing its nature. That is absurd. Anything may be altered in ways that would not alter a particular integrity. A poem may be read in a variety of ways which are all acceptable. A good translation preserves the identity of the original though in another language, and there may be many equally good translations. Many paintings would remain balanced if a background figure were moved slightly or a brushstroke altered. The view that a great work of art is so perfect that nothing could be altered without transforming its identity commits a fundamental error, confusing what a work is—its integrity—with whatever is relevant to it—its scope.

It is a fundamental metaphysical principle that some of the constituents of an order may be altered without altering its integrity in a particular location. Nevertheless, they are its constituents, belong to it and contribute to it. Every order has both an integrity and a scope in any location, what comprises its unitariness and what comprises its ramifications, its larger sphere of relevance. There are at least three senses of being involved here: integrity, scope, and gross integrity over many different locations, as well as the senses of being given by the other ordinal categories. A changed constituent changes a work, but not always its integrity, sometimes only its scope. Variant readings and editions of works of literature show how often a work preserves its forcefulness and character in variant forms.

Perfection is not a superlative, for it is not a comparative: a work of art is perfect if nothing should be changed, for no alterations would improve it, if no modifications would enhance its sovereignty and intensity. A perfect work is not so much better than another in common respects as it is completed in its own characteristic qualities. "Perfect works of art have this quality of infinity, that they cannot be compared."[2] This is what sovereignty means. Every shared feature of a great work of art is imbued with its unique and incomparable style. Conversely, every unique feature possesses some shared and common constituents. Perfection, then, like all the relevant properties of works of art, is a contrast among singular and shared constituents.

Even minor flaws and inconsistencies do not undermine the perfections of a great work, so long as they preserve its sovereignty and intensity. We are told that the Macbeths both do and do not have children. As a flaw, it is minor in a rich and tragic drama of ambition and greed. In the context of the horrors to which the Macbeths are led, the inconsistency is an enhancing ambiguity. Minor flaws are not imperfections in a work whose uniqueness and perfection render it incomparable. They provide room for complex interpretations and for energetic responses. Perfection is closely related to the concept of prevalence, how a work is dominant and restrictive, a function of its gross integrity. This may be what Buchler has in mind in saying that poetry conveys a sense of prevalence. (See above, pp. 11, 67). Yet the notion of conveying a *sense* seems to me inexplicable: works of art *are* perfect and *do* prevail, whatever our sense of them. Moreover, Buchler does not seem to pay due attention to invention and celebration, which are also dimensions of contrast, though celebration might be related to

2. Donald Francis Tovey: *The Integrity of Music*, London, Oxford University Press, 1946, pp. 151-52.

what he calls the *sense* of prevalence. Most important of all, Buchler does not emphasize the *contrasts* inherent in perfection: not prevalence but prevalence-in-contrast-with-deviance. This is the central difficulty which I find with his treatment of poetry.

Perfection is one of the manifestations of incomparability, expressing the sovereignty of the work. All the dimensions emphasize sovereignty, but do so in different ways. Sovereignty is a function of all the dimensions in conjunction. Intensity of contrast is an inexhaustible interrelationship of prevalence and deviance over the subaltern constituents of an order relative to typical experience. Typicality here is also a function of prevalence in relation to deviance. The interplay of prevalence and deviance that is relevant to intensity of contrast is expressed in the three dimensions of artistic value. Perfection here expresses the range of prevalence by contrast: the sovereignty of a work throughout its constituents, the conformation and identity of its gross integrity throughout a range of relevant constituents in a given location. The notion of completeness in perfection is given by stability and range; the notion of sovereignty and incomparability is given by the unique constituents which are relevant to the work. Both involve the prevalence of orders among themselves and throughout lived experience relative to its typical characteristics. The character or integrity of a perfect work is sustained throughout its different locations and constituents, in manifold relevant respects, though never over all relevant locations and respects. There are always discontinuities and disconnections, for every order. There are always deviances amidst prevalences. Nevertheless, the sovereignty of the integrity of a work over its multiplicity of relations is what has been called the transcendence and timelessness of art: prevalence over plural locations not by resisting alteration, but through such alteration and by means of it, since it is the source of the relevant contrasts.[3]

Perfection expresses two major contrasts involving prevalence. One is perhaps more fundamental, certainly more directly and obviously what we mean by the completeness of a finished work: the completeness of its execution, the fulfillment of its conception over its constituents, the prevalence over subaltern orders of the work in contrast with their deviances among themselves. In an imperfect work, the dominant idea is incompletely fulfilled, not carried far enough, not executed completely, so that deviance enters into the relevant constituents of the work, dividing it. The integrity of the work does not prevail over the relevant constituents that enter into it.

3. See Gadamer, *Truth and Method*.

Inexhaustibility and ordinality are essential here. No order can prevail over all of its locations, relative to all its constituents. Neither, however, can constituents be counted. Therefore, perfection expresses the range of prevalence over an order's constituents in contrast with other modes of realization, some of which are incomplete by comparison, easily exhausted, but others of which are perfect and sovereign in their own right. Inexhaustibility is manifested by contrasts among perfect alternatives far more than by contrasts involving perfect and imperfect realizations of a single conception.

A perfect work is complete in that every further addition will either divide it or increase its dominance in some respects only at the expense of other respects. The inexhaustibility of respects entails that many equally fine works can coexist, none more perfect than the others. In every case, perfection is a double contrast of prevalence and deviance: the contrast of prevalence over subaltern orders amidst their deviance relative to each other; the contrast of a particular mode of prevalence relative to alternative, possible realizations. In every case, the constituents or respects relevant to an order's perfection are determined as relevant in virtue of typical characteristics of human experience. Perfection is a completeness and incomparability over relevant subaltern orders which is doubly relative to typical experience. Both the relevant subaltern orders and the typical range of prevalence of constituents among subaltern orders are defined relative to typical experience. Perfection, sovereignty, and incomparability are ordinal concepts, expressing inexhaustible prevalence amidst deviance relative to the conditions of typical experience. Inexhaustibility conjoined with limitation, determinateness with indeterminateness, is the basis of all contrasts including that of perfection.

The second form of prevalence related to perfection is given by the relation of intensity to typical human experience. It is closely related to the first to the extent that constituents of experience become constituents of works of art, especially as they change over time and through the changing sensibilities that are brought by future creations. We develop expectations relevant to art from our experience, both from other works of art and from typical, everyday experience. Both of these change and develop through time, and the field of experience to which new works are relevant changes constantly. Nevertheless, it is not lived or historical experience which is determinative of perfection, but typical experience—though this is obviously a function of lived historical experience, what prevails therein. It does not, however, include scopic variations in human life. Perfection is not simply *endurance,* but *sovereignty:* a dominance, prevalence, of the work within and

for, relevant to the integrities of, characteristic traits of human experience.

Again, no order can prevail throughout all its locations. Every work of art will be interpreted in aberrant ways which express its scope but not its integrity in historical and communal experience. Nevertheless, part of the power and perfection of a great work resides in its capacity to absorb a wealth of aberrant and diverse readings into an enduring gross integrity. This sense of perfection is a contrast between prevalence and deviance relative to typical experience, reflecting the sovereignty of the work. Weaker works can absorb variation far less completely; everyday experience is, relatively speaking, filled with disjointedness and disconnections. Deviances are essential to both perfection and imperfection, but in very different ways, disrupting the gross integrity of an order or enriching and fulfilling it.

Any work of art may be perfect at one time and not at another insofar as expectations and features of typical experience change. Perfection here is a contrast relative to typical experience—but what is typical changes with time and location, for different individuals and different societies, even at different times in one person's life. Perfection too is variable with location, and a given work may possess different perfections relative to very different fields of experience. Nevertheless, in the richest and most supreme works, variations in interpretation are absorbed into the work as part of its perfection through integral-scopic contrasts (see below, pp. 147-51). This sovereign perfection in interpretive variation is the mark of the greatest works of art.

Other human creations are perfect besides works of art. Great scientific theories are perfect in their own ways; so are important philosophic works. Both can include a remarkable range of different orders within their spheres of prevalence. Both are aesthetically valuable because of their perfection, though they are not works of art. One important difference concerns the interrelationship of the dimensions of contrast. Invention and celebration are essential to art but not essential to science in the same way. Invention is required by the exigencies of scientific creation, but not by the nature of perfection. In art, invention and perfection are intricately conjoined. Indeed, invention is the primary source in art of the departures which it is challenged to overcome: a challenge to prevail in intensity amidst the opposition of novelty.

Another related difference is that the relevant constituents determinative of the integrity of a scientific theory are sharply constricted by conventional expectations. A scientific theory that explained everything —though such a theory, I would hold, is incompatible with inexhausti-

bility and ordinality—would be perfect relative to what it explained, but not to what it was made of, nor its language, symbols, experiments, and social contexts. In this sense, a work of art is relevant to a far wider range of constituents drawn from experience and life than even a very powerful scientific theory because of the limited *ways* in which the latter is relevant to what it applies to. Scientific truth establishes an external standard which limits the range of relevant perfections. It limits as well the deviances which, in interaction with prevalence, constitute intensity of contrast. Scientific contrasts are infinite but not inexhaustible; when they become inexhaustible, science is regarded more as constructive than as assertive judgment.

Nevertheless, quantification without qualification over scope and range is unintelligible, and we may not say that science is of narrower purview than art. Every order has limitations and restrictions, works of art as well as works of science. Yet even the greatest works of science are clearly imperfect, possess deviant integrities, relative to certain obvious constituents—their language, for example—while a work of art must be perfect without such systematic restrictions. No *kind* of constituent may be excluded from art in general—if irrelevant to a particular work—that is recognized to prevail in historical experience. The importance of the art medium is manifest here. Nevertheless, the difficulty of these relative measures suggests that we should resolve the difference in an alternative way, relative to the dimension of invention. Originality is as important for science as for art, but in a very different way, and irrelevant to perfection. A scientific theory could be perfect in all relevant ways without invention. A work of art cannot.

"Perfection" can suggest balance and order, too much the fulfillment of a plan and the attainment of a beauty indifferent to the materials of the art. Such a perfection is not without value, but it is not the equal of the perfection which is a triumph over and upon the materials of the medium. Here the importance of construction in art, of contrivance, is paramount: what a work is made of characterizes all its contrasting perfections. This is expressed in the central role played in art by intramedial and intermedial contrasts (see below, pp. 124-36). The medium is fundamental in art as it is not in the other modes of query. Perfection in art is not flawlessness but *accomplishment*, fulfillment by means of and through a resistance of materials. It is particularly striking when the task and materials are obdurate. Perfection is attainment rather than flawlessness, mastery rather than orderliness.

The standards in terms of which works are to be judged perfect are indefinite in number and diversity. The constituents relevant to the integrity of a rich and complex work are manifold and inexhaustible, a

function of the changing characteristics of experience and what it makes relevant to artistic masterpieces, but also of the inexhaustibility of orders and of ordinal locations. The purview of a great work of art is inexhaustible also, its relevance to life and experience remarkably rich and expansive, the relevance of diverse and far-reaching orders to it also inexhaustible. *Lear* is glorious in its language, noble in its character, grand in its conception, human in its perfections, towering in its dramatic movement, rich in its implications, and so forth. A painting may be regarded as well balanced, harmonious in its organization, successful within its period and genre, an excellent work of its style, typical of a school, and so forth again. It is worth repeating that a work judged perfect as an example of a style is not so much compared with a less perfect example as considered expressive of the definitive traits of the style which may be embodied just as fully (if not as succinctly or expressively) in the other work. The paradigmatic role played by works of art is a function of their perfections as definitive of a reproducible style, not their superiority on some scale of measurement.

The most obvious notions associated with perfection in art are craft and virtuosity. The former applies more to the plastic arts, the latter to performances. Nevertheless, being in the presence of a master of a craft is a great artistic value. Many of the arts thrive on craft and virtuosity—ballet, music, theater, even painting and sculpture—for virtuosity and craft are important perfections, essential to the contrast of art with what is mediocre and ordinary. Perfections in craft, skill, and technique are among the higher artistic values until they become commonplace, when they must be supplemented by originality and profundity.

It is worth comparing the arts with sports, the skillful artist with a skillful athlete. A good part of the appeal of spectator sports resides in the exhilaration provided by supreme competence. Such competence may be thought of as perfect even where surpassed by others in certain respects, in that it is incomparable in its own way. A baseball player catching a line drive with grace and ease, a football player leaping for a pass, a swimmer rippling swiftly through the water, all may be perfect craftsmen and worthy of our respect. Every movement or gesture, posture or attitude, contributes simultaneously to the act and to how it is accomplished. In some sports, perfection predominates—skating, gymnastics, and diving. Where the skill is purely quantitative—as in the running the mile as swiftly as possible—perfection is meaningless. But where it predominantly involves style—and style is relevant to all sports—perfection is an incomparable achievement and is closely related in sports and art.

Sports are not arts, and for a variety of reasons lack full aesthetic value. First, the competitive element contributes an important mode of comparison, making winning more important than style. The need to complete a specific act defined by the sport—to score a run or a goal—undermines incomparability and sovereignty. Second, the range of possibility within the medium is limited, both by the rules of the sport and by circumstances. A particular game may inhibit the players' perfections. Third, sports greatly lack the other dimensions of the arts—invention and celebration. At times, a great sporting event may attain the celebrative quality of a work of art—a day to be remembered because of the events taking place during it. But it is usually the *day our team won,* not the day in which something was made or performed well. Noncompetitive sporting events approach artistic values more closely. Nevertheless, invention is seldom present in sports for its own sake. Finally, and most important, a game is not a construction but an act, a winning or losing, not the creation of something new. Only by suspending our concern for the end of the activity and emphasizing the movements performed can we make an athletic event entirely aesthetic. It is the conjunction of construction and creativity which establishes the significant difference between great sportsmen and great artists. On the other hand, there can be no great artist who is not a consummate workman in some respect or whose work does not call for consummate craft.

I have frequently described perfection as if it were a quality of an entire work—and it always is in important ways. But there are also the relevant perfections of the details, the constituents of a work, and these are inexhaustible. The perfection of a masterpiece of art is not simply that of the work as a whole, but includes how it is perfect in all the ways it is perfect. The perfection of the whole must be sustained throughout its constituents—though never all its constituents—a notion virtually identical with the notion of perfection itself, in which a gross integrity is maintained throughout a work and the constituents of its integrity. Perfection of the whole must be sustained throughout and is a function of perfections of the parts, of the work's constituents. This is another reason why perfection is not a comparative or superlative, not an excellence, which may be neither distributive nor aggregative. Nevertheless, the relation between the perfection of the work and the perfections of its constituents is contrasting, involving an inexhaustible range of similarities and differences, prevalences and deviances. These are essential to the sovereignty and incomparability of the work.

The prevalence of perfection, through the work and its constituents, is one of the most important factors making perfection a dimension of contrast rather than simply one of its major kinds. Whatever is relevant

to a work of art, to aesthetic value, is evaluated and judged in terms of its perfection*s*, the many ways in which it is completed, its many relevant excellences, as well as its inventions and celebrativeness. Works of art are inexhaustible, along with other orders, in that their constituents and their locations are inexhaustibly diverse as well as related, but even more important, because the relevant dimensions of contrast also apply inexhaustibly to their constituents.

Although perfection is an ultimate artistic value, rooted in the primordial contrast between what is ordinary and what is supreme, it ebbs and flows in its predominance within styles of art. It is a fundamental dimension of aesthetic value, and essential to all art, relevant to any value assigned to works of art. But the relative importance of the three dimensions of artistic value within particular schools of art varies. It may be that perfection is today in a time of ebb, while invention is paramount, originality more of a value than perfection. Yet when perfection wanes and invention is maximized, the sovereignty of the work of art is undermined. The greatest weakness of conceptual art lies in its lack of created perfection: it can have only a limited perfection while content with the idea alone. Lacking execution, it lacks perfection, authority, and sovereignty. Only where ideas are fully developed and articulated—in philosophy, particularly—can they gain sovereignty as works. The principle espoused by some contemporary artists that the work of art is to be used in the act of creation and then discarded makes a fetish of invention at the total sacrifice of perfection and sovereignty. We may speculate that many contemporary artists despair at what they take to be the remaining prospects of excellence and control. Nevertheless, though the responsibilities of perfection increase with the accumulation of great works, the challenge increases also—especially of wedding perfection with invention. It may be more difficult today to create perfect and original works, but possibilities of invention and controlled construction never vanish. The greatest artists may dazzle us with their originality, but they overwhelm us with their craft most of all. Only through perfection—wedded with invention in celebration—does a work of art gain supremacy and sovereignty.

Invention

In our time, originality and invention have become predominant in the arts while in former times perfection and celebration were emphasized. Where art was perceived as imitative—whether of ordinary objects or ideals—invention had a lesser role. Likewise, where the universe was thought to possess a hidden truth, to be attained through

revelation or inspiration, invention had no intrinsic value. Romanticism brought another extreme, a worship of the idiosyncracies of personality. One of the strengths of the theory of contrast is to establish the proper value of novelty in the arts at a time when it is too often perceived as an end in itself.

The answer to why invention was a subordinate value in the early stages of Western art is that it prevailed in the service of the other dimensions of contrast. The answer to why sheer originality has little artistic value in itself is that the other dimensions are neglected. The general answer is that artistic value is none of the three dimensions of value in itself, nor even all three together, but rather, intensity of contrast by means of them all. Inexhaustibility can be manifested through none of the dimensions of contrast alone. One central mode of contrast is of excellence with mediocrity, the perfect with the imperfect. Another is between the old and the new. In both cases, however, what was once perfect in its time and place may cease to be perfect; what was once new may become trite by imitation. Even worse, what is merely new attains but a minor contrast if difference is the only accomplishment. Contrast is intense only where similarities and differences are interrelated in subtle and elaborate ways.

In early forms of art—though perhaps not the earliest known—invention had few of the characteristic forms it exhibits today. Early artists were in one sense nearly without restrictions, wholly free, in that they lacked established artistic traditions and conventions. On the other hand, their creation had to be a valid and important achievement. It had to attain intense contrast, possessing none of the conditions in terms of which contrasts are now established. The invention was that of art itself, of modes and forms of contrast. The early artist created his art to serve in celebration so that his craft could be appreciated as an achievement.

Invention was so much part of early art that more extreme traits of originality were of no importance. Today, so much of experience has been rendered stereotyped that invention must be departure to be contrast. In early art, the most ordinary elements of experience provided effective subjects, for sufficient contrasts resided in the art forms themselves. Art itself was new. Early art was so full of invention relative to its conditions that novelties needed neither to be obvious nor gross to awaken attention.

Early art could not be art for its own sake—for there had been no art before. Art had to be invented before it could demand autonomy as a means to intensity of contrast. Early art was in the service of other values, drawing its contrasts from them. It follows that there is nothing

essential to art being "for its own sake." Such autonomy is but a powerful means to intensity of contrast. Some of our finest artistic creations have been in the service of practice and the divine. A work of art may be quite practical and serviceable—as are pots and houses—provided that its celebrative, inventive, and finished accomplishments are recognized as such. A work of art need not be *for* itself; it must, however, *be* itself and accepted as such, a creation of unique craft and invention.

Invention is a form of deviance. Like all deviance, it resides within and can be understood only in relation to prevalence. The relationship here, however, is far stronger. Invention is a mode of contrast in which deviance is produced by means of and in relation to prevalence. The relevant prevalences, here, are defined by typical and historical experience. Invention occurs only within established conditions. Even more important, it can be grasped, recognized, only in relation to prevailing conditions. The fundamental contrast in invention between deviance and prevalence gives rise to the fundamental importance of traditionary contrasts (see below, pp. 118-24). Art is produced at a time and place, and can be inventive only amidst traditions and established norms. It is important to emphasize, however, that invention is deviance relative to norms and expectations, relative to typical as well as historical experience, and relative to orders that prevail within such typical experience. This is what underlies the importance of deviations from established conventions, styles, norms, rules, genres, and patterns of thought.

Perfection is a contrast of prevalence with deviance; invention is a contrast of deviance with prevalence. The relevant prevalences and deviances are, naturally, quite different, although relative to and located within typical and historical experience. Perfection is inexhaustible along with the inexhaustibility of all orders, manifested strikingly in great works of art. Anything relevant to the integrity of such a work must be judged in its perfections. Invention is fully as pervasive, relevant throughout the constituents of a great work of art in relation to other works and established norms. It is inherent in the concept of unique style: permeating every significant element of the work with its idiosyncratic character. Most important of all, however, is the way in which prevalence and deviance together, in contrast, relative to all the integral constituents of a work of art, define its aesthetic value. Perfection and invention are conjoined in the concept of individual style, and are together a fundamental feature of artistic value.

None of the three dimensions of artistic value alone, nor even all together, is valuable as such. Each is a dimension of intense contrast. Perfection can be found in science, in philosophy, and especially in

technology and machines. But a perfect circle—despite thousands of years of tradition—has no aesthetic value in itself, only in its contrasting modes. Repetitions of the Mass may possess increasing liturgical value, but their aesthetic value declines as each service becomes indistinguishable from the others. Perfection, invention, and celebration are values only when they contribute to intensity of contrast. Only all together do they engender a supreme work with unique and unimpugnable sovereignty. Only together do they intensely manifest inexhaustibility.

A perfect circle, surrounded by many and indistinguishably perfect circles, lacks both intensity and contrast. An obligation is imposed to invent distortions without reproducing commonplace perspectives. Where dances and festivals are frequent, and contrast neither with everyday life nor tragic events, they become routine, lacking contrasting intensity. Even originality, where frequent and gross, lacks intensity in its contrasts. As we say, it is *merely* new, *merely* different—the novelties and departures producing only limited levels of contrast. Invention without perfection lacks intensity and range. Perfection requires invention to manifest inexhaustibility. Contrast is intense only where there are similarities as well as differences, where the similarities and differences manifest an inexhaustible variety of intersecting dimensions, where the work stands out not only in fertility of imagination but in depth and range of associations.

The importance of continuity in art cannot be overemphasized—the continuums of traditions, genres, and schools. A work of art novel in some respects, yet still belonging to a tradition, stretches the tradition and compels us to modify our artistic categories. It manifests the inexhaustibility of the past only by remaining continuous with it, manifesting its own inexhaustibility by reciprocation. The initial work in a new tradition gains in artistic value by virtue of contrasts with subsequent works, though its value is even greater when it is a transitional work, borrowing from the past and forging the future. Invention must be more than novelty to be of value. It requires the full interpenetration of the contrasts of perfection and invention.

Invention pertains to all the constituents of works of art and to all the categories of contrast: perfection and celebration are invented, as are the other modes of contrast. Among the most important inventions, however, is the invention of possibilities including the production of novel possibilities by other kinds of invention. Art may be regarded as a revelation, a play, of possibilities—a direct consequence of the manifestation of inexhaustibility. This manifestation of inexhaustibility is an interplay of contrasts involving the indeterminateness of orders in

relation to their determinate constituents—in particular, possibilities in relation to actualities. Included here are not only possibilities for different interpretations, given the same text and painted surface, but possibilities for standard materials transmuted into art, possibilities of development and resolution in performed works based on audience expectations, possibilities for different characters and events portrayed in representational works, possibilities of structure, pattern, and system—indeed, possibilities related to all the forms of order considered relevant in works of art. This revelation among possibilities, I suggest, is predominantly an emphasis on novelty and on novel contrasts involving these possibilities. Art is a revelation in possibility by invention. The interplay of possibilities with actualities—but also of these possibilities with the other relevant categories—integrity, scope, prevalence, and deviance—is a major component of aesthetic value. The invention of novel possibilities is perhaps the most overt way in which works of art manifest inexhaustibility as no other form of judgment and query can be expected to. It is the only thorough expression of the free play of the mind testified to in many theories of art.

Celebration

An important but neglected principle is that art is celebration. It is the basis of the third dimension of contrast, and is a pervasive condition of artistic value. Art has always been part of celebrative occasions as if they require the powers of a creative artist in commemoration. An occasion is celebrated when something is made or done in its honor. But action is transitory; therefore, a greater and more enduring commemoration is provided by the creation of works of art. Works of poetry, music, architecture, and sculpture are often the celebration of persons or events. Even works which have only themselves to celebrate commemorate the exercise of creative powers.

The reason why art may be regarded in every instance as celebrative—if not only celebrative—is a consequence of the nature both of art and of celebration. Art is sovereign construction, the creation of a being to no end but itself. It is intrinsically neither instrument nor truth—though it may be both—but construction, the free revelation of human powers. The created work must be sovereign, noteworthy, remarkable. It celebrates its own creation. Inevitably, then, it bestows some of its vitality upon its surroundings. Its inexhaustible sovereignty manifests the inexhaustibility and sovereignty of what accompanies it, sovereign prevalence in conjunction with inexhaustible ramifications and relations.

111

From the other side, a celebration is the cherishing of an event or person, signifying them as notable. A birthday celebrates a life. A national holiday celebrates love of country and joy at belonging. An anniversary commemorates the significance of an event. If an event is worth celebrating, it is to be distinguished from other times and events. And the event or person commemorated is the more memorable for what has been constructed in its memory. A work of art, then, celebrates by the honor it casts, and the greater its value, the greater the honor. Even the awesome act of creation in Eternity is the celebration of God in the likeness of man. The likeness is a contrast celebrating the glory of the divine and the exercise of its supreme powers.

We are speaking again of a mode of prevalence—in contrast with deviance—but not so much of the prevalence of a work among its constituents, but of prevalence in human life. Such prevalence is not simply a matter of enduring vitality: celebration need be neither participatory nor proleptic. A work of art can be perfect and inventive though remote and unknown. It may have been celebrative in creation and in experience, though celebrated no longer. Celebration expresses the prevalence of a work in lived experience, a function of all the ordinal categories and the other dimensions and types of contrast, a function also of the sovereignty, inexhaustibility, and incomparability of the work of art. Yet we can affirm and admire the function and prevalence of works in other cultures without celebrating them ourselves. We can understand the passions aroused by certain works without feeling similarly passionately toward them. Nevertheless, the perfection that a great work possesses that is a function of its capacity to absorb variation and change in typical experience and interpretation into itself gives rise to an enduring and consummate mode of celebration. Intensity of contrast is a function of the dimensions of contrast relative to some domain of lived experience. Greatness is in part a function of endurance, and is manifested relative to typical and historical experience, requiring the contribution of both perfection and celebration in relation to the work, but also of inventive interpretations that continue to manifest its inexhaustibility and sovereignty.

Every celebration is a creation: a wedding, anniversary, march, or party. All are festivals constructed for commemoration. The celebration succeeds when it renders the event unforgettable—therefore when what is created is also unforgettable: the greatness of a work of art. Perfection is essential here: the completeness of a work in all the ways that reward commemoration. Many men have purchased immortality in the works they commissioned in their honor—portraits, symphonies, or poems. Here art produces and enriches the celebration

112

more than it is celebrated—though both are involved where celebration is complete.

It is often of little importance that the original occasion of a celebration be remembered. We frequently forget the precise origins of our holidays, yet their celebrative qualities remain undimmed as if the celebration were valuable enough. Given the great value of celebration, quite apart from the events commemorated, it is no wonder that art becomes commemorative of itself. A fine work of art, whether or not commemorative of another event, is to be celebrated as an addition to the world. Elizabethan England is celebrated as the time of Shakespeare, while the kings of England are celebrated in the histories. The golden age of Greece is honored as the time and place of Aeschylus, Sophocles, Plato, and Thucydides.

Art is not the only greatness that can commemorate a time. History can celebrate people and events while science can celebrate life and natural orders. Philosophy, history, and science can celebrate their own powers, mankind ennobled in their greatest achievements. Celebration is a fundamental dimension of artistic value, but it is not sufficient to characterize art. Indeed, it could not do so where celebration is understood as but the relevance of art to the major events of human life. Rather, it is the close similarities between the qualities of celebration and art that enables them to join forces: celebration identifies something as unique and to be celebrated. When science and philosophy are profoundly celebrative, they do not become less philosophy and science, but they do become more art. They revel in the interplay of diverse modes of judgment. They celebrate natural orders and themselves by what is made in their honor. They construct in the service of truth, but their constructions are hallowed as creative achievements.

The celebrative dimension of artistic value may be regarded slightly differently—as that capacity of a work of art to signify its own character and value. Here the sovereignty of the work of art is emphasized in its active relevance to human events. An event is honored in celebration so that it will not be forgotten. A work is celebrated in its contrasting relations with other beings. Lacking such contrasting uniqueness, it is undistinguished, in danger of dissipation. We return to the primary meaning of art—the construction of intense contrasts. An intense contrast celebrates itself in being uniquely what it is: sovereign and remarkable. Every celebration, when successful, is in sharp contrast with surrounding events.

Here we may understand the splendors of performances apart from rituals and affairs of state. An evening in the theater or at the opera

113

may be a memory to treasure. Art here is a celebration of itself and the powers of the imagination. Where the event is no reward, nothing to celebrate, the immediacy and intensity of art are lost.

Intensity is the substance of celebration. Nevertheless, celebrations from which works of art are absent can be as full of splendor as the finest works, lacking only the enduring richness which great works can provide. Greatness in art belongs not to the celebrative moment, which can be given pomp and circumstance, but to a work which endures in the richness of its powers. Greatness in art is not a function of intensity but of endurance, for intensity is not a comparative while endurance is.

Nature and the Dimensions of Contrast

Nature is a supreme test of a theory of art, for aesthetic value belongs to natural orders as well as to art, yet the purposive character of constructive judgment imbues art with distinctive and remarkable features. An adequate theory of art must accommodate an aesthetic value inclusive of both found and constructed objects, yet must allow for the transformation that construction imposes on experience. Expressionist theories tend to define art in symbolic terms, leaving only a derivative value for natural orders. Yet such orders are both supremely beautiful in their most striking forms and are inspirations of the greatest works of art. Even more important, nature changes and develops under human influence, and comes to include all human works. Where aesthetic value is essentially cognitive or purposive, grounded in intention or symbols, it applies to nature only weakly or indirectly. Cosmological theories which emphasize the beauty of nature under sublime principles tend to make art a derivative form of natural order, allowing inadequate substance to the contributions of human beings in constructive judgment.

The ordinal theory provides a full resolution of these difficulties. There is, strictly speaking, no all-encompassing order of Nature, so that no order or natural principles can impose themselves on all things, everywhere. There are many and diverse orders surrounding us, some of which are dependent on human judgment and experience for their integrities, others of which include human events only in their scope, still others of which are irrelevant to human life and conversely. Ordinality provides the inexhaustible richness found impressive in art and found orders: the inexhaustible diversity of art and aesthetic value is due to the inexhaustibility of ordinal constituents and locations. On the other hand, found and created orders may share only the most general traits in common, varying with location and function, so that while

aesthetic value is common in a very general sense wherever it prevails—of inexhaustibility and intensity of contrast—it differs in important ways where judgment is a major factor.

The three dimensions of artistic value are relevant to all contrasts and aesthetic value, though modifications are required where constructive judgment is not involved. The five general types of contrast discussed below emphasize construction and judgment far more than natural orders, and express the creation of works in particular ordinal locations for diverse audiences. In this sense, orders possess aesthetic value through the three fundamental dimensions, with minor modifications, but are constructive judgments with artistic value through the five major types of contrast. The looseness of the taxonomy reflects both ordinal inexhaustibility and the inexhaustibility of rich contrasts. Even more important, it accommodates those remarkable works of art in which natural objects are transformed into art merely by display and presentation.

The dimensions of artistic value are perfection, invention, and celebration. They do not pertain to natural events without modification, for nature neither invents nor celebrates. There are rather novelties and departures in natural events which we celebrate for their presence and perfection. In addition, though nature is full of beauty and challenge, the three dimensions are not always equally present there. They are likewise not equally predominant in every fine work of art. However, in nature perfection of form may suffice for beauty. A striking departure may fascinate and overwhelm us. A natural event may be noteworthy through a predominant emphasis on only one of the dimensions of contrast.

Nature may neither celebrate nor invent, but natural orders may contain a full range of contrasts involving prevalence and deviance. The perfection of a found order is one grounded in prevailing conditions though departing significantly from everyday events whose dominant quality permeates the relevant constituents without diminution or incongruity. Novelty in natural orders is a function of prevailing natural conditions, largely typical in human experience but sometimes an expression of a natural pervasiveness unique within human life. I have in mind here the discovery of a natural uniformity pervasive throughout space and time, yet relatively unique in human experience. For example, were life to be absent everywhere else in the universe, the coldness and remoteness of the stars would be even more intimidating, pregnant with their own aesthetic values. Finally, found orders are celebrative, like works of art, in connection with important human events, entering into life and action.

115

In orders apart from man, there is no invention but there is novelty. There is no celebration, but there is noteworthiness. Nature provides us with material for celebrative experiences, though she does not utter celebrative judgments. The climb to the top of the mountain is laborious, step after step, perspiration streaming down, the immediate view only yards ahead. At the peak is the vista, the panorama below contrasting sharply with the approach. Nature is full of aesthetic value when celebrated for her distinctiveness. The poignancy of the experienced vista is due in great measure to the context of lived experience it brings to culmination, a major element of celebration.

Found orders may be loved, the silence of the woods, the perfection of the flowers, the song of the birds. Perfection is everywhere, for anything can be celebrated as a recurrent fulfillment of natural order. God's immanence in everything repeated recurrently in all its constituents and relations is an aesthetic principle: the divine and perfect order contrasted recurrently and inexhaustibly throughout every natural order. The aesthetic value is achieved through a cosmological vision in which individual beings are taken to be expressions of a consummate design. In the small, natural objects may be imperfect in relation to their parts and constituents; these are the deviances in contrast with which the cosmic design is appreciated as prevalent.

Even imperfection carried to fulfillment becomes a natural completion—the Badlands of South Dakota or the Grand Canyon of the Colorado River. Orders imperfect in some respects can be perfect in others, a consequence of a certain focus of attention in which we dismiss the imperfections as irrelevant. We define a perspective, by our particular mode of attention, in which relevance is restricted, enabling us to regard found orders as perfect in all relevant respects, sovereign and unique. In this sense, every order can possess aesthetic value, though based on restricted locations and perspectives. In the larger matrix of human life and art, however, such orders may be incomplete and trite, and it is such larger contexts which establish the normal basis for critical judgment.

Invention as such is lacking in natural orders, and for this reason found orders cannot be art. But orders are indefinitely complex and continually new, and novelty is more than enough with perfection to provide objects for celebration. What belongs to nature is often new to mankind, in their travels or discoveries. There are also new species and mountains rising from the sea. New forms of life are often objects of celebration, even when not novel in kind, but merely in place. Landscaping is an art. But nature too, filling in a field or swamp, establishes noteworthy qualities.

116

Nature is remarkable—and that is aesthetic value: remarkable in her perfections, novelties, and what is worth celebrating. In addition, nature can be made remarkable and celebrated as our limitless home, unbounded and inexhaustible. The remarkable character of the natural world is that it is never exhausted, always new, filled with new opportunities for celebration. And yet, though inexhaustible, nature is often the same—in her basic laws, her cycles and recurrences. The central contrast of natural orders is that they are both inexhaustible and repetitive. This is the splendor of the natural world, its wonder and fascination. It is expressed most forcibly in the principle of inexhaustibility. Orders are inexhaustible, and there is no integrity to nature altogether. The contrast of orderliness and inexhaustibility is the supreme contrast inherent in the aesthetic value of our natural surroundings, manifested in an inexhaustible diversity of forms of relevance.

Nature is filled with aesthetic value though she lacks invention. The dimensions of artistic and aesthetic value are essentially equivalent; the difference is that art is intentional and methodic, the contrived pursuit of aesthetic value. Nature is filled with perfections and novelties as well as materials for celebration. But she neither constructs nor celebrates. The difference lies in judgment and method: art is methodic judgment, the construction of works to attain aesthetic value. In this methodic process, aesthetic value is transformed into artistic value: perfection remains a central dimension, imbued with imagination and methodic skill; novelty is transformed into invention, enhanced by the freedom of the imagination; materials are transformed into celebration, a fulfillment of artistic powers.

GENERAL TYPES OF CONTRAST

We move from the dimensions of aesthetic value to general types of contrast of particular importance to art. I will discuss five such general types. The fact that even these five do not exhaust the contrasts in art suggests that aesthetic contrasts are inexhaustible. Ordinal inexhaustibility is the foundation of art, the source of its richness, inventions, and complexity.

Perfection, invention, and celebration are dimensions of contrast, relevant wherever contrasts prevail, therefore relevant throughout experience and judgment, but of particular application to aesthetic value. With modifications, they are applicable to nature as well as experience, to found orders as well as created orders, and to all aspects of experience, not only to art. The five general types of contrast are particularly

117

relevant to art and to constructive judgment: they manifest the construction of a work of art at a time and place, in relation to traditions and expectations, and out of materials which in art are transformed into a medium; they also manifest the plurality of arts and artistic mediums, of modes of judgment, and of audiences and their interpretations. Art is constructive judgment, expressed in five general types of contrast. Art also attains aesthetic value, expressed in the three dimensions of contrast and in the importance of integral and scopic contrasts, which are a direct function of ordinality.

Many other types of contrast are relevant to works of art and aesthetic value. Several of these will be discussed in the next chapter. All are relevant to different kinds of aesthetic value, to art and to found orders, but in different ways depending on the aesthetic values involved. Contrasts are inexhaustible because orders are inexhaustible and because art is the manifestation of inexhaustibility. The inexhaustibility of contrasts is expressed in two general ways: in the interaction of contrasts at higher levels of complexity, producing contrasts upon contrasts indefinitely, involving all the different types of contrast in further contrast; and in the inexhaustibility of kinds of contrast, the emergence of new kinds of contrast, entering into new forms of interaction at still more complex levels of contrast. Inexhaustibility makes every taxonomy of contrasts insufficient in fundamental ways. Nevertheless, the classification I am proposing makes this inexhaustibility central.

Traditionary Contrasts

Human beings live in societies and inherit from their environments. Artists and their works therefore belong to traditions, schools, and cultures, and even more generally, to time and space. We might say that all human works have a temporal character—though I am not sure that the real number system and abstract algebras have temporal locations, nor even that *Hamlet* and *Don Giovanni* are to be located in a particular historical time and place. More to the point, however, if such works belong to their periods, Ophelia and the Commodore's ghost have a time and space of their own, fashioned through art, and do not belong to the space and time of everyday experience. Art creates new times and spaces, new *worlds*, in which events transpire and creatures act. More precisely, works of art create (or "are") new and complex orders in which novel spatiotemporal relations sometimes prevail. Ordinality and relevance are of general applicability to art, as are spatial and temporal contrasts. But there is the special importance for

118

works of art of their historical and traditional locations, of their con-
struction in human milieux. Traditionary contrasts do not simply ex-
press the historical truth that an artist is certain to borrow from
predecessors, to be influenced by and to influence others. They man-
ifest the important values which belong to a work by virtue of its
traditions. In Donald Francis Tovey's words:

> It is very doubtful whether we could fix our attention on any work of art
> unless a majority of its elements were familiar to us. It is only by that
> majority that we could notice the strangeness of the rest. On the other
> hand, where we can see no strangeness, we can feel no interest. All that is
> new must be true, but it depends on our own experience how far anything
> is new.[4]

A work of art may be viewed as a historical product. This is a function
of its character as a judgment. It belongs to a time, a country, and a
social or economic class. It may be a revealing example of the work of a
school, a break with its predecessors, or a transitional movement to new
directions. It may be interpreted to display the character of its time or
to significantly depart from it. It may be contrasted with other works in
the same medium or with works in other mediums, as we consider
romanticism in both music and literature. Political, social, intellectual,
and theoretical developments may be contrasted with the work whose
character is expressed by relevant similarities and differences. An
inexhaustible range of contrasts is elicited by such approaches.

History concerns itself with spheres of human development encom-
passing diverse occurrences. Art is but one strand in the fabric of such
history, and a work of art possesses character and value in terms of the
interconnection of the various strands. History is full of contrasts,
many of which are relevant to a work regarded as a historical product.
Intentionally or not, an artist belongs to history and is influenced by it
even while he departs from it. Art in history is full of poignant and
compelling contrasts—the artist who would be the perfect embodi-
ment of his tradition only to depart subtly from it in his individual
genius; the artist who would forge a new achievement in his imagina-
tion only to belong to his time and place by influence.

Tradition represents the relatedness inherent in experience and
judgment carried over into art, supplementing the relatedness of phys-
ical objects in virtue of their spatiotemporal locations and based on the
relatedness essential to orders and their constituents. As a physical
object, a work of art reflects technological advances in its means and

4. Donald Francis Tovey: *A Musician Talks*, "Musical Textures," London, Oxford
University Press, 1946, p. 1.

perfections. As a member of a school, an artist exemplifies and departs from his tradition. As a member of a society, an artist reflects his inheritance and creates what will be inherited by his descendants. A work of art always belongs to an age which provides a diversity of contrasts for it. The history of art is a branch of history, but it is also a branch of criticism, elucidating the values of a work of art in terms of the contrasts within and among its traditionary relations.

All judgments belong to history and emerge from traditions. Works of science and philosophy as well as art, great political enterprises, all engender traditionary contrasts. A fundamental and pervasive feature of constructive judgment is involved here. Science and politics are wedded to goals and standards which engender traditionary contrasts but which only restrictedly value them. Art pursues intensity of contrast, including contrasts within and among traditions, involving conformities and departures. As a consequence, tradition and history play a role in art which they are not allowed to play in science—though there are philosophers who believe that the traditions of philosophy are essential to the intelligibility of contemporary works. It is often said that the history of science is fascinating—but for philosophy and history, sometimes for art, almost never for scientific progress. Where history and tradition appear essential, as in the understanding of social institutions or history itself, it is not as a source of contrasts, but as a determinate basis for understanding. History and tradition, as a basis of contrasts upon contrasts, are essential components of the inexhaustibility of art, but are not similarly regarded in the advance of science, and are frequently neglected, manifesting the disregard of inexhaustibility typical of scientific understanding.

Like every other type of contrast, traditionary contrasts manifest the three fundamental dimensions of contrast. Works may be perfect embodiments of their traditions or depart inventively from them. Indeed, the interaction of traditionary contrasts with the dimensions of perfection and invention engenders much of what we think of when we speak of artistic *style:* the establishment by an artist of a tradition inventive relative to its antecedent traditions yet pregnant also with their qualities. We celebrate art in relation to a tradition wherever we think of common and enduring styles or consider contrasts due to changing conventions.

Where inventiveness is overemphasized, traditions in art may be viewed as fetters confining the imagination of the artist. Constraints of circumstance pertain to all men, and the artist no more than the scientist or philosopher can transcend the confines of historical condi-

tions. But in art, unlike philosophy and science, whose rigor imposes restrictions commensurate with natural orders, artistic invention has suggested a total freedom of imagination, soaring without confinement of any sort. The absurdity is often masked by the natural restrictions of the medium, where it is not imagination that is thought confined but the realization of a free vision in dross matter.

Properly respected, tradition in art is not confinement, for sheer invention is no value without intensity of contrast. What is merely new means and says nothing, lacks potentiality for interpretation, and lacks significance as well. It is what is new in contrast with what is old, ordinary, and mediocre that bears aesthetic value. Such novelties, though seemingly restricted in comparison with what is utterly new, are opaque and alien enough. The history of music is filled with the outrage of audiences and the shock of novelties—even for musicians themselves—where conventional expectations have been violated. Tradition defines a floating ground against which inventions may have meaning. It is the field of common, hallowed, and ordinary expectations against which may be defined the oppositions of intense contrasts, typical experience in contrast with variations and departures.

Where artists would defy all traditions—as if they could—they do not merely stunt their imaginations, which grow large in the soil of community and order, but abandon nearly all prospects of greatness. This claim is somewhat exaggerated, for tradition is neither the sole nor the basic source of contrast in art: but it is an established and vital contrast—that achieved within classical style by Haydn who developed it and Beethoven who departed from it; within impressionism by Seurat as contrasted with Matisse who departed from it; within architecture by Sullivan and Wright. One of the most prominent and important contrasts in art is among the members of a natural grouping—within a genre, period, school, or common location.

André Malraux makes much of the collective style of works of art, the enhancement of works by their context, the informing of a style by the different works belonging to it. Art galleries rip art from its contexts, making presented works quite style-less. "The modern art-gallery not only isolates the work of art from its context but makes it forgather with rival or even hostile works. It is a confrontation of metamorphoses."[5] "For over a century our approach to art has been growing more and more intellectualized. The art museum invites criticism of

5. André Malraux: *The Voices of Silence,* tr. by Stuart Gilbert, Princeton, Princeton University Press, 1953, pp. 14-15.

each of the expressions of the world it brings together; and a query as to what they have in common."[6] Malraux's most compelling observation is that:

> It is a revealing fact that, when explaining how his vocation came to him, every great artist traces it back to the emotion he experienced at his contact with some specific work of art. . . . What makes the artist is that in his youth he was more deeply moved by his visual experience of works of art than by that of the things they represent—and perhaps of Nature as a whole.[7]

Art arises from art, collectively and in a tradition. A common style is no accident and no limitation, not even a common language as if many artists had no other. It is a profound and important element of art, the contrast between what is common and what is individual. Invention can never be entire, nor should it be: variations within and among a common style are more intense and powerful. Perfection requires a community of standards, however broadly conceived. It seeks style rather than individualized creation. "The striving for perfection implicit in all works of art incites it far more to stylize forms than to imitate them."[8] Many works together in a common style celebrate each other as well as their individual achievements.

Except in extreme forms, the contrasts available through tradition do not require weak traditions and expectations. Any tradition, however strong, provides more than enough room for invention. This is a consequence of the prevalence of possibilities in every order. No rule, law, compulsion, or order can be so complete as to eliminate all possibilities. There is always room for originality among the possibilities of a tradition. Analogously, the absence of tradition would inevitably leave room for similarities, at least within the confines of the constraints of the medium. There cannot be inventiveness so total as to lack order. Nevertheless, the presence of strong traditions makes inventions and departures more compelling, and leads directly to complex and higher-level contrasts. Of particular importance in traditionary contrasts are contrasts involving actualities and possibilities. These are relevant to all orders, and traditionary contrasts are relevant to all judgments. They are emphasized in art by the value of intensity of contrast, in particular, building upon the complex contrasts among the work, the traditions to which it belongs, and the standpoints from which it subsequently is

6. Ibid., p. 15.
7. Ibid., p. 281.
8. Ibid., pp. 71-72.

viewed. From such later standpoints, there is an irresistibility to the larger traditions of art, for originality is often attained by a revival of older forms. An impetus to imagination is often found preeminent in what was earlier abandoned.

Traditionary contrasts are relevant wherever there are traditions— including those of a non-artistic nature. Where traditions endure, works gain vitality from their roles within and departures from the tradition. Where traditions change, works gain vitality from inhabiting diverse traditions, possessing contrasting qualities for different audiences and resident within different cultures. I will classify such contrasts as "intersubjective." though they may be regarded as traditionary in part. Traditions are a vital constituent of value in all works of art; so also are the communities to which works of art are relevant. Traditions and communities are inseparable; still, there is the social community with its traditions in which art plays a role, and there is the "artistic community"—be it one or many—including artists, critics, and audiences. It has been thought useful to interpret works of art entirely in terms of their communal or institutional roles.[9] Where changing communities and divergent traditions are emphasized, this approach can be among the most effective avenues to the values of works of art. Some of the relevant values are clearly traditionary. But unless emphasis falls on the contrasts which are a result of disparate communities and roles in relation to individual works, the artistic community is made too monolithic, as if a single tradition could establish the nature of a work of art.

Related to traditionary contrasts are contrasts drawn from even larger temporal perspectives, ascribing permanent myths to mankind which recur in changing forms, archetypic interpretations seeking a unity throughout art based on central metaphors and dominant symbols. Mythic and archetypic interpretations reach an extreme in one sense: they ascribe permanent features to art reflecting an unchanging character of human life manifested throughout an indefinite variety of individual forms. The basic principle, however, is one of contrast, finding within the individual work a uniformity larger than itself, larger than the corpus of the artist's work—whether social, historical, mythic, or archetypic—and treating aesthetic value as a function of complex, subtle, and inexhaustible interrelations between individual works and the enduring uniformity. Whether the enduring character be unconscious and hidden as in myth and underlying feeling, or

9. George Dickie: "Defining Art," *American Philosophical Quarterly*, VI/3, July 1969, pp. 253-56.

explicit and intentional as in conventions and norms, the value found within the individual work is a function of the contrast of its specific individuality with the larger uniformity. Tradition belongs to every work of art as a fundamental element of artistic value—though the contrasts attained by a sovereign work may be anything but traditional.

Intramedial Contrasts

To this point I have made little of the art medium—perhaps the most salient characteristic of works of art. All created orders, all human judgments, are made from materials. Yet for many judgments, materials are minimized if not neglected altogether. The shape and strengths of the body are paramount in sports but largely neglected in political and social action. The sound and figurative aspects of language are frequently neglected in scientific discourse. Materials are always present in judgment, and some features of materials are important in any particular judgment. But only in art do materials become transmuted into a medium. This is because of the paramount importance of intensity of contrast. It is a consequence also of the importance of inexhaustibility in art and constructive judgment. The development of strongly characteristic mediums with established traditions produces intensity of traditionary contrasts but also intensity in intramedial and intermedial contrasts—those dependent on the medium of an art. The heightening of the qualities of the medium leads to intensity of contrast both by augmentation—the development of the medium—and by variation—the characteristic properties of the medium in contrast with inexhaustible departures. Contrast is particularly intense where every feature of the work of art can be traced to its medial expression. Inexhaustibility is manifested most thoroughly where the medium, in its inexhaustibility, is prominent by contrast in the inexhaustibility of the work of art, relevant throughout its major contrasts.

Writers on art have paid great attention to the *purity* of an art—music without words, dance without music, unpainted sculpture, and the like. Far too often, they have reached exaggerated conclusions concerning the importance and value of pure arts—chamber music compared with opera and song, painting compared with stage design, sculpture compared with architecture, modern dance compared with ballet. Such conclusions betray simplistic conceptions of artistic value. Even Susanne Langer's relatively sophisticated theory of *assimilation*, that a mixture of arts is always in the service of a dominant art, makes the development of a novel art nearly unintelligible. She expresses some of the interesting characteristics of intermedial contrasts, but entirely

124

neglects the richness and intensity of contrasts engendered through intermedial invention, the creation of new arts.[10]

There is a truth inherent in the conception of pure arts. It is quite unrelated to their relative value. There are remarkable differences among several of the major arts—not all, for where there is mixture, as in opera, song, poetry, and theater, there are bound to be similarities. However, among several of the most important forms of art, there are few surface similarities and many salient differences. Although painting and sculpture may have similar content, their mediums are remarkably different. The so-called "pure" arts—painting, sculpture, dance, music, and poetry—may be regarded as essentially distinct in virtue of the different possibilities inherent within their mediums. Such distinctiveness of art mediums is an important component, I am suggesting, of intense contrasts in works of art.

Emphasis upon intramedial contrasts does not diminish the importance of intermedial and extramedial contrasts, though it may affect their character. Emphasis upon one of these can contribute to the others. This is one of the major features of the notion of contrast and is essential to artistic value. Intramedial contrasts express the materials of the work of art, its production as constructive judgment. But emphasis upon the uniqueness of particular materials is attained in relation to and in contrast with other materials. The singularity of one art medium is particularly intense when conjoined with possibilities inherent in other mediums and outside art—through intermedial and extramedial contrasts. Nevertheless, intramedial contrasts are of prime importance because they express the technical powers of the artist in relation to what he has made as no other type of contrast can.

An artistic medium, even where there is little admixture of forms, possesses considerable complexity. Painting, for example, admits of variations of line, color, and texture as well as of space, form, and various modes of balance. Thus, as in the middle works of Matisse, we may find relatively smooth lines coordinated with obtrusive and demanding conjunctions of color. There may be contrasts in line, some heavier, more curved, more angular, longer or shorter than others; contrasts in color, varying shades of the same hue, varying intensities in the same space, as well as contrasts among juxtaposed colors—whether alike or very different; textural contrasts, paintings with heavy textures and prominent brushstokes, others with nearly hidden brushstrokes and smooth textures, also variations within a single painting; contrasts related to the balance of forms—triangles, rectangles, forms upon

10. Langer, *Feeling and Form*, Chapter 10.

forms, etc.; diverse compositional balances achieved not only by lines and shapes, but by the "weight" of the colors and their intensities. These are all contrasts in the two essential respects that the properties of a given pictorial element are a function of other elements in the particular painting as well as pictorial elements of other paintings, and that a painting is a complex composite of similarities and dissimilarities among pictorial elements, each retaining individual properties while affected in important ways by the conjunctions. I am not including here the contrast between a represented object and its form in the painting. A portrait is constructed within its medium and contrasts with the person it would represent—for it can never copy him exactly. This contrast I will postpone to later discussions, though it could be intramedial in a highly representational medium.

In music, the elementary components are notes and their varying durations as performed by different instruments with distinct auditory characteristics in unison, harmony, or counterpoint. Various musical lines may be developed for each instrument, playing against each other, forming harmonies as well as varying textures, melodies, movements, dynamic tensions, dissonances, tonalities, phrases of varying length and structure, and so forth indefinitely. Every important art medium is inexhaustible in its intramedial contrasts alone, since medial complexity is so prominent and obtrusive. Where we come to sense the depletion of possibilities in an art, it is usually due to the depletion of possibilities within a style rather than the medium.

A striking feature of Western music is that while sounds in music are, like all sounds, comprised of tones, pitches, timbres, and varying amplitudes, the basic timbres are found in music alone—or have largely been so until the twentieth century. The basic pitches are also more definite in music—clearer and more analytical. On the other hand, as if to compensate for such a singularity of medial elements, ensembles of instruments have until the twentieth century been relatively conventional—the string quartet, quintet, solo piano, symphonic orchestra, etc. The great range of novel possibilities in music has frequently been circumscribed by instruments and ensembles of a conventional nature. Although admixed with traditional and intersubjective contrasts, these stable forms, pitches, and timbres comprise a rich panoply of intramedial contrasts. We may describe them in terms of a contrast between familiarity and novelty—a familiarity bred of standardized expectations and primordial responses to sound coupled with novel combinations of tones and timbres.

A striking example of intramedial contrast—though conjoined with important elements of intermodal contrast—is that of metaphor in

poetry. In a metaphor, two or more significant meanings are held in identity, unlike a simile or a comparison, where the terms are merely alike. A simile is a genuine contrast, since the terms are represented as alike but the respect is not specified. In a metaphor, however, two obviously unlike terms are brought into identity, and the force of the connection either produces a remarkable intensity of contrast or dissipates itself entirely. Were there a complete identity, there would be no metaphor. Thus, a metaphor is one of the most poignant contrasts available in art, with a subtlety and richness attainable only in language. I am classifying it here as an intramedial contrast insofar as metaphor is the play of words and meanings upon each other. Insofar as metaphors look beyond (or "through") language to what is brought into contrast by means of symbols, to implicit claims and imperatives, they lead to intermodal contrasts. Metaphor is a profound and remarkable artistic device, containing elements simultaneously of many of the basic types of contrast. In this respect, it frequently attains a remarkable richness and intensity, involving level upon level of contrast.

A contrast which may be considered intramedial, but which I have classified as traditionary, is the contrast within a given medium of novel developments with older techniques. None of the types of contrast is entirely distinct from the others; they blur at their boundaries and overlap in complex ways. This provides an unlimited source of inventive possibilities for enrichment in art. Not only are the elements within a medium—tone and timbre, for example—interconnected in contrasting ways within a work, but both prior and later conventions of the medium inhabit our perception of the work and engage it in further contrasts. A medium may be viewed in longitudinal as well as horizontal relations. The relevant principle is that what an artistic medium is belongs in large measure to what it has become and how. Traditionary contrasts overlap with all other types of contrast, as they do with each other. This interplay is the source of some of the most intense contrasts in art, ascending to more and more complex interconnections and interrelations, all conjoined within a single work.

We may return to intramedial contrasts proper to note several relevant considerations, some by way of review. First, an artistic medium is inexhaustibly complex, comprised of diverse constituents which may be contrasted in diverse ways. There is multiplicity even where the range of materials is limited, a multiplicity from which an indefinite variety of contrasts may be generated. Pastel shades of color in juxtaposition may provide a more enduring intensity than gaudy and striking colors, which after awhile may pall. Although contemporary artists constantly seek new mediums for their work, and combine and

127

mix various arts, the possibilities within each medium have by no means been exhausted. There is novelty possible in electronic instruments, in wholly new sounds, but there are new arrangements of standard sounds as yet unrealized in music. The string quartet endures as a vital musical form. Nevertheless, a medium may appear to be exhausted, as nearly every harmony possible on a keyboard instrument has probably been played at one time or another, though not every cadence or sequence of such harmonies.

Second, the mediums of the arts are very different from each other. Such medial differences provide important contrasts where works of different arts share some common character—a common theme or content. Religious arts together illuminate and comment upon a common diversity, one especially intense in contrast where the arts involved are quite dissimilar.

Third, each medium has salient characteristics perceivable by quite untutored audiences; yet each also contains very subtle and sophisticated qualities. Paint, sounds, gestures, and language all are immediately recognizable and appealing. Certain colors appear to have standard associations—though I doubt that these in general are merely biological. Within a given medium it is the responsibility of the artist to work with both obvious and immediately perceivable aspects of his medium and more difficult, indirect, and even arcane aspects, if he is to create intense and enduring contrasts. These surface-depth contrasts are an important feature of the vitality of an art, and are admixed with all the other types of contrast.

It is worth emphasizing here the familiarity of bodily movements in dance. Unlike arts whose craft cannot be appreciated by a novice— instrumental music or sculpture—the medium of dance is apparent. We live with our bodies and have a strong sense of our capacities and limitations. Perfection of craft is apparent in all dance performances, more available for general appreciation than the craft of many other arts. The presence of the body and its possibilities in dance offers an extraordinary range of surface-depth contrasts that are inherent in the dance medium. Dance discloses to us possibilities for bodily movement that we could not imagine for ourselves, but which we can appreciate in manifold ways when we encounter them.

Analogous elements of craft and ability may be appreciated in both sports and song. Indeed, there are in all performing arts, but especially dance and vocal music, works which endure in their performative qualities because they exploit and amplify the achievements of the performer. Perfection is frequently appreciated in a performance as part of the vitality of a work, and virtuosity may sometimes be a

128

sufficient artistic value where the performer and the work attain a remarkable match, where the virtuosity leads to complex, higher-level contrasts. Not only virtuosity, but perfection in some performative quality such as tone or color may lend to works an enduring excellence and fascination.

Competitive sports are sources of spectacle because the audience can readily appreciate their craft and excellence. What we have all tried to do, when it demands extraordinary standards of performance, is appreciated by us in terms of its perfection in intramedial contrasts—in this case, bodily movement and consummate execution. There is virtuosity in sports that is the equivalent in perfection of the greatest virtuosity in music or dance, limited only relative to the other dimensions of artistic value.

Dance is always a perfection in bodily movement, and nearly always at the very limits of bodily capabilities. Moreover, a good dance is seldom good enough: we expect more than perfection, even bedazzlement, yet with a sense of ease. Dance is like sports in which the extreme possibilities of the body are continually being tested, and the celebration of consummate achievement is a central and supreme value.

The intramedial elements of an art provide a great range of valuable possibilities. The medium may be fulfilled, exploited, even violated. We may look within a work for perfection in its use of the medium, for originality, and for a celebration of the possibilities inherent within the art. Various colors and shapes may be perfectly balanced, attaining a perfection of order; sounds may be interrelated so as to fulfill conventional expectations or to violate them. Finally, in remaining within a given medium the artist celebrates his art as a form, bestowing new possibilities upon it. Michelangelo seems to draw out of marble forms of grandeur and repose wholly appropriate to it. Bernini elicits from the same medium movements and textures that stone could not apparently afford, releasing novel possibilities within the medium. Each generates a remarkable intensity of contrast, one by fulfilling our sense of the medium, the other by triumphing over it.

Every medium employs its materials, transforming their crude possibilities into the inexhaustible richness of a medium. In some arts, however—sculpture and architecture particularly—materials are exceptionally important, defining the major contrasts of the medium. Sculpture is less the formation of materials, as if any forms whatsoever might be imposed on any materials, and more an elicitation from a block of stone or vat of metal possibilities inherent within it yet invented for it. Strikingly, we often prefer works whose materials resist the forms imposed on them over those which are completely subordinated to the

artist's will. Such an emphasis on resistance of materials is fully explained by the theory of contrast as it cannot be by many other theories of art.

Materials are often crude and unformed, while necessity may compel us to use available materials as a tool. Sculpture, however, explores the novel possibilities of contrast inherent in formed tangible materials. Such contrasts include those between the traditional forms given to the material and the novel forms invented by the artist. The major contrast—the power of the greatest sculpture—is between the final form and the original material, which we did not imagine might be given so remarkable a form.

Like sculpture, architecture develops possibilities within physical materials. However, where sculpture is concerned with representational or formal and textural possibilities, architecture emphasizes habitational and functional possibilities. To an architect, a material is pregnant with possibilities of *use*. Here architecture is not clearly distinct from engineering, both seeking applications within human life. The importance of use and applications to human life colors every contrast in architecture, so that materials are always judged by how they function in human experience. Nevertheless, the importance of physical materials in architecture gives rise to a remarkable range of intramedial contrasts in which forms and tangible materials are both implicated.

The medium of poetry is language, and this is sufficiently unique that special attention must be paid to it. Poetry is the thorough exploitation of language as a medium—far more than prose, which is consequently more capable of rich and profound intermodal contrasts. Poetry revels in the music of language, its sound and rhythms, tones and lines, cadence and flow, even its appearance on the page. Where prose is musical we call it poetic—for prose otherwise emphasizes meanings, a vehicle for the transmutation of meanings into art. Of course, to the extent that prose is stylistic and idiosyncratic, and is comprised of motifs, repetitions, and imitative themes, it makes of language far more than a vehicle. Language is as inexhaustible in the novel as in the sonnet. No literary art can escape from the nature of its medium, nor should any art wish to do so. But poetry can least of all, since it is play in and upon language, the invention of inexhaustible possibilities for and within language, in inexhaustible forms. This is why poetry is so difficult to translate.

The basic character of poetry is its exploitation of the medium of language. Yet this is not sufficient to characterize poetry as distinct from poetic prose or elegant writing of moral persuasion. We may add,

130

then, the central impulse in poetry to economy and compression, to the maximization of contrasts within language with minimal means. This imperative is expressed most clearly in shorter poems, where compression is essential if a poem is to have significant scope. But even in the great epics, compression is exhibited in the rich and inexhaustible qualities given to the narrative that only poetry can provide—literary, economical, and sonorous. The *Iliad* revels as does all poetry in the images and associations possible through the medium of language. It tells its tale well, but does far more, inexhaustibly more.

Through emphasizing intramedial contrasts we come to one of the greater truths about art: that a work within its medium is remarkably specific in its techniques and accomplishments—a feature of its sovereignty. Not to know enough about the medium to understand these accomplishments is to fail to understand a great deal—not everything, for a fine work possesses intermedial and intermodal contrasts also, along with other kinds of contrasts inexhaustibly. Nevertheless, a work of art is always made in and of its specific medium, and if making is important, so are the intramedial contrasts within the work. Perfection, invention, and celebration are all quite specific in their role in individual works, particularly in relation to the art medium. The perfections of a work of art include its mastery of its medium, its originality in the medium, and the celebration of its particular medial powers.

Intermedial Contrasts

Properly speaking, intermedial contrasts are possible only after distinct mediums have been defined. Historically, however, mixed arts have often preceded the so-called "purer" arts—dance with music, music with words, painted sculpture, and so forth. It follows that we must consider intramedial and intermedial contrasts not as intrinsically distinct, or reflections of different stages in the development of art, but two facets of the same principle: the development of intense forms of contrast among and within the arts.

The significance of purity in art is two-fold: It contributes to the distinctiveness of a given art and its medial characteristics and enhances the intensity of intramedial contrasts. In addition, the plurality of diverse arts and art mediums, with relatively little intermixture, enriches the intensity of intermedial contrasts.

An obvious intermedial contrast is the song, music with words. Aesthetic theories have frequently exaggerated the differences between poetry and music, while the song is among the most natural and common forms of art. The result has been theories such as Beards-

131

ley's—where the poem and music must possess the same surface qualities—or Langer's—where the words are assimilated to the music.[11] Both theories are mistaken: the music of many fine Schubert songs could be hummed without words in quite different ways with different qualities; the first principle of lieder singing is to recite the poem to the music. The relation of text and music in song and opera is far more complex than the above views indicate, and looks to inexhaustibility and contrast. Sometimes there is mutual support, where music and words provide similar qualities which reenforce each other. Martial music supports a martial text. Bombastic music supports as bombastic text—as in "La Calunnia" from the *Barber of Seville*. Nevertheless, such a view is limited. There are two reasons why: First, though music and text may correspond in their emotional qualities, they frequently contrast emphatically—as Wolf's songs are often ironically bombastic in relation to Heine's romantic text. The music here adds dimensions to the poetry by contrast the way a fine actor can add to a drama what was not there before, in effect developing its character beyond its written indications.

The second reason, however, is of major theoretical importance. Musical emotions are not the emotions available in poetry and drama. Emotions in art are medium-specific, grounded in the importance of intramedial contrasts. Music can be martial by imitation, but it cannot be unequivocally sad, bombastic, wry, humble, elated, or shy. To any given musical setting, a variety of texts might be set with different emotional tones. The emotions contrast, but so do the consonants and phrases. Musical emotions are important, but they do not duplicate poetic emotions. Rather, they enhance and enrich them through intermedial contrasts. Differences of emotion and medium are as important as similarities. Words add qualities to the music it could not of its own possess, and conversely. Sometimes it is sheer sound—consonants and vowels imposed on the musical line. But there is little duplication, and little is needed, for it would be redundant. A great poem needs no redundancy of emotional tone through music. Rather, adding a musical setting can enrich the poem through higher-level contrasts. Added depth is gained through alternative and contrasting emotional qualities. Donald Francis Tovey has this to say here:

> We shall never begin to understand musical rhetoric until we realize: first, that not only are the habits of verse widely different from those of prose, but that the habits of music are widely different from those of words; and

11. Monroe Beardsley: *Aesthetics: Problems in the Philosophy of Criticism*, New York, Harcourt Brace, 1958; Langer, *Feeling and Form*, Chapter 10.

secondly, that it lies in the very nature of art to reconcile such oppositions, and that nothing is more radically inartistic than to sacrifice one of the opposing principles wholly to the other. It is doubtful whether art begins to exist without a reconciling of opposite claims, not by compromise, but by actual indissoluble compounding.[12]

The constraints of words can be severe, and the intensity of pure music is far greater than music on the stage. On the other hand, the fusion of words and music can be of immense emotional effect.

Music for the stage must live at a much lower temperature than purely intrumental music. . . . There are other intensities than that of temperature, and we need set no limits to the depth that is attainable in music for the theatre. While the temperature of *Fidelio* is consistently reduced at every point from that of *Leonore*, the depth is as consistently increased; and the listener need not trouble to explain the paradox that the emotional effect of *Fidelio* is point for point incomparably greater than that of *Leonore.* [13]

No account could more clearly represent the intensity of higher-level contrasts achieved in the greatest art. Music and text can engender a unique and intense contrast precisely because they are so different in their properties and in their capacity for interpretation. The poem and setting must be compatible—but not in the sense that one may be subordinated to the other or that they may be fused together at the expense of their distinct qualities.

The song is an ancient art. An intermedial contrast is not more unnatural than pure art forms employing primarily intramedial contrasts. There is nothing esoteric about intermedial contrasts, as if purity in art were natural or especially desirable. We may wonder, then, whether the entire notion of an artistic medium is arbitrary, misleading us into thinking that there might be a standard number of pure mediums which may be combined in intermedial complexities. Intermedial and intramedial contrasts cannot easily be separated, for the character of an art medium is manifested by both of them in any particular work.

The distinction between intramedial and intermedial contrast depends on the nature of a particular medium, and this is largely a matter of historical accident, a function of the turns art has taken in its development. The notion of contrast here is essential, for it entails the double movement of art both to greater complexity among medial components and to simplicity relative to past complexities. Given the

12. Tovey, *Musical Textures*, pp. 32-33.
13. Tovey, *The Integrity of Music*, p. 97.

arts of music, theater, and song, composers were bound to experiment with musical drama and opera, interpreted here as intermedial contrasts. But also, given the art of song, composers were bound to experiment with instruments and voice alone. Such a simplification is first of all an intramedial contrast, the isolation of elements among complex contrasts. But as the innovation becomes standard, it defines a novel artistic medium and engenders works which gain power from complex intermedial contrasts.

Whether a given contrast is intermedial or intramedial depends on the nature of the relevant mediums, and this is always partly a historical matter—in terms both of the time of the work and the time the contrast is interpreted. Traditionary contrasts are inseparable from intramedial and intermedial contrasts. The historical development of the arts has tended toward the analytical, as the intramedial contrast of simplification leads to purer arts which are then recombined in intermedial contrasts. A proven way to intense contrast is through purification and simplification, a trend often found within the developing stages of an artist's work. A painter, for example, may experiment separately with colors, then lines and shapes, thereafter with a variety of sizes and patterns, subsequently recombining them in terms of his separate discoveries. Whether painting is regarded as a simple medium affording primarily intramedial contrasts, or as a mixed medium comprised of drawing and coloring, depends on the analytical skills of the viewer and the separate development of the relevant mediums. Drawing is regarded as a separate art; coloring is not. Intermedial contrasts depend upon the audience's sense of the possibilities resident within the established mediums. Our evaluation of a work looks to how these possibilities are realized and whether they are enlarged by other arts.

I have considered only the song as an example of intermedial contrast, though there are many others. Painted wooden statues were common in medieval art, and our perceptions are strongly affected by our experience with marble and wood in unpainted forms. The *Parthenon* reliefs were painted, though we do not know quite how, and are satisfied with the purity of their intermedial contrasts. Dance is nearly always to music, though there is a purity of dance alone, analogous with *a cappella* singing. A component which is usually conjoined with others in an art form can take on striking qualities when isolated from them—as does color alone in minimalist painting. Such art partly draws its power from the other works with which it stands in contrast. White on white alone, were it the only type of painting made, would be an absurdity (unless there were subtle variations possible in intramedial

contrasts). Traditionary contrasts are essential to both intermedial and intramedial contrasts.

Theater is an art which dwells permanently among intermedial contrasts, converting other arts to its purposes, continually transforming intermedial into intramedial contrasts. The plays of Shakespeare comprise an obvious and excellent example of intermedial contrast: the poetry make sublime works of well-constructed dramas. Of course, theater—though a great art—is not a supreme art, for there is none. Complexity is a supreme value in art, but only to a point of fatigue, whereupon intensity of contrast reverts to simplicity.

Traditional ballet is dance with dramatic character: it employs music and costumes, and tells a story—though not in words. The major contrast in ballet is between the dance proper and the dramatic elements. Great performances can be achieved where primary emphasis is given to virtuoso dancing and also where the drama is made supreme and the dance—though flawless—is subordinated. The same is true in opera, where the singing and the drama are in permanent tension. Perfect vocal phrases are not quite dramatic enough, while magnificent acting would upset the pace and character of the musical development. Every great performance of *Otello* is a compromise among the purer arts achieved at the level of more complex contrasts. I consider this state of affairs to be the essence of intense intermedial contrasts. Each of the purer arts is transmuted in their interplay. Wagner sought to recapture ancient drama, yet he subordinates the voice to the orchestra and the drama to the music. Nothing could make *Tristan* a great drama; its achievements are primarily musical. Nevertheless, Wagner has capitalized on intermedial contrasts, in this case by subordinating one medium to the other in a supremely musical way, the voice nearly become an instrument—though it can never quite be one. The *Liebestod* without voice is another work, not Isolde's elegy to posthumous love, a work based on both intramedial and intermedial contrasts.

Intermedial contrasts thrive on the development of the separate arts and their established mediums. They are the source of new arts yet are dependent for their force on older forms. Here again, tradition plays a central role. Great works of art define new possibilities for their mediums while subsequent works feed upon the achievements of their forebears. Intermedial contrasts depend upon and manifest inexhaustibility, the capacity of works and their mediums to take on novel integrities in the context of prevailing conditions and established norms. It is in virtue of the greatest achievements within an art that the most profound and intense intermedial contrasts are produced, their intensity provided in part by reflected light.

135

Intermodal Contrasts

The diversity and variability of different arts and their mediums are the source of both intramedial and intermedial contrasts depending on the precise boundaries of particular arts. These contrasts work together, producing additional contrasts, and are a function of the historically determined characteristics of particular arts. From a purely theoretical point of view, we might transform all arts into one, all intermedial contrasts into intramedial contrasts relative to the one Art. This would affect our interpretations of individual works but not our theoretical understanding of contrasts in art. It would affect the kinds of contrasts understood to be relevant to particular works, even the complexity and richness of levels of contrast relevant to individual works. Art is divided into diverse arts to produce new and rich types of intense contrast. Nevertheless, however we view the relationship between intramedial and intermedial contrasts, individual works are both sovereign and inexhaustible, expressed through inexhaustible contrasts of either type.

Of far greater importance for the theory of art, and especially for the ordinal theory of judgment, is the plurality of modes of judgment. Art is a mode of query emphasizing constructive judgment. But it also emphasizes intensity of contrast, and there are important contrasts inherent in the diverse modes of judgment. Art manifests inexhaustibility—an inexhaustibility revealed in the inexhaustibility of judgment and query and manifested also in the diversity of modes of judgment and methods appropriate to query.

There are many modes of judgment. I have identified three; a fourth may be introduced here: assertion, construction, comprehension, and action. The natural paradigm for each mode is science as assertion, art as construction, metaphysics as comprehension, and morals as action—though each is enriched by intermodal interactions and is more properly a mode of query emphasizing a given mode of judgment. Each of the modes of judgment possesses a unique mode of validation: truth, artistic value, adequacy, and moral value. For our present purposes, it will suffice to note that "judgment" designates appraisal, evaluation, choice, and decision in relation to its defining mode of validation. Propositions, actions, categories, and constructs are all chosen, correctly or mistakenly, as a result of deliberate and methodic decision, and may further be judged as valid or not. Each mode of judgment has its unique methods and types of validation.

Art is primarily a form of making and is predominantly constructive judgment. But art is the creation of intense contrasts, and cannot be

136

expected to forgo contrasts among the different modes of judgment. Even more important, a work of art cannot be confined solely within constructive judgment. An artist acts in constructing a work and implicitly expresses claims about himself, the world, and art. A fundamental principle is that every judgment may be interpreted in any mode. Every mode is pervasive throughout judgment, in that every judgment may be given any modality.

The mixture of modes inherent in every work, coupled with the imperative of intensity of contrast, lead easily to the problems of truth and utility in art. If a work may trifle with the truth in its pursuit of contrast, it may also pass for the truth, even *be* the truth. It cannot help us to take refuge in the view that art is imitation, for an even greater contrast awaits us than that of conveying the appearance of truth—that of attaining it.

Thus, if there are works of literature which are pure fantasy, there will be others seeking to reproduce the qualities of human life in minute detail, however trivial or ugly. If there are works of philosophy of breadth and compass, there will be works of art imitating them closely. Most important of all, there are ascending levels of complexity in contrast, and if it is possible and legitimate that a work of art might *pretend* to be truthful (in contrast with those that do not), there are other works which *are* truthful and which must be accepted as such. Here we may consider not only literature but impressionist paintings which are claimed to reproduce the interplay of light and shade. It is not possible to read *The Brothers Karamazov* without consent to its premises and conclusions—though perhaps, only so far as necessary in order to grasp the contrasts involved, and not so far as to act upon them. What is called "suspension of disbelief" is a misnomer, as if we are to read a work of literature dispassionately. Rather, we are to read it with complete conviction, though there remains the contrast of not quite capitulating—for after all, we are seldom being argued with, nor must we be convinced to the point of action.

Plato condemns Homer and the Greek dramatists for lacking the epistemic authority to be morally and factually persuasive. He admits, then, that art may pose as assertive. We are also aware that works of art can exert a strong influence on their audiences, and are thus active. However, a work which is obviously false cannot provide effective intermodal contrasts. It can neither persuade nor move us. It is the greater works which seem most true, at least in their parts, sometimes in their compass. And there comes a point where the illusion of truth is indistinguishable from its realization.

137

Nevertheless, intensity of contrast may be dissipated where a work is primarily a vehicle for truth or action. A scientific treatise may be elegant and influential, but its primary function is to be faithful to the facts. A moral action may be skillfully rendered, but its primary function is to be right in terms of principles and consequences. A work of art may be regarded as propositional in character—in which case, its arguments and the available evidence are of utmost importance, not the attained contrasts. It may also be regarded as an act of creation, and we look to its consequences and to the principles which govern them. However, it is not the created contrasts which are essential here, but their effects. Truth and utility are part of art in intermodal contrasts, though they are never the ends of construction as a mode of judgment.

I argued in Chapter 2 that appearance-reality contrasts do not provide a sufficiently general foundation for artistic value. Nevertheless, there are arts and works of art in which appearance-reality contrasts play a central role. I will classify these as intermodal to the extent that they involve a concern with truth about what is real and what is illusory. In an ordinal theory, appearance and reality are functional distinctions, for all orders are real as orders though they may be appearances relative to their function in other orders, passing for them. Art is profoundly concerned with the richness and inexhaustibility of ordinal functions, in intense contrast; as a consequence, appearance-reality contrasts are of major importance in many works of art.

In particular, we may consider representational, illusionary painting. Such painting can be realistic, nearly like its object. But it cannot attain flawless reproduction. It can neither reproduce any object in any particular respect exactly—for there are always relevant differences— nor reproduce any object in all respects satisfactorily—for again there are relevant differences. This is a direct consequence of the difference between the representation in its medium and the object of representation. It has as a consequence, however, the conclusion that verisimilitude passes over into contrast, an interplay of both similarities and differences. Exact verisimilitude is either the ultimate aim, never to be realized, or is to be replaced by intensity of contrast. Once such contrasts are introduced, they suggest that the differences involved in representation are virtues as well as limitations. A painting is surrounded by a frame, walled in as the world cannot be. Oils are textured and gross, bearing the impress of the brush. It is but a step from obliterating the brushstrokes in the interests of verisimilitude to reveling in them as part of one's artistic powers. Appearance-reality contrasts are heightened wherever verisimilitude is involved, whether predominant as in illusionary painting or minimized by a close attention to the artist's contributions.

138

If painting is affected by appearance-reality contrasts in most of its works, sculpture is characterized by very different contrasts. Both music and painting rely on disparity with everyday experience. Sculpture, however, is by far the most verisimilar of the plastic arts. This is the truth of the Pygmalion myth—that a statue might come to life. A musical composition given life could be no other than it is—it has the only life imaginable for it. A full-length portrait, having flesh and blood life given to it, would also need to triumph over two-dimensionality. But *David* might well step down from his pedestal, unchanged in outward form, at worst a trifle pale.

The Pygmalion myth may be embedded in all arts and all creators, who may wish that their creations might live. But only sculpture can pretend to a literal reading of the myth (though literature and drama may make us wish that a world might exist for their characters to inhabit). In no other art might a non-living creature step down from its pedestal to walk among us. And what is even more striking is that all sculpted works constructed of gross materials might take on such an independent existence, because they are so completely three-dimensional objects. Even nonrepresentational forms, though unlike anything else in human experience, might well be found there, useful tools or weathered instruments. A piece of three-dimensional sculpture is always an independent, substantial, and enduring object.

The haunting resemblances of constructed objects are the basis of fundamental intermodal contrasts in sculpture, for the Pygmalion myth is untrue, and a statue is neither living nor dead. Other myths emphasize this contrast—for example, Lot's wife turned into a pillar of salt. The truth is that sculptured creations have never lived and never will, but only imitate a living being or pass for one. In part or in whole, most works of sculpture are reminiscent of something else occupying three-dimensional space. Because a statue can be so very like its model, a living person, its differences are enhanced. A statue may be felt as well as viewed, and the coldness of the marble or rough surface of the metal is always a significant contrast.

Architecture must be considered here, for intermodal contrasts are essential to it in remarkable ways. Indeed, architecture cannot be a pure art—*merely* an art. It is always in intermodal contrast, and this is its paramount source of artistic value. A work of architecture is not pure form but is a *habitat*. It is where human beings live or work, and is *for them*. The significance of architecture resides in its influence upon the lives of human beings. Released from its function as an abode, such a work would be very different, even a work of sculpture. In this respect, architecture is always and fundamentally a mode of active judgment. What is achieved is the organization of the environment in which

people live. An architect must consider how his works will be lived among and what their consequences may be for their inhabitants.

All finished architecture is a form of action; nevertheless, some actions are of greater significance than others, and have more important consequences. Architecture is always an intermodal contrast, and any architectural work may be regarded both as a deed and as a work of art. We emphasize the work when we pay attention to the construction as it functions in human life but do not unduly emphasize the effects it has for particular human beings. We emphasize the political and social aspects of human life when we concern ourselves with the experiences of people, their pain and misery, their satisfactions and achievements.

The two modes of judgment are inseparable in architecture. More important, the value of an architectural work turns on the intermodal contrasts engendered by the interplay of the two modes. All human products may be regarded in terms of the various modes of judgment. In architecture, however, a work can *only* be regarded functionally and as an action, for that is the primary source of architectural value: how we live around and within it. A painting or musical work may in some cases be considered valuable regardless of its active consequences. An architect is always an engineer, but his engineering is devoted to artistic purposes, to contrasts, creations, and constructions. The art of architecture consists not in *successfully* changing human lives—which is a political and moral responsibility—but in constructing works to make possibilities of change manifest. It is not judged by its particular consequences but by the contrasts it establishes between possibilities for life and what actually transpires, by its revelation of inexhaustible possibilities within and for human life. All great works of architecture recreate the human environment and expose us to possibilities for further creation. If we appreciate the clash of possibilities, the manifestation of inexhaustibility, we consider the work as art; if we seek to capture particular unrealized possibilities of life, we move more to action. And when we reply to a great architectural work by another, we do both at once, articulating that work both in action and in our own art.

Architecture shares with sculpture a concern for possibilities inherent in materials—forms and textures. Dance shares with sculpture a basic representational element which is the ground for its most important contrasts. Works of sculpture are three-dimensional volumes, created objects, and are always reminiscent of other volumes and spaces. All dance is reminiscent of gesture—the varied movements of the body in its life activities. Volume is central to sculpture; the body—its gestures and movements—is central to dance. It follows that dance capitalizes on intermodal contrasts involving important human activities.

140

Dance may execute and may prefigure action; above all, dance is one of the most compelling modes of celebration—the stylization of important life activities.

Intermodal contrasts pervade literature. All arts may be interpreted in terms of claims and assertions, but only literature can explicitly present a claim for our consideration. Poetry is filled with claims, sentences, descriptions, even moral judgments. Yet there are constant variations in association, language, style, and metaphor, as well as sound and rhythm. In poetry, assertions are frequently overwhelmed by the compression and economy of the art, to the point where we might wish to accept an assertion as such, but could never accept it as an assertion alone. The interplay of such assertions with inexhaustible poetic means is the fundamental source of the intermodal contrasts which are at the heart of poetic value.

I have described poetry as "compressed": the maximal compression of the wealth of possibilities inherent in language. A fourteen-line sonnet endures in our estimation because of its polymorphous intensity, a jewel of compressed vitality. The shorter the poem, the greater the burden of compression. Each and every word must carry an enormous weight of significance, sound, and value. The burden on the poet is unbelievable; so is the difficulty for the reader.

Prose *opens* the literary style. One gain is in accessibility: a work of prose is frequently far easier to read. On the other hand, stylistic nuances have a larger scale, and require close attention to details and themes widely separated in the larger work. A second advantage of the expansion lies in the greater range of control available. The compression of poetry is so great that the entire poem is always threatened by its details, its flow constantly interrupted by its own music and perfection of line. Poetry is nearly always quotable, line by line or stanza by stanza. Too great a compression makes attention to the entire work nearly impossible. Phrases and lines get in the way, and ask us to consider them in themselves.

In opening up language and avoiding its most compressed possibilities, prose moves from a focus on every word and line to a different scale, to a created world. The novel is the creation of a world—sometimes rather like our own, though different in important and contrasting respects; sometimes full of fabulous characters and events, novel possibilities of life and being. Poetry emphasizes the multiplicity of aesthetic values within the moment; prose emphasizes the larger world which language can create.

Literature creates worlds for us to ponder and celebrate, worlds of incredible variety and scope, inexhaustible in their imaginative

achievements, inexhaustible in their contrasting implications for ordinary experience and everyday events. Prose literature, even more than poetry in its most compressed forms, attains an extraordinary range of intermodal and intermedial contrasts, encompassing a remarkable range of contrasts with ordinary experience enhanced by its own forms of invention.

The world created in literature is often not very different from commonly experienced events. Some powerful works draw their forcefulness from the insights they provide into our own experiences. In every case the world defined is new—a "fiction"—containing persons we cannot find around us and events which never happened. It is the likeness of the narrated world to our own, coupled with interesting and subtle departures in both presentation and substance, that provides the intensity of contrast which is the value of a literary work. Most important of all are the unique perspectives which the author or his characters define for us. I have spoken of created "worlds"—yet there is no unified world, nature, or universe, but rather, many interrelated orders and perspectives. The orders in which we live, love, inquire, and act are many and inexhaustible. The many worlds of literature are not then complete universes—though in the same sense, neither is the physical universe complete—but complex and far-reaching orders whose value lies in their details and comprehensiveness in rich and complex contrast with our daily experiences. Literature provides an escape—so it is said—from one world to another, though never a total escape. And even the most realistic literary works are creations of contrasting worlds relative to our own.

The value of the greatest works of literature lies in their conjunction of detail and range. A great novel creates a complex world for us to witness, often in compelling and intricate detail, illuminating possibilities in our own lives in contrast with the events and actions depicted. The specific features of literary presentation may highlight aspects of our own experience while the gross worlds may be sharply divergent. In one sense, it is the interplay of illusion and reality that is present in all such literature. In another sense, literature creates genuine alternatives, revealing possibilities in our world and the created world of great influence upon the lives of many people. In still a third sense, literature—especially when highly self-conscious—emphasizes the contrast between its inventive capacity and its resonance in our experience as part of ongoing human life. All of these contrasts are rich and inexhaustible, and are to be classified among many if not all the major kinds of contrast. But central to all the contrasts in literature and to its particular manifestation of inexhaustibility are intermodal contrasts

142

given by the play of actualities and possibilities in relation to the propositional character of language.

Intersubjective Contrasts

The contrasts which fall under this heading have not been neglected in traditional theories of art, but have been frequently given too great an importance. I am speaking of contrasts which turn on the public availability of works of art to many different audiences. Works of art lend themselves to diverse interpretations as if none were "correct," and are perceived differently by audiences at different times as if artistic response were entirely relative to the audience's circumstances. Variations in response lead to the problems of relativism, even to the extreme position that a work of art is whatever it is taken to be and possesses whatever values it is assigned by an audience. The most important and fundamental intersubjective contrast, however, is that produced by the artist's understanding of his work in contrast with the responses of any audience whatsoever.

A work is a play of contrasts, and an obvious source of contrast is the multiplicity of variant responses it may engender. Not only are many works of art complex and difficult, permitting no fixed and definite understanding, encouraging different audiences to come to different interpretations. More important, there are works for which disparity in audience response is an opportunity for complex contrasts in which one interpretation is played against another, one possibility of response against another. The variety of interpretations found in the critical literature are a value of the work. I am speaking here not of works which can be given no plausible interpretation, but of works—such as *The Castle*—which can easily be given too many.

Three major types of intersubjective contrast are worth specific mention: (1) contrasts belonging to a work in virtue of diverse responses of different generations of audiences; (2) contrasts which arise from the diversity of interpretations given a work by major critics; (3) the fundamental contrast between the work viewed as a product of the artist and as an object to be responded to by an audience. The last is of such importance, and so inescapable in art, that it may be taken as the central intersubjective contrast.

1. The contrasting modes of aesthetic response to a work by different audiences, especially where widely separated in time, might be viewed as a traditionary contrast. However, we are not here addressing the traditions to which the work belongs in its contrasting features, but differences and similarities in responses among members of different

audiences stemming from differing critical perspectives and differing experiences. *Oedipus* may be regarded in its relations to other Greek tragedies, as part of a tradition—its consummate achievement, perhaps, as Aristotle takes it to be, or a stylistic variant relative to Aeschylus and Euripides. However, *Oedipus* has also been read and appreciated very differently by baroque, romantic, and contemporary audiences. These differences produce intense intersubjective contrasts.

Where this mode of contrast is of greatest importance is with respect not to such extreme differences as may lead some audiences to despise a work, others to admire it greatly, but with respect to those variable but important features which enable a work to endure in its appeal. Greatness in art is a function not of one critical reading—though a sensitive critic may sometimes recognize greatness immediately—but of permanence, the greatest works belonging to no particular audience, but to all. We who live after many great traditions of art come to an awareness of the differences time makes in art, aware both of novel forms and of the history of variant readings. The history of art becomes embedded in our thoughtful responses, and we look into a great work for what others have found as well as to make our own discoveries. Keats expresses some of this in *On Looking Into Chapman's Homer*. Many variations on classic works—Racines' *Phédre*, Anouilh's *Antigone*, O'Neill's *Mourning Becomes Electra*—share in the same contrasts, though they are to be classified more with traditionary contrasts.

The point is twofold: works of art come to contain within themselves the contrasting responses of different audiences, as we may be struck by the different perceptions the *Iliad* provides for seventeenth- and nineteenth-century audiences; in addition, artists are themselves audience to past works of art whose responses to such works are the source of important new interpretations. In both cases, it is not a problem for a great work that it leads to diverse apprehensions, but one of its values. It endures by its capacity to engender contrasting and mutually enriching aesthetic responses. Deviance in response is essential to the character and value of the greatest works of art, which absorb the plurality of interpretations into themselves as part of their richness.

Remarkably, found objects, uncreated by human hands, can possess striking intersubjective contrasts in the absence of an artist, since our normal expectations of intention and control influence our perceptions of natural orders even where such intention and control are absent. Thus, we apprehend natural works *as if* they were human works, knowing they are not. This is manifested particularly in our understanding that such natural orders lend themselves to the same variety of audience responses as works of art, uniquely intense in virtue of the absence of an artist.

144

2. The capacity of works of art to absorb different readings into themselves is manifested within the critical tradition to the extent that we do not seek in criticism for a *correct* reading or appraisal, but for possible and important interpretations. Intersubjective variation in criticism is one of the most important characteristics of art. Intersubjective contrasts are as important for criticism as for art. Many important works are difficult to interpret. The critic's task becomes no less ingenious than the artist's: of providing a reading persuasive to his audience while enriching their sensibilities. As this audience becomes more knowledgeable, especially as they are aware of variant readings and diverse interpretations, the critic's task becomes more difficult—not because everything of importance has been said before, but because his interpretation will have to absorb the critical tradition into itself through intersubjective contrast.

Diversity in interpretation follows from the character of constructive judgment. Art is not intrinsically right or true—though it may be both—but intense in its contrasts and rich in its qualities, manifesting and enhancing ordinal inexhaustibility. Interpretation shares in many of the contrasting features of art, sometimes in an exaggerated form, reveling like its master in richness and inexhaustibility. I will discuss criticism and interpretation in detail in the final chapter, particularly the importance of constructive judgment within them, lending them the full powers, in some of their forms, of intensity of contrast and ordinal inexhaustibility.

3. There remains for consideration that type of intersubjective contrast which is fundamental to art, pervasive throughout constructive judgment. The artist-audience contrast reflects the fundamental condition that a constructed work is a public object, available to anyone. Certain types of anguish among artists—connected, for example, with selling their works—stem from this fact. Works of art cannot be wholly possessed by their makers, not completely controlled. A stranger may make of a work what he will. Every creation transcends its conditions.

It is possible to imagine cases where a painting is responded to by an observer precisely as the painter intended, a composition performed exactly as the composer dreamed, a play performed to perfection from the playwright's point of view. Intersubjective contrasts do not depend only upon actual or overt differences of understanding between artist and audience, but may rest on alternative possibilities of understanding. Directness of understanding with respect to a particular work is augmented and its vitality increased where other works engender diversity of interpretations. Thus, the audience-artist contrast is not only relative to individual cases, but is a general condition of art, a basis upon which other contrasts play their roles. It underlies the entire

theory of romantic irony. Nevertheless, an artist's conception of his own work will always in fact differ in some respects—large or small, integral or scopic—from the conception anyone else may form of it. These differences may be treated as errors—effectively weakening the scope and richness of the work. They may also be absorbed into it as contrasts manifesting its complexity and inexhaustibility—an inexhaustible range of possibilities in the public life of a created work.[14]

The intentional fallacy persists in art, committed even by those who deride it, precisely because it is a manifestation of the artist-audience intersubjective contrast. What the artist intended is a permanent fascination within art—sometimes revealing aspects of a work otherwise to be missed, sometimes in sharp opposition to depths apprehended though not intended. A work comes to possess traits the artist did not and could not have intended, traits arising within the later experiences of future audiences. On the other hand, time may bring the expiration of personal and social qualities embedded within a work at its inception. By looking to the artist's intentions, we enrich the relevant intersubjective contrasts, adding dimensions to a work which could not otherwise be discerned there. If we fully accept the artist's intentions as definitive of the character of his work, we eliminate intersubjective contrasts from one side. If we entirely dismiss his intentions, we nullify such contrasts from the other side. Intersubjective contrasts are a central and important value within art, especially for enduring and time-proven works or those which depart radically from conventional expectations.

The prevalence and importance of intersubjective contrasts, especially where diversity is emphasized—among contemporary critics, different generations, or relative to difficult works of art—are factors of utmost relevance to any theory of an "artistic community." Such a theory is based on a principle essential to both traditionary and intersubjective contrasts: that the social and human functions of a work of art are of fundamental importance. But there is no monolithic

14. It is worth mentioning here Hans-Georg Gadamer's hermeneutic theory in which the temporal (and therefore historical) distance separating artist from audience is an intrinsic condition of interpretation, to be resolved by a "fusion of horizons" between artist and audience. (Gadamer, *Truth and Method*) Gadamer emphasizes one form of the artist-audience intersubjective contrast, but has no theory of contrast (or of ordinality) which permits him to emphasize the ascending levels essential to interpretation and art. In a fusion of horizons, there are similarities and differences, thus the production of a complex contrast. What needs emphasis, however, is the way in which other contrasts enter the interpretation, including intervening interpretations and other intersubjective variations. Moreover, "fusion" is too pregnant with unity and resolution, where contrasts often depend on differences and variations.

artistic community—rather, many relevant communities. Intersubjec-
tive contrasts highlight the multifariousness of social and communal
relations relevant to all important works of art.

In addition to the three fundamental dimensions of contrast—perfec-
tion, invention, and celebration—and the five general types of contrast—
traditionary, intramedial, intermedial, intermodal, and intersubjective—
there are many other important contrasts. This diversity of contrasts
relevant to art is due in part to ordinality, the inexhaustibility of orders
and of relevant contrasts. Every category in an ordinal theory is func-
tional and qualified, and all the dimensions and general kinds of
contrast express particular ways of understanding works of art—but
not all; particular ways of classifying contrasts—but never all. At best,
contrasts, like orders, may be classified in certain respects, but never all
relevant respects.

Nevertheless, the inexhaustibility of contrasts relevant to art is not
only an expression of the pervasive condition of inexhaustibility, but is
specific to the nature of contrasts. Contrasts lend themselves to varied
interpretations, varied conceptions, even varied descriptions. This is
an important aspect of their richness and complexity. It is manifested
in the inexhaustibility of levels of contrast. It is manifested also in the
inexhaustibility of intensity of contrast. In this sense, constructive
judgment manifests inexhaustibility as no other mode of judg-
ment can.

The fundamental dimensions, as well as the five general types of
contrast, are in a sense exhaustive. Perfection, invention, and celebra-
tion embody the fundamental characteristics of aesthetic value, applic-
able wherever such values can be found. Similarly, the five general
types of contrast manifest the basic characteristics of constructive judg-
ment: at a time and place, utilizing definite materials, and inhabiting a
human world. Nevertheless, works of art attain intensity of contrast by
playing various modes and kinds of contrast upon each other in com-
plex ways. The dimensions and general types of contrast alone are
insufficient for understanding individual works. Other types of con-
trast are needed—an inexhaustible variety of kinds—to express the
manifold ways in which intensity of contrast can be achieved through
the dimensions and general types.

There is a very general and important type of contrast that is essen-
tial to the sovereignty of works of art which I have not yet considered

147

explicitly. It is implicit in the incomparability of the dimensions of aesthetic value, but it must be rendered explicit. I have traced the sovereignty and incomparability of works of art to a contrast of prevalence with deviance, in particular to the dominance of a prevailing gross integrity of a work over many constituent integrities. What is essential here is the plurality of integrities constitutive of a gross integrity of a work of art.

The concept of integrity carries the force of what an order is (unitarily) in a particular ordinal location. An emphasis on the sovereignty of a work may then be interpreted as a recurrent and irresistible emphasis upon the integrity of the work—in many cases upon its diverse integrities. The dimensions and general types of contrast here are recurrently integral. Perfection is fulfillment *within and of the work*. Invention is novelty *within the work*. Celebration is achieved *by the work*. It is the specific *work* which is contrasted with its tradition and held in focus in its time and place. It is the technique within the work which gives us intramedial contrasts, elements of the work which provide its intermedial and intermodal contrasts. And finally, it is the work to and for its various audiences which generates intersubjective contrasts. This recurrent emphasis upon the work and its integrity pervades all the contrasts relevant to that work and its artistic values. There is a continual emphasis upon the integrity of a work in contrast with its scope, and a continual interpretation of contrasts within the work in relation to that integrity.

Integrity and scope are functional distinctions, relative to interpretations and other locations. Like every order, a work of art has a different integrity for every different ordinal location. Some intramedial contrasts may not be part of a particular integrity of a work—for example, brushstrokes may not be relevant to a painting taken as representative of a cultural *Weltanschauung;* some poetic details may not be relevant to a drama in performance. On the other hand, these intramedial contrasts are part of the scope of the work within the interpretation indicated, while each work is also a constituent of the scope of the medium in the historical development of art. Contrasts within a work are to be distinguished into those relevant to its integrity and those relevant to its scope, but they lead also to more complex contrasts engendered by the plurality of integrities and scopes relevant to any important work throughout its manifold ordinal locations. Given a distinction between integral and scopic contrasts, we are led directly to higher-level, complex contrasts among these different contrasts and among contrasts produced by different integrities and scopes of the same work. The recurrent emphasis on integrities of the work em-

phasizes its sovereignty—but always in relation to other integrities and to constituents of its scope. The distinction between integral and scopic contrasts serves to highlight the sovereignty of the work, but it is both sovereign and common, as are all orders, expressed in the inexhaustibility of integral-scopic contrasts.

Integral and scopic contrasts are essential to the theory of criticism. The persuasiveness of a critical interpretation turns heavily on the degree to which it succeeds in ordering the constituents of a work into its integral and scopic contrasts. Nevertheless, every interpretation of an important work is continually threatened by the richness and diversity within the work which can be realized only through other interpretations. Criticism here both employs the distinction between integral and scopic contrasts to produce an understanding of the work and leads directly to more complex contrasts engendered by a plurality of interpretations and understandings. Criticism, like art, manifests and revels in inexhaustibility, even where it strives for directness and simplicity.

Interpretations of works of art are affected not only by cultural changes and new critical methods, but by performance and exhibition. When we exhibit a painting in a museum our responses to it change in relation to the other works with which it is conjoined.[15] We are led to the remarkable phenomenon that a larger setting of a work, an aggregate of many works, or even a part of a larger work, may be regarded as works themselves. Such variation of integrity is a direct consequence of ordinality. A movement of a symphony may be performed separately with a different integrity than when performed with the entire symphony. An aggregate of musical works—an evening's program—changes the way we respond to each of the works. While to interpret a work of art demands that we conceive its integrity, what it is, there is implicitly involved a conception of its scale and functions. A section of a longer poem may be not only a superior but a very different poem.[16]

These considerations are of importance to all works of art, emphasizing that the integrities of such works (and of all orders) are variable and complex. In the performing arts, the point is fundamental. A performance includes the audience as well as the performers, but also their particular circumstances. To attend the theater after dining in a fine restaurant, dressing for the occasion, traveling many miles, and so forth, is to engage in a profound and important celebrative event, and

15. See Malraux, *The Voices of Silence*, discussed above, pp. 121-22.
16. See my "Some Ambiguities in Identifying the Work of Art," *Journal of Aesthetics and Art Criticism*, Winter 1977, XXXVI/2, pp. 137-45.

the performance has an integrity appropriate to the occasion. To what extent, then, is this social environment "part" of the work in performance? The simplest answer is that the setting belongs to the scope of the work, but to the integrity of the performance, while the latter is an integral constituent of the work—a possibility inherent in its integrity realized in the performance. As a result, the relevant integral and scopic intersubjective contrasts are remarkably enhanced.

An important application of integral variability with ordinal location pertains to the distinction between major and minor arts, fine and popular arts. Popular arts contain neither geniuses nor masterpieces. In this respect they are thought minor. However, the notion of a "lesser" art is misleading. Surely the popular arts are not inferior *because* they are popular, and although popular arts may not generate masterpieces, they fill human life with joy and vitality. What is distinctive about them, however, is that they emphasize social activities and participation rather than the singularity of individual works. We may therefore consider the hypothesis that while no particular folk dance or song is of paramount excellence, repaying a detailed study of its construction and ramifications, yet the whole *genre* of folk music and dance may admit of varied and intense contrasts, rivaling any artist's corpus of work. While no popular dance form survives the transitions of fashion, still the many activities which comprise popular dancing as an ongoing form may have remarkable value for generations of participants.

The hypothesis is that popular arts are collectively to be regarded as major arts. The ordinal integrity that is relevant to such arts is not the individual work but the tradition, the genre, the collective activity. The basic dimensions of contrast—perfection, invention, and celebration— apply without exception to such arts with but a minor shift in emphasis. Celebration becomes most important. Invention becomes a subordinate value. Yet novelty and originality are not absent from cuisine and design: they are simply subordinated to the constraints of the social functions of the art. New forms of popular and folk dancing are invented but dominated by constraints of fashion and national identification. Perfection is a major value, though far more a matter of execution than of imagination. Popular arts revel in all the types of contrast I have emphasized: traditionary, intramedial, intermedial, intermodal, and intersubjective. Perhaps the last two are less important in most popular arts than the first three. These arts often lack major political or philosophical implications. Folk arts, on the other hand, are intimately interwoven with religious and moral activities—emphasizing those intermodal contrasts. Diversities of interpretation are often minimized. Yet in some cases—detective and mystery novels, for example—the

popular art is entirely dependent on moral and political concerns. The fundamental point is that each work in a popular art is relatively undistinguished, yet the art as a whole may be both remarkable and noteworthy.

The phenomena I have been discussing, wherein aggregates of works and details—especially in popular and folk arts, but including recital programs and museum collections—are frequently appre- hended in terms of their own integrities with sovereign aesthetic values, cannot be understood except in terms of a functional, variable, and ordinal theory of identity and integrity. What possesses aesthetic value is an order with an integrity in a particular location, and not only the value but the nature, identity, and integrity of the work may vary with location. This produces the diverse integrities that are essential to all contrasts, establishing the deviances which are relevant along with every prevalence and, in particular, the deviances essential to intersub- jective and integral-scopic contrasts. Not only are there important contrasts inherent in every integrity of a work relative to its scopic constituents: there are inexhaustible contrasts inherent in its diverse integrities relative to any of its gross integrities. These are essential to its inexhaustible perfection and to its inexhaustible integral-scopic contrasts.

These considerations relate to the very meaning of contrast in art, since the integrity of a work is involved in all of its contrasts and is essential to its sovereignty. The distinction between integral and scopic contrasts effectively defines the work in a given location, though always in contrast with other integrities, especially gross integrities. The natural focus on intramedial contrasts—line, color, expanse, shade, hue, and intensity in painting; tonality, rhythm, meter, harmony, melodic line, and movement in music—reflects a particular way in which we identify a work, while the remaining complexities and associ- ations may be thought of as enrichments belonging to the medium as possibilities. Nevertheless, contrasts relevant to a great work of art are inexhaustible, manifested in an inexhaustible range of integrities. The integrities of a work of literature, painting, or music include meanings and associations inherent in its intermodal contrasts. Literature espe- cially is enriched in its metaphorical qualities by representational as- sociations and by complex and far-reaching implications. The judg- mental and assertive character of some poetic statements falls both within and without the poem at once, part of some of its integrities, part of other scopes, engendering particularly rich integral-scopic con- trasts. The variability of the integrity of all orders is the foundation of some of the most remarkable effects in art, produced by the interplay and variety among integral-scopic and intersubjective contrasts.

151

CHAPTER 5

Contrasts and Aesthetic Value: Specific Kinds of Contrast

The three dimensions and five general types of contrast represent fundamental and pervasive characteristics of art. The three dimensions are essential features of aesthetic value; the five general types express pervasive features of constructive judgment. In addition, there are integral and scopic contrasts which express the metaphysical conditions of ordinality and inexhaustibility. Wherever there is art, there is an inexhaustible variety of contrasts involving perfection, invention, and celebration, as well as contrasts based on artistic mediums and traditions, diverse audiences, different interpretations and conceptions, and a plurality of modes of judgment. Wherever we find aesthetic value—for example, in natural events—we find contrasts involving perfection, rarity, and memorability, but also contrasts based on the ways in such found objects function celebratively in human experience: relative to established traditions and expectations, to diverse audiences and their different responses, in terms of materials and composition. All contrasts can be uniquely intense where methodically created. The most striking difference, however, between constructed and found works resides in intersubjective contrasts, for the prominence of the artist-audience contrast in art makes the absence of the artist for found objects the basis of a particularly intense appearance-reality contrast.

These nine general types of contrast, with modifications, are therefore pervasive throughout art and natural orders, wherever aesthetic value is to be found. This pervasiveness and generality may obscure the intensity of the contrasts which fall under them. This is an important feature of generality, and produces an important type of contrast. It reflects an important characteristic of all aesthetic contrasts. General types of contrast are pervasive throughout experience in just those ways that obscure their contrast precisely because their generality is at

152

the expense of diversity and detail. Very specific types of contrast, however, resonate throughout works of art and natural events at every general level and throughout virtually every other specific type of contrast. This is a consequence of the nature of contrasts, of inexhaustibly complex levels of contrast, and of the richness of works of art. The most specific artistic elements engender relevant contrasts by further contrast over all the general types and among other specific types of contrast. This phenomenon is an essential feature of the richness of works of art and the powers they have for us.

There is a technical reason for the importance of specific contrasts in aesthetic value. General modes of contrast are relevant within all works of art, therefore prevalent indistinguishably within them. Contrast requires deviance and opposition amidst such prevalence. The relevant deviances can only be among some constituents of the work which function also as constituents of the general, pervasive contrast. Thus, there is an essential and prominent contrast wherever aesthetic value is to be found between the generally prevalent modes of contrast and the unique and specific contrasts which manifest the sovereignty of the work on the one hand and its relevant complex contrasts on the other. In this sense, the contrast involving specificity and generality (discussed below) is a pervasive condition of aesthetic value, as general in its own way as any of the types discussed in the last chapter.

What this means is that the distinction between generality and specificity in art is functional and that it functions particularly to produce intense contrasts. The specific types of contrast to be discussed below all manifest remarkably pervasive features of aesthetic value. But even the most unique and specific types of contrast express such generality and pervasiveness. This is a consequence of the nature of ordinality and of contrast. The first four specific types of contrast which will be discussed in the first section below directly express the particular qualities of generality and specificity in works of art. The other three, however, have frequently been given equally general and pervasive interpretations. Such indeterminateness is a manifestation of ordinal indeterminateness, heightened in art, but also of the indeterminateness of intense contrasts, which continually lead to new contrasts by invention, deviation, and addition, inexhaustibly.

TYPES OF CONTRAST

Generality and Specificity

As I have noted, the contrast of generality and specificity is a fundamental and pervasive component of aesthetic value. Yet we need not

emphasize the most pervasive features of this contrast to appreciate its power in art. For example, it has special importance for "abstract" representational art. "Abstract" here refers to a work representing *generally* as compared with specific representations—the way in which a work may represent mankind rather than a particular person or truth and divinity rather than a particular scientist or saint.

It is remarkable how specific features of a work of art always take on a general significance. The more perfectly a portrait represents a unique individual, the more profoundly do we sense insight into the character of human beings in general. Many extreme cases can be found. Literary characters are delineated so superficially that they can be little more than representatives of a type, caricatures of certain traits. Still lifes simplify their objects to the point where no particular vase or apple can be recognized, only vases or apples in general. Nevertheless, many sensitive critics have argued that a work of art is truly successful only where specificity and generality stand in strong tension: a drama in which the literal and symbolic levels are each successfully maintained; a portrait midway between a detail sufficient to represent individuality and a perfection that could belong to no individual. Lear in all his particular qualities expresses dotage and overweening pride. Michelangelo's *David*, perfect in its line and form, is also complete in sufficient detail to be a copy of a living youth.

The contrast between generality and specificity is pervasive throughout the arts provided we do not understand it merely as a contrast between a particular element of a work and some general idea, but as a contrast involving features of art and experience which have a general or pervasive character in relation to particular and highly specific properties of an individual work. The individuality, uniqueness, and sovereignty of a work of art engender the prominence of contrasts involving idiosyncratic features of the work, specific to it, and pervasive and general features of experience. The very nature of contrast is implicated in this relation, an opposition of shared and singular features. The contrasts discussed below between simplicity and complexity, surface and depth, token and type, are all particular versions of the contrast in question, and they express, in different ways, the location of a work of art in a context larger than itself and the contrasts produced by that location.

The contrast between generality and specificity is important wherever a work of art has significance beyond itself—and all works do, as expressed in the distinction between integrity and scope. The relations of a work are many, giving it a general, manifold character, while the

work is individual and sovereign in its integrity. Even where we cannot find a general meaning in a work, as in a string quartet, it is nevertheless for mankind in general, to be appreciated in terms of general principles. This feature of art is shared by all orders. The significance of the contrast for art is to be utilized as the basis of artistic value.

Simplicity and Complexity

If the goal of art is intensity of contrast, it is plausible that complexity should be one of the greatest values and purity be commonplace. History quite fails to support that conclusion. Trends in the twentieth century toward minimalist art have been strong. Twentieth-century sculpture is often nearly a single pure form. Purity and simplicity return with regularity to art as if complexity and richness cannot be of sole value.

Music provides us with a salient example of the recurrent interplay of simplicity and complexity, and large-scale orchestral works with complex textures contrast with the simplicity of song and the narrow instrumental range of the string quartet. Minimalist art places colors in juxtaposition, utilizing only space and hue, abandoning variations in texture, line, and intensity of color. If there is any value to such art, it resides in the complex contrasts accruing to such simplicity relative to traditional complexities. Purity and simplicity possess poignancy in contrast with intricacy, mixture, and complexity.

Complexity needs no defense nor explanation as an avenue to intense contrasts. Contrasts may sometimes be attained by addition—a wider range of elements brought together in narrow compass. Simplicity, however, is a persistent element in the arts, and to many observers, an important component of beauty. The reason is simple: the contrasting interplay of simplicity and complexity is the relevant aesthetic value. That purity and richness might contrast within a single work is obvious. Yet even in works of relative simplicity, artistic value is a function of contrast with other, more complex works. Were we to know of no other works than Brancusi's *Bird in Flight* or Malevich's *White Square on a White Background,* they would soon bore us with their limited possibilities. Even the most serene lines of poetry would pall were they our only encounter with poetic language. The imperative toward new and different works is based in part on this contrast between simplicity and complexity, the art in the aggregate providing a continually more complex background for contrasts with individual works. Simplicity of itself has limited value, and draws its powers from the complexities with which it stands in vital contrast.

Simplicity and complexity are ordinal, qualified concepts. A work of art can be simple only in certain respects while complex in other respects. Complexity can be given a categoreal integrity, largely equivalent with inexhaustibility and ordinality. Yet this inexhaustibility, I have recurrently indicated, involves an inexhaustible contrast of multiplicity with singularity, commonality with unity, and complexity with simplicity. Every order is complex in certain respects and simple in other respects, at least from some point of view. This contrast is an important and pervasive expression of the contrast between multiplicity and singularity that is essential to the value and sovereignty of works of art.

The interplay of simplicity and complexity within a single work can be of considerable richness, since simplicity is always in some respect and may be contrasted with a great variety of complexities. Thus, etchings are complex in line and structure but may be single-hued. Impressionist paintings are complex in texture and color yet may be nearly devoid of line. Music may be melodically simple yet harmonically complex, harmonically simple yet structurally complex, and even rhythmically complex as well. Elliott Carter's work is frequently simple in its musical lines, each relatively independent, yet remarkably complex in notation and interconnection as well as in temporal structure. Sheer complexity degenerates into confusion and is conceptually unintelligible. Sheer simplicity is without depth or range, and is likewise unintelligible.

Especially striking is the way in which simplicity and complexity interact with other types of contrast, especially those of pervasive character. Thus, there are works of literature of nearly transparent language and surface qualities which are the more ominous and poignant in their suggestiveness. Parabolic literature is filled with tensions generated by its abnormal restriction of language in range or color. Similarly, limited medial elements frequently provide greater intermodal complexities. A particularly poignant effect can be provided by a small variation in an established technique—as in the harmonic variations in Wolf's lieder or Mahler's rendering of a familiar melody in increasingly minor variations in the final movement of his *First Symphony*. Here simplicity is provided by conformation to a tradition or slight departures from it, resulting in significant and complex contrasts. Finally, straightforward difficulties in interpretation may engender violent and intense contrasts, a sense of profound complexity produced by the negation of expectation. I have Pinter's plays in mind here.

The contrast between simplicity and complexity is particularly relevant to poetry due to its economy and compression. Intensity of con-

trast in poetry depends on this compression; even the music of poetry flows from the same economy. Where literary prose must be grammatically clear and complete, at the expense of both sound and richness of meaning, "poetic license" is precisely the imperative to produce contrasts through compression—omitting words which would interfere with the musical line, relying on the power of an image to triumph over equivocation. All the possibilities inherent in language are fused in poetry as if intensity of contrast were the sole consideration and as if language had to be bent to the breaking point to accomplish the task. The inexhaustible range of poetic language, conjoined with its supreme economy and compression, produces incredibly powerful contrasts involving simplicity and complexity, as if the simplest means had the most complex realizations.

Token and Type

I have been discussing how specific elements within a work of art, or even the work itself, gain intensity by contrasts involving pervasive features of art and experience. A portrait of an individual may speak to our sense of all mankind. A particular trial for a particular murder may suggest implications for all deaths and justice in general. And a particular work may have implications for all works in that medium or for art in general. In all these cases, specific elements are included within a more general category, but are very different in form and character— the way a mistrial speaks to the general nature of justice and mercy.

The type-token distinction has the special property that both the general category and the individual exemplification are represented in precisely the same way. The most obvious example is that of a word or other conventional symbol: the inscription "table" is a *token* of the word which is the *type*. What is unique about types is that they are universals which behave in many respects like individuals and that they are inseparable from their particular tokens. There are no words without inscriptions; tokens are always tokens-of-a-type. Conversely, types are created and destroyed by what is done with their tokens. Every instance of a type is both type and token together, inseparably. A performance of Beethoven's *Fifth Symphony* is a token of Beethoven's *Fifth* which exists only in virtue of some of its tokens, performances or scores. This intimate relation is an expression of the meaningfulness or intentionality belonging to works of art as well as symbols and signs.

The type-token relation is fundamental wherever there are symbols with recurring instances: many symbols tokens of the same type. Works of art or their components are often regarded as symbols and, where they perform a significatory function similar to that of words and

157

phrases, are to be regarded as tokens of a common type. Here we emphasize the commonality and recognizability of a given symbol: the cross symbolizes the agony of God come to save man from sin. Here every cross is a token of a common type: symbol of the crucifixion. Even depiction and representation convert an individual into a type wherever recurrence is emphasized. For example, a map represents the topography of a region. Many maps of the same region engender the type *map of that region*. Analogously, many portraits of Sasha engender the type *portrait of Sasha* of which each painting is a token.

Not all artistic symbols are to be regarded as common throughout different works. If we emphasize the singularity of individual works, we may emphasize the uniqueness of their symbolic functions. Thus, in Susanne Langer's theory of virtual space, a painting may be a unique symbol of space, having no other token instances.[1] Here all paintings may be symbols of space, each in its unique way. I am arguing that *as* a symbol, each of these is a token. As expressing space, they may be taken indifferently as tokens, but they are unique and individual works also. An individual presentational symbol of virtual space is a token of the type *symbol of virtual space*. Without such an understanding, intentional symbolization in art would be unintelligible. Thus, the notion of symbolization in art involves a contrast between type and token. The type is the symbol expressed through its tokens, the tokens the singular and unique artistic elements. Generalizing, we may conclude that every significant element within a work of art is both type and token at once and, in its multiple capacity, productive of a wide variety of contrasts. Archetypic analyses which view works as recurrent manifestations of a general pattern convert the unique elements of the work into tokens of the type *manifestation of the archetype*. Without the work, there would be no such manifestation. And although there may be only one such token, there could always be more of that type.[2]

The type-token contrast in art follows directly from the interplay of generality and specificity, from the tension between a work in its singularity and uniqueness and in its general relations. A work that exhibits to us the divine in its singular expression bears general significance in its own terms. The divine becomes *its* divine, *its* Christ, *its* sense of order. Grünewald's *Crucifixion* is unique, perhaps like other crucifixions in certain respects, but a unique type nevertheless. Divinity, the humanity of Christ, are universals. When portrayed or symbolized in

1. Langer, *Feeling and Form*, Chapters 4-6.
2. For a detailed discussion of these issues, see my "The Work of Art and Its General Relations," *Journal of Aesthetics and Art Criticism*, Summer 1980, XXXVIII/4, pp. 427-434.

an individual work which gives them a unique stamp, a unique type is engendered—Grünewald's crucifixion—with a unique token. The artistic significance of the crucifixion makes Christ type and token at once in the work. I do not mean to suggest that they are indistinguishable, but that there is a unique token of a general type closely conjoined with it in intense contrast, singular and recurrent elements in profound tension.

There is a reason why this is so. It is expressed by Kant in his second condition of genius. Genius is not rule governed, but it is exemplary. A great work of art is paradigmatic, a model for others to follow. Now this is true not only in the whole, but for any significant and valuable part of a work, any feature of the artist's unique style. And it is not to be interpreted as imitation. What is involved is an understanding that what is singular and unique in a work of genius is not individual alone, but is a unique type with a singular token. It may, as type, have other tokens; and in treating any aspect of a work as paradigmatic, we make it a token-of-a-type. For only the type can be recurrently expressed. It follows that any aspect of a work that is regarded as paradigmatic is a type with a unique token; moreover, every artistically relevant feature of a work is type and token at once. This contrast, between token and type, therefore manifests the uniqueness and sovereignty of the work (as token) in contrast with its potential generality as a model (as type), a contrast repeated at the level of every integral constituent of the work, engendering remarkably rich and intense contrasts.

I have argued, on the basis of the ordinal theory, that not every element of a work of art is artistically relevant. Even the most consummate and singular masterpieces may be modified in some ways without changing their integrities. Some elements of works of art belong to their scope and not their integrity. With the passing of time, colors dim, varnish cracks, masterpieces are reduced in size, cut out of their frames. Only what is taken to embody the essential values of a work or style is paradigmatic, type and token at once. Nevertheless, for those who accept the total relevance of every component of a work as the artist fashioned it, the conclusion is that every such component is both individual and type, for it establishes standards for others to take as paradigmatic.

Thus, a lamb in a medieval painting is individual but also a symbol of all lambs and of the lamb of God as well. *David* is at once this beautiful youth, any beautiful youth, an individual portrait of a mythical giant-killer, a representation of a historical person, a universal image of admirable courage, and so forth. Christ on the cross is a token of a religious symbol, an instance of a divine occurrence in an individual

devotion, and a celebration of the coming of God to save mankind from sin.

No significant feature of a work of art can be merely individual without echoes of the type of which it is a token. This is why art is so often called "symbolic" and is the basis of all mimetic theories. It is also the reason why Platonistic theories of art persist: the form emerges from the particular through the type of which it is a token. Conversely, generality is attainable in art only by the presentation of an individual object which is a token of a general type. Individuality in works of art is maintained by the uniqueness of individual tokens; generality is attained through the types serving as instances of more general universals. The sovereignty of the work of art is preserved in its singular tokens; its shared and public features are manifested in the types which correspond to those singular tokens. The value of the work of art lies in its sovereignty in contrast with its commonality, a contrast involving types and tokens inexhaustibly.

Semiotic theories which interpret the values of art in terms of a general theory of signs effectively emphasize this type-token relation, but take it to an extreme, and cannot include all the other relevant contrasts in art. They tend also to minimize the creation of new types, absorbing all aesthetic features of works of art into the structured properties of the symbol-system. Much of what they have to say is included in the three types of contrast I have discussed to this point in this chapter. There is clearly far more to art than has been expressed here.

An important example of the type-token relation is found in performances of dance, theater, and music relative to the composed or written work. Here the type-token relation is distinct from the relation between generality and specificity, and is more a relation involving commonality and singularity, since a musical composition is not general relative to an individual performance, though it is common to all performances. The composed string quartet is the type of which the individual performance is a token. There is similarity of structure among diverse performances, though considerable variation as well. The common character from which every individual performance is drawn—as utterances of a work may all differ although the word is common to them all—is the composition and is the type.

The type-token relation in works of art is fundamentally a contrast in the sense that the composition as a type resides in every performance insofar as the latter is *its* performance, while each performance is a contrasting variation relative to the composition as a type. The performance may look to standard interpretations and to the composer's

intentions. Nevertheless, the performance must illuminate the work while the composition may be violated even in a thrilling performance. The contrast involves traditionary contrasts insofar as the history of all performances and of the individual work is relevant to a given performance as a standard against which an individual rendition is evaluated. However, tradition is insufficient to characterize the type-token contrast, since the composer's intentions may also be significant as may future events and audience expectations. The type-token contrast is important even for improvisational works where the type is indeterminate, since even these works belong to classes which they define as recurrent instances of common character.

Dance, theater, and music require performance, and we may regard composed works in these arts as types of which performances are tokens. In painting, sculpture, and architecture, however, there are only singular works, and we may believe that there are no relevant types. There is no performer or reproducer in these arts whose interpretations provide the variety inherent in the type-token relations of the performing arts. Nevertheless, the contrast is of importance with regard to a painting viewed as an instance of the artist's corpus of work, the school to which he belongs, or the art of his century. The movement from the individual to the general here is more akin to a movement from token to type than from specificity to generality. For example, Renoir's hundreds of silvery-pink bathing nudes may be viewed as variations on a common type with all their token instances. There could be no Renoir-bathing-scene without individual paintings; each painting is a token of the specified type. This is true even where we emphasize the uniqueness of each painting. The painting is a unique, idiosyncratic token of a common type in an important style. The type-token contrast is relevant wherever we employ the concept of style, therefore throughout all arts and works of art.

Surface and Depth

The surface-depth contrast has been mentioned several times, and is of such importance and is so common throughout art that it may be regarded as one of the most general types of contrast. It may also be viewed as a manifestation of the contrast between generality and specificity, though it involves some very different features. It is closely related to the contrast between simplicity and complexity. Intersubjective contrasts also depend heavily upon it—between what may be simply perceived within a work and what requires careful examination, between the immediate and mediate, direct and indirect, the surface

and the depth. In every work of art, as in everything around us, there is a surface which is relatively accessible, capable of immediate apprehension; there is also a deeper aspect, subtleties accessible only to a persevering and uncommon taste. Naive responses may be stronger, yet no great work of art could long endure in its surface qualities alone.

All works of art—with all orders—have a surface and depth: traits which are immediately recognizable and traits which are hidden or recondite. In some cases, however, little of significance turns on the surface-depth contrast; little is made of the contrasting elements. Often when we speak of beauty in a work we refer almost entirely to the surface appearance—the form and finish in Michelangelo's *David*, the control in phrasing and line which a great singer may give to a *bel canto* aria. Craft can provide a surface perfection and may altogether hide the labors to attain it. Nevertheless, where craft produces such supreme control that we are given a sense of total spontaneity, we have contrasts of both perfection and surface and depth. What lies on the surface and what can be apprehended only through arduous labor are in contrast, and their opposition can be a remarkable achievement.

The contrast between an immediate, emotional response and a reflective, interpretive understanding of a work is particularly striking in the case of music. Immediate responses to music are frequently emotional, but conventionally. A knowledgeable response is based on sophisticated perception and technical understanding. Great works of music possess powerful surface qualities without which we would not take the time to listen to them. Yet the surface is transformed by what we come to understand, while the strangest and most bizarre sounds become familiar to us and part of the surface. The surface-depth contrast is with us in all art, especially between remembered responses and a present reaction. But I believe music especially capitalizes on this contrast because of variations in performance and the temporality of musical works. All listening to music turns on the contrast between the sharp, felt emotion and the richness and depth of structure that may be grasped in more sophisticated responses.

To this point I have suggested that the basic contrast of surface and depth is one which turns on the appeal and character of the surface relative to deeper meanings and hidden techniques. There are cases where the surface is not appealing but ugly, yet deeper considerations provide great appeal and even beauty. Kafka's writings have always seemed to me of this nature. The surface is so pregnant with parabolic significance and simple in its elements that it possesses a remarkable power given by the contrast between surface and depth. The power is derived from our fascination with how so great a depth of significance can be conjoined with and realized by such modest means.

I have to this point strongly underplayed the importance of perception in art and aesthetic response. There are two reasons for this. First, perception is of little importance in the language arts; second, where perception is of importance, it provides only some of the elements on which aesthetic value depends. Memory, thought, reflection, feeling, analysis, interpretation, all make significant contributions to the values of works of art. Perceptual qualities are very important, but never simply as what they are in themselves, only in their contrasting relations. Many important contrasts are perceived as such. Others are less perceived than understood, reflected upon, or appreciated.

The surface-depth contrast is of great importance here. Where qualities are on the surface, nevertheless there are other qualities and features of a work which contrast with them, and the values attained are provided by the contrast. Some artistic qualities are surface qualities in contrast with deeper significations. Some perceptual qualities are relatively common and of trivial value except for their contrasts with deeper qualities which emerge from them. Intensity of contrast is the goal; perceptual qualities are merely one element of some works of art from which intensity of contrast may be created.

The theory of contrast entails that an inexhaustible wealth of contrasts is essential to any fine work of art. It follows that detailed and subtle analyses of any great work, tracing its contrasts and their complex ramifications, will inevitably lead away from surface responses to deeper and more complex appreciations, though in many cases, only to return. Where a work is essentially the same in its deeper ramifications as upon the surface, it will not endure in our estimation for long. Where the depths which are sounded are remote from the surface, we are dissatisfied by disunity and inadequate interconnection. What remains is the thorough interpenetration of surface and depth within the work promoting those intense contrasts which are available in sensitive and profound understanding.

Beauty and Ugliness

Perfection is one of the three fundamental dimensions of aesthetic value, comprised of extraordinary and singular conjunctions of relevant components in works of art or natural objects carried to completion, producing an incomparable and sovereign creation. Perfection includes whatever is extraordinary and remarkable, in any respect, provided it contributes to the sovereignty of the work.

There is a less fundamental contrast related to perfection: beauty as the orderly fulfillment of the perceptual conditions of a medium. Such beauty is a limited value in art: many important works are extreme,

skewed, violent, and quite lack orderly or harmonious balance. There is a perfection in horror, brutality, foreboding, and outrage that may have little to do with beauty, but a great deal to do with art. Horror can be of great artistic value if it is extraordinary, controlled, and complete in execution.

Many works of art, however, are legitimately to be deemed beautiful, at least in part, as a painting may be of a beautiful woman, a modulation or melody may be lovely, a pastoral scene may quietly fill the eye, a dance may be flowing and gently moving, serene and fulfilling. Beauty here is allied with quietness and serenity, simplicity and purity. Its apprehension gratifies the spirit. *Lear* is not in this sense beautiful, though it has glorious passages. Longinus first, Burke and Kant later, contrasted beauty with the sublime—orderly perfection with grandeur, depth, and power. Beauty is often contrasted with power and limitlessness.

However, the problem with emphasizing the contrast between beauty and sublimity in art is that while beauty is reasonably common, sublimity is rare. It transcends beauty, transcends the measure of our comprehension. Sublimity and greatness become nearly synonymous. However, great and sublime works may also be beautiful—for example, Dante's *Commedia*. Nevertheless, great works are often *more* than beautiful. The greatest works are filled with perfection upon perfection, while beauty as harmonious fulfillment is at best one of the many forms of perfection.

The alternative is to regard beauty as one pole of a prevalent tension in many works of art—if not all. We may find it contrasted—even violently—with what is powerful, overwhelming, even ugly. Ugliness here is to be taken not as revolting, but as the opposite of serenity and harmony: violence, turbulence, disorder, and distortion. Ugliness in works by Bosch and Bruegel contrasts forcibly with their beauty of technique. Expressionist painters frequently revel in ugliness, but with a masterly control that transforms distortions into significant contrasts.

Dissonances in music appear to be an example of this contrast, especially in their early appearances in Wolf and Strauss. Nevertheless, such examples highlight an important point—that standards of beauty change over time. Principles of balance evolve. Relative to classical style, twelve-tone music seems dissonant and ugly, distorted and crude in its impact. Nevertheless, Schoenberg's compositions are quite controlled, and may today be thought quite beautiful. Poetry in T. S. Eliot's hands possesses a colloquial character jarring relative to the rhetorical tone of romantic poetry. Yet it has a striking beauty. New arts must be

assimilated, and they may become beautiful in terms that they them-selves define.

It follows that beauty is not to be classified as a species of perfection alone, but belongs, in its contrasts with ugliness and distortion, also to invention and novelty. What is new is often discordant, doing violence to traditional orders and established expectations. The transition in a work from disharmony to harmony comes with acceptance and under-standing, transforming our standards of beauty. Beauty here is closely related to rule, and the beauty-ugliness contrast fundamentally in-volves a contrast between rule and departure from rule. In this sense, it involves invention as well as perfection, and is an expression of the general contrast of deviance and prevalence in aesthetic value.

We may hypothesize that art can transform any ugliness into beauty, any disharmony into harmony. Every deviance prevails somewhere, and the interplay in contrast can be the foundation of aesthetic value for any order whatsoever. Here anything may be an object for aesthetic consideration, may be made beautiful as the source of a new and successful work of art. Nothing is ugly in itself, but in expectations and traditions. Nothing is intrinsically beautiful but in the eye of the be-holder. Such a conclusion is tempting, though apparently false, since evidence suggests that some simple lines and colors are found im-mediately gratifying in most experience. Nevertheless, the conclusion is an expression of the truth that within all art there is a contrast between formal satisfaction and dynamic imbalance, conformity to rule and departure from rule, if only within and among various works. The surface-depth contrast is essential here. Beauty as harmony is always in contrast with disharmony, and immediate delight is always in contrast with underlying departures. Even among those forms which gratify us immediately, the contrast of harmony and disharmony, preva-lence and deviance, is the essential basis of aesthetic value, not the surface beauty alone. A striking effect of art altogether—not just individual works—is to transform our sense of order in our surround-ings, both perceptually and by novel additions, changing their relations and constituents. The contrast between beauty and ugliness is a dy-namic one, expressing developments within the different arts and within human life.

Space

All arts develop spatial contrasts. Space is, however, a central con-cern of representational painting. A canvas or board occupies two-

dimensional space, but the painting has its own space—Langer calls it "virtual."[3] The painter is faced with two spatial imperatives: (1) to create a three-dimensional space by means of a two-dimensional medium. Sometimes the answer is remarkable—the surface of the three-dimensional space must lie in front of the canvas space. (2) to fill the canvas space. Cubism does not create a likeness of three-dimensional space in two-dimensional terms, but rather, provides analytical elements of one space in terms of the other. The two imperatives are met by the creation in the medial space of analytical components of the constructed space. Finally, the imperatives of space may be generalized: in action painting, for example, to create time by spatial means.

Spatial contrasts are central to the visual arts: their works occupy space and engender rich contrasts between created and medial spaces. Painting has recurrently emphasized spatial contrasts through the hierarchical perspectives and two-dimensional representations of medieval art and the single- and multi-point perspectives of later art. Spatial contrasts reached a peak in Cezanne, whose subtle shifts of perspective develop to an extreme the contrast among the object space, the created space, and the spatial means inherent in the medium. It is no wonder that the still life reached consummation in Cezanne, and that painting underwent a major revolution after him, as if its fundamental spatial problems had to be redefined. The imperative in painting changed from creating one space within the means of another to constructing space—the contrast residing in simplification.

Verisimilitude in painting, the representation of a three-dimensional volume on a two-dimensional surface, is to be attained only through the contrasting interplay of the dimensional spaces in a viewer's perceptions. As a consequence, the fundamental characteristic of representational painting is neither verisimilitude nor an illusion of space, but a contrast between the canvas plane and the representational space.[4]

I have mentioned three examples which manifest the relevant contrasts strongly. One is cubism, viewed as an analytical resolution of the problem of defining a three-dimensional space in a two-dimensional medium: the analysis of space into surfaces and edges, presenting multiple aspects of an extended object in the plane of the painting. The result is no likeness, but an expression of space by varied projective means. The spatial relations within the painting bear unique and multi-perspectival relations to each other. The normal relations of

3. Langer, *Feeling and Form*, Chapters 5, 6.
4. See above, Chapter 1, pp. 17-18.

near and far, behind and in front, are transformed into the relations of left and right, up and down. The result is a novel two-dimensional surface, divided into atypical regions and forms.

The second example is that of early medieval paintings, whose three-dimensional representations are strongly dominated by the two-dimensional surface. The constructed space is hierarchically related to a divine cosmological order. Figures are larger when more important, not because they are closer. We have here a created space quite different from the space of visual perception. Nevertheless, it is to be visually perceived in the painting, and the contrast between the two spaces is a primary element of its value.

The third example is one of the great contributions to the development of painting—the Cezanne still life. Cezanne violated most conventions of perspective in the still life, particularly by letting the surface of the scene fall in front of the surface of the painting, thus "opened up" to the view, also by representing within the same canvas diverse visual perspectives on the same three-dimensional objects. Loran summarizes his analysis of Cezanne's spatial composition in the following words:

> Cezanne's genius in organizing three-dimensional space is the basic foundation of his composition. We have said, using many different examples, that space organization is something other than three-dimensional volume building in a sculptural sense. To quote again the words of André Lhote, 'It is necessary to repeat it: the picture, regardless of the exigencies of the subject represented, *must remain faithful to its own structure, to its fundamental two dimensions.* The third dimension can only be suggested; it is from this double necessity that most of the inventions in the art of painting are born.'
>
> Cezanne is essentially a classicist, then, for having 'rediscovered this science of the compensation of values.' He has appeared in the role of a revolutionary because so vast a heritage of misconceptions and bad taste about painting had to be overcome. A blind acceptance of scientific perspective, plus the invention of photography, brought all but complete death to painting in the nineteenth century. Insipid imitation and inartistic illustration held sway when Cezanne and others appeared on the scene with their new concepts of painting. By this time we are likely to forget the great change that had been wrought when Cezanne could say: 'The transposition that a painter makes with an original vision gives to the representation of nature a new interest: he unfolds, as a painter, that which has not yet been said; he translates it into absolute terms of painting, that is to say, something other than reality. This, indeed, is no longer shallow imitation.'

Nevertheless, as important as composition and spatial organization may be to Cezanne's work, painting requires more than spatial contrasts alone:

While Cezanne has been regarded here as the greatest artist of modern times, it should not be assumed that he was greater than many of his illustrious contemporaries only because of his superior composition and the accompanying problems of form which he brought to consciousness. Today it is possible to teach these principles to entire classes of art students. But only a hopeless academician of the modern breed would suggest that the cold presence of these elements of composition alone makes for artistic importance in the ultimate sense. Art is, fortunately, a little more mysterious than that.[5]

Spatial contrasts do not depend only on the plane of the painted surface relative to the represented space, but are inherent in other features of painting—notably geometrical forms and surface textures. The latter are particularly important since they are the only means by which a painting can literally be in three dimensions. In extreme cases, textures in oil or collage may be so varied and forceful that painting verges on a form of sculpture. To the extent that varying thicknesses of paint can provide depth, the created space belongs neither to the space of the plane nor to the space in the painting.

Of particular importance are the geometrical forms which permeate our perceptions in the painting plane. All paintings, whatever their representational character, are inhabited by these geometrical forms which are an important ingredient of their composition. Within the plane painted surface, triangles, rectangles, and circles predominate as compositional elements. The plane surface of the painting is constructed upon the canvas plane by means of these geometrical forms. In some paintings—those of Kandinsky, Braque, Klee—the plane of the painting is defined in almost a purely geometrical character, dispersed and coordinated by overlapping figures. So strong is this geometrical tendency that visual art may be regarded as pervaded throughout by relevant spatial tensions.

> There is tension in any perceived obliquity, in any departure from an open framework: there is pull, direction, the sense of weight and movement. Even a vertical ellipse strives upward in the top half, downward in the lower. A vertical line seems to be far longer than a horizontal line of equal length; and so on. Such forces, such bents, I repeat, are the words, the language of visual art.[6]

Sculpture is inherently a three-dimensional medium, and apparently lacks the central contrast of created and medial space. Nevertheless,

5. Erle Loran: *Cezanne's Composition*, Berkeley, University of California Press, 1943, p. 133.

6. Adrian Stokes: *The Invitation in Art*, 1965; reprinted in *The Image in Form*, Richard Wollheim ed., New York, Harper & Row, 1972, p. 103.

the contrast between created and medial elements is central to art as construction. Space must be created for and within the work. In representational works such as Michelangelo's *David,* the created and medial spaces seem nearly identical except for distortions of scale. Where there is no variation in size, as in Greek sculpture, differences of scale are relevant as alternative possibilities. Dynamic possibilities are often defined in spatial terms. *Moses'* unity and stability are in large part a consequence of the stability and integrity of the formed marble. Similarly, Brancusi's *Bird in Flight* occupies a *space in motion* though the medial space is quite stable. Reliefs highlight the contrasting spaces, since the constructed space is only partial, yet appears complete. Finally, in twentieth-century sculpture, we find a greater freedom of technique and medium—welded bronze, plastics, etc.—and note that the constructed space and the surrounding three-dimensional space are often in extreme contrast. The extrusion of shapes and forms from flat surfaces conveys the sense of unknown spatial dimensions entering upon and overlapping with each other.

Dance and theater also create and control spatial contrasts, usually by means of the included stage. On a bare stage, dancers rise and fall, move and rest, go back and forth, creating space as well as movement. In the theater, the constructed space is usually subordinate to the drama, and created by the designer rather than the action. But the illusion of closed space is always present and important. Finally, in literature there is frequently the construction of a detailed and ramified space in contrast with our own as part of a created world. Sometimes these spaces are very similar, contrasting only subtly through medial expression. Sometimes, however, as in *Alice Through the Looking Glass,* or *The Castle,* the constructed space is remarkable in its dissimilarities with our own.

One of the distinguishing characteristics of music is the minor role played by certain kinds of spatial contrast, though they are not absent. There is a remarkable possibility for intermedial contrast here: music as dynamic, auditory, and temporal; painting as static, visual, and spatial. The differences between the mediums appear to be so great, however, that successful conjunction may be impossible. It is far easier to conjoin music with other dynamic arts and painting with other spatial arts. Only language can belong to all worlds, partly because it has so little sensory character of its own, partly because of its versatility and range.

The claim that spatial contrasts play but a minor role in music is misleading in an important way. As an alternative, we may consider the following:

We comprehend musical sounds in time and in space. . . . height, interval, simultaneity, line, density, range, register, depth, counterpoint, even repetition. These, I suggest, are all spatial relations.[7]

It is an essential characteristic of space that at every position within it like bodies can be placed, and like motions can occur. Everything that is possible to happen in one part of space is equally possible in every other part of space and is perceived by us in precisely the same way. This is the case also with the musical scale. Every melodic phrase, every chord, which can be executed at any pitch, can be also executed at any other pitch in such a way that we immediately perceive the characteristic mark of the similarity.[8]

Voices and lines move up and down, together and apart, closer and more distant. Even more important, configurational patterns relevant to harmony and tonality may be viewed as predominantly spatial.

Every pitch, timbre, dynamic, every group of tones, every formal intricacy, every durational emphasis, even every rest—in sum, everything about a piece of music—contribute in some manner, substantial or only slightly, to the spatial organization of the work.[9]

Two main points are involved: (a) we apprehend certain musical values in terms of positions and locations, extension and range; (b) the homogeneity we assign to space pertains intrinsically to many musical elements. (a) is predominantly analogical in character: positions and locations pertain to music in ways quite similar to the positions and locations of bodies. (b) is more directly affirmative: identifying with space the homogeneity of extension. Both principles involve the same kinds of considerations: identifying as spatial certain properties which belong to musical elements and values as well as bodies.

An analogous approach can be taken to poetry. Here the contrast is between the dynamic, sequential flow of words and images and the

7. Vincent McDermott: "A Conceptual Musical Space," *Journal of Aesthetics and Art Criticism,* Summer 1972, XXX/4, p. 489.

8. Hermann Helmholz: *On the Sensations of Tone as a Physical Basis for the Theory of Music;* quoted by McDermott, *op. cit.* See also Victor Zuckerkandl: *Sound and Symbol,* New York, Pantheon, 1956, p. 339.

Far from taking us out of space—as common opinion holds—music discloses to us a mode of being of spatiality that, except through music, is ascernible only with difficulty and indirectly. It is the space which, instead of consolidating the boundaries between within and without, obliterates them; space which does not stand over against me but with which I can be one; which permits encounter to be experienced as communication, not as distance; which I must apprehend not as universal place but as universal force.

9. McDermott, *op. cit.,* p. 491.

completeness of image produced by certain poems. The fact that we must read the words in sequence is in sharp contrast with the homogeneity of the image. One may define space as nontemporal, homogeneous, simultaneous, and unmoving. I prefer to interpret the relevant contrast in poetry to be between the temporal and nontemporal, and do not consider the values involved to be particularly spatial.

What shall we take space to be? The question has a long and involved history, and is very complex. I will not undertake a rigorous answer. But we may distinguish this question from the related one: what *is* space? Here we may beg the entire question for art, since the only acceptable space appears to be that defined by astrophysics or in which we live and move as physical beings (though we may raise the question of whether these two spaces are the same). Still, our imaginative and memory spaces are not physical space, and there is some doubt that astrophysical and quantum mechanical spaces are the same. Is geometry the defining characteristic of space? A particular geometry or any geometry? Is a metric?

The example of music suggests that the wider category of spatial contrast is the more productive relative to art, and that the relevant value is indeed one of contrast. To deny that music employs spatial contrasts is of no great help in defining the contrasts music does provide. Indeed, the purpose of the denial appears to be no more than to prevent comparison, while contrasts are a function of interaction and interrelation. The narrower category of space simply weakens music and diminishes the range of its contrasts. The wider category admits of important distinctions within it: paintings where the representational and audience spaces are very similar; paintings where the painted space has extraordinary spatial qualities, though including positional and geometrical properties; paintings where the painted space is only presentational, not geometrical at all. Only the wider notion of space supports the pervasiveness of spatial contrasts throughout the arts wherever positional, extensive, and non-dynamic values are preeminent. The importance of differences as well as similarities to contrast ensures that the fundamental disparities of musical and visual spaces will not be neglected, while preserving also the richness of extensive elements throughout all the arts. Here all works create spatial or extensive elements, though of very different kinds, in marked contrast with the geometrical, metrical, and dynamical spaces of our practical and scientific experiences.

The ordinal theory provides us with a theoretical basis for regarding all contrasts involving extensive, positional, and non-dynamic values as spatial. The reason is that the question "what is space?" has no unqual-

ified answer, only an ordinal answer. Space is wherever a functional identity of spatial character is maintained, where a relevant gross integrity expresses a functional unitariness over a range of subaltern integrities. Here the generalization is not by analogy, but by qualified respects and functions. The basis for the generalization is reasonably clear. The reason for making it is extremely important: it provides a richer and clearer range of intense contrasts for works of art. It manifests the inexhaustibility of space in relation to art and the inexhaustibility of art in relation to space.

Time

A representational painting is constructed within one space and constructs another in contrast with it. Analogously, music is constructed in one time and constructs another in contrast with it. Temporal contrasts are pervasive throughout the arts as are spatial contrasts, and depend on a similar generalization of the dynamic properties that define temporality.

In her mature account of music, Susanne Langer discusses the idiosyncratic character of musical time, calling attention to the fact that motion and change are apparent in music, yet nothing moves. She concludes that music represents duration in Bergson's sense—the inner passage of awareness and life. Such a view is a consequence of too narrow a theory of time and events. Spinoza, for example, distinguishes time from duration, the former a measure of relative durations and their changing interrelations, the latter a fundamental condition of being—to endure until destroyed by an external cause. All being here is durational, and the measured interplay of extensive durations is time.

Spinoza's position is in effect that durations bear contrasting relations to each other, and that these are the conditions of time. Duration is the primary notion belonging to all things as such, while time expresses varying durations in their interrelations. We may generalize to any system of events in dynamic relation. Music is then the construction of alternative times, the interplay and coordination of sonorous events —voices, cadences, melodies, tonal progressions, rhythms, and the like—overlapping, succeeding one another, beginning and ending. All are enduring beings, and their coordinated relations are temporal. Throughout any musical composition is a meter—regular or intermittent, fundamental or relative—upon which and coordinated with which a sequence of varied durational events is laid. In some simple cases, we have a single vocal melody sung without accompaniment to a

172

regular beat. The constructed time is the coordination and contrast of the melodic line with the regular meter. In some more complex compositions, there are many voices, coordinated yet varied, sometimes lacking a primary meter, engendering a thoroughly relational temporal system. In the most extreme case—Elliott Carter's music, for example —there is no fundamental beat, only the exigencies of notation, and several distinct lines in independent and coequal development, approaching as closely as possible the Spinozistic sense that durations are central while the temporal measure is conventional. In Carter's music, there is no fundamental time or measure, but many sequences of musical events, coordinated and interrelated, of distinct character and equal importance.

A musical performance takes place in time—in *our* time as we listen, in the measured time given by the meter where present, and in the time defined by the coordinated musical occurrences. All these times are relevant, in complex contrast. The metronome time is not the time of the composition in two respects. First, no musical work is performed strictly according to the clock. To perform a composition so regularly is to ignore its lines and phrases, its internal tensions and movements. Thus, the second consideration is that musical events are not given by the metronome markings, but are the interplay of phrases, lines, and voices. The metronome is a means of control, not a component of the work. A man may cough during a musical performance in the fifty-seventh measure. There is no intrinsic connection between the audience time in which the cough occurs and the musical occurrences, though the metronome brings them together. Audience time and musical time are different temporal orders. Likewise, within the work, for example in a complex figure, the concurrence of various lines in a given measure may be largely a coincidence produced by the independent musical events taking place. The ongoing and developing musical events come together in our time as we listen, but may follow rigorous principles of their own development. The interplay of the diverse lines, each with its own principles, in their interconnection and concurrence, is the material in such works from which the central contrasts are constructed.

In the respects mentioned, and others as well, a musical composition is a durational microcosm which does not reproduce our spatiotemporal world, but rather has its own extensive character.

> Both in the guise of musical compositions and otherwise, musicry is the art of creating time. This time is new, quite distinct from any time experienced or known in other ways. Each part of that time makes a difference to other parts. No part has a magnitude which can serve as the measure for the rest.

Nor is there a measure which can be applied indifferently to them all. Nothing can measure the time of music; its time is one within which all measures, all notes, all subdivisions are to be located.[10]

Weiss' point is apt and important, though he provides no theoretical foundation for such created times. Even worse, he overemphasizes the uniqueness and novelty of musical time, and fails to grasp that it is the contrast among the various times involved which is of artistic value. Weiss quotes with favor Zuckerkandl's claim that "to form in tones is to form the stuff of time."[11] Elliott Carter writes concerning his first two string quartets of his "impression of their living in different time worlds." He admits that

it is quite true that I have been concerned with contrasts of many kinds of musical characters—'many selves'; with forming these into poetically evocative combinations—'many sensuous worlds'; with filling musical time and space by a work of continually varying cross references.

In addressing his late work, he speaks of discovering "the idea of metrical modulation," and "the contrast between psychological time (in the cello) and chronometric time (in the piano), their combination producing musical or 'virtual' time."[12] He has not found, any more than Langer, a language for describing the temporal discoveries and inventions he has made. Yet his contributions to novelty in musical time are immense. Moreover, his sense of contrasts in time producing musical times and values is very clear.

Musical time differs from the time of other events in important respects: lack of regularity, internal tensions, repetitions and variations, dynamic impulsions. Most important of all, it is a coordination not of common but of unique events and characters. Because music is not conventionally spatial except in instrumental location, it creates no ordinary world. Yet it weaves a varied and complex interrelated temporal pattern, often of great intricacy. If we take the wider meaning of spatiality—all values of a positional and extensive, nondynamic nature—then music creates a radically novel, yet intelligible, complex, and contrasting world of many dimensions for our apprehension. A complex musical work is a constructed world comprising varied qualities and contrasts, a world which we may appreciate and understand, yet not reside within.

10. Paul Weiss: *Nine Basic Arts*, Carbondale, Southern Illinois University Press, 1969, p. 124.

11. Victor Zuckerkandl, *Sound and Symbol*, quoted in Weiss, *op. cit.*, p. 125.

12. Elliott Carter: *Program Notes for Sonata for Cello and Piano (1948) and Sonata for Flute, Oboe, Cello, and Harpisichord (1952)*, Nonesuch H-71234, 1969.

In physical time, there are several sets of nearly parallel sequences of events—many regular clocks. A clockmaker constructs a causally ordered sequence of events which provides a measure of these coordinated strands. He thus constructs a way of measuring time, and does not construct time itself. But a composer may abandon all conventional clocks, define his own sequence of meters, even abandon all meter, creating a unique order among unique sequences of sonorous events. Except for his arranging them so, the varied lines of his work may have no lawful interrelations, as do separate sequences of events in physical time. In addition, all clocks in physical time are repetitive. In music, there may be little or no repetition—though musical clocks are far more interesting when repetitive as well as varied. Again, it is not the mere construction that bears value, not even the construction of a new time, but invention harnessed to intensity of contrast. Musical time is a distinct value in its contrasting relations as well as in contrasts with physical and audience time. All these times are disparate, affording no common measure. The various events within a musical work are constructed durations, neither measured nor quite measurable. The number of measures in a work tells us nothing about the number of musical events it contains. In this sense, music creates its own modes of coordinated durations, its own time, quite unlike the measured coordinations within ordinary and scientific experience. Music creates its own space in precisely the same sense, since it is constructed of entirely non-material—though perceivable—elements.

Langer claims that in music there is the appearance of motion, but nothing "really" moves.[13] Her categories are impoverished. There are no motions through ordinary physical space. But there is motion as change, measured by musical events relative to each other. While one voice is repeating the first theme, the other may be developing a secondary theme. Here there is both motion and also change, though not of material objects. Time is a constituent of many orders besides those involving ordinary material objects, insofar as contrasting durations and change are relevant. Such diverse forms of time are a major source of intense contrasts in music and the other arts,° especially performing arts. Music does not directly compete with everyday events, for we cannot live wholly in musical time. But we sometimes wish we could after having nearly done so for a while.

The fundamental spatial contrast in painting is between the constructed space—whether of two or three dimensions—and the two-dimensional medial space. The fundamental durational contrast in

13. Langer, *Feeling and Form*, Chapter 7.

music is between the time of the performance—the basic meter or audience time—and the musical events coordinated with it. Music which lacks meter lacks an important component of temporal contrast —the play of musical events upon a regular metrical base. The result is akin to nonrepresentational painting: the musical events are not easily coordinated with events in audience time as a region in such a painting is not identifiable as an object in the audience's experience. Such dislocations can provide remarkably intense contrasts. In music, the dislocations are akin to those produced by relativistic theories of space and time. Space is vital in contrast for painting; time is vital for music. But there is much more to painting than spatial contrasts and much more to music than temporal contrasts. The essence of neither resides in a single mode of contrast.

In painting, time is representable as a displayed passage of events— in a tryptych, for example, where portrayed events are given in sequence, or in many medieval crucifixions, where the events displayed took place at different times. In being so representational, painting can portray experienced events and their passage as music cannot. Here painting does not create sequences and passage—though in Max Beckmann's tryptychs it approaches such a construction—but rather takes advantage of its pictorial nature to gain an overview of related events. Time here can be a component of important contrasts—time as separation and passage crystallized in the togetherness of a spatial representation. Representation accommodates a great variety and intensity of temporal contrasts—usually closely intermixed with spatial contrasts.

Another type of temporal contrast within painting is given by action painting. A given brushstroke is an act, and bears its character as a dynamic movement. In the case of Jackson Pollack's work, the space is so filled with contrasting colors and forms that the individual acts are blurred. The action seems a means to a relatively static end—though the result is a remarkably dynamic spatial quality: time transformed into space. In Franz Kline's black and white paintings, however, each stroke is vividly preserved as a single act, and the movement of the stroke retains its temporal character. The space is filled by movement —not only as represented, but as action completed in line and stroke. Time is made visible, in intense extensive contrast with visual space.

Painting is inherently static, yet it may communicate a sense of motion and may take on dynamic qualities. Painting can therefore possess important temporal contrasts—the time within and the time of the painting in opposition. Temporal contrasts belong to all the arts which construct orders at variance with ordinary, lived time. A drama may move at the time of its audience, but they will be bored. Stage time

is usually at breakneck pace, though sometimes by way of contrast slowed to a point of extinction. Dance draws upon music, but even silent is a cadence of gestures with their own times. Cinema notoriously plays with time, changing rhythms and pacing, slowing or increasing the rush of events.

Space and time are the source of fundamental and intense contrasts in architecture, but always the space of human life and the time of human movement. While architectural monuments have sometimes been created largely indifferent to the lives of human beings around them, imposing edifices of formal character, they are always interpreted once in place in terms of the space they control surrounding them: plazas and squares, the buildings in their shadows. By such control of space—utilizing whatever materials and devices are available—architects influence life and action. Space and time are therefore both fundamental to the intermodal contrasts of architecture.

> It must seem evident to anyone that the serious issues of environment revolve around either the preservation of the past or the control of the future. But that is wrong. We preserve present signals of the past or control the present to satisfy our image of the future. Our image of past and future are present images, continuously re-created. The heart of our sense of time is the sense of 'now.' The spatial environment can strengthen and humanize this present image of time, and I contend that this function is one of its vital but most widely neglected roles.[14]

Time has always been of significance in literature, In a tale told well, the time of events is in a twofold contrast with the reader's time: it is not his time, not even his history, certainly not something he can remember; in addition, a narrative well spun will not pretend to give events in the close measured sequence of either lived or physical time, but creates its own sequence and pacing from dramatic and narrative necessity. It follows that the simplest good narrative depends for its value upon the temporal contrasts it can generate, though they may not be obtrusive.

There is also the temporal contrast—a very simple one perhaps—which pertains to all the arts due to diverse temporal locations. It may be primarily a form of intersubjective contrast, but it is specifically relevant to a single individual at different stages of his life relative to the same work: for the work is both the same and different for him at the different times. There is significant integral and scopic variation. We remember our earlier experiences, and they engender important contrasts, filling the work with richness.

14. Kevin Lynch: *What Time is This Place?*, Cambridge, MIT Press, 1972, p. 65.

A particularly interesting and relevant example of this is given by photography, especially the use of it at special occasions: weddings and anniversaries. Photography has become the art of celebration—weddings, births, parties, travels. Indeed, the camera is sometimes interposed between events and the participant as if he cannot experience his surroundings directly, but must experience them afterward through the camera. Yet the passing of time transmutes our memories. We often find it difficult to remember past events precisely as they occurred. Flavors and atmospheres change, and so do images. A photograph provides an alternative perspective upon the passing of time, remarkably different from what we remember, different also from what we come to understand from others. A photograph also "spatializes" the passage of time, laying out in space the events of a process. If the photographs are regarded as the only truth, there has been distortion and alienation. But the vital and remarkable contrast between the perspectives of spatialized distance and emotional involvement is a great aesthetic value. Photographs enable us to recapture past events not so much as they were (or are), but in an alternative perspective which, in conjunction with our memories, restores to us a greater vitality upon the events brought by intense contrasts. Understood in contrast and with their profound limitations and relevance, photographs manifest inexhaustibility inexorably and irresistibly.

IMPORTANT CONTRASTS IN ART: HUMOR, IRONY, VIOLENCE

There are contrasts which are important features of some works of art, though not of all, which can be understood only in terms of the theory of contrast or some similar theory. Many of these contrasts are worth considering in themselves as well as to develop important applications of the theory of contrast. I will discuss three such contrasts here. It is impossible to list, much less discuss in detail, all the important forms of contrast in works of art. This is a consequence of the inexhaustibility of orders manifested in the inexhaustibility of types and levels of contrast in works of art.

Humor

Consider the following:

The most adequate generic definition of the comic is: the presence of an incongruity, contradiction, or absurdity that is humanly relevant without being oppressively grave or momentous.[15]

15. Marie Collins Swabey: *Comic Laughter*, New Haven, Yale University Press, 1961, p. 28.

The perceiving of a situation or idea, L, in two self-consistent but habitually incompatible frames of reference.[16]

Le comique naît de la confusion, naïve ou simulée, de deux ordres de faits aussi différents que possible.[17]

Consider instead:

Why did the nincompoop throw the clock out the window? He wanted to see time fly.

Why did the chicken cross the road? To get to the other side.

Or the true anecdote:

A thousand Edinburgh schoolchildren burst into laughter when David Oistrakh, the Russian violinist, snapped a string while playing Schubert's *Fantasy in C Major* during a recital at a city housing estate yesterday. Their studious attention broke when Mr. Oistrakh—guest of honour at the Edinburgh festival—held up the violin and looked with consternation at his accompanist.[18]

It would be foolhardy to expect an adequate theory of humor in a limited space—perhaps foolhardy altogether:

Laughter manifests itself in such varied and heterogeneous conditions ... that the reduction of all these causes to a single one remains a very problematic undertaking. After so much work spent on such a trivial phenomenon, the problem is still far from being completely explained.[19]

These remarks could have been uttered today. Nevertheless, I will consider certain aspects of humor in relation to the theory of contrast. As the passages above indicate, many theories of humor are based on incongruity, and this is closely related to contrasts and their intensity. In addition, it is important to understand how low humor can contribute to the highest artistic values—as in Shakespeare and Cervantes.

There are incongruities which are not humorous. In Alexander Bain's words:

A decrepit man under a heavy burden, five loaves and two fishes among a multitude, and all unfitness and gross disproportion; an instrument out of tune, a fly in ointment, snow in May, Archimedes studying geometry in a siege, and all discordant things; a wolf in sheep's clothing, a breach of bargain and falsehood in general; the multitude taking the law into their own hands, and everything of the nature of disorder; a corpse at a feast,

16. Arthur Koestler: *The Act of Creation*, New York, Macmillan, 1964, p. 35.

17. Fernand Janson: *Le Comique et L'Humour*, Bruxelles, La Renaissance du Livre, 1956, p. 17.

18. *The Guardian*, 5.9.1962; quoted in Koestler, *op. cit.*, pp. 59-60.

19. T. A. Ribot: *La Psychologie des Sentiments*, 1896; quoted in Koestler, *op. cit.*, p. 32.

parental cruelty, filial ingratitude, and whatever is unnatural; the entire catalogue of the vanities given by Solomon are all incongruous, but they cause feelings of pain, anger, sadness, loathing, rather than mirth.[20]

Incongruities as such are no more humorous than they are beautiful or sublime. It is not clashes or incongruities which are of value, but contrasts and their intensity. Humor is an important application of the theory of contrast, both in and out of art. We may begin with the question whether the same relations that transform oppositions into complex and intense contrasts are also significant in humor. What is the difference between humor and aesthetic value?

The first riddle above establishes two incompatible meanings of "time flying": the result is humorous. The second riddle is humorous in a way analogous to the workings of artistic contrasts. If we take the question seriously, the answer is not humorous. It is humorous only relative to riddles of the first type: we are amused when our expectations prove their own undoing. There is a second-level incongruity. Contrasts in works of art have precisely this property: established contrasts engender conditions for novel contrasts and their intensity.

If jokes are made, if they depend on incongruity and incompatibility, and if they attain levels upon levels of incongruity (as does irony), are not jokes works of art? A normative reply seems appropriate: jokes are not works of art because they are not graceful enough, not beautiful. But there are works of art which are neither graceful nor beautiful. The answer cannot be given in such terms.

As an alternative, I suggest that humor is *abruptly truncated contrast*. It is closely related to intensity of contrast, but by negation. Jokes are very much like works of art except: (a) They are abbreviated. When a funny story is expanded sufficiently, it may become a work of art. (b) Jokes are relatively impoverished in their range of contrasts. Richness is a primary value in art and a minor value in humor. When a joke is sufficiently embellished, it may become a work of art. (c) Jokes collapse contrasts into incongruities. Humor collapses the manifold possibilities of rich contrasts into mere differences. Another way of putting this is that humor takes the initial steps toward intensity of contrast, but collapses into discordance. It promises inexhaustibility, but collapses into surface.

This gives us a theory of laughter: laughter is a response to a sudden collapse of intensity of contrast: *de-tensified contrast*.[21] This explains

20. Quoted by Swabey, *op. cit.*, pp. 208-209.
21. See Kant, *Critique of Judgment*, I, par. 54: "Laughter is an affection arising from a strained expectation being suddenly reduced to nothing."

why laughter is so often associated with the ridiculous: the beautiful dissolved into the absurd. It also explains why the breaking of a violin string during a concert occasions laughter. A broken string is not humorous in itself, but only in disruption of the intensity of the concert: the sublime dissipated into the trivial. It is common during intense dramatic performances for painful moments to be broken by the laughter of the audience—seizing upon any excuse to release an intensity of involvement that approaches pain. The close association of intensity of contrast and its abrupt release in laughter explains why many incongruities are not humorous: it is not the incongruity which is humorous but the disruption of intense contrasts, the release of intensity into incongruity. Where intensity of contrast is not established as a preliminary, incongruity is pitiful, serious, or embarrassing.

We may turn now from the merely humorous to the humorous in art. It is appropriate to begin with a distinction between humor in art and humorous art. By the latter I mean works created to be funny. By humor in art I mean to note that a great many works have humorous moments. Even works of gravity may be humorous without sacrificing their power—sometimes enhancing it remarkably. The more interesting question here is how humor in art can enhance artistic value, how intensity of contrast can be enriched by humorous disruption.

At the elemental level of humor and art, there are works with jokes in them. Such a work may be very funny, but attain no greater intensity of contrast. There are also works with humorous moments that are not very funny. Even a great work may have lighter moments which are not humorous enough to explode the intensity involved.

At a more sophisticated level, a humorous work may both be very funny and build its jokes upon each other to great effect. Usually both the humor and the art are enhanced by such interplay. Moreover, such a work may involve a great many contrasts which are not humorous, blurring the line between humorous art and humor in art. In some cases, a work may attain an utter frenzy of humor, where the various jokes and humorous moments interrelate within and upon themselves. The various humorous releases provide their own energies for novel contrasts. Alternatively, there may be fine works with humorous passages where the de-tensification of the humor only provides prospects for further contrast. Incongruities can be transmuted into contrasts at higher levels of complexity. The disruption of some contrasts into humor simply enhances the complexity and richness of the contrasts at other levels in a complete and perfect work. All the general types of contrast can contribute here, especially traditionary, intermodal, and intersubjective contrasts.

181

At its most elemental level—in its relative purity—humor is neither art nor intensity of contrast, but is closely related to both of them. It depends on fundamental contrasts—especially of invention and celebration. And there is a perfection appropriate to humor. But the essential character of humor is *de*-tensification of contrast: the release of the powers of art in explosive laughter. The explosion is greater where the intensity was most completely developed. Here art and humor contribute to and sustain each other. In their opposition and interplay, enrichment and opposition, inexhaustibility is thoroughly manifested. In the finest works, humor and art enrich each other: humor enhancing the intensity of contrasts; art enriching the energies that are released in laughter.

Irony

Irony is an extraordinarily complex phenomenon, and in two senses: it is complex in the diverse forms it takes in different works of art; it is complex in its various meanings. I will emphasize two meanings or kinds of irony: specific and general. I mean by general irony that which may be interpreted to belong to all works of art as such: the double character of being created and having meaning. A work may be regarded as a mirror of another reality—internal or external. Even so, it is also a work, exhibitive of itself.

I will begin with more elemental forms of irony, both to establish how simple irony is to be interpreted as a form of contrast, but also to develop an understanding of how irony in its specific forms within particular works is to be distinguished from a general irony applicable to all works of art. Specific irony is a mode of value pertaining not to all or even most works of art, but a specific device or tone possessed by particular works.

A preliminary definition would be useful: let us consider two definitions of simple, single irony:

> . . . an apparently or ostensibly true statement, serious question, valid assumption, or legitimate expectation is corrected, invalidated, or frustrated by the ironist's real meaning, by the true state of affairs, or by what actually happens.

> . . . ways of speaking, writing, acting, behaving, painting, etc., in which the real or intended meaning presented or evoked is intentionally quite other than, and incompatible with, the ostensible or pretended meaning.[22]

We seem to have irony where a person says or does one thing and means another. But this will not do. A lie is not generally ironic. Two

22. Muecke, *The Compass of Irony,* pp. 23, 51.

meanings are involved in a play on words, but it need not be ironic. Finally, every work of art in an obvious sense says one thing and means another.

Several other considerations are worth noting. The multiple meanings involved in irony are not simply plural: there is negation and opposition among them. Irony demands incongruity and opposition, yet if either meaning is overwhelmed, there will be contrast but not irony. In addition, we may remain on the elemental level of simple irony but add embellishment. There is simple double irony without the cancellation or enhancement of one meaning by another, but an opposition in which the two meanings cancel each other—for example, in *Candide* the line

> When all was over and the rival kings were celebrating their victory with Te Deums in their respective camps . . .

And there is complex irony of a single or double nature where the levels pile upon each other.

If there are double meanings that are not ironic, but irony is a form of double meaning, a plausible hypothesis is that irony is a mode of contrast. "The basic feature of every Irony is a contrast between a reality and an appearance."[23] There are cases of double and complex forms of irony where the appearance and the reality are difficult to distinguish—but the theory of contrast explains this readily, since if a simple appearance-reality contrast is intense, a complex, negating, or multiple contrast can attain higher levels of intense contrast. Nevertheless, there surely are appearance-reality contrasts which are not ironic: simple representations, for example.

What is missing here is the force and complexity of the ironic contrast. A representation or symbol gives us one thing for another, but we do not take the one for the other. Irony depends on a confusion on someone's part: a victim is involved. The speaker—if only the artist—is ironic at the expense of some inferior obtuseness, belief, attitude, or behavior on the part of another—real or alleged. Where there is no overt victim present, there is at least an imaginary victim toward whom the reader and artist may feel superior, a point of view to be overcome. In more complex irony, as standpoints cancel each other, various points of view are cast into discredit. The concept of a victim is too narrow for all cases of specific irony. The corresponding analogue is a perspectival standpoint. Specific ironies involve both appearance-reality contrasts and varied points of view. It is not merely multiple

23. Haakon M. Chevalier: *The Ironic Temper: Anatole France and his Time*, New York, Oxford University Press, 1932, p. 42.

meanings that produce irony, but multiple perspectives associated with them where one perspective is played off against the other.

Another feature distinguishing irony from the multiple contrasts of most great art is the extreme reversal of attitudes and perceptions that is involved in the apprehension of irony. A missed image or association is not always productive of a complete transformation of poetic understanding. A missed irony radically transforms our perceptions of the work. Irony almost always imposes integral-scopic contrasts and reversals upon our apprehensions. Is is heavily dependent on the cancellation of integrities, the introduction of deviance into established, prevailing perspectives. The ordinal theory offers a very general basis for the possibilities irony finds for pervasiveness throughout all human perspectives. Any viewpoint may be cancelled by irony.

It follows from these considerations that specific irony may be defined as *a complex or higher-level contrast among appearance-reality and overt intersubjective contrasts which engenders extreme and complex integral-scopic contrasts.* In many cases, the reality is implicitly the superior—and in irony, there is always this suggestion. But irony can become double- and multi-leveled, so that the superiority and the nature of the reality may be impossible to determine. Still, the tone in such irony always suggests the possibility of a resolution, even if it is cancelled out. The resolution is often moral or propositional, and we add the further proviso that *the appearance-reality and intersubjective contrasts usually emphasize possibilities of judgmental validity in other modes*—scientific, moral, or philosophical. Irony frequently involves intermodal contrast.

Appearance-reality, intermodal, integral-scopic, and intersubjective contrasts are relevant to all works of art. But there are works where these contrasts are merely enumerative, contributing little to each other. For example, a medieval painting employs the appearance-reality contrasts of images of God in the world and the intermodal and intersubjective contrasts of religious art. But there will be no irony where no point of view is challenged by the work in terms of appearance-reality and integral-scopic contrasts. Perspectival discreditation is essential to irony. Specific irony is a form of contrast to be found only in certain works—those which establish a putative reality through contrast for some persons which implicitly and radically transforms the integrity of the work.

We may now consider general irony from the standpoint of the above definition. In its most general form, such irony depends on the double condition that a work of art is an artifact and has meaning. Now whatever has meaning has such a double existence. In addition, some works of art signify nothing beyond themselves: they simply are what

they are—a Calder mobile, an action painting—located in a common world with common properties and constituents. Not all interpretations of such works will be so modest, but many are. We may, then, introduce a distinction between a work of art—intentionally or under interpretation—which explicitly plays upon the duality of being created and having significance, and a work which simply is such a duality. The word "mosquito" does not reflect on itself. To the contrary, it is nearly transparent. But we may reflect on it as a word and as referring to a flying insect.

From this point of view, the theory of general irony is not adequate to all works of art, to all interpretations of such works, or to all the values of works of art, but it is an interpretive standpoint which may be imposed on all works. Some works explicitly flaunt their dual natures; others do so only implicitly. A scale may be established which suggests that explicit irony is artistically superior to implicit irony, though it is not a value which would be accepted by all who love the arts. I have discussed general irony as a theory of art in Chapter I. It is a theory of contrast, and it is a theory of levels of contrast. However, it is too narrow to include all the many kinds of contrast we have discussed, and its narrowness rapidly leads the production of irony upon irony to a sense of sterility.

Specific irony is the interplay of appearance-reality, integral-scopic, and intersubjective contrasts. General irony is also—emphasizing the appearance-reality contrasts of the work in its various perspectives and the intersubjective contrasts of the artist and his audiences, and minimizing the transformations of the integrity of the work. Specific irony emphasizes variations in the integrity of the work relative to diverse modes of judgment. General irony emphasizes instead the intermodality of art, the existence and pervasiveness of many modes of judgment including constructive judgment.

If neither specific nor general irony is sufficiently comprehensive to serve as the basis of artistic value, nevertheless irony can be extended even further, beyond the double nature of works of art, to the multifarious role played by every element of a work of art.

> . . . irony is the most general term that we have for the kind of qualification which the various elements in a context receive from the context. This kind of qualification . . . is of tremendous importance in any poem. Moreover, irony is our most general term for indicating that recognition of incongruities—which, again, pervades all poetry to a degree far beyond what our conventional criticism has been heretofore willing to allow.[24]

24. Cleanth Brooks: *The Well Wrought Urn*, New York, Reynal & Hitchcock, 1947, pp. 191-92.

Here irony passes over into the theory of contrast and the theory of orders. Yet such irony is limited to poetry, which is insufficiently general, and multifariousness in the visual arts seems inappropriately rendered as irony. It would seem far clearer to recognize that what is meant here by irony can be expressed in terms of linguistic contrasts, that the more general theory is the theory of contrast, and restrict irony to a specific and complex mode of contrast.

Violence

From the standpoint of theories of beauty, or theories which emphasize sensuous delight, violence in art is at best irrelevant and at worst conflicts sharply with our moral sensibilities. Works which contain violence must either be immoral, where violence gives us pleasure, or if the violence horrifies us, possess a value other than delight. On the basis of the theory of contrast, we may hypothesize that one role of violence in art is to establish remarkable and intense contrasts. Nevertheless, the difficulty repeats itself if we hold that violence that repels and frightens us is transformed by art into pleasure and satisfaction.

Should violence be enjoyable? Or, where it is not enjoyed but present in contrast, should it have a place in works of art? These questions are not aesthetic, but moral. Violence in art cannot be discussed except from a moral point of view. To understand it, we must begin by conceding that for some people, violence has a direct appeal: it is enjoyable to witness, pleasurable even to cause pain. It is worth noting that for those who enjoy causing pain, portrayed suffering on the stage or in a painting may not be very pleasurable. However, for those whose moral scruples outweigh the pleasures of violence, overt violence may be revolting while portrayed violence is fulfilling.

Sometimes violence in art serves a moral function: to depict the brutalities of suffering with a poignancy otherwise lacking from everyday experience. Violence may help us to despise the brutality of the evil persons portrayed, may enlist our sympathies for the brutalized, or may enable us to understand the characteristics and temptations of suffering and violence. Such a moral role is intelligible through the category of intermodal contrast. Yet we must examine more closely the relationship between morality and contrast in works that involve violence, for that relationship is exceedingly complex.

At an elemental level, violence in art may give us pleasure because we have profound and hidden aggressive feelings which are submerged in everyday life. At the same level, violence may be enjoyed in art as a contrast with our revulsion against genuine violence and suffering.

186

The appearance-reality contrast overcomes the natural feelings we would have when confronted with such genuine violence in our daily lives. Both of these values are contrasts: that of moral situations and natural feelings contrasted with the portrayed events in the work of art.

At a more complex level, violence may not give us pleasure at all, but may revolt us even in art. Yet the very revulsion it produces may engender contrasts of intense artistic value—contrasts of beauty with ugliness, perfection with brutality, intermodal contrasts intertwined with appearance-reality and generality-specificity contrasts. Intermodal contrasts are predominant wherever violence is presented, for violence is always of moral concern.

At a still more complex level, the various contrasts that are produced by violence are played upon each other—humorously, ironically, self-consciously. Here we may note a fascinating phenomenon. The intermodal contrasts essential to violence in art can be entirely submerged by the other contrasts involved. Where appearance-reality and intersubjective contrasts become predominant, where irony is emphasized, the censure of violence may be diminished or even inverted. Put a bit paradoxically, where violence is treated more artfully, it must be treated less morally. This is true in works ranging from the *Iliad* to *L'Etranger*. To the extent that violence is intrinsic to the work, other contrasts besides intermodal contrasts are important. Even where the moral position of the work is relatively secure, the many other related contrasts which depend on the presence of violence distract from its moral purity—indeed, compromise it.

> There is an important paradox that . . . art can indeed help to alert one to alarming possibilities, both in groups and individuals. And presentations of violence can help us to understand more fully the nature of various kinds of violence, and of attitudes that make for violence, and so, in the long run, help us to be better able to deal with them. But an essential condition is that one empathize with the perpetrators of the violence, however much one may deplore or abominate the violences themselves.[25]

I would not describe the paradox so, for the issue is more general than that of empathy versus revulsion: it is inherent in the nature of intermodal contrast. Violence in art can serve a moral purpose, and it must possess a moral character in order to engender the intermodal contrasts which are relevant to its role in art. But the artistic drive is toward intensity of contrast, toward richness and range, and there are many other contrasts besides intermodal ones. As perfection, inven-

25. John Fraser: *Violence in the Arts,* London, Cambridge University Press, 1974, p. 85.

tion, and celebration are emphasized relative to violence, intermodal contrasts are relatively diminished.

Let us assume, contrary to the evidence, that violence in art is unambiguously revolting, engendering intense intermodal contrasts. In other words, let us put aside all morally questionable attitudes toward violence in art. Nevertheless, the fundamental dimensions of artistic value are relevant to all the constituents of works of art. If there is violence in a work, the dimensions of perfection, invention, and celebration apply. Violence may be represented perfectly, given perfect form; may be originally conceived and portrayed, given novel forms; may be celebrated or made part of a ritual. All of these values oppose the relevant intermodal contrasts. Even where the moral position is secure, the other contrasts compromise it—at least distract from it, weaken its force. This, I believe, is the general difficulty. Even where the moral function of a portrayed violent act is without moral ambiguity, the relevant aesthetic values render it relatively unimportant. Because artistic values are plural, because intensity of contrast is plural within any work, different contrasts compete with and distract from one another. A violent person must be characterized perfectly and inventively. The language and portrayal must enlist our sympathies, at least our interest. Violence which is noteworthy and distinctive is not in the same sense despicable. All the other modes of contrast—especially intersubjective and traditionary contrasts—transmute the purely moral function of intermodal contrasts. A further complication is that assertive and syndetic contrasts may also transmute the moral or active character of a work, as if truth about violence is not always relevant to our moral outrage.

Violence in art is both morally relevant through intermodal contrast yet muted in its moral force because of the relevance of an inexhaustible range of other contrasts and levels of contrast. What is exemplified here is the predominance of intensity of contrast in art in relation to other modes of judgment. Art can include all the modes of judgment through intermodal contrast, and can include every mode of validation as well. In this sense, truth and rightness are relevant to art. Nevertheless, their relevance is subordinate to intensity of contrast. In science, truth is predominant; though contrasts and intensity are relevant, they are subservient to truth. As a consequence, the greatest art simultaneously enriches the power of our moral sensibilities and subordinates them to artistic sensibilities concerned with intensity of contrast. Every means in art that has a moral purview—violence and sexuality, politics and heroism—is rendered more powerful through art yet diminished in its supreme importance in human life. This is a natural consequence

of the concern of art with inexhaustibility: from the standpoint of inexhaustibility, supremacy and priority are always qualified. Art here wars with morality for our attention and energy—if not our allegiance —and both enriches our moral capacities and distracts us from their use. This is a consequence of the plurality of modes of judgment and one of the most important features of our intellectual experience.

OTHER MODES OF CONTRAST

In Whitehead's theory, contrasts are a characteristic property of complex experiences. Analogously, in the theory proposed here, contrasts are not found only in art, but are everywhere in and out of experience. They belong to nature and found orders as well as to constructed orders; they are also present typically in science and philosophy, morals and politics, throughout the complex forms of human experience. We commonly grant this pervasiveness of contrast by noting the aesthetic values of the greatest works of philosophy and science, the elegance and vitality of the works of Newton, Einstein, and Darwin. Nature is fascinating; so are our discoveries in nature. Some of our greatest theoretical discoveries provide the most intense contrasts known to us. In other words, intensity of contrast is evident in science as well as in art, and the greatest works of science and philosophy possess aesthetic values as striking as those of the greatest masterpieces of art. Yet we are reluctant to consider science and philosophy art without qualification.

This is an important issue for the theory of contrast. In the next chapter, I will distinguish science, philosophy, art, and ethics as modes of query related to the different modes of judgment. Far more important here, however, is a discussion of the ways in which the different kinds of contrast function in science and philosophy as distinguished from their function in art. Perhaps the simplest place to begin is with the principle that intensity of contrast is present throughout human experience, but is emphasized and predominant only in certain spheres of experience, certain perspectives and orders. Related to this principle is the phenomenon that we must learn to evaluate works as art rather than as science, as if they may be confused in certain cases. Conversely, it is common to regard major scientific theories—of Kepler and Newton—philosophically and aesthetically, for they are amenable to interpretations that emphasize their intensity of contrast. Put another way, there is indeed an aesthetic attitude, which consists in attention to intensity of contrast in its inexhaustible manifestations. All works of

189

mankind, as well as all orders in experience, may be judged in terms of their intense contrasts. Nevertheless, many works will not profoundly repay such a mode of judgment; others virtually demand that we acknowledge their complex contrasts and their intensity, profoundly rewarding us with enrichment and heightened awareness. Such demands, of course, depend on ordinal conditions, on our attitudes and expectations and on the settings in which we encounter these works. We learn to respond to intensity of contrast and to apprehend its richness and inexhaustibility; we also learn that many forms of contrast depend on the negation of antecedent expectations and the development of new attitudes and modes of sensibility.

Important works of science and mathematics offer us rich and rewarding contrasts. Yet science and mathematics are not art. This is no more remarkable a condition than that works of philosophy and art often make true empirical claims. I have noted the relevant principle that all the modes of judgment interpenetrate, so that science is not only assertive but constructive; art is not only constructive but assertive and active. Works of art can achieve certain intense contrasts by emphasizing assertion through intermodal contrasts. However, scientific works are not so obviously enhanced in their assertive validation by intensity of contrast over a richer range of contrasts. This is one of the major differences between science and art. It is a function of the different emphasis in science and art played by intensity of contrast and inexhaustibility.

Another way to indicate the role of intensity of contrast in the different modes of query is to consider the different kinds of contrast in relation to conventional standards of validation. For example, the three dimensions of aesthetic value—perfection, invention, and celebration—are relevant to all contrasts, in science and philosophy as well as art. There could be no intellectual achievement, no validation in judgment, that did not attain perfection. Perfection in science, however, is sharply constrained by standards of verification, logical consistency, and fruitfulness. *How* a scientific theory is perfect is relatively restricted compared with the range of perfections relevant within the complex masterpieces of art. Perfection in art is inexhaustible in both number and kind. There are no extrinsic standards which determine the scope of relevant perfections. A major scientific theory is complex and inexhaustible in its implications and ramifications yet relatively restricted in the *kinds* of perfection relevant to it: restricted in kind but remarkably pervasive in its scope. This engenders another level of contrast, perhaps the most remarkable for major physical theories:

that they may explain so much despite their limited means. Analogously, invention in science, while all-important and pervasive, is restricted by utilitarian or pragmatic considerations: invention not for contrast, not to manifest and augment inexhaustibility, but for scientific efficacy. Nevertheless, invention always engenders novel contrasts, frequently extraordinary and intense ones.

Perfection and invention in philosophy suffer from few of the restrictions described. This is in part due to the fact that no clear and independent criteria exist for the validation of a philosophic theory. Criteria are frequently developed as the theory is developed. This is manifested by the wealth of different approaches taken by different philosophers. Thus, what a philosophic theory is supposed to do is frequently indeterminate; as a consequence, the many ways it may be perfect and incomparable are all relevant, almost without restriction, as the importance of Plato's, Nietzsche's, and Kierkegaard's writings indicate, all richly artistic, intense, and varied in their contrasts. In particular, invention is a primary value in philosophy, as it does not appear to be in science, a value not always instrumental to another standard. Philosophy, here, especially metaphysics, is assertive and constructive, but especially the latter, in that it greatly depends on a wide range of intense contrasts created in the establishment of a new and systematic point of view, thereby manifesting inexhaustibility.

Celebration is perhaps a more telling condition separating science and philosophy from art. Here the timelessness to which science and philosophy aspire undermines their celebrativeness—though when we emphasize the time of human judgment, we frequently refer to the celebrative powers of scientific and philosophic works. A historical perspective on the works of science often makes them more aesthetic. Still, celebration is the dimension of contrast most closely related to intensity of contrast, and the subordination of such intensity in science to assertive ends is usually accompanied by a diminution of celebration. We may celebrate the invention of the theory of relativity, but we constantly seek to improve it, even to replace it by a better theory. In art, not only the work as a whole, but an inexhaustible range of its constituents are celebrated as achievements and as models to be emulated. In science, many of the details of a theory are kept only until we develop a superior alternative. The sovereignty and incomparability of a scientific work are constantly being undermined by questions of confirmation and efficacy. Philosophy here is much closer to art, especially in its major works, to the extent that the details of a complex theory like Whitehead's or Spinoza's are admired and celebrated almost independent of questions of superiority and competing alternatives.

191

The dimensions of contrast are pervasive throughout judgment and experience, and are relevant to science and philosophy as well as to art, but in very different ways based on the importance of intensity of contrast. Invention is necessary to all of them, but it is a means to intensity of contrast in art while a means to truth and effectiveness in science and politics. All have aesthetic value, but only in art does intensity of contrast become predominant, a thorough manifestation of inexhaustibility.

The five general types of contrast are equally pervasive throughout experience and judgment, for they represent the general conditions of works and judgments: at a time, in a particular medium, relevant among different modes of judgment, and relevant to different audiences. Yet while all the types of contrast are relevant to scientific and philosophic works, they are frequently neglected. Tradition is a minor element in science, and regarded as minor by many philosophers—though there are philosophers who believe that every philosophic work and issue must be located in a philosophic tradition to be understood. The medium of expression in science is language, but it is usually greatly diminished, as if science has no medium. There are schools of philosophy which follow a similar practice, though style and language are often of great importance in certain philosophic works—Hegel's and Whitehead's, for example. Intermodality is far more important in philosophy than science, though it is unavoidable wherever there are diverse modes of judgment. Finally, intersubjective contrasts are relevant but to be overcome in science, while they are essential components of the richness present in the major works of philosophy.

Intersubjective contrasts are no less important in science than in art and philosophy, but they function there in very different ways. In art and philosophy both, variability of interpretation is of fundamental importance, and frequently referred to directly or addressed explicitly. The writer-reader contrast is highlighted in many philosophical works by reference to obscurity and difference. In science, there may or may not be a narrower range of variation between writer and reader, but it is radically subordinated to assertive validation, confirmation, and verifiability. Intersubjective contrasts are to be minimized and overcome in science, while they are magnified and enriched in art and, if not augmented, constructed and manifested in philosophy. This is a straightforward consequence of the fact that intensity of contrast—along with all forms of contrast—is pervasive throughout judgment and relevant to science as it is to art, but subordinated there, while in art it is the primary mode of validation.

Integral-scopic contrasts function in all orders, in and out of judgment, in virtue of variations of integrity with ordinal location. Such contrasts are particularly intense in scientific theories which define a remarkably general and pervasive gross integrity, unifying under the purview of a general theory a wealth of divergent orders and their integrities. Yet the value here is given by unification, by the gross integrity. Integral-scopic contrasts are relevant in only some of their forms. In art, integral-scopic contrasts are produced both by synthesis and by variation. Art manifests inexhaustibility and revels in it. Science is haunted by inexhaustibility, and achieves its greatest successes and most remarkable contrasts by regulation and limitation.

Perhaps the most important types of contrast in science are those involving simplicity and complexity and generality and specificity. The most important property of a scientific theory is its range of effective application over many different cases, the transformation of complex and diverse phenomena into a systematic scheme with a relatively simple structure. Even here, however, the emphasis on adequacy rather than intensity of contrast minimizes the importance in science of the expanding and complex levels of contrast, while that expansion is the key to the history of art. Science seeks always to explain more in the simplest possible terms, to gain the greatest generality applicable to the widest range of specific cases. There is a relatively restricted range of contrast emphasized here in comparison with art and philosophy in which earlier levels of contrast inhabit later ones through traditionary contrasts and the medium is emphasized in its diverse manifestations.

All of these specific characteristics of contrasts in science follow from the prominent aim of scientific inquiry to attain assertive validation based on the available evidence. Contrasts of a rich and complex nature are generated by such activity, but they are restricted by their subordinate purpose. Certain forms of contrast—truth and falsity contrasts most of all—are at a peak in science, effectively diminishing the range of all other relevant contrasts. A useful comparison is with the truth of a theory in relation to anomalous evidence as compared with the truth of testimony in a court proceeding based on diverse witnesses and interpretations. The latter cannot attain the pointedness of the opposition of truth and evidence that is pertinent in science, but the range of relevant alternatives is far greater. The richness at higher levels of contrasts is far greater. Art is typified by an emphasis on intensity of contrast that rests on richness and scope, inexhaustibility and intricate reflexive contrasts, manifesting inexhaustibility through richness at the higher levels of contrast, while science and morals subordinate the

range of contrasts to specific ends, and achieve intensity of contrast over but a few of the relevant forms and higher levels. Intensity of contrast is present in science but restrictedly compared with art, due to the predominant emphasis in science on assertive judgment and truth.

Science and politics, like philosophy, may be regarded from an aesthetic perspective, an interpretive point of view in which intensity of contrast in its rich wealth of forms is predominant. Only some forms of contrast are relevant to the adequacy of a scientific theory, but all the other forms may be imported from an aesthetic or philosophic perspective. This is an important and legitimate act of mind, but it should not be confused with science. Science, morals, and politics—possibly including some forms of philosophy—are dominated by ulterior ends that limit the range of relevant contrasts in the perspectives defined by the ends of truth and control. Many other perspectives exist in which intensity of contrast can be made predominant. Predominance here refers primarily to the enhanced range and scope of relevant contrasts and their intensity with minimal subordination to particular alternative standards. This explains what happens to doctrinaire and ideological works of art which enter a different social context: freed in part—but only in part—from their doctrinal aims, they can engender a greater range of contrasts for whose intensity we admire them.

This entire account can be traced back to the inexhaustibility of orders and their integrities. Such inexhaustibility haunts science and morals, requiring further inquiry without end in science and frustrating every act with unforeseen consequences. It offers a challenge to art, however, of novel and divergent contrasts, for art creates works to augment the inexhaustible character of things. Science and morals are inexhaustible because orders are inexhaustible, but inexhaustibility is a problem for them, a condition to be overcome or at least constrained. Art revels in, manifests inexhaustibility: it reveals inexhaustibility by its constructions and enriches it by addition. Philosophy, here, shares an ambiguous relationship with inexhaustibility. Like science, it seeks answers but is faced with inexhaustible demands. Like art, it revels in the inventions it achieves that augment the richness of experience. Contrasts in philosophy are essential as they are in art, but revolving around the central importance of generality and complexity over as wide a range of intermodal contrasts as possible. Like art, philosophy manifests inexhaustibility, but from the standpoint of generality. Art manifests inexhaustibility from any standpoint it can achieve.

CHAPTER 6

Criticism,
Interpretation, Illustrement

In order for a work of art to maintain its vitality, it must be complex in both its integrity and its scope. Greatness in art depends on an enduring richness within the integrity of the work that sustains a remarkable, inexhaustible range of possibilities for the enhancement of its scope in subsequent experience. Great works enrich our lives in myriad ways, providing extraordinarily different significations for different audiences. In addition, different world views and cultural expectations provide different conceptions of art within which a given work has varied integrities as well as scopes. Every location establishes a different integrity for a work of art, some widely varied because of major changes in life and experience. If greatness in art is enduring intensity of contrast, endurance is a function of the capacity of a work to adapt to new developments by absorbing them into its range of contrasts. A work of art is multifarious both in what it is and in what it makes possible, varying with the conditions of life and art. Such a multiplicity is required by the inexhaustibility of orders made manifest in art.

We are led to the inevitable and important function of interpretation for the arts—of delineating determinate orders within which a work possesses intense contrasts. The inexhaustibility of contrasts in art must be complemented by the specification of integrities if inexhaustibility is to be anything but indeterminateness and if works of art are to possess sovereignty and incomparability. The theory of orders may be expected to provide a foundation for settling some of the controversies concerning the functions of criticism—especially, whether criticism may be descriptive as well as interpretive; whether the arts require critical analysis; or whether, instead, criticism is merely a parasitic activity feeding off great works, providing fulfillment only for minds

incapable of creative thought. The answer to these questions given by the theories of contrast and ordinality, in brief, is that the inexhaustibility manifested in art *demands* interpretation and criticism, inexhaustibly and multifariously. Criticism—especially in that form which I call "illustrement"—is the judgmental fulfillment of art as art is the manifestation of ordinal inexhaustibility.

DESCRIPTION

We may begin with the conventional, three-fold distinction between *description, criticism,* and *interpretation.* The limitations of the distinction will be made clear in the ensuing discussion. The first question we may consider is whether description is a significant possibility for the arts. Can a work be described without interpretive and evaluative components? This is a different question from whether description is *distinguishable* from interpretation and criticism. It might be that no act of description could be *merely* that—the sense in which the modes of judgment are always intermingled. Yet description might be well defined and unique. An alternative possibility is that the concept of description is inappropriate applied to art, that only interpretation is significant and meaningful—interpretation understood as the creative reconstruction of the work rather than a faithfulness rendered by description.

The theory of plural modes of judgment and their intermingling settles the issue of whether any judgment might be wholly descriptive, uncontaminated by interpretation and criticism. Every human product may be regarded as a judgment within any of the modes, "is" a judgment of any modality. An act may be considered an implicit claim. An assertion may be regarded in terms of its elegance and form. A work of art may be considered in terms of its political and moral consequences. Analogously, the most meticulous description of a work of art, however minimal its pretensions, will have evaluative implications. Evaluation and description are distinct but interwoven functions. Not only may a person *intend* one function and have his work regarded in terms of another: it is entirely appropriate that this be so. For no judgment once produced belongs exclusively to the agent. His intentions are only one of the considerations relevant to the integrity of any of his judgments.

Analogously, a particular description will be an interpretation relative to certain norms. A description of the symbolic representations within a painting is an interpretation relative to a formalistic norm of lines, planes, and colors. Conversely, a description of a painting assign-

196

ing a fine grid to the canvas, and defining each element of the grid in terms of color gradients and textures, is an interpretation relative to a representational norm, since it would not be possible to define represented objects within such a grid. It is interpretive to the extent that contrasting differences are essential, descriptive to the extent that accurate resemblances are emphasized. If a portrait is (described as) a representation of a person, then a formal reading is an interpretation of the work. Music may seem most susceptible to formal description without interpretive components—the score itself providing such a description. But musical performances indicate how unmusical is such a score relative to what may be heard in performance. We may describe the notes in a given measure. We cannot describe the tone or the flow of line within that measure in terms of the notes alone. The performance expresses the work by contrast as well as by exemplification. The latter may be descriptive; the former is essentially interpretive.

Description is always relative to a particular integrity of a work: relative to that integrity, other descriptions, of other integrities of the work, are interpretations. Description and interpretation here express the prominence of integral and scopic contrasts, which are largely founded on the activity of interpretation relative to works of art. Description and interpretation are context-sensitive in this very strong sense, affecting both the integrities and the scopes of works of art. Alternatively, interpretation establishes a particular integrity of a work relative to particular contexts and norms. Only given such an interpretation can description be intelligible—a description of certain features of the integrity established by that interpretation. It follows that any description of a work of art is limited relative to many of its artistic values, for the description always pertains to an interpretation, never the work "itself."

This conclusion lends itself to generalization. Consider the description not only of works of art but of any order. A description can be provided of an order's integrity and scope only within some superaltern order. No order simply is "in itself" or "altogether." Since its integrities vary with ordinal conditions, its description requires a specific ordinal location. No matter how complete and accurate a particular description may be, it can serve only in clusters of related orders, and will be incomplete relative to other orders. Description then is dependent on the gross integrity of an order, and is limited to that integrity and some related constituents of scope. Inexhaustibility entails that every description be limited in fundamental ways, relative to certain ordinal locations, for every order possesses many integrities and many scopes, requiring all the modes of judgment for its understanding.

There are descriptions appropriate to highly restricted orders and integrities, but the most effective descriptions pertain to relatively comprehensive gross integrities. Nevertheless, the adequacy of a description over a range of subaltern integrities is both a profound achievement and a consequent limitation. In this sense, description is a direct expression of the determinateness and indeterminateness in every order, its boundaries and its inexhaustibility. The description of works of art is in this sense no different from the description of any order, requiring supplementation by other modes of judgment.

A work of art may be described as any order may be described—by stating true propositions about it, a sufficient number to satisfy our desire for completeness, though ordinality entails that no description of any order can be complete or univalent without qualification. Assertive judgment is that mode in which accuracy is the predominant goal—an accuracy realized in propositions and subject to the constraints of evidence and the logical conditions of discourse. Wherever there is an appeal to logical conditions, information, and evidence such that a meaningful question is expected to have a single, univalent answer, we are functioning in the assertive mode of judgment.

If science is loosely identified with systematic and inventive assertive judgment—it is that mode of query in which assertive judgment is predominant—then description of a work of art can be given by the science of art. There may, of course, be descriptions drawn from everyday experience which fall under no known science. These may always be improved, rendered more effective and precise, by scientific development. Nevertheless, there are many sciences which can describe works of art: behavioral, social, and physical. A work may be described in terms of its physical materials. It may be weighed, its volume measured, its dimensions charted, its various outlines and profiles reproduced and delimited. A work or a performance may be studied like any physical object or event. A work may also be described in terms of the psychophysical responses of a given individual or group of individuals. The various emotional responses of an observer may be charted by instruments measuring his blood pressure, heartbeat, brain waves, and the like. If such descriptions seem somehow irrelevant, we may simply examine the physical properties of works of art. A musical or theatrical performance may be described in terms of the events taking place on the stage. Every such description will be limited and relative, for ordinality entails the incompleteness of every assertive account relative to the inexhaustibility of orders. Nevertheless, de-

198

scriptions of works of art may be entirely adequate for the purposes to which they are put, if such ends are defined carefully enough.[1]

The intentions of an artist are sometimes appealed to in order to establish a univalent account of his work—a "description" in our sense, though often called "interpretation."[2] Where facts and inferences establish a single version of a work of art as correct, and plurality is rejected, we are in a the province of assertive judgment and description. If there were a science of reading, establishing a univalent meaning of a work in terms of the artist's intentions. it would be a mode of description. Ordinality entails that every such description would be relative to location, that univalent accounts always have patent limitations and must be supplemented inexhaustibly by other accounts, descriptive and interpretive.

Some particular difficulties for description concern works apart from their performances. A musical composition, for example, is not merely one performance nor the set of all possible performances, as if these were independent of conditions, merely logical possibilities. To describe the score is not to describe the work—at least, not in performance. The score is itself a description of the work but, relative to any performance, a highly restricted, limited description. In this sense—and it is a strong one—every work to be performed is incomplete apart from performance. Prominent integrities are still undetermined by the score. However detailed the score may be, the performance contains features only imaginatively present within the work as possibilities—and frequently not present at all until new cultural norms and standards of performance have been established. The theory of possibility is essential to the relationship between score and work. The score is a complete score, but the performed work realizes certain possibilities resident within it. Not only does the score contain possibilities as alternatives among which the performer selects those he will realize: he invents, constructs, and produces additional possibilities for the work

1. Relativistic and interpretationistic theories of art and criticism emphasize ordinal variability without an adequate and systematic theory of inexhaustibility. As a consequence, they generally overlook two important and relevant principles: (a) While an inexhaustible number and variety of descriptions is relevant to a work of art, depending on ordinal location and interpreting perspective, the determination of a perspective does provide the basis for a thoroughly satisfactory description of the integrity of an order in that location. The inexhaustibility of orders, integrities, and ordinal locations, with the consequent inexhaustibility of relevant descriptions, is essential to an adequate theory of interpretation. (b) This inexhaustibility of perspectives, locations, and descriptions is not a property of works of art alone, but is pertinent to every order.

2. See E. D. Hirsch: *Validity in Interpretation*, New Haven, Yale University Press, 1967.

by his performance. We have here an important example of the ways in which the inexhaustibility of orders, manifested through the plurality of possibilities engendered by ordinal interrelations, especially *deviant* possibilities, are conditions for all assertive judgment and understanding, defining variable but essential limits to all descriptions.

To many sensitive critics and observers, what I have called description is of no aesthetic relevance. While there are true descriptions of a work of art, they are held irrelevant to its artistic qualities. The ordinal theory entails that every such description is limited and incomplete: there is no ideal description, complete in every way, to which all other true descriptions approximate. Nevertheless, it is untenable to hold that what can be truly described is irrelevant to a work of art, since the components of contrasts as well as works can be delineated accurately. I have suggested what I take to be the kernel of truth in this view that description is irrelevant to aesthetic value. It is founded on the inexhaustibility of orders and the manifestation of such inexhaustibility in art. The inherent limitations of description relative to ordinality are a mortal weakness relative to the values of art.

A description can at best delineate the properties of a work of art relative to a given interpretation—that is, relative to one of its integrities. If every order had a single gross integrity, defining its place in a world order, then an ideal description would provide all the information that could be provided about any of them. But orders are inexhaustible, and every order has multiple integrities. Possibilities as well as actualities, scopes as well as integrities, deviances as well as prevalences, are present in every order, making every description inadequate in fundamental respects, exhibitive of the indeterminateness inherent in every ordinal condition. It follows that only a given integrity can be described relative to a given superaltern order, and only those possibilities relevant to the superaltern order can be delimited. The superaltern order provides both the conditions that establish validation for any judgment—including description—and the intrinsic limitations of every such determination. Insofar as artistic inventiveness provides novel integrities for works of art, novel possibilities and spheres of application, insofar as changing conditions introduce novel perspectives with novel integrities, assertive judgment will inevitably fail relative to those perspectives. Insofar as the contrasts pertinent to works of art are multifarious, multivalent, and inexhaustible, insofar as such works continually demand from us new and important interpretations, description can provide information of only limited relevance. The multiplicity of contrasts relative to any fine work relegates description to a subordinate, highly circumscribed role, heavily dependent on locating conditions defined by other modes of judgment and chang-

ing conditions of experience. The truer the description, the more publicly available, the more definite its confirmational conditions, the more definite are its artistic limitations. A poor work of art, lacking multiple richnesses, might seem to encourage a univalent interpretation and thereby a satisfactory description. But even here, the work has multiple integrities, though they may not represent to us forceful values. It has the changing integrities given by the changing face of art itself, due to the contributions of novel masterpieces. Art revels in the plurality of contrasts and possibilities relevant to created works, rendering every description, however detailed and accurate, a limited, almost useless expression of the values of such works and a clear manifestation of the limitations of assertive judgment relative to ordinal inexhaustibility.

Inexhaustibility has both a positive and a negative side. The limitations of description relative to inexhaustibility can be reformulated in a more positive way. Description is relative to integrities: the inexhaustibility of orders and their integrities entails that description too is inexhaustible. There are inexhaustibly many descriptions, related in many ways but also distinct in ways that are important in other respects. This inexhaustibility is expressed by the multiplicity of sciences, irreducible to any supreme science, but also constantly growing and developing sciences produced by new questions and points of view. It is expressed also in the multiplicity of modes of judgment, irreducible to any supreme mode of judgment, so that assertive judgment alone is incomplete, requiring supplementation by the other modes of judgment, and requiring supplementation inexhaustibly by other descriptions, relative to other locating perspectives. Description is inexhaustible in the two major senses indicated and, confronted with the inexhaustibility manifested by contrast in art, almost always appears irrelevant to art. The most accurate and truthful description of a work of art cannot fundamentally express its inexhaustibility, which requires the supplementation of inexhaustibly other descriptions and modes of query. Works of art call for inexhaustibly many and diverse descriptions—physical, psychological, historical, sociological, psychoanalytic, etc.—drawn from all the spheres of assertive judgment as well as inexhaustibly many methodic approaches and modes of query. Art, like being, calls upon the inexhaustible resources of human thought for its illumination.

CRITICISM

We may now consider the mode of active judgment in relation to art—in particular, a work of art regarded as an act looking to actions in

response. The artist, the performer, the impresario who collects, exhibits, or arranges for the works, even political forces which make them possible, all may be regarded as agents. All of them—including the performer—act by looking to consequences, however difficult it may be to forecast them precisely. A composer whose work is never performed acts abortively. The act of composition seeks performance; the act of performance seeks an audience; the act of attendance seeks appreciation. A work of art may be regarded as a consequence of the artist's activities. It may also be viewed in terms of the emotions it produces in an audience. A creation has a wide range of effects and consequences, as do all important activities within human life.

Insofar as a work is the result of an action, its values reside not in accurate reconstruction, in correct inferences, nor in contrasts within the work, but in consequences and impacts. Action seeks control over events. The production of a work of art is no different in this respect from other actions, a means to ends sought. The ruling considerations are the responses of human beings, their pleasures and satisfactions, sufferings and joys, ennui and enlightenment. We may emphasize also the impact of works on social institutions, ideals, and programs of action. Art as action is judged by its results. Whenever we move from a work to its impact, even upon the feelings of an audience, and evaluate the work in terms of its effects, we judge it as a deed, not a work. The difficulty of separating a work from such consequences as the experiences of its creator and audiences makes obvious the difficulty involved in separating artistic from moral values. A work of art as an act is for human beings, judged in terms of what it leads to and principles evolved through years of life and action. I do not mean to imply that the experiences engendered by a work of art and its impact within human life are unimportant, simply that they are relevant to works of art only as active judgments.

What is commonly called "criticism" is frequently associated with evaluation in terms of consequences and effects. Works are criticized for being morally confused or reprehensible, vague in their solutions to the problems of life. By comparison, science provides solutions to its problems. But a scientific textbook is often evaluated as an act in terms of its success in communicating the principles and facts of the science to students. Art is often judged similarly as successful communication of an idea—thus an act to be apprehended in terms of its effectiveness and success. Artists are sometimes expected to have a complete moral vision, and their works are criticized for betraying moral confusion— even where situations are confused and afford only partial understanding. If art is not to be dogmatic, nevertheless it is to be enlightened

and humane. Art is often thought a great teacher, and it can wield great influence. Such influence is not aesthetic, but active and moral.

The pervasiveness and intermingling of the modes of judgment entails that no particular mode of response to a work of art is of sole or even primary legitimacy. A work may be judged in any of the modes and regarded as a judgment of any modality. Nevertheless, a response in a given mode alone inevitably sacrifices values belonging to other modes. What is sacrificed is precisely what is expressed by those other modes. This is a direct consequence of multimodality in judgment. The inexhaustibility manifested in art requires an inexhaustibility in modes of response and articulation. For this reason, a given description may be accurate yet effectively irrelevant to many of the aesthetic values of a work of art. The accuracy of the description is at the expense of the profound and inexhaustible richness of the work, its inexhaustible integrities. Similarly, response to a work of art in the mode of active judgment may be equally restricted, even irrelevant, limited to consequences and influences in human historical experience that express a meager portion of the work's richness as a created being. Any response to a work of art, however rich it seeks to be, is certain to have important limitations.

Despite frequent protestations that art is not to be bent to moral dogma, art criticism is often an implicit form of moral criticism in the double sense of evaluating works in terms of their consequences and in being an active judgment itself. It is important to distinguish these two senses: regarding the work as an active judgment is quite different from responding to it in the mode of active judgment. Nevertheless, the two are commonly conjoined in evaluative criticism. I will identify "criticism" with evaluation predominantly within the mode of active judgment. This identification is primarily for analytic purposes, since I will also discuss the intermodal conjunction of the modes of judgment and query in response to works of art, but the identification of criticism with active judgment is justified by remarks like the following:

> The true critic, indeed, is he, and he only, who can teach us rightly to enjoy.[3]

> Criticism is: a verbal performance whose nature is to support the evaluation of some object that it takes as its subject.[4]

Criticism here is associated with active judgment and corresponds only slightly to the better forms of literary and artistic criticism. I will argue

3. Bernard Bosanquet: *Three Lectures on Aesthetics*, London, Macmillan, 1915, Lecture I.
4. Francis E. Sparshott: *The Concept of Criticism*, Oxford, Clarendon, 1967, p. 38.

that the most complex forms of criticism—which I call "illustrement"—establish a novel form of intermodal query which is not to be associated primarily with any of the particular modes. Illustrement is inherently inexhaustible, as a mode of query, and manifests the inexhaustibility of art by its own richness and creative powers.

Verdicts and assessments are always in part—and usually predominantly—in the mode of active judgment. The criticism seeks effects and influences, consequences and controls. In addition, criticism nearly always tends to emphasize the consequences of the work involved—its effects upon its audiences. While criticism may address a work of art as such, in terms of its intensity of contrast, evaluation is explicitly an act—seeking to manipulate taste and judgment. In addition, it frequently—if implicitly—assesses the work as an act by the artist: whether it should have been produced; whether the artist should have done this rather than something else. The work is replaced by experiences and effects; attention is conveyed from the work to what it produces. All theories of aesthetic experience which determine the validity of a work of art in terms of the experiences and responses of its audiences regard it predominantly as an act. Construction is dissipated into action, and utility if not morality becomes the dominant measure of artistic achievement.

Thus, to say of a work that it is "boring" is to condemn it for its tedious effects. Such a judgment may be distinguished from calling a work "trite," which does not explicitly depend on consequences. In fact, triteness is far from boring to many people, and can be employed to significant artistic effect. While originality is a primary artistic value, traditional components of a major work may be trite themselves yet interesting in virtue of their complex function within the work. Unfortunately, the word "interesting," like "boring," is more pertinent to active judgments. A work of art as such is neither interesting nor uninteresting, but is rather worthy or not worthy of attention, important or unimportant. Likewise, to say of a work that it is "unsatisfactory" is effectively to criticize it in terms of its impact as an act, rather than for being "incomplete," "disorganized," or "repetitious." The latter epithets look to the created work, not to its consequences and effects. A great work may be moving and interesting and our emotional responses may be overpowering. But we may also be moved by heroism in action and by scientific discoveries. Emotions do not establish greatness, though they may be aroused by our encounter with it. There are cases where we are profoundly cognizant of the greatness of a work yet are neither moved nor interested—sometimes due to some defect in our sensibilities, sometimes due to the difficulty of the

work. And there are cases where we are greatly moved by a sentimental and mediocre work.

It is no error to criticize a work of art in terms of its consequences and effects. Artists are human beings and they act. They may be criticized for their evil and thoughtless deeds and praised for their accomplishments. Their artistic deeds are particularly susceptible to such criticisms, especially where the works they create are important and influential. The inexhaustibility manifested in art requires all the modes of judgment and query in response to exhibit the richness of contrasts in the finest works of art. Intermodality in contrast can be understood only through active judgment, in terms of at least potential if not actual consequences and effects. Active judgment is necessary to an adequate understanding of works of art, but it can be overdone, can become predominant, overshadowing other modes of articulation and response which are equally necessary. Far too much criticism of works of art unduly emphasizes the mode of active judgment, blinding us by neglect to the uniqueness of art and constructive judgment. Too many important artistic values are obscured by overt assessment or when viewed as a result of the artist's activities. Consequences and effects are frequently part of the scope of works of art, not part of their integrity as intense contrasts.

This point may be emphasized by considering the *review* of a work of art or performance. The functions of a review are persuasion, prediction, and manipulation: to persuade someone to read a book or attend a performance; to define the probable effects of the work on its public; or to affect the responses of the public to the work. A review is primarily an active judgment, at best a description of the work and its effects on the reviewer. Its most defensible function is of accurately forecasting audience reactions, a descriptive function. Its least defensible role is of influencing a reader to approach or withdraw from a work. A review is primarily an act upon the sensibilities of its audience. In addition, it has the egregious responsibility for regarding a work of art not as a construction but as an act which should or should not have been undertaken. The reviewer guides his reader's responses to the work as if it were a deed, though in terms too narrow to reach a justified moral judgment.

Extending the range of this discussion, I claim that the judgment of a work as good or bad is always, if covertly, a judgment as to whether the work should have been created—a judgment concerning the actions of the artist. The evaluation of a work as inferior is a condemnation of the artist's actions in creating it. Now it is true that what is condemned is the creation of a work of art, and the artistic values of the work are relevant

to the depreciatory judgment. Nevertheless, verdicts are directly relevant only to actions, not to constructions. The validation of a work of art resides in its intensity of contrast, its distinctiveness—what it is, not what it does. The verdict that a work lacks or possesses intensity of contrast does not directly enhance or diminish this intensity, but looks to consequences for the work in public and private experience. The conclusion is that assessment of the value of a work of art, estimation and appraisal, while legitimate as a mode of response, is not intrinsic to, essential in, its aesthetic value. Inexhaustibility is constrained in evaluation by the questions of good for whom and for what, leading us away from the higher levels of contrast and the manifestation of inexhaustibility essential to aesthetic value. Active judgment is so limited a response to a work of art as to appear, along with description, to be almost entirely useless and irrelevant.

A species of validation is appropriate to every mode of judgment: truth to assertive judgment; successful control to active judgment; distinctiveness to constructive judgment. However, the validation of a judgment must be distinguished from a further judgment concerning that validation. The further judgment possesses a character and validity of its own. This is a fundamental source of the ongoing nature of query: judgments in query call for further query indefinitely, in part to evaluate the validity and applicability of prior judgments. The statement that a work of art is excellently or poorly constructed is primarily an act, seeking to influence an audience and to estimate the effects of the work upon them. *Calling* a work "excellent"—as against responding to it as such in an indefinite variety of ways—is an attempt at communication and influence, seeking to persuade, to affect sensibilities, to direct activities. It is essentially an act—though like all judgments, it may be located within any of the modes. The judgment that a work is well made or poorly constructed is not typically a true or false report about responses and reactions, nor even about the structural characteristics of the work, but is a deed performed to attain specific effects—to lead someone to attend to the work or to refrain, to manipulate taste, or to manifest the reviewer's sensibilities.

Suppose a sensitive, educated person reads a book of poems and finds them flawed. What is the function of his *saying* that the poems are weak?—educative, manipulative, predictive at best. An insensitive student may be taught how to read poetry more critically. A philistine may have his sensibilities challenged. A reader may have his responses articulated. What, however, of another reader who finds the poems excellent—for good or ill, justified or not? The criticism is irrelevant to his responses except to engender antipathy and controversy. At best,

evaluative criticism offers prospects of effective intersubjective contrasts, but in severely truncated form. What of the poems themselves: are they good or bad? They may be good in some respects, poor in others; good in some contexts, poor in others; good for some audiences, poor for others. There is no single set of criteria, no overarching perspective, for which a work of art is unqualifiedly good or bad. Some of the contrasts comprising the poems' values may be intense only in certain perspectives; other contrasts may be irrelevant in those perspectives. Criticism as assessment sacrifices the multifarious and intense contrasts of a work to a particular end, and cannot therefore portray an adequate portion of the range of values relevant to any complex work of art.

Criticism is largely active judgment directed toward influence and persuasion. In this form, it has no specifically aesthetic function. Even worse, it frequently though inadvertently defines a work as an active judgment, the artist as a social agent. Now works of art do have consequences and play roles in social and political affairs. Were there a single, supreme political order, then art would have its role to play there with all other social instruments. We may even entertain the principle that constructive judgments are to be avoided when their moral effects are undesirable. This is what Plato tells us, and nearly all theories of a supreme polity reach the same conclusion. If the moral and political order of judgment is more important, then art must be subordinated to moral considerations.

Ordinality, however, suggests that constructive judgments have their own values. The conclusion is that there is no supreme utopian state, no political and moral order supreme in all respects, no perfect balance of all relevant considerations. Art emphasizes plurality within and among moral orders, invention within action as well as science. Marxists may forswear bourgeois art, but it is the inventiveness and plurality of the arts they condemn. From their point of view, art is to be original only within circumscribed limits. Art pursued for its own sake is too free—and, from a moral point of view, that may be so. Yet there is no comprehensive order of experience within which all the modes of judgment may be assigned a univalent function. Art manifests inexhaustibility by contrast; evaluative criticism must locate a work in a particular context of social and individual experience to reach its verdicts, necessarily diminishing the work's range of inexhaustibility. Moral and political judgments cannot tolerate inexhaustibility, and find it a constant challenge to overcome, frustrated by the omnipresence of failure in human experience.

207

My discussion of criticism has been based on a relatively simple conception of evaluation which ignores the complexities of the finer works of criticism. Criticism has significant value when it casts a new light upon works of art, when it awakens our sensibilities toward them, when it manifests the inexhaustibility of the work of art by its own creative powers. Sometimes we find so constricted an account—the number of metaphors, words of a certain kind, similes—as to qualify as a description. Far more often, we find works appraised with persuasive justification to influence a reader's view of them. Too rarely do we find illustrement: the suggestive, complex interpretation of a work to bring a reader to new and significant insights into the contrasts resident within it as well as to open new possibilities of understanding, to engender new and significant contrasts for that work. I am speaking here of a mode of articulation which so complexly interweaves the various modes of judgment as to manifest and even enhance the rich and profound aesthetic character of the work of art.

Given the intermixture of the modes of judgment, the diverse judgmental responses possible relative to a work of art, the inexhaustibility manifested in masterpieces of art, it is essential that illustrement should be an intermixture of description, criticism, and interpretation located in a broad context of theoretical generalization. Illustrement must be accurate and perceptive, detailed and explicit, faithful to the work and its uniqueness—descriptive judgment though more than scientific. Illustrement is also expected to have an impact on audience sympathies and responses, educating them as well as enlarging their capacities for feeling and response—active judgment. More seldom, but of fundamental importance, an illustrive work must be a salient, important achievement in its own right, illuminating the work of art through created contrasts. The more complex the interfusion of these diverse modes of judgment, the more remarkable is the product involved—accurate, informative, illuminating, yet important in its own right. We may conclude that the most effective response to a work of art demands all the modes of judgment and query intertwined—emphasizing once again that there is no "best" way to respond, since the intermixture of judgments permits an indefinite range of styles and forms. Still, illustrement should be accurate; it should be perceptive; and it should be noteworthy. As such a fusion of the modes of judgment, it may constitute a novel mode of judgment and query—for it cannot simply attain the standards of validation of each of the other modes alone, and it cannot simply meet their standards collectively. This subject will be considered recurrently throughout the remainder of this chapter.

INTERPRETATION

We may now consider constructive judgments in response to a work of art—what I call "interpretation." Setting aside the effects and consequences of a critical work, we may find it noteworthy itself in its intensity of contrast. A critical work is constructed, and can itself be a work of art or approach one. My concern now is with elucidating the connection between a fine work of art and a superior work of interpretation, the latter noteworthy in its own right yet also illuminating the work with which it deals. This relationship of illumination seems to undermine the sovereignty of the critical work, and such works are often denied the sovereignty, the incomparability of masterpieces of art. Yet it is essential to avoid conceiving a constructive judgment so that it is an active judgment in disguise, interpreting it entirely in terms of its utility.

A constructive judgment in response to a work of art is the creation of another work which articulates the first, which fulfills some artistic possibilities for it in further judgment by contrast. Insofar as the second work profoundly realizes possibilities belonging to the first, it illuminates it, promoting new and higher levels of contrast. Works in intense contrast illuminate and illustrate each other. A contrast among a variety of orders is exhibitive of each of their integrities in a particular location.

It is tempting but misleading to say that we have here a *re*construction of the original work: we would expect too great a similarity. Our concern is not with *re*construction, but with *construction in contrast*. The two works may have little in common—as a modern dance may be choreographed in response to the story of Oedipus, lacking all language and poetic devices, yet enhancing the original work and its human implications. We might regard a constructive judgment in response to a work of art as a *comment* upon it except for the connotations of assertion and discourse. The point is that a work may be illuminated more by another work, illuminated more in particular ways, than by a faithful description or by an active appraisal. Assertion and action provide illumination, but so does construction: by intensity of contrast. I have in mind here Keats' *Upon Looking in to Chapman's Homer* and Nietzsche's *Birth of Tragedy* as well as Racine's *Phédre* and Anouilh's *Antigone*. Any work created in response to another work is a constructive judgment which may illuminate it through contrasts. Artistic works can be profoundly revealing of qualities of other works through irony and emphasis, by omission and augmentation, even by mere relevance. We need not restrict ourselves to works of art. The writings of Hume and

Berkeley are more illuminating of parts of Locke's *Essay* than any commentaries. And they would be so without mentioning Locke by name or taking up his particular claims polemically.

What is required is that the contrasts which are part of the integrity of the interpretive work include the integrity of the original as a constituent (always a *particular* integrity). More precisely still, the interpretive work establishes an order within which the original is given an integrity and in which this integrity and certain features of its scope are articulated by contrast. Such a relationship need not interfere with the sovereignty of the work except where there is implied comparison with the original. This is the difference between interpretive critical works, which illuminate by contrast, and interpretive artistic works, which also illuminate by contrast, but through their own sovereignty. Where a great artist is influenced by another, his work manifests important judgments relevant to the other's work. It is natural for us to say that the second artist interprets the work of the first in his own creations. Because of this, influence studies have a fundamental artistic significance, not merely that of historical reflection. In a like manner, the common style or genre of several artists is revealed through the work of each of them, and each is enhanced by the comparison. This is fundamental in traditionary contrasts. Mozart, Haydn, and Beethoven provide the clearest and most illuminating "comment" or judgment upon the classical style and upon each other's work. Artists who work in the same time and culture reflect constructive judgments upon each other's works, sometimes by rejection and selectivity, sometimes by influence and a common attack on similar problems. Where inexhaustibility is manifested by construction, the created work is art. Critical works do not manifest inexhaustibility individually, through their own sovereignty, but only in the aggregate. That is why they are not as such art.

Not only major and important works may serve as examples, but so may relatively modest critical treatments. Consider a narrative interpretation of Kafka's *Castle*. We may put aside the descriptive elements and ignore the evaluative criticisms. Nevertheless, the study is a new work reflecting upon and interpreting Kafka's novel. We expect the study to reveal the impact of Kafka's work upon it in its moral vision, its emotional qualities, even its cadence and rhythm. The two works need not be similar in style. A narrative interpretation may be regarded not only as true about the work of art or influential with respect to an audience, but valuable in contrast with the original work in providing reflections on common aspects of experience in disparate forms. An insightful narrative interpretation presents another work closely related to the first in themes, elements, and representations, yet in a

completely different form, illuminating the ways in which the first work attains its particular values. The stylistic innovations of a work of art can be illuminated both by a work of similar style and by one of similar subject matter in different form. Important, though different, contrasts are involved in the two cases. Insight and enrichment may be provided not only by description but through the mutual interplay of the characteristic traits of the different works. Two works of significant but related excellences implicate each other. When a critical work has its own aesthetic qualities, is a substantial and important work in its own right, yet is also pointedly relevant to another work, we have interpretation at its best and fullest. Such an interpretation is no substitute for the original work, but is rather an amplification of its scope and an expression of its integrity, a realization of some of its possibilities. Such an interpretation both establishes an integrity for the original work and expresses or articulates that integrity through contrast. When a work provides such an amplification of the scope and expression of the integrity of another work, but is sovereign in its own prevalence and manifestly inexhaustible, it is not criticism but art, judged by its intensity of contrast rather than its articulative attainments. It may, however, be no less illuminating, no less illustrive, of the original work for its intensity of contrast.

Where the interpretive work is a construction with sovereign and supreme values, there interpretation will be most remarkable, illuminating the original work at the highest levels of contrast. Yet even private readings and transitory interpretations can be illuminating by contrast in remarkable, sometimes important ways. Every point of view on a work of art, however insular or transitory, which affords a location for constructive judgment determines a basis for interpretation of that work. Interpretation, like the other modes of articulation of works of art, depends on ordinal location. The construction of a perspective or point of view in which a work of art is given a rich and effective integrity is a significant interpretation. The relevant questions are: significant for whom and where? Passing interpretations do not have major impact on historical or typical experience. Important interpretations of major works affect human experience by their power and scope, simultaneously modifying typical experience and illuminating by contrast why these works have a singular impact on human life.

The best works of interpretation are excellent constructions, illuminating their works through contrast.[5] Now faithfulness is an important

5. This is the basis of certain current trends in the theory of interpretation—for example, the works of Gadamer and Derrida—emphasizing the interplay of identity and

means to intensity of contrast, and interpretive works will utilize faithfulness to their ends. Constructive judgment is but one of the modes of judgment, and we may respond to works of art not in terms of constructive judgment alone, but in terms of an amalgam of description, criticism, and interpretation. The best works of illustrement are just that: accurate when necessary, implicitly favorable or unfavorable to the works they address, and well constructed also. Often a brilliant study need never explicitly condemn or praise the work it addresses, but may achieve its critical function by description and construction. It manifests its appraisal in the context of interpretation, defining a significant integrity for the work. It is no better for a critical work to be didactic and crudely evaluative than for a work of art. Illustrement which expresses by contrast the strengths and weaknesses of a work of art can be a far more profound achievement, since it supplements one set of contrasts by other enriching contrasts, adding to the richness of experience and manifesting the inexhaustibility of art and experience by supplementation and enhancement.

Any work of art may be judged in any or all of three fundamental modes of judgment: assertive, active, or constructive. A work of art may be described, criticized, or interpreted—or all of them together. It may also—though I will not explore this mode of judgment here in detail—be regarded in terms of the relation of the work to our comprehensive sense of art, experience, and the world, within a general theory of art located within a still more general philosophical theory of judgment and being.[6] An example is the theory of art developed here: the theory of intensity of contrast located within the theory of orders and multiple modes of judgment and query. The fusion of the modes, each implicating the others, is illustrement—the revelation of the plural integrities of a work of art through ongoing judgment in the modes intermingled.

difference in every significatory relation. The limitations of Derrida's view that there is writing and only writing reside not in his understanding that major works offer themselves for interpretation in other major works, that such works effectively define interpretations for each other by contrast, so that none is fundamental within the mode of constructive judgment. Both work and interpretation are constructed works, sovereign beings, illuminating each other by contrast, but each inexhaustible, leading to further interpretations indefinitely. There are, however, other modes of judgment and query which do not emphasize constructive judgment so emphatically, which are subservient to the original work as constructive judgment may not be. Inexhaustibility demands all the modes of judgment and query in response to sovereign masterpieces of art. It is as limited to emphasize constructive judgment in articulative response to other judgments as to ignore it.

6. See the discussion of syndetic judgment in my *Transition to an Ordinal Metaphysics*.

We may ask—with little hope of a precise reply—what is the proper, the appropriate, the correct way to respond to a work of art? The question is a moral or active one, and calls for an answer in terms of conduct. From this point of view, the answer is obvious: as Stephen Pepper tells us, we are to maximize our aesthetic response to attain the fullest realization of the powers of the work.

> In a consummatory field of activity a person is drawn to the optimum condition of consummatory response with respect to the object—and, when the object is a work of art, specifically with respect to the stimulating aesthetic vehicle. And all positions or conditions less than the optimum are by the dynamics of the field rejected as less good than the optimum to which the dynamics of the field draw the spectator.[7]

We are to choose the conditions carefully, set ourselves at the optimum distance, in a suitable frame of mind, consider the work in terms that enrich our experience, and so forth. A work of art levies an obligation upon us to respond to it in a manner suitable to its nature—though unlike Pepper, we may doubt that a single, ideal, optimal response is possible. In any case, the obligation is an active or moral one, not aesthetic, for we are seeking the best way to act toward or live with the work. We are to respond to it so that it may have the most effective consequences. The modes of judgment interpenetrate again, for relevant here are considerations to be drawn from all walks of intellectual and emotional life.

A work of art is created to provide intensity of contrast and we are called upon to help it to do so. Such a claim is an active judgment indicating the appropriate mode of response to a work of art regarded both as an active and a constructive judgment. The importance of this perspective on art indicates the irresistibility and relevance of active judgment in relation to art. And it is irresistible, though it is also profoundly limited. The claim has the virtue of avoiding too passive a conception of aesthetic experience. If a work does not overwhelm us, making us love it, we may regard it as insignificant. All subtlety then vanishes. Not only is there an obligation upon an observer to maximize his responses, but an obligation upon the work to fulfill its promises. In addition, the principle helps us with the issue of truth in art: if aesthetic response is to be maximized, then we must frequently suspend our concern with practical and veridical matters in works of art. However, there are works which depend on moral and factual considerations, and we are to know them where we find them. Analogously, though the

7. Stephen Pepper: *The Work of Art*, Bloomington, Indiana University Press, 1955, pp. 50-51.

artist's intentions are often irrelevant to the contrasts within a work, there are cases where the intentions are important—portraits, for example, where physical accuracy or a faithful rendering of personality is of central importance to some audiences: those who commissioned the work. Sometimes—though not always—truth and faithfulness are of particular relevance. Thus, we are to maximize the intensity of contrast of the work in our experience, and our attitudes will vary depending on the works before us and our circumstances. One of the functions of interpretation is to define for us an appropriate approach to a work of art so that we may maximize its intensity and inexhaustibility. Though the contrasts belong to the work in the context of typical experience, not to our individual subjective responses, there are many contrasts which require audience responses for their realization: in particular, traditionary, intersubjective, and integral-scopic contrasts. Interpretation fulfills certain possibilities of contrast in works of art that are essential to their manifestation of inexhaustibility. We again see the poverty of analyses which overtly appraise the values of a work rather than establishing conditions for its maximal fulfillment.

Nevertheless, there is no single and best way to respond to a work of art, for it belongs to many different orders and has many different integrities, is full of rich complexities and is susceptible to many kinds of articulative judgment. The principle that our response to works of art must maximally fulfill their inexhaustibility and intensity of contrast is a moral one, relevant in particular to the mode of active judgment. From a scientific point of view, understanding the conditions and relations of works of art is more important. The values of assertive judgment are not always coordinate with moral and active values. With respect to constructive judgment, the creative and artistic response to one work by another may be of little moral value, yet it produces another work, sometimes a greater one. The enrichment of works by other works is a fundamental constituent of their richness and inexhaustibility. No particular way of responding to a work can be the only correct one, for all the modes of judgment and query, including new modes to be developed in the future, are fulfillments of its inexhaustibility. Nevertheless, the foundation of illustrement resides in the imperative to maximize the intensity of the contrasts in the works it addresses, realized in an inexhaustible range of articulative judgments.

ILLUSTREMENT

There is no single and best way to articulate a work of art, but different ways valid relative to different circumstances and modes of

judgment. It is appropriate to respond to works of art by assertive, active, or constructive judgments—description, criticism, or interpretation. It is also valid to regard works of art in relation to general theories or in their role in a cosmic or pervasive human order. And it is valid as well to respond to assertive or active judgments by works of art. The interpenetration of the modes of judgment is of central importance, as is the inexhaustibility of ordinality.

Illustrement is therefore not the *right* or *best* way to articulate a work of art. It is simply one of the forms of articulation, of profound intermodality. It is not even the only or best way to *explain* a work of art: all of the modes of articulative query are forms of explanation, of knowledge, relative to different standards and expectations. Illustrement coordinates the various modes of judgment within a methodically inventive enterprise: it is therefore a mode of query which articulates a work of art emphasizing none of the modes of judgment in particular, employing them all to its particular purposes. It is the rational fulfillment of intensity of contrast by means of all known modes of judgment and query together. The question I will now address is whether illustrement is itself a novel mode of judgment—in effect establishing a novel mode of validation distinct from those appropriate to the modes of judgment discussed above. The question is intelligible only if we grant the possibility of novel modes of judgment and query, novel forms of validation. Inexhaustibility and functionality are the central conditions on which this possibility is based, establishing diverse modes which function pervasively throughout judgment and query.

I have identified criticism with assessment, with active judgment. But clearly the finest works of literary criticism are illustrive and multi-modal.[8] It is necessary here to introduce some distinctions. Illustrement is a mode of articulation, but so are description, criticism, and interpretation. Illustrement is a mode of query, but so in general are description, criticism, interpretation, and philosophy of art. Illustrement is the illumination of a work of art through further judgment—methodic, inventive, and interrogative—in which no mode of judgment in particular predominates.

Articulation is judgment for the sake of further judgment, establishing and ramifying spheres of continuing judgment. Query is methodic, inventive, and interrogative judgment concerned predominantly with validation. Science, ethics, art, and philosophy are the major forms of

8. For an informal presentation of this view, see Morris Weitz: *Hamlet and the Philosophy of Literary Criticism*, Chicago, University of Chicago Press, 1964. Weitz finds elements of description, explanation, evaluation, and poetics in literary criticism, but offers no systematic theory of how they function in relation.

query. The principle of the interpenetration of the modes of judgment entails that every mode of query is intermodal, for every mode of judgment may be regarded as applicable to any particular judgment. Nevertheless, there is an important distinction for query relative to the pervasiveness and plurality of the modes of judgment. Every judgment is located in all the modes of judgment at once, but disjunctively or plurally. A statement is an assertion but may be regarded as an act. The two modes of validation here are relatively independent (except from the standpoint of pragmatic theories which make active judgment primary or psychological theories which would explain everything said in terms of aims and consequences). The modality of the judgment is not transformed by interpenetration and interrelation, but is essentially disjunctive. Query may be carried on predominantly within a single mode of judgment, methodically and interrogatively, inventively and validly. Where other modes of judgment are introduced, they do not affect the character of the query or the predominant mode of judgment. Description, interpretation, and criticism are methodic and inventive ways of articulating works of art and are modes of query. But in each the emphasis on a particular mode of judgment is predominant when not exclusive, and a single mode of validation is also predominant.

Alternatively, query may be typically and insistently intermodal. My particular concern here is with distinguishing illustrement from description, criticism, interpretation, and the theory of art. The latter are either unimodal or disjunctively multimodal (except for the last, which emphasizes generality, syndetic judgment). Illustrement is methodic, inventive, deliberative intermodal query relative to works of art. There is description, but in the service of evaluation and interpretation. There is a concern for the larger issues of art in relation to individual works. There is implicit evaluation based on both interpretation and description. There is interpretation to establish the integrity of the work relative to an accurate understanding of its effects. There is a deliberate and methodic enterprise in which a work of art is illuminated or revealed—illustred—in several modes of judgment conjunctively. None of the modes is predominant, though one may be emphasized, and an amalgam of all the modes is established.

Illustrement is query in which the variety of modes of judgment is employed to illustre a work of art—to reveal its nature, heighten its intensity, transform our understanding, improve our sensibilities. The best works of illustrement transform our perceptions of art by employing all the modes of judgment, none in particular. Illustrement is the manifestation through query of the powers of a work of art—and,

216

through controlled and inventive judgment, actualization of the powers of art in general relative to the nature of life and experience. Illustrement respects the powers of art, intensity of contrast, in relation to both art and judgment, leading to still more complex contrasts produced by the synthetic powers of the mind. Illustrement both illuminates intense contrasts and produces higher contrasts. It thereby fulfills the inexhaustibility of art in its own inexhaustibility, bringing all the powers of judgment to bear upon the inexhaustible richnesses of art. Art manifests inexhaustibility; illustrement needs the complete rational powers of the mind to fulfill that manifestation.

A brief review of the dimensions and general types of contrast may be useful in the context of illustrement. We clearly value works of art for their excellences and perfections, their achievements and triumphs: but in illustrement, we describe and evaluate such perfections, place them in a general context of a theory of art, and establish interpretations which exhibit such perfections by contrast. Analogously, every work of art is valued for its originality and invention, however subtle and restricted, manifested in illustrement by all the modes of judgment. Perfection and invention are particularly manifested by illustrive perfection and invention, a reason why illustrement is no less a mode of query than art itself. The celebrativeness of great works is perhaps more difficult to describe, except in terms of social expectations and responses, but is interpreted by contrast and evaluated implicitly. Here the power of contrasts to produce intensity through synthesis at higher levels is very important, for the celebrativeness of art is enhanced by the celebrative power of illustrement. The greater the power of the works they inspire, the greater the celebrative power of masterpieces of art. The orders created in illustrement, to the extent that they are sovereign and compelling in their own terms, engender effective and intense integral and scopic contrasts, manifesting the inexhaustibility of orders directly through the inexhaustibility of art.

More interesting, perhaps, are the general types of contrast, for they are relevant to some of the central controversies in the theory of criticism. Traditionary contrasts are relevant not only to stylistic and historical readings, but to the entire conception of *intertextuality*, where a work's relations to other works, earlier and later, are primary determinants of its identity and value.[9] Yet such traditionary contrasts are

9. See the works of Julia Kristeva and Harold Bloom, in particular: "Influence, as I conceive it, means that there are *no* texts, but only relationships *between* texts. These relationships depend upon a critical act, a misreading or misprision, that one poet performs upon another, and that does not differ in kind from the necessary critical acts performed by every strong reader upon every text he encounters. The influence-relation

only one of the major kinds of contrast. The importance of the medium and its relation to some domains of application and meaning are closely related to intramedial and intermodal contrasts, while relations among different arts are pertinent to intermedial contrasts. Variations among readings and interpretations, including differences between artist and audience, are included within intersubjective contrasts, leading to various integral and scopic contrasts that are relevant to the multifarious identities of works of art, their radical context-sensitivity and variability.[10]

It is essential to emphasize that all these contrasts are available to judgment and articulation, in all the modes, that even integral–scopic contrasts may be described, evaluated, and interpreted. More important still, since variability of identity is a central type of contrast relevant to works of art, it is absorbed into the work's identity and character, part of it, a constituent of its integrity. This may be the central reply to unrestricted relativism: not any and all readings may be assimilated to the public integrity of a work of art, though aberrant and idiosyncratic readings are part of the scopic vitality of important works and contribute to their influence in human experience. Works of art are inexhaustible and multifarious in their integrities and possibilities, and illustrement of such works may take an inexhaustible number of forms. Nevertheless, the constraints on illustrement defined by intermodality of judgment and the theory of contrast establish important and determinate criteria for illustrive validation.

How is the validation of illustrement to be established? In reading the best works of criticism, do we expect them to meet the criteria of validation of each of the modes of articulation separately—description, criticism, interpretation, theory—or do we expect a novel mode of validation? There are three possibilities: (a) Illustrement might be a conjunction of all the modes of query in relation to art, illustring a work and its value, but ultimately attaining validation only relative to modes

governs reading as it governs writing, and reading is therefore a miswriting just as writing is a misreading. As literary history lengthens, all poetry necessarily becomes verse-criticism, just as all criticism becomes prose-poetry." (Harold Bloom: *A Map of Misreading*, New York, Oxford University Press, 1975, p. 3.) This view is a confused and limited harbinger of the theory of illustrement, limited by its emphasis on traditional contrasts and confused altogether by the notion of *mis*reading and *mis*writing.

10. The fundamental and inalienable *difference* between the perspectives of author and reader is the foundation of Hans-Georg Gadamer's *fusion of horizons (Truth and Method)*. Gadamer's is perhaps the most effective and constructive theory founded on intersubjective contrasts, though it is greatly weakened by its emphasis on fusion and on historical time. The contrasts which are essential to art and interpretation are, as the theory of contrast indicates, inexhaustibly diverse, not simply a function of artist-audience variability.

of judgment taken singly. Here we may regard illustrement as method-ically intermodal, yet successful only relative to each mode taken indi-vidually. A given work of illustrement would thus be a satisfactory or true description, a convincing critical appraisal, a compelling interpre-tation, and a revelation of artistic principles in application. It would be each of them singly and many of them only in sum. (b) Illustrement may be an amalgam of the modes of judgment which attains a mode of validation comprised of each of the others in some aggregate: accurate where necessary, convincing in its evaluation, compelling in interpreta-tion, and systematically effective. It must meet all the criteria of the different modes of judgment, but in different ratios and emphases, based perhaps on a certain sum or balance of all the separate modes of validation. (c) By conjunction and the establishment of unique methods of judgment and query, illustrement may attain a novel mode of validation comprised of all the modes of judgment and query, but reducible to none of them in particular nor to any aggregate sum.

I do not believe that alternative (a) is persuasive. We have descrip-tion, criticism, and interpretation, but we also have methods for the analysis of works of art which are far more complex and illuminating. However, establishing which of alternatives (b) and (c) applies to illustrement in its more complex forms may be impossible at this time. No field today is more in flux and more critical of its fundamental tenets than the theory of reading—interpretation and illustrement. Some literary criticism is merely multimodal. Some is more complex and functions within all the modes of judgment together, providing a form of validation involving all the different modes. Nevertheless, it is far from clear whether illustrement has evolved and established a novel and intermodal species of validation unique to the reading and under-standing of works of art. In fact, there is a continuing conservative tendency to reject the uniqueness of illustrive judgment, dividing intermodal articulation into its component modes. An alternative ten-dency has been to reject the uniqueness of illustrement relative to art, seeking a uniform theory of interpretation and analysis appropriate to all language codes or texts. The latter development may be the out-come of an intuition that interpretation is effectively based on a unique mode of judgment and query. Nevertheless, it appears that illustrive works are sometimes based on conceptions of validation appropriate to (b) and sometimes to (c)—when not to (a)—and that the issue of whether illustrement is a novel mode of query is as yet an open question.

There is an important reason why it may remain an open question indefinitely, a reason rooted in inexhaustibility and contrast. In order to establish a plausible case for the uniqueness of illustrement as a

mode of query, it would be necessary to define a unique and clear method of illustrive validation. Yet all the modes of judgment and query are relevant to criticism and interpretation, and no particular synthesis or composite is primary. There is, then, a continual contrasting tension between alternatives (b) and (c) relative to every work of art and illustrive interpretation, leaving open the inexhaustible possibility of further contrasts and types of interpretation. Alternatively, there is an indefinite variety of kinds of illustrement, with different modes of validation relevant to them, so that no one particular mode of illustrive validation can be the maximal fulfillment of aesthetic value.

This brief discussion indicates clearly that illustrement is not a *superior* mode of articulation and query relative to individual works of art, and that it certainly is not the only appropriate mode. Moreover, there is no systematic basis for determining whether illustrement establishes a novel coordination among the modes of query in the articulation of works of art or whether it establishes a hybrid aggregate of the various modes of judgment producing only aggregative validation. Every mode of judgment is pervasive through experience and judgment—a consideration against viewing illustrement as a fundamental mode of judgment. Therefore, every mode of judgment, including hybrid modes engendered through query, is appropriate to works of art. Query is methodic and inventive interrogative judgment, and works of art may be queried in any, in all, or in a few of the modes of judgment, separately or in the aggregate. Nevertheless, I will argue that we may generalize illustrement so that it manifests the rational fulfillment of articulative query.

It is appropriate here to return to the principle that a fine work of art is a created order of intense contrasts. Value is found within a work through response to these contrasts—whether conscious or unconscious, explicit or implicit, in discourse, action, or further construction. A work of art succeeds if it engenders articulative responses to its contrasts in some mode of judgment. A momentary aesthetic experience may be poignant and intensely effective. Though never repeated, it may be remembered. Some works have effects in their own time, or upon a small audience, and pass from the scene. Yet they are not failures for their small term if their articulative impact has been significant. It is a remarkable thing to be deeply moved by a work of art or to sense that one is in the presence of an exceptional creation—though the emotion may pass never to be recaptured, and even if what was once exceptional later becomes trite. Some works have an impact for a certain age or walk of life, their contrasts having significance for a particular audience.

Fashions come and go in the arts, especially romances and adventures. As life changes, and our surroundings are transformed, fashionable works of art change also. What was fascinating to readers of two hundred years ago is no longer fascinating; today there are new idols. In contrast with such fashionable works, there are others which endure in their remarkable qualities, fascinating to all ages, all generations, and at all times—and for varied reasons.

Such works are often not *more* intense emotionally than are other, less successful works. They are often less affecting, and may be less immediately satisfying. They may be very complex, requiring profound study. Or they may be very subtle, appealing to rarified sensibilities. Their distinguishing characteristic is their endurance as remarkable for nearly all human beings who gain access to them. These works I have called "great"—the monuments of art: but such an epithet is meant more to describe their endurance than to capture specific qualities inherent in their construction.

Illustrement is faced with a complex task: to gain understanding of the significant contrasts found within important works of art and to estimate their enduring greatness. The latter judgment is so corrupted by expectations concerning the future of mankind and the need to manipulate taste that it can seldom be defended. Human life might change to the point where the most important works of our time would be meaningless, devoid of relevant comparisons. It is more important to know what within works of art may be found valuable than to predict whether human beings in some distant future will understand those contrasts. It is more important to define taste and to educate it than to foretell enduring aesthetic values. And finally, it is more important to add new works to the store than merely to enjoy the old—especially where old and new are illustred by contrast. All of these normative judgments are active and moral, and are subservient to that mode of validation. Nevertheless, in the same terms, it is more valuable to emphasize that constructive judgment is a distinct mode than to regard all works of art as a result of deeds and actions—though they are such and may be evaluated as such.

Interpretation and illustrement are of paramount importance to the arts. The greatness of a work resides in its enduring value for mankind. But its service to art and to humanity resides not so much in enjoyment as in further articulation. Here I must emphasize again that personal responses are judgments and may be articulations, though often of minimal scope. Response in terms of new works is the most sublime realization of possibilities in art.

221

The basis of art is pluralistic: creations within the arts show us that the world is not one but continually new and inexhaustible. We must respond to even the greatest works with other works, perhaps lesser ones, but which contrast with and thus illustre the greatness of the works of the past. Here personal responses—in one's conversations, works, and fantasies—are to be regarded as creative interpretations, though of modest ramifications. Science seems to tell us that knowledge might reach completion. And even morals would appear to afford a remarkable degree of systematization. Both are but appearances. Nevertheless, it is the arts which communicate to us unmistakably that greatness is never at an end and that artistic values reside in further judgments, especially novel creations, inexhaustibly.

ART AND QUERY

Science, ethics, art, and philosophy are modes of query, each emphasizing a particular mode of judgment. There are also other modes of query, less clearly identified since they do not correspond so closely to a particular mode of judgment. History, psychoanalysis, and illustrement appear to be unique and important modes of query, comprised of intermodal judgments, each emphasizing a particular mode of validation, emergent from interactions among established modes of judgment and query. I have defined query functionally: the inventive, interrogative, ongoing pursuit of valid judgments. Questions, judgments, and validation are modal concepts (in the sense of modality defined here), and are to be classified according to the modes of judgment: assertive, active, constructive, and syndetic. Query, however, is intrinsically intermodal, though there are different kinds of intermodality relative to the modes of judgment. My concern here is to delineate briefly the typical characteristics of artistic query relative to the other modes of query. As query, art is knowledge. The valid outcome of query is what we mean by knowledge.

Constructive judgment is creation directed toward a new and distinctive order. Yet an important scientific discovery is distinctive and we may engage in noteworthy and remarkable deeds. Heroism is seldom commonplace. The basis upon which the modes of judgment are to be distinguished is in terms of relevant methods of validation. A valid assertion may be new and distinctive, but it must be true relative to available evidence and theoretical principles. A successful act may be important and distinctive, but it must be effective in terms of the relevant circumstances and principles, including the commitments and

powers of the agents involved. A construction, however, is valid when intense in its contrasts, richly and inexhaustibly.

An important and novel assertive judgment may be thought of as a *discovery:* a truth brought to light by effort and imagination. A successful active judgment may involve the discovery of a principle, yet an agent does not "discover" a valid action but performs it. The gap between deliberation and action represents the difference between discovery and the exercise of active powers. A work of art, however, is *created:* invented not discovered, constructed not unearthed, contrived not disclosed, made not performed. Even the principles of art are invented, not discovered, established through contrivance as a consequence of constructive judgment. Where science and ethics are thought to invent their principles rather than to discover them, they are taken to be arts, subservient nevertheless to external standards of validation.

Any human product may be interpreted as an assertion, an act, or a construct. In art, however, we look neither to evidence nor to consequences apart from the work, though it may be compared with other works and we expect it to affect us. Validation in constructive judgment involves paying attention to the work and its constituents—that is, elucidating its contrasts and responding to their intensity. Validation in science and morality involves looking beyond the judgment to confirming evidence or practical consequences. Validation in art remains within the scope of the individual work. That is what we mean by the sovereignty of artistic masterpieces.

Presence will be noted here of some elements of the doctrine of the work of art itself, though nothing is in itself in an ordinal theory. The solution to this difficulty lies in what is taken to be "in" the work. A work of art cannot be separated from its constituents and relations, for as an order it both establishes and inhabits spheres of relevance. Its sovereignty is comprised of its constituents and its relations. Its being includes all its constituents and their different modes of relevance, expressed in all the ordinal categories. This is the inexhaustibility manifested in constructive judgment. An order is constructed, inexhaustible in its relevance and integrities, intensities and levels of contrast. The very notion of contrast involves relations and oppositions, orders in complex and inexhaustible interrelations. The sense in which we are to pay attention to a work of art, to emphasize its sovereignty, is not of paying little attention to anything else. There are its constituents and relations. Rather, the work is the only relevant standard, including its relations and constituents—but an inexhaustible standard. The work-in-its-manifold-relations is the standard of constructive validation. This is why the integral-scopic contrast plays a central role in artistic query.

223

The inexhaustibility manifested in art is precisely this contrast of the work in its manifold relations, its many integrities in contrast with its prevalence, the constituents of its scope in contrast with its integrity, its sovereignty in contrast with its relationality.

Assertive and active judgment emphasize respectively facts and consequences. These judgments are a means for attaining faithfulness or control. In constructive judgment what is sought is the creation of a new order subservient to no other standard. In such judgment the work is sovereign; in assertion and action, other orders define the standards. The validation of a constructive judgment turns entirely on what belongs to its integrity in a given context along with the relevant integral-scopic contrasts. The validation of assertive and active judgments may depend on what belongs only to their scope.

Validation in assertive and active judgment leads to conflicts: judgments compete as logical or practical alternatives. In this sense, assertive and active judgments are exclusive and restrictive as constructive judgments are not. Constructive judgments do not conflict, but enhance each other by their diversity and contrast. This follows from the sovereignty and incomparability of works of art. The distinctiveness of a fine work of art is in no way diminished by the distinctiveness of other works, but is rather enhanced by them. Their distinctiveness contributes to the intensity of the contrasts in which they all participate. A departure from a tradition is more compelling if the tradition is strong. Great works illuminate each other. One fine work may illustre another, a mutual illumination in intense contrast.

It is important to consider mixed constructive judgments such as an elegant mathematical proof or a remarkably executed athletic feat. In general, the validation of a judgment is determined by its particular modality—that is, a scientific paper must be true and an athletic feat must be successful. Yet we may imagine an elegant and compelling mathematical paper unsound in its argument, and a skier might be remarkably graceful yet lose the race. In both cases, however, the aesthetic value of the judgment would be enhanced were it valid within the other mode: an elegant theorem would be more fascinating were it true; a particular graceful end run in football would be more interesting were the runner to score. Great plays in sports nullified by penalty lose most of their vitality. The reason is that intermodal contrasts are heightened by validation in all the relevant modes of judgment. This is the final answer to the subject of truth in art: where aesthetic value turns on intermodal contrasts involving the truth of assertive judgments, then truth is relevant to art. On the other hand, intensity in contrast may be attained in many other ways, so that truth is not

necessary. Moreover, intense intermodal contrasts may interfere with, diminish the intensity of, other kinds of contrast. More important still, there are works of art where intensity of contrast depends in part on the falsity of certain assertive judgments—a fantasy or allegory, for example, or where irony is predominant.

The elegance of a mathematical proof or the grace and perfection of an athletic feat do not establish the relevant judgments as competitive with others. Elegance is a function of economy in mathematics, and is enhanced by other attempts at economy and brilliance. While we may consider a proof more graceful than another, we are more likely in our aesthetic appreciation to be concerned with the varieties of proof possible. In sports the point is clearer still, for we admire different athletes for their different styles. Constructive judgments are inexhaustibly plural in relation to other constructive judgments.

In the mode of constructive judgment, a great plurality of distinctive and important works is an end to be attained, but it is not easily won. Repetition blunts the intensity of variety; a surfeit of excellence increases our demand for perfection. Univalence is an ideal for assertive and active judgment, but it is impossible to attain for assertive judgment without qualification, while all actions are haunted by unresolved alternatives and possibilities of failure. In constructive judgment, by way of contrast, plurality is the end, and our ideal is that all constructions would be distinctive and important, coexisting and enhancing each other in our experience.

This difference among the modes of judgment may be formulated in a different way by appealing to the distinction between actualities and possibilities. There is a relationship between any given constituent of an order and its other constituents which may be interpreted as one of determinateness or, conversely, degrees of freedom: given an order and a subaltern order of its constituents, some of its other constituents are determined as actual relative to a superaltern order, others are but possibilities. I am distinguishing what is actual within an order relative to a subaltern order—the respects in which a given constituent is determined by other constituents—and what is possible—the respects in which a constituent is amenable to specification or modification, the persistence of alternatives. I am concerned with the extent to which and ways in which the constituents of an order are determined, compelled, or actual relative to some other constituents. It is necessary to repeat that possibilities are relevant to every order.

Ideally, assertive judgments would be determined by their grounds—in the sense that a conclusion follows from or is compelled by the evidence. Less ideally, assertive judgment is the order of maxi-

mal compulsion in judgment; constructive judgment is the order of maximal possibility in judgment; active judgment, turning as it does on the precariousness of experience, seeks the maximal compulsion consonant with irreducible possibility. No assertion can in fact be wholly compelled by evidence. But we suppose that what is not compulsive in an assertive judgment is irrelevant to assertive validation. Ideally, what is possible in assertion, given the evidence and formal constraints, is only variation in form and language, not in content. In fact, intermodality in scientific query is demanded by the requirement of maximal compulsion: formal and pragmatic conditions are imposed to maximize the compulsion of evidence. In active judgment, though compulsion is sought through deliberation and evaluation, an irreducible range of possibility remains within the integrity of every active judgment. We seek universality but fail to attain it. In constructive judgment, possibility is maximized—except that compulsion is essential to possibility. There are possibilities in every order, but there are actualities also. And some actualities are determinately related to other actualities within the order. Compulsion compatible with maximal possibility is the distinguishing property of constructive judgment, and is intimately related to its manifestation of inexhaustibility.

ILLUSTREMENT AND QUERY

Art is query: inventive and validational constructive judgment to attain intensity of contrast, to manifest inexhaustibility. Science and ethics are also modes of query emphasizing respectively assertive and active judgment. Philosophy too is query, emphasizing syndetic judgment. We may return to illustrement and our earlier discussion of its judgmental modality.

Illustrement is a form of query—but unlike science, ethics, art, and philosophy, without predominant emphasis on a single mode of judgment. Query is intrinsically multimodal: its indefinitely interrogative character leads it into diverse and plural modes of judgment. Yet only in some cases does query become fully intermodal—that is, involving so complex and interpenetrating a coordination of the modes of judgment that a novel and distinctive form of validation is engendered. Where such new modes of validation are produced, grounded in specific and determinate methods, we have a *prima facie* case for query having produced a novel mode of judgment.

There are two defining criteria of a mode of judgment: (a) a unique and dominant form of validation, with appropriate and relevant methods; (b) pervasiveness throughout judgment. I have emphasized

226

the latter condition: each of the modes of judgment is all-pervasive in the sense that any judgment may be regarded as possessing any modality. Illustrement seems to be of limited pervasiveness in pertaining specifically to works of art. Yet we may generalize illustrement so that it is pertinent to all orders including works of art: where all the modes of judgment are employed together to illustrate the distinctiveness of an order. Here the line between constructive judgment and illustrement becomes very thin, since art frequently employs intermodal contrasts to maximal effect. Illustrement here becomes the paradigm of intermodal interpretation and articulation.

For the moment, we may restrict ourselves to the illustrement of works of art. In this narrower sense, illustrement is to be distinguished from description, criticism, interpretation, and the philosophy of art: each is methodic and interrogative query articulating a work of art predominantly within a particular mode of judgment. Each is a mode of query relative to individual works of art, multimodal to the extent that it involves considerations relevant to several modes of judgment, but typically and predominantly emphasizing a single mode. The remoteness of philosophy of art from individual works is a function of the predominance of syndetic judgment for philosophy: an emphasis on generality and comprehensiveness. Illustrement is intrinsically and completely intermodal in its concern with the articulation of a sovereign and distinctive work of art: the interfusion and interpenetration of the four modes of judgment into a novel and distinctive form of query. Description, criticism, interpretation, and philosophy of art are forms of query; illustrement is to be distinguished from them by its far-reaching and singular intermodality in relation to the sovereignty of the work of art. I have distinguished the forms of query in relation to intermodality: there is intermodality in the service of a single mode of judgment and query emphasizing a single mode of validation; there is multimodality of an aggregative and disjunctive nature, where validation in each of the modes is relevant severally; and there is intermodal query which establishes a novel mode of validation through the interaction of the different modes of judgment.

The first criterion for judgmental modality is the establishment of an intrinsic mode of validation. While illustrement is intrinsically intermodal, its validation might simply be aggregative: the validation of an illustrive work a sum of the validations appropriate to the different modes of judgment and query—some truth, some assessment, some illumination by contrast, and some philosophical generality. It is not unreasonable that illustrement should be intrinsically but only summarily intermodal, defining no novel mode of validation, but attaining

its ends through satisfying the separate imperatives of assertive, active, constructive, and syndetic judgment.[11]

The alternative is that illustrement is a novel methodic activity—perhaps many such methodic activities—whose validation is not aggregative but synthetic. The goal is of illustring the work of art and its diverse values—revealing and highlighting them. A highly suggestive and plausible example is Frye's *Anatomy of Criticism*. Oddly enough, Frye has little interest in evaluation and enjoyment: illustrement for him is essentially a form of knowledge. But all modes of query are rational modes of knowledge. The point is that illustrement is here autonomous with its works of art.

Confronted with a masterpiece, how are we called upon to respond? By maximizing its powers and values. But there is no determinate measure in sum of such a maximization. We may describe a work, assess it, construct another work contrasting with it, or interpret art in terms of it. We may also create—perhaps recreate—its diverse values in full intermodality. And it would appear that a masterpiece compels us to illustrement in the latter sense: creating an interpretation of the work so that its structure, greater values, and contributions to art are unfolded together. Illustrement is the creation of another work that illustres the inexhaustible values of a given work inexhaustibly—that manifests its inexhaustible range of intensity of contrast inexhaustibly. Multimodality of judgment is essential to such inexhaustibility, but so is the synthesis of modes realized in intermodal query. Inexhaustibility can be illustred maximally only through further inexhaustibility, in this case through all the modes of judgment and query individually and in conjunction. Illustrement can realize its promise only through the invention of inexhaustibly novel modes of validation: it manifests inexhaustibility through the inexhaustibility of forms of query.

I have restricted the scope of illustrement within the preceding discussion to works of art. Yet illustrement has no such intrinsic limitations, but may be applied to all the modes of query and judgment. Philosophical and historical analyses are not, in their most complex intermodal forms, so very different from the illustrement of works of art. Perhaps the hermeneuticists are correct—especially Gadamer and Derrida—that all reading is ultimately the same: to describe, assess, interpret, and synthesize whatever is involved in a complex work, and, in a comprehensive embrace, to express the values and powers of the work over an inexhaustible range of possible modes of articulation.

In this sense, not only art but its most complex form of articulation, illustrement, is a unique and important mode of judgment. There are

11. See Weitz, *Hamlet and the Philosophy of Literary Criticism*, for such a view of literary criticism.

narrower forms of interpretation and analysis, but relative to all texts and judgments, especially within query, there is a fusion of modalities that can take an inexhaustible range of forms. As art is the fulfillment of constructive judgment, illustrement is the intermodal fulfillment of articulation through query. Every judgment here may be articulated illustrively; more important still, every judgment may be regarded as a component of one's personal life in which his judgments are articulated, even illustred together. Here biography may be viewed as a major form of illustrement—though by no means the only or supreme form. In addition, every judgment may be located relative to the major forms of query and illustred in relation to the life of reason.

Illustrement, then, is not only a fulfillment of art, but of all judgments, even of natural orders as they enter human experience. More accurately, in the full intermodal range of query relative to complex judgments in human experience, illustrement represents a fundamental and pervasive paradigm essential to the rational life.

Viewed in this light, illustrement offers a reply to the sceptical notes sometimes rung in response to the inexhaustible plurality of works of art and their interpretations. I have noted the growing body of work developed on the Continent, but moving in spirit across the Atlantic, in which epistemic authority is always in question relative to interpretation and understanding, especially where language is involved. A major feature of this development is a suspicion of philosophy, primarily of metaphysics, insofar as it would establish a basis for the other cognitive disciplines.[12] The fundamental argument is essentially that philosophy can establish no adequate grounds for knowledge because there are no such independent grounds. Knowledge—including the most rigorous physical sciences—emerges from social conditions and human practices, and is conditioned by history and tradition. In this sense, the conditions that make science possible are also conditions that enable us to call it into question, and the sceptical note rings loud and clear.

The most strident note is sounded by Derrida, who emphasizes the conditioned nature of all expression in his claim that there is writing

12. See here Heidegger's later works, especially "The End of Philosophy and the Task of Thinking," (*On Time and Being,* Joan Stambaugh ed., New York, Harper, 1972) and "The Onto-theo-logical Constitution of Metaphysics" (*Identity and Difference*); all of Jacques Derrida's works, but especially "'Ousia and Grammē': A Note to a Footnote in *Being and Time,*" (tr. by E. Casey, *Phenomenology in Perspective,* F. J. Smith ed., The Hague, Martinus Nijhoff, 1970); and Richard Rorty's claim to follow Heidegger and Dewey in rejecting the possibility of a philosophical theory of foundations as the basis of all knowledge (*Philosophy and the Mirror of Nature,* Princeton, Princeton University Press, 1979).

and only writing.[13] Writing here is contrasted with speech, which Derrida claims has been traditionally held to be natural, a direct expression of the nature of things. If there is no such direct expression, then all language and understanding is a writing conditioned by circumstances and history. There is an ultimate and irreducible excess, supplement, or difference in every signification or understanding which calls into question its very foundations. What we say is always a function of what we have said before, and cannot be separated from the human activities surrounding the use of language. On the other hand, we can only speak and write: we cannot escape from language, though its tyranny blunts the force of every truth.

The ordinal theory has no difficulty with the substance of this account, only with the sceptical spirit that seems to move it. There is, in every text, in every writing, in every cognition, an interplay of identity and difference, an opposition of justification and assumption. In Heidegger's *Identity and Difference,* each is shown to involve the other, identity leading to and being intelligible in terms of contrasts, differences presupposing identity. In *On Grammatology,* Derrida's fundamental concepts of *trace* and *différance* together manifest the same conjunction: the opposition of differences in every condition, the conditions inherent in every determination. Yet the conclusion, that philosophy and metaphysics are undermined by such differences, is unimaginative, as if philosophy is obligated to attain total determinateness or be altogether rejected. The key position is Heidegger's:

> Philosophy is metaphysics. Metaphysics thinks being as a whole—the world, man, God—with respect to Being, with respect to the belonging together of beings in Being, Metaphysics thinks beings as being in the manner of representational thinking which gives reasons. For since the beginning of philosophy and with that beginning, the Being of beings has showed itself as the ground (*arche, aition*). The ground is from where beings as such are what they are in their becoming, perishing and persisting as something that can be known, handled and worked upon. As the ground, Being brings beings to their actual presencing. The ground shows itself as presence. The present of presence consists in the fact that it brings what is present each in its own way to presence. In accordance with the actual kind of presence, the ground has the character of grounding as the ontic causation of the real, as the transcendental making possible of the objectivity of objects, as the dialectical mediation of the movement of the absolute Spirit, of the historical process of production, as the will to power positing values.
>
> What characterizes metaphysical thinking which grounds the ground for beings is the fact that metaphysical thinking departs from what is

13. Derrida, *On Grammatology.*

present in its presence, and thus represents it in terms of its ground as something grounded.[14]

Presence here seems to require a determinate ground, one which cannot be established without arbitrariness, rather than being what an ordinal theory would take it to be: one ordinal condition among others, of no particular primacy.

The Heideggerean-Derridean program—or *anti*-program where its scepticism is emphasized—is a natural conclusion of Hegelianism gone astray, a dialectic without Spirit. History here becomes the ground of meaning without a purpose, a meaning therefore with no ground larger than the particular reflection. A hidden dialectic, a play of opposites, haunts every signification, transforming it into its opposite. Identity entails difference, but difference entails identity. Language then is haunted by concealment and arbitrariness, an irrelevance inherent in every expression. The play of identity and difference, opposition in determination, is found explicitly in Heidegger. Yet Heidegger appears to believe that a more poetic rhetorical style can manifest truth amidst indeterminateness, unconcealment amidst concealment. Derrida rejects Heidegger's later writings and his apparent worship of poetry over science, for no rhetorical mode can resolve the differences or fully manifest the oppositions. All expression is "only writing" in its arbitrary historical and social conditions. The infinite arbitrariness of these conditions—expressed in Derrida's trace of the trace—is manifested in the infinite play of deconstruction, as if meaning resides in the quest for total determinateness and as if without total determinateness all other forms of determinateness are without significance. Every mode of expression is equally arbitrary and conditioned, requiring an infinite process of deconstruction and rewriting.

The theory of contrast, grounded in ordinality and a plurality of modes of judgment, resolves the central features of the Derridean program without the sceptical tone. The metaphysical basis for this is the determinateness that is functionally relevant to every indetermination. Both deconstruction and query are infinite and inexhaustible, but in very different ways, based on very different principles. In this sense, the ordinal theory of contrast can respect the inexhaustibility of art without succumbing to destructively sceptical implications.

Identity and Difference

Every determination is replete with indeterminateness. Being is pervaded by differences and oppositions. But the inexhaustible open-

14. Heidegger, "The End of Philosophy and the Task of Thinking," pp. 55-56.

ness of every determination to further determination is conditioned in the theory of orders by functional categories. Relative to every integrity there are other integrities of the same order as well as its scopes. But given an ordinal location, an order has precisely the integrity and scope it has, and no others. Relative to every prevalent order there are relevant deviances—but these prevail elsewhere, while what is prevalent is deviant somewhere. Relative to what is actual in an order, there are always possibilities, but these too are actual elsewhere. Moreover, possibilities are a function of intersecting orders. Ordinal location is the fundamental concept that bridges determinateness and indeterminateness in every order, but it is a reciprocal relationship. Determinateness is as relevant as indeterminateness. This is the final reply to scepticism.

It follows that determinateness and indeterminateness are not so simply related as Heidegger and Derrida seem to believe: they are not opposed but are complementary and functionally interrelated. Because the opposition is qualified by ordinal location and function, determinateness and indeterminateness may be regarded as traits of orders, of beings, not simply of our modes of conception and expression. The opposition is neither extraordinary nor incoherent, but is a manifestation of complexity and inexhaustibility. Inexhaustibility here is a feature of ordinality, and ordinality entails integrity as well as relationality. Metaphysics is then not incompatible with indeterminateness, but only with a limited conception of unqualified determinateness and presence. Judgment also is pervaded by indeterminateness, along with determinateness, but not more so, or more destructively, than orders in general. The openness and inexhaustibility of query is a consequence of the indeterminateness and inexhaustibility of orders of judgment, but complemented by the determinateness and efficacy of validation produced by query. The inexhaustibility of query does not undermine the validity of query where attained, but is its basis as well as its fulfillment. Query would not be possible without both determinateness and indeterminateness, requiring determinateness for validation and indeterminateness for development. The full complementarity of determinateness permeates all indeterminateness, and emphasizes the grounds of meaning and validation established within query.

Writing

The infinite relevance of antecedent conditions to every judgment, which transforms expression into writing in Derrida's formulation, is mirrored by the ordinal conception of relevance as the basic constituting ground for ordinality. Every order inhabits an inexhaustible sphere

(or inexhaustibly many spheres) of relevance, inexhaustible both in its possibilities and in its mediating connections. Yet not all constituents of an order contribute to its integrity in a given location. A plurality of integrities may all be functionally compatible with a particular gross integrity. The foundation of language and intelligibility on inexhaustible conditions and ramifications need not affect the determinateness of integrities and identities. All expression, all determinateness, is conditioned. But not all conditions are integrally relevant. Moreover, indeterminateness cannot undermine determinateness, for each requires the other.

The absence of ultimate grounds of knowledge establishes an infinite succession of questions and responses, an infinite process of construction and deconstruction. Such infinite questions are inherent in the infinite nature of query. But they are not incompatible with argument, validation, consensus, or understanding. Query is an infinite project of interrogation, the source of novel judgments and novel modes of query. But it presupposes validation and determinateness. Those questions that may admit of consensual resolution will do so through query; other questions may not.[15] Nevertheless, if not attainable through query, epistemic resolution is not only impossible but meaningless. Both the questions and their answers rest on the methods and principles of query. Without the determinateness grounded in query, both questions and answers must be dismissed as pointless and unintelligible.

Only Writing

This is the answer to the Derridean claim that all writing is only writing, as if there are no fundamental differences among the modes of query. Relative to certain general features, all judgments are the same as judgments—similar in certain respects. All modes of query are modes of query—that is, interrogative, inexhaustible, methodic, inventive. But some produce publicly grounded conclusions that further query refines and enriches, but whose integrity is maintained throughout all additional query (relative to the relevant modes of judgment). Other modes of query open infinitely new questions and forms of interrogation.

There are at least four modes of judgment and at least four modes of query emphasizing respectively one of the modes of judgment. There are other modes of query, for by intermodality query produces new forms and new standards of validation. Illustrement is one of them.

15. For a detailed discussion of these issues, see my *Philosophical Mysteries*.

The ordinal theory emphasizes the common properties of judgment and query—but also their differences: differences realized through query itself and grounded ultimately only in query. Nevertheless, the openness and inexhaustibility of query does not eliminate its conditions or its determinateness.

Deconstruction

The conditions of judgment require an infinite and inexhaustible project of interrogation to refine and re-validate the conditions themselves. What Derrida calls deconstruction I see as the very nature of query: its infinite and inexhaustible openness to new questions and new modalities. Yet the notion of *de*-construction is greatly misleading, especially where it entails wholesale scepticism and indeterminateness. Query reflecting upon the validity of earlier query is not *de*construction, for it cannot simply dismantle, but must build another valid outcome. What I have called interpretation comes closest to deconstruction, the creation of another work illuminating a prior work of query by contrast. Still, the standards of validation are inherent in the intense contrasts required, and cannot be entirely abandoned. Multiplicity here is a value, manifested in the enrichment of contrasts. Deconstruction is always construction; construction is always judgment, subject to its modes of validation, enriched by the activities of query.

The ordinal theory includes within it a fundamental and inexhaustible opposition of determinateness and indeterminateness. Every pair of categories expresses a functional relationship that may be characterized as determinateness conjoined with indeterminateness: integrity with scope, prevalence with deviance, actuality with possibility. Yet the functionality of the theory means that determinateness is no less relevant than indeterminateness, for what is indeterminate in some locations is determinate in other locations and conversely. As a consequence, the inexhaustibility of ordinality contains within it everything of importance in the hermeneutic emphasis, but completely avoids the scepticism which rests on unwarranted assumptions about the determinateness of metaphysical philosophy.

An ordinal theory offers a metaphysics which includes determinateness and indeterminateness, qualifications and conditions, within its central categories. The determinateness of integrity, the basis for unitariness, is grounded in ordinal location, establishing inexhaustible constituents of scope and possibility. Nevertheless, there is integrity wherever an order possesses a location, and it can be known and understood, as well as modified and transformed.

Art, here, is the revelation of inexhaustibility in ordinality through contrasts and by creation, attaining its value of intensity of contrast only because of inexhaustible indeterminateness. Yet without the corresponding forms of determinateness, art would be impossible and unintelligible. In this very general and profound sense, art offers a complete reply to hermeneutic scepticism. What a work is (or means) is inexhaustible, requiring an inexhaustible wealth of additional works interpreting it by contrast. But the same is true for any order, and is the basis for the inexhaustible wealth of great works of art which enrich each other's integrities through contrast, indefinitely, but dependent on the precise limits of both art and human experience for effectiveness.

The final answer to the scepticism inherent in deconstruction is given by illustrement. Here it is not dismantling but creating, yet not only the creation of another work, writing followed by writing, but the creation of another mode of query. We may think of novel modes of query as effectively undermining established modes of query, increasing the modes of validation. Yet the striking truth is that illustrement enhances and supports the validation of the work it addresses. It can do so because it defines new ordinal locations for such validation. Query meets the force of plurality and relativity by its own resources, developing new modes to exhibit and establish the validity and meaning of older modes. Reason here is fulfilled by query, in all its forms but especially by intermodality.

Illustrement is intermodal query in the service of understanding a complex human judgment, utilizing all the means available. There is no supreme method or form of illustrement that tells us what a work is altogether or without qualification. But nevertheless, its integrities are both engendered and exhibited through illustrement. Query here is indefinitely and inexhaustibly unterminating, yet its very existence—its possibility—manifests the determinateness of the orders to which it pays attention. The inexhaustibility of query expresses not the indeterminateness of human experience as such but the inexhaustibility of orders. This inexhaustibility is a function of both determinateness and indeterminateness, for indeterminateness also depends on conditions grounded in the functional interrelationship of determinateness and indeterminateness. The power of illustrement in relation to the complex works it illustres manifests their inexhaustibility and indeterminateness but their determinateness as well including the integrities established by that illustrive activity. In other words, the variability of interpretations of works of art and other writings and judgments is a variability present in experience, either antecedent to interpretation or engendered by it. Nevertheless, variability—deviance—is cofunctional

with prevalence, and what is prevalent over many orders of judgment and experience is also manifested by art and illustrement. Illustrement fulfills the determinateness of orders and judgments as well as their indeterminateness, the integrities of works of art as well as their inexhaustibility. Deconstruction is simply the inexhaustible articulation of judgments by further judgments, query by further query. This is the very foundation and fulfillment of illustrement.

The inexhaustible plurality of orders generates an inexhaustible plurality of interconnections. Some of these relations are transitory and minor; some are of great influence within experience. We require inclusive orders in terms of which to grasp the interplay of subaltern orders, a synthetic realization of new connections. Here is the great responsibility of philosophy. But it is a responsibility also met by the other central forms of intermodal query: history, religion, and illustrement. All of the modes of judgment together, in ongoing and recurrent interaction, comprise the life of reason. Here is the only true rational life, permeated throughout by unrealized possibilities, freed by the critical powers inherent in the interplay of all the modes of judgment, constantly achieving new forms of synthetic achievement.

Index

Abstract art, 154
Accuracy, 14, 19, 198. *See also*
Faithfulness, Representation, Truth
Action. *See* Active judgment
Action painting, 166, 176, 185
Active judgment, 27-29, 39, 52, 68,
88-91, 106, 111, 124, 136, 138-41, 190,
196, 201-209, 212-16, 221-28. *See also*
Judgment
Actuality, 58, 62, 68, 71-77, 80, 90-91,
95, 111, 122, 143, 200, 212-225-26,
232, 234. *See also* Ordinality,
Possibility, Reality
Aeschylus, 113, 144
Aesthetic attitude, 5, 16, 189-90
Aesthetic judgment. *See* Aesthetic value,
Constructive judgment
Aesthetic value, vii, ix, xii, 4, 8-9, 20, 25,
29, 33, 35-36, 49, 56, 69-70, 79, 81, 84,
94-194, 200-202, 206, 220-21, 224. *See
also* Artistic value, Contrast,
Inexhaustibility, Intensity of contrast
Alice Through the Looking Glass, 169
Ambiguity, 51-51. *See also* Contrast,
Inexhaustibility
Analysis, 63, 70, 163. *See also* Criticism,
Description, Illustrement,
Interpretation
Anouilh, J., 144, 209
Appearance, 14-17, 29-32, 65, 183-85;
and reality contrast, 15, 138-39, 152,
183-85, 187
Aquinas, T., 2, 35
Archetype, 23, 123, 158. *See also* Model

Architecture, 14, 16, 22, 111, 121, 124,
129-30, 139-40, 161, 177
Aristotle, 25-26, 30, 72, 144
Art. *See* particular topic in connection
with
Art for art's sake, 28, 39, 79, 89,
108-109. *See also* Sovereignty, Work of
art itself
Articulation, 92, 140, 203, 205, 208-209,
211, 214-16, 218-21, 227-29, 236
Artifice, 32-34. *See also* Constructive
judgment
Artist, viii, 3, 5, 21, 33, 41-42, 46-47,
105-107, 122, 125, 143-44, 146-47;
and audience contrast, *See* Audience.
See also Constructive judgment
Artistic production, x, 90. *See also*
Constructive judgment
Artistic value, viii-ix, xi, 1, 5-8, 14, 16,
20-21, 26, 34-35, 38, 41-42, 44, 46, 51
53, 58, 70, 73, 78, 82, 97, 106, 111,
136, 155, 180, 205, 222. *See also*
Aesthetic value, Constructive
judgment; Aesthetic value
Artworld. *See* Social milieu, Tradition
Assertive judgment, 27-29, 51-52, 88-90,
104, 136-37, 141, 151, 188, 190,
192-93, 196, 198-201, 206, 209, 212,
214-16, 222-28. *See also* Judgment,
Truth
Audience, 25, 46-47, 66, 70, 75, 84, 96,
111, 115, 118, 123, 143-47, 152, 171,
173, 175-76, 192, 195, 202, 204-205,
208, 210, 214, 218, 220; Artist and

237

Stokes, A., 81, 168n
Strauss, R., 163
Structuralism, ix. *See also* Generality and
specificity contrast
Style, vii-ix, 13, 24-25, 34, 37, 41-45, 68,
100, 105-106, 109, 120-22, 126, 141,
159, 161, 192, 210-11, 217, 225
Subjectivity, 5, 35, 46-49, 56, 79, 214. *See
also* Experience, Intersubjective
contrast
Subject matter. *See* Content
Sublime, 33, 35, 38, 54, 163. *See also*
Aesthetic value, Greatness
Sullivan, L., 121
Surface and depth contrast, x, 20, 128,
154, 161-63, 180
Swabey, M. C., 178
Symbol, 8-10, 14-15, 18, 22-23, 25, 30-31,
104, 114, 123, 127, 154, 157-58,
160-61, 183, 196
Syndetic judgment, 188, 212n, 216, 222,
226-28. *See also* Judgment, Metaphysics

Taste, 1, 35, 46. *See also* Aesthetic value
Techne, 25. *See also* Active judgment
Technology, 34, 110, 119-20
Theater. *See* Drama, Performance
Theories of art, 13-57. *See also*
Philosophy, Theory of art
Theory of art, vii, x-xii, 1, 3, 7, 13-14, 41,
49-50, 52, 114, 212, 215-16
Thucydides, 113
Time, x, 7, 30-31, 49, 51, 62, 67, 69-70,
95, 102-103, 107, 115, 118-19, 146,
162-63, 166, 170-78, 192; contrasts,
172-78; virtual, 31, 174; timelessness,
101, 191. *See also* History, Tradition
Token, 157-61; and type contrast, 154,
157-61
Tolstoi, L., 22n
Tovey, D. F., 100n, 119, 132-33
Tradition, viii-ix, 2, 7, 11, 34, 37, 72, 95,
108-10, 118-24, 130, 135, 144, 148,
152, 155-56, 165, 204, 229. *See also*
Traditionary contrast
Traditionary contrast, x, 94, 109, 118-24,
126-27, 134-35, 143-44, 146-47, 150,
161, 181, 188, 192, 210, 214, 217-18.
See also Contrast, Tradition

Tragedy, 25-26. *See also* Drama
Transition to an Ordinal Metaphysics, xi, 2n,
67n, 69n, 212n
Translation, 66, 99, 130
Tristan and Isolde, 135
Triteness, x, 5, 23, 83, 98-99, 204, 220.
See also Celebration, Perfection
Truth, 2, 19-20, 26-29, 79, 89-90, 104,
107-108, 111, 113, 136-38, 145, 178,
188, 193, 198, 200, 206, 213-14,
223-25, 230-31. *See also* Assertive
judgment, Validation
Type, 157-61. *See also* Token and type
contrast

Ugliness, 35, 162-65. *See also* Beauty
Ulterior ends, 89-90, 189-94. *See also*
Sovereignty
Uniqueness, of work of art, ix-x, 6, 15,
20, 28, 35, 38-39, 60, 70, 79, 87, 109,
116, 158, 160. *See also* Incomparability,
Sovereignty
Unity, 35-36, 53-55, 60, 63-64, 66-67, 74,
76-78, 86-87. *See also* Contrast,
Integrity
Universality, 8, 22. *See also* Generality,
Pervasiveness
Utility, 38-41, 79, 111, 130, 137-38, 209.
See also Active judgment, Morality

Validation, x, 27, 79-80, 88-89, 91, 135,
184, 188, 190-94, 200, 206, 208,
215-16, 218-28, 232-33, 235. *See also*
Judgment, Query, Truth
Value, *See* Aesthetic value, Artistic value,
Intensity of contrast, Validation
Van Gogh, V., 18
Variation, viii-ix, 4, 58-59, 156. *See also*
Deviance, Invention
Verisimilitude, 16-20, 25, 28-29, 46,
138-39, 166. *See also* Realism, Truth
Violence, in art, 186-89
Virtuosity, 105, 128-29, 135. *See also*
Performance
Vision, and art, 41, 44, 50, 166-69. *See
also* Painting

Wagner, R., 135
War and Peace, 55